The Subordinated Sex

The Subordinated Sex

A History of Attitudes Toward Women

Revised Edition

Vern L. Bullough,
Brenda Shelton, and Sarah Slavin

The University of Georgia Press

Athens and London

© 1988 by the University of Georgia Press
Athens, Georgia 30602
All rights reserved
First published in 1973 by the University of Illinois Press, Urbana, as
The Subordinate Sex: A History of Attitudes Toward Women
Set in Linotron Trump Mediaeval at The Composing Room of Michigan, Inc.
The paper in this book meets the guidelines for permanence and durability
of the Committee on Production Guidelines for Book Longevity of the
Council on Library Resources.

Printed in the United States of America

93 94 95 96 97 P 6 5 4 3 2

Library of Congress Cataloging in Publication Data

Bullough, Vern L.
The subordinated sex : a history of attitudes toward women / Vern L.
Bullough, Brenda Shelton, and Sarah Slavin.—Rev. ed. p. cm.
Rev. ed. of: The subordinate sex. 1973
Bibliography: p.
Includes index.
ISBN 0-8203-2369-1
1. Women—Public opinion—History. 2. Public opinion—History.
3. Men—Attitudes—History. I. Shelton, Brenda K. (Brenda Kurtz).
II. Slavin, Sarah. III. Bullough, Vern L. Subordinate sex. IV. Title.
HQ1121.B84 1988
305.4—dc19 87-23292
CIP
British Library Cataloging in Publication Data available

To our children

Contents

Contents

Preface to the Revised Edition

This book is not a history of women. Rather it is a study of the way people, almost always men, have looked at women, a quite different thing. Though occasionally women speak for themselves, in the past it has been men who acted as gatekeepers as to what was written and recorded and, in the process, impressed their own versions of women upon history. In recent years growing numbers of feminist-oriented historians have challenged this traditional view and have given us a somewhat more complete view of how women lived, what they thought, and what they did. Gradually this scholarship is working its way into popular history texts and into the public consciousness and bringing about a reassessment of the role of women in the past. To effect change, however, we need to know what the traditional views were, and it is to this end that *The Subordinated Sex* has been written.

This is the second edition, newly revised and updated, of a book published over a decade ago and includes two collaborators who are primarily responsible for the last three chapters. The rest of the book is mainly an updated version of the earlier one. We have attempted to include much of the most recent scholarship, always keeping in mind that our book is about attitudes, not actual accomplishments. For this reason, in many cases we often have not included feminist challenges to what can only be called a male view of history. As we arrive in today's world, women have increasingly begun to speak for themselves, to

counter the generalized putdown of women so evident in much of this book, and here we have tried to cast our net wider to reflect new attitudes that are developing.

The three authors do not espouse any particular theory about the development of civilization, nor do we posit any simple reason for the past subjugation of women. We lack a satisfactory explanation of why women apparently failed to rebel against this subjugation. Instead the book summarizes attitudes and the implications of these attitudes for women as a group. If we were to advance a reason for change, our answers would be multiple, but among the variables that appear most obvious is biology. Though the statement that biology is destiny has been deservedly criticized, to the extent that it once was a major factor, it no longer looms so important. With contraceptives to help plan or avoid childbirth, better diets to lessen anemia, the development of machines that lessen the importance of muscle power and brute strength, and wide use of sanitary pads and tampons to remove the stigma from menstruation, women have been better able to assert their identity. Tied in with the lessened impact of biology, of course, are the number of economic, social, and political changes, some outlined in this book, that have decreased the inequalities of the sexes. Still we lack full equality, although the foundations for equality are stronger than they ever have been. The problems that remain are psychological and attitudinal rather than biological, and both of these have their roots in history.

In a sense this book grew out of a variety of projects in which the first author was engaged. His first book-length studies were of nursing and of prostitution, both "women's" occupations, and although there is a world of difference between them, there are also striking similarities. From these projects he developed courses concerned with the history of women before the feminist movement developed. Since he also spent many years studying the history of sexuality and of sexual attitudes, sexual attitudes probably loom more important in this book than some others. The two women who have contributed to this new edition come from different disciplines. One is an American historian who began teaching courses in women's history in 1974 and has continued to do research in that rapidly expanding field. The other is a political scientist who has written extensively about women in the twentieth century both under the name of Slavin, her maiden name and the one she now uses, and under Schramm, the name under which she began her political and scholarly career.

The authors hope that the combination of these backgrounds will en-

Preface to the Revised Edition

able the reader to understand the historical forces that formed our society and still influence our attitudes. We would like to acknowledge the assistance of Debra Heisler, Janis Bolster, Debbie Winter, and Nancy Holmes. Special thanks are due to Elizabeth Makowski and Jo Ann McNamara, without whose help this book would not have been published, and to Patricia Messinger, who prepared the index.

The Subordinated Sex

1 / The Background

Humanity could not have existed without women. Women, like men, have suffered through plague, war, depression, famine, tragedy, and have had the added burden of childbirth. Yet compared to men, we know very little about women in the past. Men have been generals, kings, writers, composers, thinkers, and doers, according to the history books, while women have been wives, mistresses, companions, friends, and helpmates. In short, men have defined women in terms of themselves and assigned them a role subordinate to their own. The very word *woman*, in fact, emphasizes this passive, subordinate position. It derives from the Anglo-Saxon *wifman*, literally "wife-man," and the implication seems to be that there is no such thing as a woman separate from wifehood. As individuals, with few exceptions, women were not counted as important. They were simply mothers, wives, daughters, sisters, proper and forgotten.

Unfortunately, we do not know how most women in the past regarded either themselves or their roles as almost all we know about them comes from the writing of males. Until recent times few women left written records of themselves. This means that those women of the past whose names we know or whose deeds have been recounted come to us through male transmitters. The male-controlled records imply that women accepted their subordinate role, but even if they did not, there was little society permitted them to do about it, nor did it record the many times when they expressed their discontent.

One of the few ways women could make a living on their own

1

throughout much of history was by selling themselves, and it is worthy of comment that until almost the nineteenth century history records more famous prostitutes and mistresses than it does women writers, composers, or artists. In fact, about the only way a woman managed to appear as an individual in the historical record was when she scandalized her contemporaries. Even if a woman held a powerful position, she is much more likely to be remembered if her actions, particularly those connected with sex or her personal life-style, shocked her contemporaries. Simply being a queen was not enough to make the history books. Scandalous conduct as queen counted for more. Theodora, the Byzantine empress, is remembered because of her irregular sex life before she became empress rather than for her accomplishments as empress. Eleanor of Aquitaine, Hatshepsut (the Egyptian pharaoh), Cleopatra (the Ptolemaic queen), Catherine the Great of Russia, and Lucrezia Borgia are others who could be listed who scandalized their contemporaries, and there are many more. Even the great Queen Elizabeth I is no exception. It is Elizabeth's insistence on not marrying and her unconsummated love affairs that have been the focus of attention. Because Elizabeth was such an effective ruler, some nineteenth-century (male) historians believed the only possible explanation for her achievements was that she was really a male in drag. According to these accounts, the real Elizabeth had died as a young child, and a neighbor boy of the same age was substituted in order to fool her father, Henry VIII, on his occasional visits with her. In a sense such a story is a credit to Elizabeth's abilities because only by inventing such legends could some men understand how a woman could be an outstanding ruler. This one incident helps explain the difficulty of any study of woman in the past.

Since both the actions which went into the making of history and the records kept by a society have in general been determined from a male point of view, any history of women must of necessity be primarily a history of man's attitudes toward women. This not infrequently is a depressing kind of history since men have usually tended to see women from two extremes, as the perfect mother symbolized by Mary or as temptress symbolized by Eve. Only rarely is she pictured as a real living human being with ideas and emotions like those of other (male) human beings. Inevitably, also, history has been written to emphasize that the proper role of woman is to be subordinate to man. As a leading American historian of the early twentieth century explained, everything in women's "existence is subordinate to their indispensable functions of continuing and rearing the human race and during the best years of their life, this work, fully discharged, leaves little room for any other."[1] But

why such self-assured consignment of women to a subordinate role? Oscar Wilde, who always tried to say clever things, had one of his better moments when he pointed out that "All women become like their mothers. That is their tragedy. No man does. That is his."[2]

Men have usually believed they are the superior sex, but is it not possible that they both fear and envy women? Biologically of course woman is different from man, and as the French say, *Vive la différence*. Usually this statement has been taken as a paean of praise to the pleasures of sex, but can it not just as easily be taken as a man's way of asserting his relief that he is not a woman? If woman's biological differences set her apart from the male of the species, these differences in the past have tended to hamper her rather than help her in any struggle with the male. During the prime of their lives, women were usually pregnant, probably at least every other year until menopause. The long periods of gestation cut them off from the freedom to roam and help account for the male monopoly on hunting and fishing. Even though there was a high proportion of miscarriages and a high infant mortality in the past, still the continued pregnancies and the slow development of the child from infancy to puberty curtailed the scope of feminine activities. Men on the other hand were free to leave the home, to roam at will in the forest, to hunt, to fight, even to contemplate. In spite of the current male tendency to make fun of female fashions, originally it was men who had the time to put feathers in their hair and rattles on their wrists and ankles, to paint their faces, and to more fully develop their personalities. This does not mean that women were not productive in advancing civilization. They were. Anthropologists in general believe that women were the key innovators in basketry, weaving, pottery, in domesticating grain and improving its seed-bearing ability. Their contributions to agriculture are held by some to have created one of the major revolutions in human history. Women's contributions have often been trivialized and hidden by the power of men to label their own contributions as "important" and to reward their own labor with praise, money, and status. Moreover, in the field in which women made significant contributions they were often later pushed aside so that men could assume both credit and control. For example, once agriculture developed and specialization occurred, most of the tasks previously done by women were taken over by men, although their wives and daughters continued to work as their assistants.

One explanation for this subordination might be that women lacked the physical energy to assert themselves. Biologically women are prone to anemia, and the lack of protein in their diet during much of recorded

history probably made them more willing to accept male domination. John Stuart Mill, the nineteenth-century advocate of rights for women and a major figure in modern thought, held that the reason for women's submission was the superior strength of the male.[3] Obviously the rape of the female is an example of the power of this strength; it is also an assertion of control and power. Most male writers, however, have been reluctant to accept arguments based on brute strength and have tried to find other explanations more suitable to their egos.

Even if strength was its own law, at least until organized society was well advanced, we must question whether it alone was the cause for male supremacy throughout so much of history. The problem has intrigued investigators from a variety of disciplines. Some argue that dominance is due to biological factors and that women have been handicapped by the necessity to give birth and provide milk to children; others argue that male dominance was evolutionary or that the dominance was situational, related not to biological sex but to activity and skill. Still others look to cultural or social or economic factors. No one explanation seems satisfactory and each can be doubted.[4]

What appears most evident from the historical record is that, regardless of explanation, most general theories of the past seemed to have assumed the domination of the male either as inevitable or as good and necessary for society. This kind of justification appears in the biblical explanation of male dominance, discussed later in this book. Even as the biblical explanation was challenged in the nineteenth century, other explanations—some have called them "social charter myths"—arose to justify male domination. Two men who wrote about the nature of society and woman's place in it, Sir Henry Maine and J. J. Bachofen, both published their works in 1861. Both developed theories about the early nature of society that helped perpetuate myths about the importance of male dominance. Maine held that the patriarchal system of authority was the original and universal system of social organization. The family was the original unit, and the eldest male parent held supreme authority in the household. From the family such authority had been extended into clans, from clans into tribes, and so on. Almost always men were the rulers, although occasionally, when for some reason or another women outnumbered men, matriarchy temporarily existed, but only as an unstable and degrading form of organization.[5]

Bachofen agreed that patriarchy was a superior kind of organization to matriarchy, but he did not feel it was the original or universal system of social organization. Instead it represented advancement on the evolutionary scale. Originally society had existed in a state of sexual promis-

cuity with no stable family life, and in such a state women, "defenseless against abuses by men" and exhausted by male "lusts," felt the need for regulated conditions and purer ethics. Since mothers were the only parents the younger generation knew with certainty, they could use their position to lay the foundation of a rule of women (*gynecocracy*). Men accepted these new female constraints unwillingly, but in return for man's giving up the right to any woman he wanted, woman surrendered herself for a limited period to one man. In this evolution of society women were aided by religious beliefs, since humankind at this stage in its development was wholly dominated by faith. According to Bachofen, it was women, with their profound sense of the divine presence through their ability to bear children, who capitalized on man's reverence for nature, and though physically weaker, they were able to assert their strength over the male as the repository of the first revelation. Eventually, however, men usurped power and subjugated their women, and their society was able to advance further on the evolutionary scale. This was because women ruled only when society remained close to nature, but when intelligence was essential, men were needed to rule.[6]

Maine and Bachofen shared the assumption that societies passed through a series of differing stages. Several scholars set to work studying primitive societies to find out whether matriarchy or patriarchy was the earliest form of organization. The American ethnologist Lewis N. Morgan believed he had observed the transition from a system based on *jus maternum* (mother right) to *jus paternum* (father right) among the Iroquois Indians. From his observations he evolved a system of sex and family law for primitive peoples in which society progressed from the complete promiscuity of the primitive horde into the organized hunter tribes in which sex life was strictly regulated. At this stage the mother, since the father was unknown, remained the decisive factor in all questions of family relationship and inheritance. It was only when production developed enough for two human beings, man and woman, to maintain themselves economically by stock breeding and agriculture that the family split off and became a monogamous unit. In effect monogamy went hand in hand with the evolution of private property, and since economically the male was more active and physically the stronger, the woman fell under his domination, sexually and otherwise. The natural superiority of women, natural because she was more closely connected with offspring, was succeeded by the unnatural primacy of man.[7] Man held this primacy on the basis of his physical strength.

Probably the nineteenth-century arguments over whether society was matriarchal or patriarchal would have been forgotten, or relegated to

debates among scholars,[8] if they had not been entangled with larger issues. A major reason for this is that myths have symbolic value. Mircea Eliade, for example, claims that myths are "paradigmatic models"[9]; that is, they set a pattern for belief and give us a mindset that is difficult to overcome unless we challenge the myths themselves. Whether society was matriarchal or patriarchal at first, patriarchy was conceived as an evolutionary step, and both the Marxists and the Freudians made use of the patriarchal theory to buttress their own explanations about the nature of society. The most influential Marxist theoretician was Friedrich Engels, who, utilizing Bachofen and Morgan as his base, elaborated to some length on ideas earlier espoused by Marx. Engels held that the passage from matriarchy to patriarchy marked not only the great historical defeat of the feminine sex but also the development of private property. In the Stone Age, when land belonged in common to all members of the clan, the rudimentary character of the primitive spade and the limited possibilities of agriculture meant that woman's strength was adequate for gardening. Though the two sexes in essence constituted separate classes, there was an equal division of tasks, with no one task more important than another. The men hunted and fished; the women remained at home doing the essential domestic tasks. With the discovery of copper, tin, bronze, and eventually iron, and with the appearance of the plow, agriculture and other economic activity became so important that more intensive labor was required. To accomplish this man turned to the labor of other men, whom he often reduced to slavery. Private property appeared, and as man became the master of slaves, he became the proprietor of women. Mother right was overthrown by decreeing that the male offspring remain with their family while the female take up residence with their husbands.[10] The male in effect took command in the home, the "woman was degraded and reduced to servitude," and the female "became the slave of his lust and a mere instrument for the production of children."[11] Man in his new-found sovereignty indulged himself in all kinds of sexual caprices because woman was subjugated and her only revenge was through infidelity. Therefore, according to Engels, adultery was endemic in societies that emphasized private property.

As a good socialist Engels believed there could be no change in this subordinate nature of women until there was a change in the economic system allowing women to participate in the labor force on an equal basis with men. As August Bebel, a disciple of Engels, emphasized, the problem of women could be reduced to their capacity to labor, and it was the resistance of the "capitalistic" paternalism that prevented the

female from fully developing her personality. Bebel criticized the "bourgeois emancipationists" for failing to recognize that the "woman question," as he called it, could not be solved until the "social question," the economic reorganization, was solved.[12]

Matters, however, have not proved to be so simple, and though socialist parties and societies originally gave women more influence than nonsocialist, equality has not yet come. As a result, feminist critics hold that the gender hierarchical system is more deeply embedded in the male ego and has managed to survive the various changes in the social order that have remained male dominated, whether free enterprise, socialist, fascist, or communist.

The Marxists held that the repression of women by men was an easy task, although women rebelled in a few instances. It was these rebels whose story was kept alive in the tales of the Amazons. To some Marxist theoreticians, in fact, the Amazons represented a last-ditch attempt by the matriarchy to assert itself.[13] Many feminists have looked on the myths of the Amazons as important sources for a feminist identity.

Tied in with controversy over the nature of the evolution of society is the debate over the original nature of marriage. Here also there were at least two camps: those who believed in original monogamy and those who upheld the hypothesis of promiscuity. The most important twentieth-century study emphasizing both promiscuity and mother right was Robert Briffault's *The Mothers*, in which the side of mother right as a means of ending promiscuity was argued without compromise or reservation. Briffault went so far as to claim that mother right was the source of all social organization, that male influence was entirely irrelevant in the dawn of culture, and that kinship, political organization, the beginnings of law, economic life, magic, and religion were created and completely dominated by women until men had seized power.[14] Opposed to Briffault was Edward Westermarck, who held that monogamous marriage was a primeval institution, rooted in the individual family; that the matriarchate had not been a universal stage of human development; that group marriage never existed, much less promiscuity; and that the whole problem had to be approached using biology and psychology as well as a critical application of ethnological evidence.[15] Unfortunately neither Westermarck nor Briffault can be regarded as a critical user of ethnological evidence.

Much more acceptable to the contemporary social scientists who investigate the problem is the answer of Ernest Crawley, who regarded sexual communism, mother right, and the total eclipse of the male sex as imaginary fantasies constructed against all evidence. Crawley, how-

ever, still felt that men were fearful of women. This fear, he held, was due to "physiological thought" rather than any primitive fear of matriarchy or its consequences.[16] By physiological thought he meant the concentration of the male upon physiological functions, particularly nutrition and sex. Theodore Besterman, who revised and enlarged Crawley's original work, held that the antagonism between the sexes was so great that man had continuously attempted to protect himself against women, and the result was a collective emotion of sexual solidarity in both men and women.[17] Following Crawley's path, he held that the fear of the female was due to the belief that human qualities could be or might be transmitted by contact with others. Since in savage psychology female inferiority was a firm assumption, Besterman held that men in such societies would try to keep women in their place so the male would not catch the female weakness. It was when their femininity was most accentuated, at the time of sexual crises such as menstruation or childbirth, that they were most rigidly secluded and avoided. This fear of the female was also present in sexual intercourse, and inevitably there were elaborate precautions taken in order to avoid its weakening effect and certain specific periods when sexual avoidance was required.[18]

Bronislaw Malinowski, one of the leading anthropologists of the twentieth century, believed that Crawley and Besterman were probably on the right track but felt that their view should be further explored before any final conclusions could be drawn.[19] As anthropologists have examined the problem, they have become increasingly reluctant to speak of matriarchy, and in fact most now would deny the existence of societies where women have been or are dominant regardless of whether promiscuity or monogamy turns out to be the original form of sexual union. As research into the question has progressed, it appears that most of the so-called mother-right societies could better be called matrilineal societies in which descent is traced through the female or matrilocal societies in which the husband lives with the wife's people. This kind of organization does not make such a society a matriarchy since authority is still vested in the male. He is the head of the household, the important position in most such societies.

Without delving further into the controversy, it is possible to conclude that the male has approached the female with mixed feelings, showing considerable fear, awe, and even reverence. As Joseph Campbell put it: "There can be no doubt that in the very earliest ages of human history the magical force and wonder of the female was no less a marvel than the universe itself and this gave to woman a prodigious power,

which it has been one of the chief concerns of the masculine part of the population to break, control, and employ to its own ends. It is in fact more remarkable how many primitive hunting races have the legend of a still more primitive age than their own, in which the women were the sole possessors of the magical art."[20]

This early conception of woman as a magical force was due to her creative process. Some investigators feel that ancient man long thought, and some primitive societies apparently still hold, that the male played no part in conception. Somehow ancestral spirits in the form of living germs found their way into the maternal body. Sir Henry Maine, in fact, dated the origin of patriarchy from the discovery of paternity, but there is no consensus among historians about when and if such a momentous discovery took place in history. Certainly among the most common representations that have survived from the paleolithic period are figurines with female characteristics such as hips and mammary glands considerably exaggerated. This might well indicate a worship of the generative power of the female, but it might also indicate that ancient men were the artists and took pleasure in portraying or observing the opposite sex, much as men do today. The *Playboy* centerfold, for example, is not necessarily indicative of the worship of the female.

It is not impossible that there was a downgrading of women when men discovered that they too played a part in procreation. Moreover, since the semen is visible while the ovum is not, it is easy to understand why throughout recorded history man assumed that he was primarily responsible for procreation. This does not mean the female was entirely excluded, a difficult thing to do in terms of the biology of reproduction, but that she was often conceptualized as only carrying and nourishing the seed planted by the male. In the Greek period Aristotle gave women a slightly more important role than some of his predecessors in that he felt the fetus was formed from the union of sperm and menstrual blood, but Aristotle remained true to male presuppositions by holding that it was the male who furnished the active principle while the women only supplied the passive element. For Aristotle, the male principle represented form, motion, activity, while the feminine was equated with matter and potentiality. In the universe the earth represented the womanly and the maternal, hence mother earth, while the male represented the sun, the source of life. Those societies that followed such identification usually regarded the natural position for intercourse as that in which the woman was underneath the man, just as the earth was beneath the sun. Not all the Greeks agreed with Aristotle, and the compilers of the Hippocratic corpus, for example, recognized

two kinds of seed. But the effect was the same since they regarded the female seed as weak and the male as strong. This male-oriented belief dominated concepts of sexual reproduction in Western society until the time of William Harvey in the seventeenth century.

Even if we accept the theory that most societies have been paternalistic, with men holding the key positions of influence, we need to explain why in the past women have seemingly had periods of greater or lesser influence. Though undoubtedly part of the explanation is how we define influence, something that feminist anthropologists and historians have begun to challenge, women seem to have more prominence in some periods of history than others. This observation has inevitably led to a lot of theorizing, and the explanations are for the most part also couched in male-oriented terms.

Many answers have been advanced. One is the difference in nutritional requirements of men and women. Men in general are less susceptible to anemia than women, because women need more iron in their diet to offset that lost through menstruation, bleeding during childbirth, and needs of a growing fetus during pregnancy. Anemia is seldom the primary cause of death, but it is a predisposing factor. Even if death does not come quickly, a general debilitation occurs that makes it difficult for the female to challenge the male. Though research is not yet adequate for a universal statement about diet and women's subordination, it seems that when women eat better and have a diet with adequate iron and protein, they are likely to be far more assertive than when they are inadequately nourished. The new assertiveness of women in the later Middle Ages, for example, probably resulted in part from increased protein and iron in their diet.[21] The diet explanation, however, is a recent one, and in the past, the answers about women's greater or lesser influence have relied upon the concept of historical cycles as developed by Oswald Spengler in his *The Decline of the West* (1917, 1921). Though most of the current generation of historians regard Spengler's attempt to couple theories of social evolution and the organistic nature of society as historical poetry rather than social and institutional history, some of his concepts were adopted by Mathilde and Mathias Vaerting to explain the status of women.

The Vaertings believed that there had been various periods in history in which men were dominant and others when women had been. In those states where women ruled, woman was the wooer. The man contributed the dowry, and the woman extracted a pledge of fidelity from her husband. Woman had the sole right of disposal over the common possessions and she alone was entitled to divorce her partner should he

no longer please her. In fact, much of what we regard as the proper roles of men and women were reversed, with the woman leaving home to attend to her occupation while the husband managed domestic affairs. The husband adopted the name and nationality of his wife and adorned himself in fancy clothes, and girl children were valued more highly than boys. The gods were for the most part feminine, and males were regarded as somewhat less intelligent and somewhat more benevolent than the females. Most societies, they felt, had been a mixture of male dominant or female dominant, with one sex having a slight edge over the other. Eventually, they predicted, there would be equality.[22]

Although the Vaertings classified ancient Egypt and several other societies as female-dominant ones, most historians would reject both their assumptions and their explanations out of hand. But then how do we explain why the influence of women seems to have waxed or waned at different periods? Instead of trying to define such modifications of position in terms of institutions, where power and property are concentrated in the hands of one sex or the other, some recent investigators have turned to a study of attitudes. This implies that though institutions are persistent and last with little change into a period in which attitudes have altered considerably, it is possible for more "feminine" attitudes to be given currency in a patriarchal society. Recognizing this possibility G. Rattray Taylor, for example, proposed that past society be classified as patrist or matrist. He categorized the two as follows:

Patrist	*Matrist*
1. Restrictive attitude to sex	1. Permissive attitude to sex
2. Limitation of freedom for women	2. Freedom for women
3. Women seen as inferior, sinful	3. Women accorded high status
4. Chastity more valued than welfare	4. Welfare more valued than chastity
5. Politically authoritarian	5. Politically democratic
6. Conservative: against innovation	6. Progressive: revolutionary
7. Distrust of research, inquiry	7. No distrust of research
8. Inhibition; fear of spontaneity	8. Spontaneity; exhibition
9. Deep fear of homosexuality	9. Deep fear of incest
10. Sex differences maximized (dress)	10. Sex differences minimized
11. Asceticism, fear of pleasure	11. Hedonism, pleasure welcomed
12. Father-religion	12. Mother-religion

Taylor felt that these two patterns were extreme, and that as society changed there were intervening periods in which patterns would become confused, but owing to the nature of the Oedipal conflict there was a natural tendency to fall on one side of the fence or the other.[23] Taylor's listing was a modification of an earlier listing by J. C. Flugel,

but the whole catalog was value prone and not subject to any objective proof.[24] Many of the characteristics he assigned to a female society could just as easily be assigned to a male society or vice versa.

Both Taylor and Flugel based their key assumptions upon Freudian concepts. Freud, like Marx and Engels, posited an original state of nature that is no more subject to verification than theirs. "We believe that civilization has been built up, under the pressure of the struggle for existence, by sacrifices in gratification of the primitive impulses, and that it is to a great extent forever being re-created, as each individual, successively joining the community, repeats the sacrifice of his instinctive pleasures for the common good. The sexual are amongst the most important of the instinctive forces thus utilized: they are in this way sublimated, that is to say, their energy is turned aside from its sexual goal and diverted towards other ends, no longer sexual and socially more valuable."[25]

Put in simple terms Freud seemed to be subscribing to a kind of organistic theory of history in which there was only a limited amount of vital energy in every culture and the losses suffered through sex could not be replaced. In this he was following the historical beliefs advanced by such individuals as Henry Adams and Oswald Spengler, but such analogies were and are unverifiable and misleading. The antiwoman implications Freud drew from his beliefs have been criticized by various scholars,[26] including some of his contemporaries. It was in part for Freud's emphasis on "masculinity" that Jung parted company with him. Instead Jung emphasized that each of us has both male and female elements within us, although in some of his works he tended to equate the femininity in men with weakness and the masculinity in women with strength.[27] More recently, through such tests as the Bem Sex Role Inventory, psychologists have attempted to measure masculinity and femininity as independent constructs instead of opposite poles of a single dimension of personality.[28] Jung and some of his disciples also put considerable emphasis upon the concept of the "great mothers," although in popular culture it never gained the attention of the concept of "penis envy" asserted by Freud.[29] Freud believed that the female held great feelings of inferiority over her lack of male genitalia, while the male, conscious of his possession, feared that women wanted to castrate him. In brief, the narcissistic rejection of the female by the male is liberally mingled with fear and disdain.[30]

It was some of the followers of Freud, however, who carried the arguments over female subjugation to an extreme. One of the early anthropologists, William Stephens, concluded that primitive tribes had greater

sexual freedom than civilized communities,[31] thus emphasizing the need for sex control as a mark of civilization. Carrying the argument further was J. E. Unwin, who held that since the cultural conditions of any society were dependent upon the amount of its mental and social energy, and this in turn was dependent upon the extent of compulsory continence, creative societies could only exist when sexual outlets were highly restricted. He postulated that "no society can display productive social energy unless a new generation inherits a social system under which sexual opportunity is reduced to a minimum. If such a system be preserved, a richer and yet richer tradition will be created, refined by human entropy."[32] He then argued that historically the only way sexual opportunity had been kept at a minimum was under "absolute monogamy," where the husband had absolute power over his wife and children. Unfortunately, he wrote, no society ever tolerated this male domination for long since it made women and children legal nonentities, and as women made demands for changes, the result was a reduction of marriage to a union made and broken by mutual consent, with a demand for relaxation of prenuptial continence. "As soon as a lack of compulsory continence became part of the inherited tradition of a complete new generation, the energy of each society decreased and faded away."[33] In effect women have to be kept in their place for civilization to progress. Unwin was not particularly happy with the subordination of women in absolute monogamy, but he believed that by historical accident this was the only way that regulations between the sexes had been accomplished in order to keep sexual opportunity to a minimum.[34]

More recently H. R. Hays attempted to apply the findings of modern anthropology to attitudes toward women. He was influenced by Freud as well as Marx, but his conclusions can be better documented than those of Unwin. Hays held that male attitudes toward women and toward images of women were strongly influenced by deep anxieties that were almost universal. The anxieties, he felt, seemed almost basic to the kind of family relationships that mankind created, but they were further shaped by the pressures in the various cultures that were built up as men compounded their fears by creating situations that rationalized and perpetuated them. Few human beings can easily face their own compulsions, and inevitably the male has tended to project his fears and antagonisms into derogatory attitudes toward the female by insisting that women are evil, inferior, and valueless. Thus men have tended to insist that women should be made to obey, be kept in their place, or be assigned to some unreal role that neutralizes them and removes them from the sphere of competition. Emerging from such attitudes are tradi-

tions and stereotypes that are used to justify male domination of the female.[35]

Hays found that in preliterate cultures there was almost a universal fear of women's sexual functions. This fear was institutionalized in sanctions and restrictions not unlike similar restrictions in more sophisticated societies. While economic factors might have influenced the treatment of women, Hays himself felt that psychological factors were the most important, although it was often difficult to separate the psychological from other factors. He believed, for example, that the male's insistence on a monopoly of his wife's sexual services, but not vice versa, and the requirement that she be intact on marriage, but without restrictions for the male, was involved with feelings about private property. He also held that marriage in the past had been combined with the acquisition of property. Even as property, however, a woman's person was an extension of the male ego. Hays would emphasize that the continued existence of a double standard is largely dependent upon male anxiety. Such anxiety occurred because the male was keenly aware that a woman's ability to perform sexually was limitless compared to his own; there was always the fear and suspicion that he had not fully satisfied her or that she would turn to more potent males. Inevitably a fanatical desire to control her sexual activity arose. This accounted for the fact that the faithless woman was made a stereotype and punished by male writers, while the faithless male (such as Don Juan) became a heroic figure regarded by males with considerable admiration.[36]

The problem of the double standard is also tied up with the denial of the female's need for sexual fulfillment. Men have always assumed that they are the active element, women the passive. Mechanically of course, men are active, since they become aroused and carry out penetration. Though women can in theory still say yes or no, the determined male can usually force even the most recalcitrant woman to submit. On the other hand, a determined female still has the problem of arousing the male and then managing to submit.

Though the status of women in society has varied in the past, sometimes higher, sometimes lower, there has been a practically universal tendency of the male to ascribe a relative inferiority to the female. Associated with this is a feeling that an excess of female company might cause effeminacy, or at least weakness, in him. This attitude might be due to actual observation, since the physiological process of detumescence following sexual intercourse usually leaves a man feeling somewhat weakened. Inevitably man might ascribe this weakening to the influence of women. Many diverse tribes and cultures have enjoined

continence on warriors and hunters, and our society usually demands abstinence of athletes—men whose activities demand strength and fortitude. There is also a fear of contamination from sexual intercourse. Usually this fear is greater in illicit intercourse, but it also exists in matrimonial intercourse. Again there is always the possibility of contracting venereal disease, which might account for part of the fear, but this does not fully explain why illicit intercourse or intercourse without proper procedures or at the correct time might result in the blighting of crops, the ruination of hunting, or the appearance of sudden illness. Intercourse is also associated with the fertility of the earth and homeopathic or imitative magic seems inevitable, although some cultures believe sexual intercourse quickens the growth of trees while other societies hold to the opposite view.[37] Inevitably woman is associated with all of these phenomena in the male mind, and usually to her detriment. These factors should be kept in mind in this survey of the history of man's past, although rather than consciously adopting any of them, we have attempted to let the data speak for themselves with a minimum of theorizing.

By this time it should be obvious that if women as a group in the past had been in a position to do the kind of theorizing and expression of their ideas that men did, they would have seen themselves in quite different ways than men did and would also have looked on men quite differently than men visualized themselves. The major contribution of feminist scholarship has been to force us to think of women (and men) of the past in a different way. The mission of this book, however, is not to summarize recent feminist scholarship but to give the kind of overview of women that either officially or unofficially has existed throughout history. Until we come to terms with this "male mythology" of the role and place of women, we cannot come to terms with what feminism is all about.[38]

Though an occasional woman or even small groups of women protested male assumptions, they were never powerful enough to change them. Generally, in fact, punishment for challenging the traditional male view and the rewards for accepting it served to encourage women to accept their subordination. Since they could not change it, they reaped the rewards from playing a subordinate role. Only when enough women could begin to challenge this view, as they did in the nineteenth century, do we see any real evidence of change.

2 / Formation of Western Attitudes

The cradle of civilization, or at least of Western civilization, was the river valleys of the Near East (sometimes called the Middle East), particularly in the area extending from modern Egypt to modern Iraq. Attitudes formed in these areas were incorporated into Jewish, Greek, and later Western Roman and Christian attitudes. Though the civilizations in these areas underwent considerable change, it is possible to generalize about attitudes toward women in them if only because the scarcity of source materials makes it difficult to reconstruct any one period in the detail possible in more contemporary periods.

It has been said that man's vision of the gods reflects his own vision of himself and his activities. If there is any merit to this statement it seems clear that the inhabitants of the Tigris-Euphrates Valley quite early held man to be superior to woman, and in fact relegated her to being a kind of property. There are hints that in the beginning of Sumerian society women had a much higher status than in the heyday of Sumerian culture. Tiamat, a mother goddess, was a dominant figure, and it was her body that was used to form the earth and the heavens after she was killed by Enlil (called Marduk in the Babylonian versions and Asshur in the Assyrian ones). The blood of Tiamat's consort, Kingu, served to form individual humans. This death of a female goddess and her replacement by a dominant male figure is a common theme in the

16

mythology of many peoples. The meanings of this matricide are unclear, and all we can say for certain is that by the time the Babylonian theology was organized into the form in which it has come down to us, the mother goddess was clearly subordinate to male gods.[1]

The names and positions of the gods changed during different periods of Mesopotamian civilization as differing peoples achieved dominance. There were hundreds of deities but there were two major triads of gods: Anu, Enlil, and Ea; Sin, Shamash, and Ishtar. Over and above them was another god, Marduk or Asshur. The only female in the group was Ishtar, or in Sumerian, Inanna, goddess of war and of love. Like humans, the gods had wives and families, court servants, soldiers, and other retainers. Ishtar, however, remained unmarried. Her lovers were legion, but these unhappy men usually paid dearly for her sexual favors. She was identified with the planet Venus, the morning and evening star, and could arouse the amorous instinct in man, although she also had the power of causing brothers who were on good terms to quarrel among themselves and friends to forget friendship. If she perchance withdrew her influence, "The bull refuses to cover the cow, the ass no longer approaches the she-ass, in the street the man no longer approaches the maidservant." Part of her difficulty was that she did not really know her place. In the poem translated as *Enki and World Order* the god Enki (whose powers are similar to Ea's) assigned the gods various tasks. Ishtar, however, felt left out and complained to Enki. Her complaint applies to woman in general: "Me, the woman, why did you treat differently? / Me, the holy Inanna, where are my powers?"[2] She was given various tasks as a result, but because she was an unmarried and erotic figure it was no wonder that sacred prostitution formed part of her cult. When she descended to earth she was accompanied by courtesans and prostitutes. The implication might well be, as we have indicated before, that woman was to be either wife and mother or an unmarried professional, a prostitute.

The mere presence of Ishtar, or Inanna, in the heavenly triad is probably striking evidence of the great strength of the forces of nature, which were so deeply rooted in primitive society. She represented the blending of several different characters into one, most obviously the lady of love and the lady of battles, although these different aspects of her powers were worshiped at different places. If Ishtar chose to favor a mere mortal, he could gain fame and riches, and she was much sought after. Sargon, the Akkadian conquerer who lived toward the end of the third millenium B.C., felt himself to be under the protection of Ishtar and

believed it was through her influence that he became king. As he himself said, his mother was a temple priestess who bore him in secret.

> She set me in a basket of rushes, with bitumen she sealed my lid.
> She cast me into the river which rose not [over] me.
> The river bore me up and carried me to Akki, the drawer of
> water.
> Akki, the drawer of water lifted me out as he dipped his e[w]er.
> Akki, the drawer of water, [took me] as his son [and] reared me.
> Akki, the drawer of water, appointed me as his gardener.
> While I was a gardener, Ishtar granted me [her] love. . . .

And then he became king.[3]

If the place of women in official mythology was somewhat circumscribed, it was even more so in actual life. Our chief source of information about actual conditions is the various law codes. These might be regarded as the official male view of women since they are essentially male social constructs. Georges Contenau claimed that the early law codes granted to women rights, such as giving evidence in law courts and owning property, which in France have only been acquired in the twentieth century. This does not so much indicate how advanced women in Babylonia were but how subjugated French women have been.[4] Contenau himself admits that at least the Semitic-speaking portion of Mesopotamian society was unwilling to grant woman any true responsibility. Formal law codes are known from Ur-Nammu of the third dynasty of Ur (c. 2050 B.C.) and Lipit Ishtar of Isin (c. 1870). Neither of these codes is preserved completely and their great importance to us lies in the influence they had on later laws. In the Semitic dialects the first law code was that of the town of Eshnunna, dating from about 1800 B.C. The best known, however, was that of Hammurabi (c. 1700 B.C.), which contained about 250 laws. Later from the Assyrian scribes there exists another legal corpus dating from 1100 B.C., which has a long section on women and marriage.

Women legally were property. They were neither to be seen nor heard. Monogamy was the normal way of life, but monogamy meant something different for the man than for the woman. A wife who slept with another man was an adulteress but a man could not only visit prostitutes but in practice also took secondary wives as concubines. Rich men and royalty often had more than one legal wife. Women were always under the control of a male. Until the time of her marriage a girl remained under the protection of her father, who was free to settle her in marriage exactly as he thought fit. Once married she was under the

18

control of her husband. During the marriage ceremony a freewoman assumed the veil that she wore from then on outside her home. In fact the veil was the mark of a freewoman, and anyone who met a slave or courtesan wearing a veil had the duty of denouncing her. A concubine could only wear a veil on those occasions when she accompanied the legal wife out of doors. It was an offense for a woman to have any dealings in business or to speak to a man who was not a near relation.

Some scholars have argued that the earliest form of marriage required the bridegroom to purchase his bride, emphasizing even further the woman as property. In the earliest laws there were references to *terhatum* (bride money), which has been interpreted to be one of three things: the price paid for the bride, a gift made in order to ingratiate the bridegroom with the family, or simply a means of demonstrating that the union was a legal marriage. Regardless of its original meaning, by the time of the Hammurabic code it seems to have become earnest money in which the bridegroom assumed some pecuniary responsibility in case he did not live up to his undertaking. Often it was returned to him as part of the dowry.

The economic dependence of the woman upon the male was reinforced by the various provisions allowing her to remarry. In cases where a woman's husband was taken captive and he had not left enough for her to eat, she could live with another man as his wife. If her husband returned, though, she was to go back to him. Any children by the temporary husband remained with him. If, however, the absence of her husband was malicious, motivated by a "hatred of king and country," he had no further claim upon his wife if she took a second husband. Women could also hold property. An unmarried daughter, for example, could be given either a dowry, a share of her father's property, or the usufruct, the right to the profits from the land. She was free to dispose of her dowry as she wished, but in other cases her property rights upon her death reverted to her brothers, except under special conditions.

The purpose of marriage was by law procreation, not companionship. The wife's first duty was to raise her children and a sterile marriage was grounds for divorce. The wife who gave birth to children, particularly to sons, was accorded special protection. The man who divorced the mother of his sons or took another wife was committing a culpable act. Her childbearing responsibilities were emphasized by penalties to anyone injuring a woman sufficiently to cause a miscarriage and also by statutes against abortion.

Adultery was not a sin against morality but a trespass against the husband's property. A husband had freedom to fornicate, while a wife

could be put to death for doing the same thing. Freewomen were inviolable and guarded; a man who gave employment to a married woman not closely related to him was in difficulty. A man caught fornicating with an adulterous woman could be castrated or put to death, while the woman could be executed or have her nose cut off. Offenses with unmarried freewomen were treated differently from those with married women because there was no husband. If the offender had a wife, she was taken from him and given to her father for prostitution and the offender was compelled to marry the woman who was his victim. If he had no wife, he had to pay a sum of money to the woman's father as well as marry her, although the father might accept money and refuse to give him his daughter. In any case, the payment was for damaging property, lessening the value of the woman. If a man could prove by oath that an unmarried woman gave herself to him, he was not compelled to surrender his own wife, although he still had to pay a sum of money for the damage he had caused. If a married woman was seized by a man in a street or public place and, in spite of her efforts to defend herself, was violated, she was regarded as innocent. If, however, she was acting as a prostitute either in a temple brothel or in the street, the man could be convicted of engaging in an adulterous relationship only if he was shown to have had guilty knowledge.[5]

These laws applied to freewomen. There were other women, particularly slaves. A slave had no human personality but instead was real property. If she was injured, it was her master and not she herself who was entitled to compensation. A female slave was under obligation to give her purchaser not only her labor but also herself, without any counter obligation on his part. He could in fact turn her over to prostitution. Even when she became the purchaser's concubine and had children by him, she still remained a slave liable to be sold. At her owner's death, however, she and her children received liberty. If a female slave was bought by a married woman either as her servant or as a concubine for her husband (as in the case of a childless woman), she remained the property of the wife. A male slave could, with his master's consent, marry a freewoman, and even if she lacked a dowry, she and her children would still remain free. If she brought a dowry, she could keep it, but any increase from investment was split with her husband's master. There were also temple slaves who were not confined to the temple but worked in the towns and hired out to private employers. Their legal status was harsher than that of ordinary slaves since they had no hope of adoption, while their children automatically became the property of the gods. Children and wives of freemen were different from slaves, but the

father still had almost total control. He could deposit his children with creditors, and apparently also his wife, although she could not be kept for more than four years. There was also a class of poor who existed at the beginning of the second millenium, who were above slaves but below freemen. Little is heard of them in later laws. Special exceptions must have been made for some women of this class since the Hammurabic code refers to "ale-wives," or women winesellers in taverns. Perhaps such women were regarded as prostitutes and not the freewomen with whom the laws were most concerned.

Specific laws dealt with women as tavernkeepers, priestesses, and prostitutes, occupations in which women could act outside conjugal or paternal authority. In general, however, the law failed to recognize women as persons. For example, a woman could be careless with animals just as a man could, but the law only refers to men. As far as priestesses and prostitutes were concerned, there were various kinds of both. At the head of the priestesses was the Entu, the wife of the gods, or the "lady [who is] a deity." They were of very high standing and the kings could make their daughters Entu of a god. They were expected to remain virgins, although they might eventually take husbands, perhaps after menopause. A second class of priestesses was the Naditu, who were lower in rank but who were also not expected to have children. The Hammurabic code had several provisions attempting to ensure the rights of a priestess to dowry and other shares of her father's goods. Apparently their conduct was rigidly circumscribed since any priestess who went to a tavern to drink could be put to death. Prostitutes seem to have been quite common and there was a considerable variety of harlots and hierodules, each described by a different technical term. Some were attached to the temple and were known as *qadishtu* or *qadiltu*. It is possible that the term *kulmashitu* may have been used to refer to a similar class of women.[6]

With such a male-oriented society, few women emerged as real individuals in the history of the Mesopotamian civilizations. Two women seem to have exercised some influence as rulers, but they were comparatively late in the history of the area, and they seem to have merged to form the legendary figure of Semiramis. Herodotus, the Greek historian, reported the existence of two women rulers, Semiramis and Nitocris.[7] Later Diodorus Siculus, the Greek historian who lived during the time of Roman Emperor Augustus, amplified the story considerably, combining both into the figure of Semiramis. It is in this legendary form that her name has survived. According to Diodorus, Semiramis was born of a goddess and married an Assyrian officer at the court of King

Ninus. The king was so captivated by her beauty and valor that he took her as his wife. Soon afterward Ninus died, leaving a son, Ninyas, by Semiramis, and in these circumstances Semiramis assumed power, reigning for many years, building Babylon, and turning to the conquest of distant lands.[8]

Modern historians believe that the legend of Semiramis was based upon a real person or persons who so impressed contemporaries that a legend developed which was passed on to the Greeks in garbled form. Semiramis herself is usually identified with Sammu-ramat, mother of the Assyrian king Adadnirari III (810–782 B.C.). A memorial stele found at Ashur and an inscription at Kalakh (Nimrud) seem to indicate that she exercised considerable influence after the death of her husband, Shamshi-Adad V (824–810 B.C.), and in fact it was during her reign that the god Nabu (Nebo) was substituted for the former patron god at Kalakh.

The identification of Nitocris is somewhat more difficult. One authority has argued that she is simply a case of sex transformation, not uncommon in legend, in which Nebuchadnezzar somehow assumed a feminine form. Those who think she was a real historical figure believe they have found her in the person of Naqi'a, a wife of Sennacherib (704–681 B.C.) and the mother of his son, Esarhaddon (680–669 B.C.), whom he selected to succeed him. It was during the rule of Esarhaddon that the reconstruction of the neglected city of Babylon began. It is quite possible that Naqi'a took an active part in this as a sort of royal representative, since the king himself would by custom be unable to appear in the city until some of the official temples and buildings had been restored. Like Semiramis she managed to impress the populace enough to survive as legend, although over the passage of time her story became merged with that of her predecessor, perhaps on the ground that one outstanding queen could be understandable but two might challenge the male stereotypes too much.[9]

In both cases, however, women were only able to exercise authority as mothers, protecting the rights of their sons. It was only through their sons that women in the Mesopotamian civilizations seem to have had any influence at all. Even the wives of the king were not important enough to be regarded as queens since the use of the term was restricted to goddesses or to women who served in positions of power. The chief wife instead was usually called "she of the palace," and she lived along with the concubines and other wives in a harem guarded by eunuchs. Their way of life was carefully regulated by royal edicts, although in the last period of the Assyrian kingdom the influence of the king's wife and mother was somewhat greater than before.[10]

Other than a few exceptional royal wives, only a handful of women managed to break through into the pages of history. There is an isolated reference to a woman physician at the palace in an Old Babylonian text, and we can assume that women attended other women in childbirth, but there is no further reference. The professional physician was usually a male. Women were also generally illiterate if only because in this period reading and writing were restricted to a professional class of scribes who underwent long training. Poetry, however, is a preliterate form of literature, and one of the most remarkable poets, in fact one of the few we know by name, was a woman, Enheduanna. She was the daughter of Sargon, whose administration marked the fusion of Semitic and Sumerian culture. As part of this fusion the Sumerian Inanna and the Akkadian Ishtar came together, and in this process Enheduanna played an important role, at least if her identification is correct. She was a high priestess of the moon god, the first of a long line of royal holders of this office, and in this capacity she wrote a poem usually entitled "The Exaltation of Inanna." Her poetry served as a model for much subsequent hymnography and her influence was so great that she later seems to have been regarded as a god herself. Her poetic style was so unique, the stamp of her personality upon her poem so strong, that her editors believe it may well be possible to detect her authorship in other less-preserved pieces.[11] Most of the cuneiform literature from the area is anonymous, or at best pseudonymous, so how many other women poets there were must remain unknown. The attitudes expressed about women in most of the poetry tend to indicate that they had male authors.

In one of the great classics of Mesopotamian literature, the Gilgamesh epic, it seems obvious that woman's duty was to keep man calm and peaceful. In the beginning of the account Gilgamesh was oppressing the city of Erech, taking the son from the father, the maiden from her lover. The people complained to the gods, who created a rival, Enkidu, from clay to deal with Gilgamesh. Enkidu was a wild man whose whole body was covered with hair, who knew neither people nor country. When the existence of Enkidu was reported to Gilgamesh he sent forth a temple harlot to ensnare the wild man: "Let her strip off her garment; let her lay open her comeliness; / He will see her, he will draw nigh to her. . . ." Then with his innocence lost he could be more effectively handled by Gilgamesh.

> The prostitute untied her loin-cloth and opened her legs, and he
> took possession of her comeliness:
> She used no restraint but accepted his ardor,
> She put aside her robe and he lay upon her.

She used on him, the savage, a woman's wiles,
His passion responded to her.
For six days and seven nights Enkidu approached and coupled
 with the prostitute.
After he was sated with her charms,
He set his face toward his game.
[But] when the gazelles saw him, Enkidu, they ran away;
The game of the steppe fled from his presence.
Enkidu tried to hasten [after them, but] his body was [as if it
 were] bound.
His knees failed him who tried to run after his game.
Enkidu had become weak, his speed was not as before.
But he had intelligence, wide was his understanding.

Eventually the woman persuaded him to set out for Erech, where he and
Gilgamesh engaged in combat and Enkidu was defeated. The two, how-
ever, became fast friends.[12] The legend suggests that woman was de-
signed to ensnare man, to weaken him, to prevent him from realizing
his full potentiality. In this forerunner of the stereotype of Eve, woman
was both a source of pleasure and yet a delusion.

This ambiguous feeling toward the female is evident in a dialogue
between a master and slave of comparatively late composition, entitled
in translation "The Dialogue of Pessimism."

"Slave, listen to me." "Here I am, sir, here I am."
"I am going to love a woman." "So love, sir, love.
The man who loves a woman forgets sorrow and fear."
"No, slave, I will by no means love a woman."
["Do not] love, sir, do not love.
Woman is a pitfall—a pitfall, a hole, a ditch,
Woman is a sharp iron dagger that cuts a man's throat."[13]

Woman, nonetheless, was designed to be at the side of man, and as a
proverb stated, "A house without an owner is like a woman without a
husband."[14] The ideal wife was both passionate and able to bear sons:
"May [the goddess] Inanna cause a hot-limbed wife to lie down for you;
/ May she bestow upon you broad-armed sons; / May she seek out for
you a place of happiness."[15] Even a good wife was a burden and responsi-
bility: "The man who does not support either a wife or a child, / His
nose has not borne a leash."[16] Or in a more hostile vein: "As the saying
goes: 'Were not my wife in the cemetery, and were not also my mother
in the river, I should die of hunger.'"[17] Women, as well as men, enjoyed

sex. "Conceiving is nice," but "being pregnant is irksome."[18] It was also recognized that the "penis of the unfaithful husband" was no better "than the vulva of the unfaithful wife," but in most things a woman was discriminated against.[19] "A rebellious male may be permitted a reconciliation; / A rebellious female will be dragged in the mud."[20] Obviously women were regarded as a mixed blessing, and it was thought best that they be kept in their place.

Life in Mesopotamia was harsh and unpredictable. There were floods, famine, scorching heat, and cloudbursts, and always the danger of invasions. It might well be that in such a society the strong man was admired while the weak woman was regarded as a liability but necessary because of her childbearing abilities. Inevitably the male was forced to assert himself, to man the armies, to do the fighting, to keep his womenfolk in subordination. Is this an adequate explanation for male dominance? The difficulty with such a thesis is that these same attitudes are found in other cultures where environmental conditions are quite different. Nonetheless environment might have had some influence, since the place of women in Egyptian society seems to be quite different from that of Mesopotamian society.

At a superficial level, attitudes toward women in Egypt appeared to be so radically different from those of surrounding society that many of the early advocates of matriarchy felt that Egypt was the case that proved their thesis. From the time of Sir James Frazer and his late nineteenth-century compilation of the *Golden Bough* until today a group of scholars have clung to the belief that Egypt was a matriarchal society. Robert Briffault went so far as to argue that Egypt "never lost its essential matriarchal character" even though it had undergone a slow evolutionary process toward patriarchy.[21] Mathilde and Mathias Vaerting believed they had found their woman's state in ancient Egypt and denounced all those who did not agree with them as being victims of patriarchal thinking.[22] The evidence for a matriarchy, nonetheless, is highly debatable. Most recent studies would not regard Egypt as a matriarchal society, but all would agree that the status of women was probably higher there than in Mesopotamia and that women had the right to own and transmit property.

The controversy in part had its origins through the efforts of Sir W. H. Flinders Petrie, one of the founders of modern Egyptology, who held that in "question of descent the female line was principally regarded. The mother's name is always given, the father's may be omitted; the ancestors are always traced farther back in the female than in the male line."[23] He went on to state that Egypt was "based on a matriarchal

system, the office-holder or farmer who married into a family was a secondary affair; the house and property went with the woman and daughters. This was a transition state from quasi-marriage to a patriarchal system eventually, where the man dealt with the property.[24]

Giving support to Petrie was his contemporary and rival the Frenchman Gaston Maspero, who served as director of the Egyptian Antiquities Service. He wrote: "The Egyptian woman of the lower and middle classes is more respected and more independent than any other woman in the world. As a daughter, she inherits from her parents an equal share with her brothers; as a wife, she is the real mistress of the house . . . her husband being, so to speak, merely her privileged guest. She goes and comes as she likes, talks to whom she pleases without any one being able to question her actions, goes amongst men with an uncovered face. . . ."[25] Though Petrie used matriarchy to describe what we now call matrilineal or perhaps matrilocal society, and Maspero was considerably more cautious in his claims, inevitably Egyptian society in various encyclopedic articles has been characterized for its "distinct preservation of matriarchy, the prominent position of women, and a comparative promiscuity in sexual relations."[26]

Most of the studies written about ancient Egypt that are more than forty years old can no longer be regarded as accurate. In spite of this revolution in Egyptian studies one Egyptologist, Margaret A. Murray, recently wrote that the throne went strictly in the female line. "The Great Wife of the king was the heiress; by right of marriage with her the king came to the throne. The king's birth was not important, he might be of any rank, but if he married the queen he at once became king. To put the matter in a few words: the queen was queen by right of birth, the king was king by right of marriage."[27]

Few scholars would now agree with her. Most recent studies are ambiguous about the position of the queen. Typical is John A. Wilson, who argued that the legitimacy of the rule was conditioned "both by the royal descent of the mother and by that of the father. Pharaohs might have many wives, taken from many sources, but the purest line to carry on the seed of the sun-god Re would show a mother directly of the royal family. This was the reason for brother-sister marriages by some of the pharaohs, for the purpose of assuring the most divine strain and for the derivative purpose of cutting down on the number of pretenders to the throne.[28] Some studies are outright hostile to any such theory. Barbara Mertz has argued that the theory of inheritance through the female can only be supported by a series of exceptions and unreasonable explanations. Since this is the case, it is safest to hold that the inheritance of

the throne was based on the simple notion of royal succession, that the king was succeeded by the oldest son of his chief wife. If the chief wife bore only daughters, the oldest one of them and the husband selected for her—preferably the king's son by a secondary wife or concubine—inherited the throne. Women could not rule in their own right and so an heiress princess needed a husband, but a properly legitimate crown prince could reign in his own right.[29]

Key to some of the theories of matriarchy was the marriage of brother and sister, but scholars now doubt that it was very common. Professor Jaroslav Cerny, after searching through hundreds of inscriptions, concluded that the term *sister* had come to mean wife and lover rather than a sibling of the same mother and father. In his study of some 490 marriages in the twenty-second dynasty he found that only two can be taken as brother and sister, and even these have been debated, although marriage of half-brothers and sisters may have been more common. It was not until Greek times, in the time of the Ptolemies, that it became a rule for a pharaoh to marry his sister. This custom may have been imported from Greece rather than carried over from ancient Egypt. In sum, though we often encounter brother and sister couples in mythological stories such as those concerning Isis and Osiris, all we can say with certainty about ancient Egypt is that if marriages between siblings were legal, they were not very common.[30]

Part of the difficulty with reconstructing the real status of women in Egypt is that we lack the kind of comprehensive law codes present in ancient Mesopotamian society. We do, however, have numerous legal documents, particularly from the time of the Persians and the Greeks who occupied Egypt in the last half of the first millenium B.C. From these it would appear that women had the right to own property, to buy, sell, and testify in court. The Aramaic papyrus documents dating from the fifth century B.C. found at Elephantine, although dealing primarily with a Jewish military colony, probably reflect Egyptian practices. From these it is apparent that women not only enjoyed full equality to own property but also could go about their transactions in the same manner as men. Moreover, they were allowed to regain the property they brought with them as dowry if their marriage broke up. If, however, the woman had committed adultery, no such guarantee existed. Women were listed as taxpayers, and they could also sue.[31] Apparently a woman did not need a guardian to be able to execute legal acts, nor did it matter whether she was married or not. A daughter, at least in the Ptolemaic period, was entitled to equal succession in the estate of her father.[32] Women could acquire wealth or property through their parents or husbands or purchase it. A

The Subordinated Sex

wife was entitled to a third of her husband's possessions after his death,
whereas the other two-thirds had to be divided among the children and
sisters and brothers of the testator. If a husband desired his wife to receive
more, he had the right to donate it to her before he died.

The comparative economic independence of women may have given
them greater freedom than in Mesopotamia, and this would give sup-
port to Marxist theories about the reason for the subjugation of women.
Such independence must have been limited to the upper levels of soci-
ety. The ordinary peasant, whether male or female, lacked many posses-
sions, and the slave was even lower on the scale. Nevertheless, women
of all classes were recognized as important, as is evidenced by the nu-
merous goddesses. Particularly important were the triads of gods com-
posed of a man, woman, and child, almost always a son. This family
portrait is evident in the Memphis triad of Ptah, his wife Skhmet, and
their son Nefertum; in the Theban triad, Amon, his wife Mut, and son
Khons; but most particularly in the triad of Osiris, Isis, and Horus. Isis
became so popular that she supplanted all other goddesses. There were
numerous other goddesses: Nephthys, sister of Isis and god of the dead;
Hathor, the cow goddess and goddess of creation; and Hekhebet, god-
dess of childbirth. Meshkhent, Taueret, and Renenet were also god-
desses of childbirth or of suckling children. There were still others.[33]

Since goddesses were so important it would seem to follow that royal
women would also be important, if only because the pharaoh's first wife
was the consort of a god. Inevitably, too, she became the "mother of the
god" who would be the successor to her husband. At all periods in Egyp-
tian society the queens were the first ladies of the land, and originally
the tombs of some were as big and as elaborate as those of the kings.
During the pyramid period, however, the queens' pyramids were much
smaller than those of the kings, emphasizing that while women were
important, they were not as important as men. There were exceptions.
The Greeks preserved a legend of an early woman pharaoh, Rhodopis,
the daughter of Cheops, the pharaoh who built the famous pyramid. All
sorts of tales were told about her sexual ability that would tend to em-
phasize her mythical character.[34] There is, nonetheless, some cor-
roborating evidence. The tomb of a fourth dynasty queen shows Khufu's
daughter (Cheops to the Greeks), Hetep-hires II, as having blond hair
instead of the conventional black hair. Since Rhodopis means "rosy-
cheeked" the resemblance is obvious. Her identity was probably merged
with that of Queen Khent-kaus, for whom the so-called fourth pyramid
of Giza, actually a huge sarcophagus, was built.[35]

Legend and the reality of history are often different, and it was not

until the eighteenth dynasty (c. 1570–1305) that the Egyptian queen achieved her highest prestige. The most influential of all was Hatshepsut (c. 1486–1468), who stole the throne from her young nephew and stepson, Thutmose III, and wielded the scepter for about twenty years. Hatshepsut, however, ruled as a king and not as a queen, an indication of the difficulties women had in ruling. The reigning monarch of Egypt had to be male: the titles, laudatory inscriptions, and ceremonies were all designed for men and were so deeply rooted in tradition and dogma that it was easier for a woman to adapt herself to fit the titles than to change the titles to fit her sex. Inevitably her reign is somewhat confusing since she is shown both in a man's kilt (and body) wearing the king's crown and artificial beard, and as a woman with feminine dress and queen's crown. She also has two tombs, one in her capacity as queen and one as king, the latter being larger. When she died or was driven from the throne by her nephew, Thutmose III, he destroyed almost anything Hatshepsut had ever touched, and even tried to obliterate all inscriptions which referred to her. Though Hatshepsut must have been a strong-willed woman, one of her great difficulties seems to have been her inability to lead an army. She recorded no military conquests or campaigns; her great pride was in the internal development of Egypt. Some would say she lacked military exploits because she may have been a leader of a peace party opposed to expansion. Actually there is nothing in a woman's biological makeup that would prevent her from being a soldier or general, in fact; many women disguised themselves as males to serve in the American Civil War, but women almost without exception were not trained as soldiers. In the past, when kings had to lead their armies, this discrimination might have prevented more women from being rulers. Hatshepsut obviously was supported by the bureaucracy of the state, but civil powers can be diffused. In a military crisis, however, power must be centralized into the hands of one person, and though a woman might appoint a male to act as commander, there is little to stop him from turning against her, particularly if he has the loyalty of the troops. It might well be that Thutmose III used his military ability to regain the throne, since he either deliberately introduced military imperialism or was forced to expand in order to defend his countries' borders.[36]

Hatshepsut was not the only woman to sit on the throne. There were at least three others, although only as regents for their sons. The mother of Pepi II (2350–2200 B.C.) was mentioned in some of his inscriptions, but the other two queens, in the twelfth and in the nineteenth dynasties, were even more obscure. Tausert, who finished up the nineteenth

dynasty, like Hatshepsut, took the title of king. Other than the fact that she was not the daughter of a king, we can say little more about her. More information is known about some of the other royal wives of the eighteenth dynasty, particularly Queen Tiy, wife of Amenhotep III (1398–1361 B.C.) and her daughter-in-law, Nefertiti, wife of Akhenaton. Tiy is interesting if only because she is usually pictured as being ugly and a commoner. This raises questions of how she got to be queen. She must have been very bright, and we know she had considerable power both under her husband and under her son. Akhenaton also raised his own wife, Nefertiti, to a high position of power, but unlike Tiy, Nefertiti was and still is known for her beauty. Women continued to exercise considerable influence down to the time of Cleopatra, the seventh Macedonian princess of that name and apparently the first Greek princess to be able to speak to the Egyptians in their own tongue. Though Cleopatra was Greek rather than Egyptian, her importance emphasizes the continuing influence of women in Egyptian affairs, whether foreign or native.[37]

The relative importance of the queen mother was no indication that the king was restricted to one wife. Concubines and harems were common, but such women seldom appeared in public. The size of the harem probably varied and at times reached remarkable numbers. Ramses II (1290–1224 B.C.), for example, had at least seventy-nine sons and fifty-nine daughters. The members of the royal harem lived apart from the rest of the court. Employees of the harem were not eunuchs, as in Mesopotamia, but included normal men, many of them married, as well as numerous women. In general the harem women were chosen by the pharaoh either for political reasons or for their great beauty. It was through this last procedure that many nonroyal women gained admission and some became queens. There were also a number of women of foreign birth. Inevitably there were conspiracies in the harem as various wives tried to maneuver their sons into key positions. When women were not in the harem for political reasons, their chief purpose was to amuse their lord. They were instructed in dancing and singing and other arts designed to arouse and delight the male. Some of the richer Egyptians also had harems and concubines, but as a general rule Egyptians practiced monogamy if only because economic factors worked against polygamy. The husband could dismiss his wife if he wished to remarry or if his wife ceased to please him, but he had to return her dowry and give other forms of settlement. Women had no such freedom.

Like most societies, Egypt practiced a double standard. Concubinage existed but not polyandry. Maidservants belonged to their owner and

adultery for the male was not considered a sin. Prostitution was widespread. In the so-called erotic papyrus of Turin the adventures of an inexperienced man in a brothel were described in such great detail that the work has remained unpublished because scholars in the past regarded it as obscene. If a married woman committed adultery, however, she could be deprived of her property and be subject to punishment. We have two folktales from the Middle and New Kingdom of women committing adultery: in the first the woman was burned to death; in the second her husband killed her and threw her corpse to the hounds. In other folktales women appeared as very sexual creatures, willing to betray their husbands, use various kinds of tricks, and do other things in order to get the men who attracted them physically into bed. Gaston Maspero, the nineteenth-century editor of a collection of these stories, said that they indicated the Egyptian morals were lax, and it is probably from such statements that the legend of the promiscuous Egyptian woman has arisen.[38]

Throwing doubt upon the Maspero concept of the promiscuous female was the Egyptian custom of female circumcision. Though such a custom was not described until Greek times and there is no ancient illustration dealing with female circumcision, as there is with male, it seems to have been widespread. Egyptian practice, sometimes called excision, entailed the resection or "cutting out" of the clitoris and labia minora, or at least parts of them. The effect of such surgical intervention is to make the female orgasm all but impossible.[39]

It is at the very time when we have the best evidence for female circumcision that Maspero labels the female Egyptian as having lax morals. Instead of evidence of female promiscuity, such tales might only be male-oriented pornography, designed to arouse the male. By emphasis on female sexual desire, however, female insubordination might also be encouraged. Thus to reassert their control men emphasized clitoridectomies, allowing unlimited pleasure for the male but only limited temptation for females to be insubordinate. We also know that before this time the Egyptian woman was seldom pictured in any negative way in the literature. She was portrayed as the faithful caring wife, the princess with many suitors, or the mistress praised by songs and poems. Motherhood was her revered function. Not to have children was a terrible and lamentable situation, and mother and children were depicted at all times in Egyptian tombs and pictures.

Women seldom appeared in public life although some women did hold public offices. There are records of a woman director of a dining hall, a manageress of a wig workshop, a headmistress of singers, a

female supervisor of a house of weavers, and numerous mistresses of royal harems or superintendents of houses. In later Egyptian history wives of eminent persons or members of old noble families also were allowed to use honorary official titles. We know of at least one woman scribe who belonged to the household of a thirteenth-dynasty queen, and it is possible some queens and princesses knew how to write. Most women, even of the upper classes, could not. Women could also serve in the temples, and priestesses were recruited not only from the royal house, the civil service, or clergy, but also from the working class. Generally women served as musicians or dancers in the temple, although some might have become high priestesses.[40]

Egyptians also believed that males rather than females were the key to procreation, and the male phallus was often portrayed. The female sex organs were not usually depicted in ancient Egypt. There was, however, a widespread belief that a woman might succumb to hysteria if the womb remained barren long after puberty. Rather late in Egyptian history, during the Greco-Roman period, importance was given to the womb, particularly in the alchemical treatises that picture the universe itself as a kind of womb which the male element somehow fertilizes. This is an attempt to explain developments in the universe in terms of the miracle of the conversion of the male semen into a human infant.[41]

The extant literature seems to be from the hands of males, and it reflects the various attitudes of men toward women. Ptah Hotep, the semilegendary sage of the Old Kingdom who lived in the third millennium B.C., said: "If you are a man of note, found for yourself a household, and love your wife at home, as it beseems. Fill her belly, clothe her back; unguent is the remedy for her limbs. Gladden her heart, so long as she lives; she is a goodly field for her lord [that is, she will produce children if you cultivate her]. But hold her back from getting the mastery. [Remember that] her eye is her stormwind, and her vulva and mouth are her strength."[42] Though wives were good if kept in their place, care should be exercised in their choice. "If you take to wife one who is well nurtured, one who is cheerful, one whom the people of her city know, put her not away, but give her [food] to eat."[43] Women were also dangerous: "If you would prolong friendship in a house to which you have admittance, as master, or as brother, or as friend, into whatsoever place you enter, beware of approaching the women. It is not good in the place where this is done. Men are made fools by their gleaming limbs of carnelian. A trifle, a little, the likeness of a dream, and death comes as the end of knowing her."[44] In the New Kingdom, from the fifteenth to the

twelfth centuries B.C., the same sort of advice was given. Motherhood was especially revered. "Double the bread that thou givest to thy mother, and carry her as she carried [thee]. When thou wast born after thy months, she carried thee yet again about her neck, and for three years her breast was in thy mouth. She was not disgusted at thy dung, she was not disgusted and said not: 'What do I?' She put thee to school, when thou hadst been taught to write, and daily she stood there [at the schoolhouse] . . . with bread and beer from her house."[45] When a man married he should keep the example of his mother in front of him. "When thou art a young man and takest to thee a wife and art settled in thine house, keep before thee how thy mother gave birth to thee, and how she brought thee up further in all manner of ways. May she not do thee harm nor lift up her hands to the Gods and may he not hear her cry."[46] A man had to be careful with his wife. "Act not the official over thy wife in her home, if thou knowest that she is excellent. Say not unto her: 'Where is it? Bring it to us,' if she hath put [it] in the right place. Let thine eye observe and be silent, that so thou mayest know her good deeds. [She is] happy when thine hand is with her. . . . Thereby the man ceaseth to stir up strife in his house. . . ."[47]

Women, in general, however, were a snare and a delusion. "Go not after a woman, in order that she may not steal thine heart away."[48] In particular beware "of a strange woman, one that is not known in her city. Wink not at her . . . have no carnal knowledge of her. She is a deep water whose twisting men know not. A woman that is far from her husband, 'I am fair,' she saith to thee every day, when she hath no witnesses."[49]

Yet a woman could also be a delight.

> When I embrace her and her arms enlace me,
> it is as if I were in Punt,
> drenched in her fragrance!
> When I kiss her with her lips opened,
> ah, then I am drunk without beer!
> Hasten to prepare the bed, handmaiden!
> Place the finest linen for her limbs,
> perfumed with precious unguents!
> O would that I were her Negro slave girl who bathes her,
> then I would always see the color of all her limbs!
> O would that I were the one who washes her linen,
> to rinse the perfumes which pervade her garments!

O would that I were the ring upon her finger,
 so that she would cherish me as something which
adds beauty to her life.
.

Lovely are her eyes when she glances,
Sweet are her lips when she speaks,
 and her words are never too many!
Her neck is long, and her nipple is radiant,
 and her hair is deep sapphire.
Her arms surpass the brilliance of gold,
 and her fingers are like lotus blossoms.
Her buttocks curve down languidly from her trim belly,
 and her thighs are her beauties.
Her bearing is regal as she walks upon the earth—
 she causes every male neck to turn and look at her.
Yes, she has captivated my heart in her embrace!
In joy indeed is he who embraces all of her—
 he is the very prince of lusty youths!
See how she goes forth—like that one and only Goddess.[50]

In sum, the Egyptian woman had a relatively pleasant life and we do not need to resort to questionable generalizations like that of primitive matriarchy in order to explain it. Her somewhat higher status than that of the Mesopotamian woman still did not mean that she was considered equal to men. Women were clearly subordinate, and compared to men's, their lives were circumscribed. It might well be that the very passivity of living in Egypt, owing to the great fertility of the soil and to the regularity of life, lent less emphasis to war and to the making of war. Women worked in the fields along with the men in ancient times, as they do now, although their assigned functions differed. Even the fact that women appeared as rulers does not mean that they had equality, since all apparently exercised their power in the name of a son or took a male name. It is also worthy of comment that most of the women rulers appeared at the end of a dynasty, apparently striving to keep the family in power either because their sons were young or their husbands were enfeebled. Hatshepsut, of course, was an exception. Some Egyptian women worked outside of their homes, but the professions were not open to them nor were any of the crafts, except the traditionally feminine ones. They were not priests, nor were they carpenters, sculptors, or scribes. Woman's place was in the home, and it was as mothers that they had their greatest influence. If Egypt is the example of the power that

women had under what some have called a matriarchy, their status in times past must never have been very high.

As far as attitudes toward women were concerned, ancient Judaism was more inclined to follow the attitudes of Mesopotamia than of Egypt. Judaism was a male-oriented religion with women clearly subordinate. Nevertheless there was considerable ambivalence expressed toward women. The nature of this ambivalence is shown in the conflicting versions of creation. In one version, God was said to have created the world in six days, including man (and woman), whom "God created in his own image, in the image of God created he them. And God blessed them, and God said unto them, Be fruitful and multiply, and replenish the earth, and subdue it: and have dominion over the fish of the sea, and over the fowl of the air, and over every living thing that moveth the earth."[51] This account, however, is generally agreed to have been composed later, following the Babylonian exile, than the earlier and better known one of Adam and Eve. In this earlier version, the male was clearly superior to the female. God created man, Adam first, but then decided that it was "not good that the man should be alone; I will make him an helpmeet for him."[52] Then out of the rib of Adam, he made Eve. The very name *woman* according to the Bible meant that "she was taken out of man." The most striking evidence of this superiority of first creation is not found in Jewish but in Christian scriptures. The Apostle Paul emphasized: "For the man is not of the woman; but the woman of the man. Neither was the man created for the woman; but the woman for the man."[53]

Woman, in his mind, had been created to assist man, to serve him, and to act as companion. Regardless of this intent, woman was troublesome. It was the women in Jewish literature who seemed to have the more constant, more aggressive sexual drive. It was Eve who led Adam astray, and so indirectly was responsible for all of his problems. For causing this disgrace God punished woman: "I will greatly multiply thy sorrow and thy conception; in sorrow thou shalt bring forth children; and thy desire shall be to thy husband, and he shall rule over thee."[54] Though ancient Palestine, like Mesopotamia, suffered from continual invasion, demanding strong men, much of the ancient Jewish suspicion of women was due to the fact that they were so sexually enticing, and sex came to be more and more a problem in ancient Israel. In general there seems to have been very little preaching on sex in the pre-exilic period (before the sixth century B.C.). In fact there was little consciousness of sex as a special problem in the pattern of social conduct. After that, however, came a radical change which lasted through the

Second Commonwealth and the entry of Rome upon the scene. In this period, when much of the scripture was put into written form, there was emphasis upon man as a weak, helpless creature, heir to inborn evil tendencies inherited from Adam, his original father. Man's greatest weakness was the lure of sexual pleasures. The urge for sexual satisfaction made man almost a helpless victim in the hands of Satan. Inevitably a rigid code of sex morality developed in which even innocent social contact between the sexes came to be regarded with suspicion and condemned as immoral. If a man felt his soul was endangered by sex, women came to be feared and suspected since he was so conscious of the impact they had on him. Asceticism, particularly in sexual matters, became an ideal, and even legitimate sexual pleasures were condemned as sinful.

In a sense this explanation appears much too simple, since it neglects the fact that there were countercurrents within this period and large segments of the population were not in accord with such ascetic ideals. It was, nevertheless, these ascetic ideals that came to be incorporated into the law and that exercised such great influence upon Christian thought. Why such hostility toward sex? One possible explanation for this increasing rigidity of attitude, even overt hostility toward sex, is that it represented a reaction to the threat of assimilation. In order to preserve Judaism from what was regarded as the threat of disintegration from contact with outsiders, who were politically and militarily more influential, rigid codes were erected, separating Jew from non-Jew. Nowhere were these restrictions more evident than in the increasing restrictions put upon social contacts between a man and a woman. Woman, after all, to the male mind is often equated with sex. She keeps reminding him of his sexual nature and therefore she must be evil. During the talmudic period, coinciding with the first few centuries of the Christian era, when Judaism was temporarily more secure, there was again more permissiveness and a tendency to accept sex as good. The rabbis of this period even went so far as to ridicule the fear of the "dangerous" woman that had occupied the minds of the teachers of the earlier period. They denied that the flesh was evil, but emphasized instead that the legitimate pleasures of sex were essentially good. Even though sex was good, it was only within marital relationships that it could afford "legitimate" physical satisfaction and further God's purpose in perpetuating the human species. Moreover, sex acts should always meet the standards of cleanliness and refinement set forth in the various codes. Still later in the Middle Ages sexual standards again became much more restrictive.[55]

The chief safeguard of sexual morality practiced throughout Jewish history was early marriage, as soon after puberty as possible. Even younger marriages were possible since the Jewish scholars regarded the boy as capable of the sexual act at nine and girls at three years of age.[56] In biblical times marriage took place around the age of fifteen, although girls were at least betrothed, if not married, at younger ages.[57] Young men who were still unmarried at eighteen might be called before the elders to account for their failure to take a wife. If the place of the bachelor was disapproved of, there simply was no place for a single woman. The aim of Hebrew society was to have every eligible person married. Tied in with this was the concept of levirate marriage, marriage of the widow to the brother-in-law. It is upon the husband's brother that the obligation was put to take the place of his deceased brother, both in providing a "name" for him and in caring for the widow, particularly if she were childless, since the childless person was cut off from the family tree and thus had to be artificially regrafted. The widow in return received care, sustenance, and protection and retained the social advantage of membership in her husband's family.[58]

Though levirate observance underwent definite and radical changes in the biblical period and probably disappeared altogether in the post-exilic period, there is still scholarly debate upon the subject.[59] Obviously the levirate marriage emphasized the nature of women as property. This also appeared in the Decalogue. "Thou shalt not covet thy neighbour's house, thou shalt not covet thy neighbour's wife, nor his maidservant, nor his ox, nor his ass, nor anything that is thy neighbour's."[60] This is in keeping with the fact that most of the biblical and talmudic references dealt with women from a male point of view. Inevitably also there was a double standard. Adultery existed in Jewish law but it applied only to the sex relations of a married woman with a man other than her husband. This could result in the death penalty, but if a married man engaged in sex relations with other women there was no punishment.[61] The subordinate status of women is also evident from the treatment of rape, most notably in the Talmud, where it is emphasized that there is always the possibility that the initial moral resentment on the part of the woman may gradually turn into an inward instinctual consent.[62] Though the sons of Jacob killed Shechem for raping their sister, Dinah, their father condemned them for it, although his condemnation might have been motivated by fear of what would happen to him and his family, who were outnumbered by the unbelievers.[63] The case of Tamar, the daughter of David, and his son Amnon[64] was less one of rape than of incest, and incest was one of the crimes that Jews could not commit

even under threat of death.[65] Rape under wartime conditions was not considered rape at all, and it was more or less standard practice for the Hebrew soldiers to ravish the women captured in war.[66] Some attempts were made to ameliorate such practices, but the custom was never fully abolished.[67]

Ancient Jews also practiced polygamy, and in the Bible it appears widespread, at least among the leaders. Gideon, the Israelite judge, had enough wives to bear him seventy sons.[68] Other polygamists included Jair, Ibzan, Abdon, David, Solomon, and Rehoboam, although sometimes it is difficult to separate wives from concubines since Abraham, Jacob, Gideon, Saul, David, and Solomon all had concubines. A concubine could be the slave girl of a man's wife, as was the case of Hagar and Sarah or Bilhah and Rachel, and several others, but a man could also buy a concubine for himself or take one captured in war. Woman's status in society depended to a large extent on her fruitfulness, and the inability to bear children was a cause of disgrace. The childless Sarah, for example, was despised by her handmaid Hagar, and poor Sarah was beside herself when Hagar gave Abraham a son.

Jewish law never prohibited sexual relations between unmarried persons, but virginity in a bride was highly prized. There were numerous Jewish ethical teachings extolling premarital chastity for both young men and young women, but no penalty was imposed for violation of this ideal. Children, whether born in or out of wedlock, were regarded as legitimate. The references to bastards refer only to offspring of unions that would have been impermissible in marriage, such as incestuous or adulterous relations or relations between a member of a priestly caste and a divorcée.[69]

The Bible also emphasizes the fact that women have special problems which further set them apart from men. A menstruating woman was held to be unclean: "And if a man shall lie with a woman having sickness, and shall uncover her nakedness; he hath discovered her fountain, and she hath uncovered the fountain of her blood: and both of them shall be cut off from their people."[70] This seems to imply exile or death as punishment for sexual relations during menstruation, and we know that such extreme punishments were not usual. Traditionally, nonetheless, a woman was regarded as unclean for seven days and everything that she "lieth upon," "setteth upon," or "toucheth" also became unclean. "And if any man lie with her at all, and her flowers be upon him, he shall be unclean seven days: and all the bed whereon he lieth shall be unclean."[71] Since women were thought to be so obsessed with sex, they had to be protected from their own natural base instincts. Talmudic writers went so far as to prohibit a widow from keeping a pet dog for fear

she might use it to commit a sexual indecency.[72] Widows were also enjoined from acquiring a slave for the same reason.[73] This fear of female sexuality, however, never led the Jews to practice female circumcision, as did the Egyptians.

Instead the Jews emphasized the importance of helping the female achieve orgasm. Talmudic writers went to great lengths to specify the minimal obligations in sex that a husband has toward his wife, and he was obliged to satisfy her even though she was barren. Still the Bible also continually emphasizes the sexual nature of women. It was Potiphar's wife who tried to seduce Joseph,[74] and there was quite frank sexual bargaining between Rachel and Leah for sex rights to their husband, Jacob.[75] Delilah was the cause of Samson's downfall.[76] Even when a woman was peacefully taking a sunbath, she caused trouble, as did Bath-sheba to David.[77] Since David was a man of God, that he committed a mortal sin must have been owing to Bath-sheba rather than to himself. Instead of the innocent victim she became the seducer and often is still so regarded. Frank S. Mead in his description of biblical characters, for example, describes her as a "dirty, apologetic gray."[78] The straying of Solomon, the "beloved of God," is also attributed to women. As the Bible says: "His wives turned away his heart after other gods: and his heart was not perfect with the Lord his God, as was the heart of David his father."[79] The word *Jezebel*, the name of the wife of Ahab, has even become a pejorative term in English because the biblical writers state that she led her husband to worship Baal.[80] In Proverbs, the most conspicuous and vividly developed theme is the importance of avoiding "strange women," or any women other than one's wife. Proverbs also characteristically presents the erring woman as more guilty than the man; while he is weak, she has deeply sinister designs on him. A poor credulous man follows a woman just as an ox goes to the slaughter.[81] The author of Ecclesiastes through diligent search found one righteous man among a thousand, "but a woman among all those I have not found."[82]

There are, of course, other portraits of women in the Bible.[83] Intelligence, after all, was not a male prerogative, but the only woman who achieved a sort of political power by common consent was Deborah, the Prophetess, the Jewish Joan of Arc, who encouraged the doubters in the fight for Canaan and helped bring about victory over Sisera, leader of the Canaanite army.[84] Deborah helped Barak plan the strategy, organized the campaign, and accompanied Barak, but once the Israelites had won, she gave all credit to God and took none for herself. In fact she only accompanied the troops at Barak's request.

The woman was supposed to be loyal, particularly to her husband and

her husband's family, and the story of Ruth and Naomi has often served as a moral lesson to impress all wives: "Intreat me not to leave thee, or to return from following after thee: for whither thou goest, I will go; and whither thou lodgest, I will lodge; thy people shall be my people, and thy God my God. Where thou diest, will I die, and there will I be buried: the Lord do so to me, and more also, if ought but death part thee and me."[85] The last chapter of Proverbs spells out what a good woman should do in great detail:

> Who can find a virtuous woman? for her price is far above rubies.
> The heart of her husband doth safely trust in her, so that he shall have no need of spoil.
> She will do him good and not evil all the days of her life.
> She seeketh wool, and flax, and worketh willingly with her hands.
> She is like the merchants' ships; she bringeth her food from afar.
> She riseth also while it is yet night, and giveth meat to her household, and a portion to her maidens.
> She considereth a field, and buyeth it: with the fruit of her hands she planteth a vineyard.
> She girdeth her loins with strength, and strengtheneth her arms.
> She perceiveth that her merchandise is good: her candle goeth not out by night.
> She layeth her hands to the spindle, and her hands hold the distaff.
> She stretcheth out her hand to the poor; yea, she reacheth forth her hands to the needy.
> She is not afraid of the snow for her household: for all her household are clothed with scarlet.
> She maketh herself coverings of tapestry; her clothing is silk and purple.
> Her husband is known in the gates, when he sitteth among the elders of the land.
> She maketh fine linen, and selleth it; and delivereth girdles unto the merchant.
> Strength and honour are her clothing; and she shall rejoice in time to come.
> She openeth her mouth with wisdom: and in her tongue is the law of kindness.
> She looketh well to the ways of her household, and eateth not the bread of idleness.

40

Her children arise up, and call her blessed; her husband also, and
he praises her.

My daughters have done virtuously but thou excellest them all.

Favour is deceitful, and beauty is vain: but a woman that feareth
the Lord, she shall be praised.

Give her of the fruit of her hands; and let her own works praise
her in the gates.[86]

It was perhaps from this description that someone coined the phrase
that while man works from sun to sun, woman's work is never done.
This is obviously again a male view of what a woman should do. No-
where does it indicate that she should have any pleasures in life, other
than pleasure in a thing well done.

Women could also be an erotic figure.

Thy lips, O my spouse, drop as the honeycomb: honey and milk
are under the tongue; and the smell of thy garments is like the
smell of Lebanon.

A garden inclosed is my sister, my spouse; a spring shut up, a
fountain sealed. . . .

My dove, my undefiled is but one; she is the only one of her
mother, she is the choice one of that bare her. . . .

Thy navel is like a round goblet, which wanteth not liquor: thy
belly is like an heap of wheat set about with lilies.

Thy two breasts are like two young roses that are twins.

Thy neck is as a tower of ivory; thine eyes like the fishpools in
Hesbon, by the gate of Bath-rabbim: thy nose is as the tower of
Lebanon which looketh toward Damascus.

Thine head upon thee is like Carmel, and the hair of thine head
like purple; the king is held in the galleries. . . .

Set me as a seal upon thine heart, as a seal upon thine arm: for
love is strong as death; jealousy is cruel as the grave: the coals
thereof are coals of fire, which hath a most vehement flame.

Many waters cannot quench love, neither can the floods drown
it: if a man would give all the substance of his house for love, it
would utterly be contemned. . . .[87]

Though the Song of Solomon owes its inclusion in Scriptures to the idea
that it portrays a close and loving relationship between God and Israel,
and this allegorical interpretation was accepted by the early Christian
church, most biblical scholars would hold that it should be interpreted
much more literally. If combined with Proverbs it gives us two faces of

woman: the dutiful housewife and loving mother on the one hand; the erotic lover, temptress of man, on the other. Nowhere was woman regarded as equal to man. In its positive aspects the ancient Jewish attitude led to a high regard for home and children and a high ideal of family life. Though woman's domestic and maternal virtues were esteemed, she was subordinate and naturally inferior to man, and she labored under various religious and social disabilities. Since the home remained the center of community life, the lot of the Jewish woman was not without either its compensation or its opportunities, but these were not to be compared, at least in the male mind, with those available to men. Women in the ancient Near East were everywhere subordinate, although their lot in Egypt was probably somewhat better than in Palestine or Mesopotamia. Woman had her greatest value as mother, but she was also important as a sex object. Though the Babylonians might have regarded her as property, it was the Jews who made her an object of evil. This facet of woman continues to appear through much of Western civilization.

3 / The Pedestal with a Base of Clay

Our nineteenth-century forebears put the Greeks on a pedestal. The classics played a great part in the education of the upper classes in Europe, as well as America, and the intrinsic greatness of much of Greek (and Roman) literature called forth unstinted admiration. The Greeks seemed to them to be the embodiment of wisdom and beauty and were regarded as setting standards by which epic, lyric, and dramatic poetry could be judged. The Greeks were called the fathers of history and geography, the founders of philosophy, regarded as having laid the theoretical basis for science, and creators of ideals that guided artists since their time. Though in recent decades we have tended to bring the Greeks down from their pedestal, to talk less of the "glory that was Greece" and more of historical reality, it is still troublesome to many historians, perhaps imbued with slightly more enlightened attitudes toward women than some of their ancestors, to find that the Greeks regarded women as such inferior creatures.

Though attitudes toward women differed over the long course of Greek history, during the period about which most is known, that of Athens in the fifth and fourth centuries B.C., the status of women seems to have achieved some kind of nadir in Western history. Modern historians, who often are imprisoned in the attitudes of their own culture, recognizing that the Greeks were intelligent, rational, and sophisticated, just as they themselves are, find this attitude toward women contradictory and not a few have tried to explain it. H. D. F. Kitto, for example, in a popular (and scholarly) history of Greece, after pointing out the

evidence for the depressed status of women, comments that the story is incomplete. In trying to develop a more accurate account, he compares himself to the detective in a mystery story who, though all the evidence seemingly leads to but one conclusion, does not fully accept it if only because there are still ten more chapters to go in the book before the real culprit is unmasked. Concerning Greek women, Kitto holds that what is wrong with the standard portrayal "is the picture it gives of the Athenian man. The Athenian had his faults, but pre-eminent among his better qualities were lively intelligence, sociability, humanity, and curiosity. To say that he habitually treated one half of his own race with indifference, even contempt, does not, to my mind, make sense. It is difficult to see the Athenian as a Roman paterfamilias, with a greater contempt for women that we attribute to the Roman."[1] The difficulty with such thinking is that the Greeks often treated a great many people with indifference, including other Greeks, and like most people before or since, were quite capable of brutality and callousness. The only way stereotypes about Greek attitudes can be challenged is by seeking new evidence and not by wishing things were different. Is there any evidence to the contrary? Arnold Gomme has argued that the negative view of women advanced by most scholars has been biased by the selection of sources from which it is drawn. A different view could be held since there is "no literature, no art of any country, in which women are more prominent, more important, more carefully studied and with more interest," than in the tragedy, sculpture, and painting of fifth-century Athens.[2] It is true that women do appear in the vase paintings, in the sculpture, and in the tragedies; particularly in the drama of Euripides women play an important role. The role, however, is highly restricted, namely that of housekeeper and mother. It is this very role that Greek males held in such low esteem. Or did they?

An American sociologist, Philip Slater, argued that the entire controversy over the role and status of women in Greece, and thus the attitudes expressed toward them in the extant literature, is based upon a "patriarchal delusion."[3] By patriarchal delusion he meant the belief that power follows deference patterns, that because men were seemingly the most important they actually held real power. Slater also held that a sizable power differential between the sexes was never possible over any length of time and that to believe the contrary was part of the patriarchal myth. According to Slater, once a scholar divests himself of such delusions and examines Greek society anew, the combination of derogation and of preoccupation with women ceases to be a paradox and becomes inevitable. This is because the rejection of the female by the

Greeks was little more than the rejection and derogation of domesticity, of home and family life, and hence of the process of rearing young children. The fact that the Athenian adult male fled the home only meant that the Athenian male child grew up in a female-dominated environment. Later as an adult male he tried to convince himself, sometimes even successfully, that women were of no account, but deep down he knew that during the most important years of his psychological development the reverse was true. In his early formative years men were trivial to him, since the most important things at that period, at least as far as he could see, were decided by women. Using some twentieth-century studies as a basis for his theorizing, Slater argued that women, excluded from outside activities, inevitably assumed more decisions regarding household activities, emphasizing their role and influence over the young.

The difficulty with such an explanation is quite simply that ancient Greece was not twentieth-century America. The mother, in fact, was not the key figure she has been in traditional middle-class American society, sacrificing herself and her independence to further her children's development, although this did sometimes happen in ancient Greece. Instead the most influential figure in reasonably well off Greek families, and it is this group with which Slater was most concerned, was the "nanny," who usually was also a slave.[4] Moreover, girl children from the moment of their birth were regarded and treated as inferior to boys, a condition which young boys became conscious of if only because their slave nannies emphasized it in order to secure their own status. It seems doubtful, at least to us, that the combination of a doting "nanny" and the concept of superiority of the male so ingrained in the young Greek male would lead to the kind of anxieties Slater argued for.

It is undoubtedly true that the psychological influence of women should be separated from their social position, but Slater was highly selective of the psychoanalytic theory he chose to buttress his position.

The Greek male's contempt for women was not only compatible with, but also indissolubly bound to, an intense fear of them, and to an underlying suspicion of male inferiority. Why else would such extreme measures be necessary? Customs such as the rule that a woman should not be older than her husband, or of higher social status, or more educated, or paid the same as a male for the same work, or be in a position of authority—betray an assumption that males are incapable of competing with females on an equal basis; the cards must first be stacked, the female given a handicap. Other-

wise, it is felt, the male could simply be swallowed up, evaporate, lose his identity altogether.[5]

It is precisely this mother-dominant, father-avoidant culture which Slater believed could explain the widespread existence in ancient Greece of male homosexuality and in which the mother would select the son as a kind of surrogate husband. Much of his theorizing on this matter was based on the conceptions of Karen Horney.

Horney, a disciple of Freud, disagreed with him on the universality of penis envy. Instead she held that the male's attempt to find a penis in the woman was an attempt to deny the existence of the intrinsically "sinister" female genitalia that represents a fear of maternal envelopment. She claimed that male homosexuals, for example, dreamed they were falling into a pit, sailing a boat in a narrow channel, being sucked into a whirlpool, finding themselves in a cellar full of "uncanny, blood-stained plants and animals," or being lured to death by a female. Slater found similar concepts expressed in Greek mythology and legend. To overcome this dread of the female genitalia Horney claimed that men developed two techniques, namely disparagement and idealization. The male reassured himself by the first that there was nothing to be feared from so poor and inadequate a creature and by the second that there was nothing to fear from so saintly a being.[6] To further support the application of this thesis to Greece, Slater pointed to the misogynistic nature of most Greek literature and to the fact that the Greeks tended to marry barely pubescent girls and to encourage their women, and only their women, to practice depilation of all body hair. Inevitably also it was the mature, maternal-type women who were the most feared and most dangerous in Greek literature.[7] But why adopt the concept of the sinister female genitalia instead of the penis-envy theory of Freud to explain ancient Greece? In fact, do either of them explain the Greeks? The real difficulty with applying any such theoretical concept to Greece is that data are conflicting and different attitudes were dominant at different periods. Slater agreed that attitudes change but held that the increasing misogyny was due to a transition from a matriarchy to a patriarchy, something that as has been indicated elsewhere is debatable.

There were, however, other changes in Greek society that can be documented from existing sources, namely, the growth of urbanization. The Greeks pictured in the earliest literary sources were rural. By the fifth century B.C., however, they were urban. It would seem obvious that as people moved into town the nature of the family life would change. But how radical was this change? Slater argued that the role of the hus-

band changed as he absented himself more and more and his economic role became less visible. The wife in turn became less mobile, more imprisoned within the household, thus upsetting some previous balance. In the process, he held, there was a breakdown of the extended family system that threw an emotional burden on the nuclear family, which was not equipped to handle it. As ties of blood weakened, there was no corresponding strengthening of the marital bond to fill the gap, and the tensions between the sexes were simply accentuated; hence the growth of misogyny and homosexuality. It is true that women were probably less important in the city than they were in the country, where they often worked alongside their husbands, but Greek cities were not modern cities and all of the major figures in Greek life were also landholders, who commuted to their farms or if wealthy supervised from a distance. By modern standards no Greek city was large, and kinship always remained important. Moreover, while the extended family was not the base unit in Athens, there were always plenty of slaves to make the Greek family different from the modern American one. Rather than the growth of urbanization in itself, it might be the rate at which the growth takes place that is significant. In periods of rapid growth there is considerable disorganization, and as growth levels off there is an easing of tension as old ways are successfully modified to meet the new situation. This might have been the case in Greece, although hard data to document such a change are somewhat elusive.

On the surface, however, it would seem that social change was rapid in Athens, so rapid that it reduced the authority of the older generation and engendered what today would be called a youth culture. Though this rising youth culture, represented in the literature by the hostility of the older generation to the Sophists, might have contributed to democracy, it also seemed to heighten the existing pathology. Slater argued, for example, that to ease tensions the Athenian males turned to the source of their own pathology, pederasty and misogyny.[8] Pederasty and misogyny, however, are not necessarily the opposite sides of the same coin, although it would seem to follow that when the female is condemned the male will be exalted. On the other hand if the female is exalted too high, males tend to turn to each other also. Overlooked in such explanations are the whole socialization and acculturation patterns, which have to be considered to explain the development of the Greek attitudes. On the basis of present evidence, it would seem to be much too simple to explain either homosexuality or misogyny in the terms set by Slater or by other theorists. The whole attitude toward sexuality, toward the meaning and purpose of marriage, toward the reasons for the exis-

tence of women has to be taken into consideration. The Greeks offer us much more fruitful grounds for speculation than earlier societies, but there are not enough data to arrive at any general conclusions about why they regarded women as so inferior. In fact, we would argue, there can be no simple answer to such a question in Greece or elsewhere.

In general scholars have argued that women in the Homeric poems, probably put into final form about the ninth century B.C., had a higher position and were better regarded than later in Greek society. Samuel Butler, who is best known for his novel *The Way of All Flesh*, a bitter and realistic study of Victorian bigotry, narrowness, and hypocrisy, was so impressed with the insight into women's character in the *Odyssey* that he felt it must have been written by a woman.[9] Though Butler has won few converts among classical scholars for his theory, it is evident that women play a more important part in the *Odyssey* than the *Iliad*, but this difference might well be due to the nature of the subject matter. The *Iliad*, to put it simply, is a story of battle, and in this activity the Greeks excluded their womenfolk. In the *Odyssey*, Ulysses (or in Greek, Odysseus), after fighting some ten years at Troy, sets out for home but is delayed some ten additional years through a series of adventures, mostly with women, who try to keep him from reaching his patient and devoted wife, Penelope. Penelope in the meantime is spending some twenty years anxiously awaiting the return of her wandering husband. Whether the portrayal of women is insightful or not might be left to modern readers to decide, but what becomes evident is that their menfolk treat them rather shabbily.

Scholars are in general agreement, however, that the Homeric poems reflect the attitudes and customs of the period in which they were committed to their final form, although they carry beliefs of an earlier age in which women probably had somewhat higher standing than they do in the actual poems. This higher standing—some would call it evidence of earlier matriarchy—appeared not so much in the portrayal of the mortals as in the goddesses. Among the mortals patriarchy was in full flower.[10] Matriarchy, we hold, is much too strong a term to describe the existence of earlier matrilineal and matrilocal societies. There is, nonetheless, general recognition that a feminine goddess, equated with mother nature, was very prominent in early Greek religion and only later was supplanted by the Olympians.[11]

Zeus and his fellow Olympians came fairly late to the mythology of the Greek peninsula and never claimed to have created the world. It was Homer and Hesiod who gave final form to the Olympians, and in the process of settling into a position of dominance, Zeus took almost every

local goddess as his consort. Each valley, isle, and cove seems to have had a local manifestation of a female goddess whom Zeus supplanted either by marrying or by having intercourse with her, dropping children all over Greece until descent from Zeus came to be a way of authenticating heroes and founders, much as some old American families claim descent from the pilgrims on the Mayflower. By the time of Hesiod in the eighth century B.C., male dominance, which some have questioned in Homer, was no longer in doubt. Women once again, as they were in ancient Israel, were looked upon as the source of evil. In his *Theogony*, Hesiod tells the story of Pandora, the first of all women, whom Zeus had Hephaestus fashion out of clay. All the gods contributed to Pandora's beauty and charm (her name has been translated to mean "all gifts"), and Athena and Aphrodite went to great lengths to make her extremely attractive. When they had completed their task they gave her to Epimetheus, the brother of Prometheus, the hero who had stolen fire from heaven. Though Epimetheus had been warned by Prometheus against accepting any gifts from Zeus, when he saw the lovely Pandora he ignored his brother's advice. The gods had also given Pandora a box, never to be opened, as a bridal gift. Inevitably the natural "womanly" curiosity of Pandora got the best of her, and soon after her arrival she opened the box, allowing the evils and diseases that the gods had put there to swarm out and plague mankind. The only thing that remained was hope, which had been caught under the lid when it was closed again, but Pandora finally allowed hope to go free also. The misogyny of Hesiod was further underlined by his emphasis on the fact that it was Pandora from whom were descended the "deadly race and tribe of women," who were always troublesome to men.[12] Men were miserable whether they married them or not. Those who managed to avoid "marriage and the sorrows that women cause" reached deadly old age without anyone to tend to them and they also lacked children. Inevitably, when such a man died his kinfolk would divide his possessions among themselves. Quite obviously the purpose of woman was to nurse a man in his senility and to bear him children in order that he not leave his money to distant relatives. Hesiod, in fact, thought of a wife as an expense, at best a constant drain on her husband's income, at worst a financial calamity. He cautioned his readers not to let a "flaunting woman coax and deceive them" and reminded them that the "man who trusts womankind trusts deceivers."[13]

Mythology, even when it is put into didactic form, is one thing, philosophy is another, and it is for their philosophic and scientific thinking that the Greeks were raised to such a pedestal in human history. Philos-

ophy is born when rational curiosity gets the upper hand, and people in rejecting the action of personal agents begin to seek to explain phenomena in the working out of impersonal forces. Mythical thinking, however, does not die a sudden death, and it is quite possible that it never dies. In Greek thought there was no sudden transition from a mythical to a rational mentality. Instead mythical concepts came to be dressed up in rational terms, where they gained new life in the guise of philosophic ideas. When Hesiod described the origins of the world, he posited certain powers as present in the beginning and derived others from them, and following his own experience he tried to explain things somewhat naturally. The sky married the earth and she bore the mountains and oceans as children, just as she also bore giants and gods whose form and function were purely anthropomorphic. In attributing certain characteristics to women in the myths, he and his fellow theologians were undoubtedly reflecting their own beliefs or insecurities. The same thing happened when scientific and philosophic thinking developed.

In Greece, mythological and religious explanations were unchallenged until about 600 B.C., yet by the middle of the fourth century the Greeks, or at least the educated ones, could move as easily as we ourselves do in the field of abstract conceptions and universal principles. Inevitably, however, these "scientific views" bore a strong resemblance to ideas that Greeks had held before, although the basis for holding them might have changed. As far as women were concerned, the Greeks have the honor of demonstrating on a "scientific basis" that women were inferior, although there were conflicting beliefs and even considerable ambiguity. Greek philosophy and science are usually associated with the names of Plato and Aristotle, who lived and wrote in the fourth century B.C., and it was their thinking about women which most often was reflected in later scientific and philosophic writings.

Plato was considerably more ambivalent on the subject of women than Aristotle. Some have even held that Plato was a feminist,[14] that is, a person who argues for greater rights for women. In a sense this is true, but Plato was, if nothing else, contradictory. Part of the difficulty is in determining what Plato actually believed: the dialogue form does not always make it possible to determine what he himself felt, though in the early dialogues Socrates often acted as spokesman. Unfortunately Socrates was a rather equivocal spokesman since his own marriage left much to be desired. His wife, Xanthippe, has come to be regarded as a classical example of shrewishness, and her consistent scolding proved trying even to the exceptional fortitude of her "saintly" husband. In her defense it should be said that while Socrates in one sense was a saint, he

was also a gadabout, who was always pestering people about truth and virtue, the very type of husband who might drive a woman to distraction. Many stories were told about Xanthippe. When Socrates, for example, was asked why he continued to live with Xanthippe, he is supposed to have replied that if he could learn to adapt to her he could adapt easily to the rest of the world. When questioned by a young man about whether or not he should marry, Socrates is supposed to have said: "On the one hand loneliness, childlessness, the dying out of your stock, and an outsider as your heir will be your destiny; on the other eternal worry, one quarrel after another, her dower cast in your face, the haughty disdain of her family, the garrulous tongue of your mother-in-law, the lurking paramour, and worry as to how the children will turn out."[15] With such a spokesman for female independence, it is no wonder that Plato's position is not at all clear.

But Plato himself was not consistent. The treatise in which women were looked upon most favorably, the *Republic*, was quite different from the *Laws*, in which he clearly made women subject to men. Since the *Laws* was written much later than the *Republic*, do the concepts presented there represent the true Plato? Did he change his ideas about women or have we read too much of an argument for equality into the *Republic*? Probably Plato was a prisoner of his own time who, though trying to solve problems, and in the process making universal generalizations, reflected the reality of the Athens in which he wrote. Plato's writings date from the period after the Peloponnesian War. Athens had been defeated by Sparta, and Socrates, Plato's teacher, had been put to death by the citizens of Athens. The war had been costly, business was bad, the future uncertain, and in such conditions many men questioned the wisdom of tying themselves down with wives who, they felt, could not be trusted. Plato was concerned with meeting the problem. One solution might have been to strengthen the control of men over women. Another might have been to give women greater legal rights, including the right to an education and a place in public life. In the *Republic*, which represented an ideal state, Plato took the latter course. He argued that it was absurd to divide the world into separate categories of men and women for the purpose of public affairs, of education, or anything other than the begetting and bearing of children. Such a twofold division made no more sense than it did to restrict bald headed men to certain tasks and hairy ones to others, since the ability to grow hair had nothing to do with other abilities. Moreover, encouraging men to claim things for themselves, such as wives, created struggles between citizens: litigations, worries, anxieties, and so forth. The obvious solution

was to abolish the family and hold everything in common, including lands and houses. Marriages at best were to be temporary. Women were to be sexually and socially equal to men in Plato's ideal state, to have the right to education, and even to become philosopher-kings. Even in this ideal state of equality, however, Plato recognized the right of a man who was more intelligent, brave, and skilled than others to have more wives.[16]

The concepts put forth by Plato in the *Republic* do not really make him a feminist. The society he pictured in all of his dialogues was essentially masculine. Even in the *Republic* he went so far as to state that a woman's capacity to learn was less than that of man,[17] although he was enough of a scientist to recognize the existence of individual variation. Moreover, Plato believed that a woman needed a man for her own well-being but that a man did not need a woman. In his *Timaeus* he stated: "The womb is an animal which longs to generate children. When it remains barren too long after puberty, it is distressed and sorely disturbed, and straying about in the body and cutting off the passages of the breath, it impedes respiration and brings the sufferer into extreme anguish and provokes all manners of diseases besides."[18] The obvious solution to any such problem was to appease the womb by passion and love, to sow seeds that would grow and develop into a child. "Such is the nature of woman and all that is female." Plato, in effect, argued that the way to keep woman happy was, as one wit put it more crudely, to keep her barefoot and pregnant.

In his old age, Plato, who was a bachelor, rejected some of the more feminist notions expressed in the *Republic* and asserted in the *Laws* that the patriarchal family was the basic unit of state. The chief purpose of marriage was to have children, and it was wicked for a man voluntarily to deprive himself of this heritage. He nonetheless recognized that women had sexual rights, and procreation like everything else in marriage was done in partnership, although the man was clearly superior.[19] He also held that women had the right to be educated, and though the sexes were to be separated at six, their education was to be the same. Daughters, however, were not as important as sons, since it was the sons who inherited. Increasingly Plato felt that licentiousness (which he had tolerated in the *Republic*) was reprehensible. Men and women were to live in moderation and not fall to the level of the beasts. For those who were unable to abstain from all sexual acts not intended to procreate children, Plato commanded the strictest privacy in philandering to avoid scandal. For those caught in the act of sodomy or incest, or committing adultery or fornication with citizen women, or in sexual

acts with slave concubines, he advocated disenfranchisement.[20] It was perhaps because of his fear of licentiousness that he idealized love, now often called Platonic love, although it seems clear that his ideal love object was a male rather than a female.

If Plato was ambivalent in his attitudes toward women, his pupil Aristotle must be regarded as a consistent believer in the inferiority of the female sex. His "scientific" proof of this subordination dominated much subsequent Western thinking. A belief in female inferiority entered into his physiology and biology, as well as his political, ethical, and aesthetic theories. Quite simply, to Aristotle women were intellectually and morally inferior to men. All men needed to prove such inferiority to themselves was to consult the voice of nature; nature, he felt, was quite unequivocal on male superiority. Everywhere in the animal world, he held, the male of the species was demonstrably more advanced than the female: larger, stronger, and more agile. So also was man, and thus male domination was the will of nature. To try to challenge nature in the name of an imagined principle of equality was quite contrary to the interests both of the individual and of the community.[21] Aristotle even believed that women had fewer teeth than men.

The key to Aristotle's concepts about the superiority of man was the overwhelming importance of the male principle in reproduction. He held that there was only male semen; female semen did not exist. It was the semen that supplied the form, and the female supplied the matter fit for shaping. "If, then, the male stands for the effective and active, and the female, considered as female, for the passive, it follows that what the female would contribute to the semen of the male would not be semen but material for the semen to work upon."[22]

Some historians of science have regarded Aristotle's view as a step forward, since he at least recognized that the female supplied the substance needed for growth of the embryo, which he identified as the menstrual blood. This implied that the role of the female was important, and while not quite equal to that of the male, it certainly was not entirely negative. Some earlier peoples had denied physiological maternity, including, it is believed, the ancient Egyptians. If this was the case then arguments about the status of women and attitudes toward them resulting from beliefs about their part in conception can be seriously challenged. This is because the Egyptians regarded women with a less-jaundiced eye than the Greeks, although they held the male totally responsible for conception. If Aristotle represented a forward step over earlier Greco-Egyptian views, he did not give women the importance that writers of the Hippocratic corpus on *Generation* did. In this work

the doctrine of two seeds was advanced, with the female seed identified as vaginal secretion.[23] This would imply an equality in conception. Other Greek medical and philosophic writers followed either Hippocrates or Aristotle, but Galen, who had more influence on later generations than other medical writers, adopted the views of Aristotle.[24]

Aristotle used his theory of conception to argue that women were meant by nature to be passive. He regarded women as less temperate and continent than men in their desires, because women were the weaker sex. From this he concluded that a man's love was passionate and open, while a woman felt desire and was cunning. This did not mean that women lacked goodness, but only that each group in society had a different excellence and function. A woman had her special goodness, a slave his, though a woman's was less than a man's, and that of a slave was wholly inferior.[25] Aristotle explained that

> the slave has no deliberative faculty at all; the woman has, but it is without authority, and the child has, but it is immature. So it must necessarily be with moral virtues also; all may be supposed to partake of them, but only in such manner and degree as is required by each for the fulfillment of his duty. Hence the ruler ought to have moral virtue in perfection. . . . Clearly, then, moral virtue belongs to all of them; but the temperance of a man and of a woman, or the courage and justice of a man and of a woman, are not, as Socrates maintained, the same; the courage of a man is shown in commanding, of a woman in obeying.[26]

Women lacked a natural capacity for virtue but they did have other merits, such as beautiful bodies and a love of work.[27]

Aristotle attempted to distinguish between the rule of a master over his servants or of the father over his child, which he regarded as the superior over the inferior, and "citizen" rule, such as the rule of one citizen over another or of a husband over a wife. There was, however, an important distinction between the rule of one citizen over another and the husband's rule over the wife, in that the former was temporary and the latter was permanent.[28] "For although there may be exceptions to the order of nature, the male is by nature fitter for command than the female, just as the elder and full grown is superior to the younger and more immature."[29] To ensure the ability of a man to always command his wife, Aristotle recommended marriage at different ages. He felt that women should marry when they were about eighteen and men at thirty-seven, when both were in "the prime of life" and the decline in their powers would coincide. Moreover, if marriage produced children it

54

could be reasonably expected that the children would reach their prime when the father reached his allotted "three-score and ten years."[30]

Aristotle believed that "silence" was a woman's glory, although it was not the glory of a man.[31] Quite simply it was through a certain incapacity that the female was a female; the female character had a sort of natural deficiency.[32] Since this was the case it was only natural that women often loved and admired the male without receiving an equivalent love in return, since Aristotle held that love was proportionate to superiority and whoever was the superior must receive more affection than he gave.[33]

Aristotle did not feel he was treating women badly or giving them any less than their due. In fact, he argued that only barbarians treated women as slaves, and he regarded himself and his fellow Greeks as far removed from them. "But among barbarians no distinction is made between women and slaves, because there is no natural ruler among them: they are a community of slaves, male and female. Wherefore the poets say, 'It is meet that Hellenes should rule over barbarians'; as if they thought that the barbarian and the slave were by nature one."[34] Aristotle, in effect, had put the subjugation of women on a "scientific basis." Did this reflect the reality of Greek life?

The answer would seem to be yes, since the general view of women in Greece was that legally and socially, as well as in popular estimation, women occupied a fairly low place. Though, as indicated, some doubt has been cast on this generalization, even those who question it recognize that women had a separate sphere from men and the Greeks regarded the female sphere as inferior. During the rising tide of democratic reform in Athens some of the freedom of the aristocracy to acquire wives and concubines at will or to regard whom they would as their heirs was restricted,[35] but this did not necessarily open up opportunities for women. Even after the Peloponnesian War, in which there was a general leveling down in Athens, it was of such overriding importance that not a breath of suspicion fall on young wives that they were protected beyond what modern society would regard as a reasonable degree. One Greek, for example, praised his sister and niece because they had lived in the woman's quarter of the house "with so much concern for their modesty that they were embarrassed even to be seen by their male relatives."[36] Xenophon in his treatise on domestic management emphasized that the girl who became a bride had often lived under such strict supervision, "seeing, hearing and saying as little as possible," that "she knew no more than how, when given wool, to turn out a cloak, and had seen only how spinning is given out to the maids. . . . in control

of her appetite . . . she had been excellently trained, and this sort of training is, in my opinion, the most important to man and woman alike."[37] Wives did not go out to dinner in other houses with their husbands and were excluded from eating with them when they were entertaining male visitors in their own homes.[38]

Women did have some legal rights and we know that they took part in making wills and in some family councils and that they had organizations of their own. When this is granted, however, it still seems that women were almost entirely dependent upon their husbands, their fathers, or their male relatives. A proper woman was cut off from a man's world, and in fact burglars and thieves were given the death penalty, in part at least, because it was argued that it was difficult to distinguish them from adulterers, and unless thieves and burglars met the same fate as adulterers, each would claim a lesser crime.[39]

The civic necessity for female virginity ensured that girls would be married very young, probably at fourteen, though there were some Athenian writers who thought it should be more like the eighteen to twenty it was said to be in Sparta. The husband was usually much older than his wife (a sixteen- to twenty-year age differentiation was not uncommon), and this led to a couple having little to share except their family. It was perhaps for this reason that Aristotle in his discussion on friendship did not bother to consider the relationship of husband and wife at all.[40] The marriage relationship was not a partnership, it was a paternalism.

Athenian girls were less educated than boys, and although many could read and write, few received any higher education. Most of the better-educated women who are known to have lived in Athens either were noncitizens like Aspasia (the beloved of Pericles) or else lived in the Hellenistic age, when there was some lessening of the sex barriers. Husbands and wives had little in common and Xenophon questioned whether there were any others with whom the husband talked less than with his wife.[41] He concluded there were few. Though it has been argued that the meaning of Xenophon's question has been misunderstood, he quite clearly envisioned a marriage in which an older husband molded the younger wife to his own image of what a dutiful helpmate should be and do.

Athenian women remained in their houses to such an extent that it was even possible in some law cases to pretend that they did not exist. Among the surviving speeches in the law courts are two in which the orator had to bring evidence to prove that a woman who had married

and borne children had actually existed. This is not to say that wives never went out, but they did so rarely, and then were veiled and accompanied by their maids. Most scholars agree that they were excluded even from attending the theater. In short, it would seem that the Athenians assumed a woman's life would be spent mainly at home, probably in somewhat less than desirable circumstances, since townhouses were small. During the day a wife would see little of her husband because he was usually away from home, and this meant she was largely dependent on the slaves of the household, on elderly relatives living in the house, or on her young children for companionship.[42] Girls were even brought up on a sparser diet than boys, with very little protein and scarcely any wine.[43]

Most of the information we have is about the more well-to-do women in Athens, and it is probably true that poorer women had fewer restrictions put upon them than richer ones. Some of the poorer women did work, either in the retail trade or as wet nurses. One female vase painter is known, vast numbers worked in spinning wool, and a few served as innkeepers. In the country, peasant women helped in the field.[44] Slave women also worked, mostly as domestics, but some slave and foreign women were employed as entertainers, such as flute girls. Many slaves and foreign women served as prostitutes and courtesans.

The chief purpose of women was bearing children, particularly sons, and children were regarded as essential in the Greek world. It was woman as mother who consistently was praised in the Greek world. Aristotle, for example, began his treatise on *Politics* by breaking the communities down into their parts. The smallest unit was the *oikos* (family), composed of three elements, the male, the female, and the servant. The servant by definition could be the plow ox in the case of the poor or the human slave in the case of the rich. Aristotle then added a fourth element, children, since the male and female elements had a natural instinct to procreate successors for themselves. He even went so far as to state that a family without children was not fully an *oikos*.[45] A true family was to be looked upon as a living organism requiring renewal every generation to be alive, supporting its living members' need for food and its deceased members' need for the performance of cult rituals. A childless family was visibly dying, and a child, particularly a male child, was essential to perpetuate the organism. If a man had the misfortune of having only female children it was arranged for each girl to be married to one of her nearest agnatic relatives (a father's brother, that is, her uncle) in order to reestablish the family in the next genera-

tion. Men without natural heirs could also adopt sons, but the adopted son could not fully inherit until he himself had begotten a son and registered him in the family of his adopted father.[46]

Most of our information on the status of women and the attitudes about them comes from Athens, and Athens was only a small part of the Greek-speaking world. In a people as diverse as the Greeks, there were obviously quite radical differences, although the source material for other parts of Greece is minor compared to that for Athens. Perhaps the opposite extreme of Athens was Sparta, a state where a small group of citizens held the vast majority of the population in subjugation. Spartans, however, were often admired by the Greeks, in part because of the rigid discipline they had imposed upon themselves, and in part because of their success. The Spartans, after all, had defeated the Athenians, and some have argued that Plato's *Republic* was modeled on Sparta, where women allegedly had a somewhat higher standing. Unfortunately the source material on Sparta is both scarce and difficult to interpret, since so much of it was written by Athenians who used it for hortatory purposes to serve as "models" for Athenians. It would seem, however, that while there were differences from Athens, women in Sparta were by no means equal to men. They probably had somewhat greater personal freedom if only because the military preoccupation of the Spartan state meant that they had to assume more duties. The vast numbers of slaves also freed them from the main tasks of women elsewhere in Greece, namely, the making of clothes and nursing of children. Aristotle claimed that the Spartan women managed their husbands' affairs,[47] but this would seem to be an exaggeration. Spartan women, however, did have somewhat greater control of their own wealth than they did in Athens.[48] Moreover, the sexes in Sparta tended to be more nearly the same age when they married, and this fact might have saved the women from some of the more obvious aspects of patriarchal domination. Women also underwent considerable training in athletics, and the comparative lack of confinement led to all sorts of speculation about their morals. Euripides in his *Andromache* has a character say: "No Spartan girl / Could ever live clean even if she wanted. / They're always out on the street in scanty outfits, / Making a great display of naked limbs. / In those they race and wrestle with the boys too— / Abominable's the word. It's little wonder / Sparta is hardly famous for chaste women."[49] The Spartan women were as militant as their men, and among the most famous of sayings attributed to them by Plutarch was that of the mother who told her son to come back from the war with his shield or on it.[50] Since it was necessary for a man to throw his shield away in order to flee

from the battle the meaning is quite clear: come back dead or a hero. Aristotle naturally was upset at the power of the Spartan women, and he held that Sparta had failed because the Spartans failed to control the women.[51] Still, when all of this is granted, the Spartan women never had the vote and were regarded by Spartan males as quite inferior. Their position might have been somewhat better vis-à-vis the male, but the general tenor of life in Sparta was so demanding and unattractive, at least to us, that it would seem that even the freest of Spartans was a slave to the system. In fact it was this voluntary submission to such a restrictive ideal that so impressed other Greeks.

Greek literature from the poets to the playwrights was essentially misogynistic. In most of the surviving poetry from the early period, there is such sheer misogyny that one scholar was moved to comment that one of the chief purposes of Greek poetry, whether lyric, iambic, or elegiac, was to degrade the position of women. In fact the "iambic metre was invented for the express purpose of satirical calumny, and the three chief iambic poets of the Alexandrian canon, Archilochus, Simonides, and Hipponax, in their scanty fragments all agree on one point: the chief object of their lampoons is—women."[52] Archilochus, for example, called women the greatest evil that God had ever created. Even when women appeared to be most useful, they turned out to be "a curse to their owners." A man who lived with a wife could never get through a day without trouble, and even when he was on his best behavior, the woman would always find some ground for fault.[53] In another surviving fragment Archilochus compared women to various kinds of animals and inanimate objects whom they resembled and stated that only one in ten could bring happiness and prosperity to their husbands. He compared women to pigs because they laid about in disorder; to a fox because they were cunning; to a dog because they wanted to hear and know everything; to mud because they knew nothing; to the sea because they were so contradictory; to an ass because they proved so difficult; to a polecat because he could find nothing lovable about them; to a mare because they would not work; to a monkey because they were a mockery to man; and finally to a bee, and only this last type of woman, working continually like an industrious bee, was regarded as a desirable wife, the best possible helpmate given to man.[54]

At least two of the early poets were women, Erinna and Sappho, and it would seem that they would give a somewhat different picture. Only a few fragments of Erinna's verse survived, mostly from a poem entitled either "Spindle" or "Distaff." For much of history Erinna was identified as a companion of Sappho, but modern scholarship places her later, at

the end of the fourth century B.C. Her chief poem was in memory of her girlfriend Baucis, who died young, and in it Erinna described their mutual girlhood. Because of this and because of the popular belief that she was a friend of Sappho, Erinna has often been identified as a homosexual. Though it might seem reasonable to suppose that women who were excluded from any kind of equality with the male sex would turn to their sisters for companionship and solace, the evidence is by no means clear. This is true even in the case of Sappho of Lesbos, from whence the terms *sapphism* and *lesbianism* derive. Sappho lived in the sixth century B.C. and was apparently the head of a school for girls in Mytilene on Lesbos. The school was dedicated to Aphrodite and the Muses. Education probably took the form of a religious fellowship, where under the direction of a mistress, young girls were fashioned to conform to an ideal of beauty and feminine wisdom. They were taught dancing, the playing of musical instruments, and singing, and the school also observed a series of festivals, religious ceremonies, and banquets. In spite of the legend surrounding her, the curriculum of the school seems to have been male-oriented, since there was an emphasis on charm and coquetry. Several sayings, such as "Don't ride the high horse when you are looking for a husband," and "A woman who does not even know how to lift her skirt to show her ankles," have survived.[55]

Other fragments of her poems seem to imply feelings and intimacy for other women, although even in antiquity there were doubts about whether her love implied carnal knowledge. There is still a group of scholars who maintain that she was a woman of absolute virtue. Some scholars have even gone so far as to maintain that there were two Sapphos, one of whom was a man.[56] Nevertheless her poems were regarded as obscene in the early Christian period, when most of them were destroyed. The only way in which a modern student can arrive at the real Sappho is through the surviving fragments of her poems, and from them it would seem to us that in spite of her marriage and her children, her love ideal was female.[57] Regardless of her sexual preference, male writers have through the ages expressed considerable hostility about her.

Sappho and to a lesser extent Erinna, if only because they were women, represent an exception to the misogynistic trend in Greek literature. Were there any males who defended women? The most fully drawn portraits of women appear in Greek tragedy, particularly in the plays of Euripides, and some have even regarded Euripides as a champion of rights for women. Women in Euripides, whether good or bad, usually seem to be more enterprising than the men; in fact, the clever woman who contrives something when the men are at a loss is almost a

stock character. In spite of this, Euripides has also been regarded by some scholars as a misogynist who merely attempted to show the evil that women did and the inevitable result if the power of women continued to increase. Regardless of which attitude one adopts, it is obvious that women were not negligible creatures in his plays, and he seems to give us real insights into what women might have felt about themselves. Medea, who is often regarded as the powerful female incarnate, gave a very poignant statement about how women were looked upon:

> We women are the most unfortunate creatures.
> Firstly, with an excess of wealth it is required
> For us to buy a husband and take for our bodies
> A master; for not to take one is even worse.
> And now the question is serious whether we take
> A good or bad one; for there is no easy escape
> For a woman, nor can she say no to her marriage.
> She arrives among new modes of behavior and manners,
> And needs prophetic power, unless she has learned at home,
> How best to manage him who shares the bed with her.
> And if we work out this well and carefully,
> And the husband lives with us and lightly bears his yoke,
> Then life is enviable. If not, I'd rather die.
> A man, when he's tired of the company in his home,
> Goes out of the house and puts an end to his boredom
> And turns to a friend or companion of his own age.
> But we are forced to keep our eyes on one alone.
> What they say of us is that we have a peaceful time
> Living at home, while they do the fighting in war.
> How wrong they are! I would very much stand
> Three times in the front of battle than bear one child.[58]

This isolation was one of the worst features in a Greek woman's life, and to many it could be soul-destroying. In trying to deal with her philandering husband, Jason, Medea usually lost the argument, and though she hissed her anger and threw forth her scorn, Jason kept cool. He indicated that he had not grown tired of her bed, but he needed money to raise their children, and this was why he needed a new wife. "But you women have got into such a state of mind / That, if your life at night is good, you think you have / Everything; but, if in that quarter things go wrong, / You will consider your best and truest interests / Most hateful. It would have been better far for men / To have got their children in some other way, and women / Not to have existed. Then life would have

61

been good."[59] Later Medea seemed to submit and apologized, "But we women are what we are—perhaps a little / Worthless; and you men must not be like us in this, / Nor be foolish in return when we are foolish. / Now, I give in, and admit that then I was wrong. / I have come to a better understanding now."[60] Jason responded, "I approve of what you say. And I cannot blame you / Even for what you said before. It is natural / For a woman to be wild with her husband when he / Goes in for secret love. But now your mind has turned / To better reasoning. In the end you have come to / The right decision, like the clever woman you are."[61]

Medea was a bitter woman, discontented with her lot, and perhaps cannot be regarded as typical. At least her solution, the murder of her children, cannot. Alcestis, however, was a saint who consented to death to save her children's position. She did not do this for the love of her husband, since the husband in Greek literature often seemed to be indifferent to his wife, but because of her love for her children. It was because she did not wish her children to be left fatherless that she consented to death; the loss of the father would be a far greater tragedy than that of the mother.[62]

Everywhere in his plays, Euripides spoke in a contradictory voice. In spite of his portrayals of women as real flesh-and-blood creatures, with feelings and responses that a man could understand if not sympathize with, he stressed that women ought to be silent, ought not to argue with men, ought not to speak first, and ought not to speak with strangers. Sensible women were supposed to let men act for them. If Euripides was really the feminist that some believe, why such a restrictive view? To the defenders of Euripides as a feminist the answer seems obvious. The audience for his plays was male, and though Euripides might portray women with great psychological insight, he was aware of the power of the box office. This meant he also had to be careful to keep women in their place, or at least what the Greek male felt was their proper place.[63] The result is that both feminists and misogynists can find in Euripides material to fuel their cases. Still, female characters in Euripides may have been somewhat realistic because of attempts to gain greater emancipation for women. Such attempts are reflected in some of the comedies of Aristophanes, particularly *Ecclesiazusai, Thesmophoriazusae,* and *Lysistrata*. In *Ecclesiazusai*, sometimes translated as *Women of the Assembly*, women, after disguising themselves as men, seized control of the government, whereupon they enacted legislation providing a community of property in which all women were to offer their sexual favors to whom they would, and they took other actions in what might have

been intended as a parody of Plato's *Republic*. Immediately women began fighting over the most desirable males. To our mind the play is left hanging; perhaps its effectiveness at that time was due to what the Greeks felt were such ludicrous ideas, ideas that only a silly woman would hold. In the *Thesmorphoriazusae* women tried to revenge themselves on Euripides for revealing their secrets and speaking ill of them; in the end he agreed not to do so again. Much more serious as a commentary on women is *Lysistrata*, where Lysistrata at least was depicted as a woman of true genius, determined to end the senseless killing of men in warfare. In spite of these portrayals of real live women in both comedy and tragedy, the conclusion seems to have been that women were almost entirely excluded from the ordinary life of Greece. They had separate sororities in which they had some say, but their sphere of influence was limited. Their life must have been depressing, and the countless hints in Greek comedy of woman's love of drink, however much exaggerated, probably had some real basis; wine may have been one of the only consolations they had to help them face their utter loneliness.

Though women were given to men to mother their children, marriage itself was something to be endured. Anaxadrides summed it up when he said "He who thinks to wed, aims at the fair but hits the foul instead."[64] Theophrastus, the pupil and successor of Aristotle, is sometimes credited as the author of a lost treatise on marriage that entered the West through quotations by St. Jerome and others. "If you give her the management of the whole house, you must yourself be her slave. If you reserve something for yourself, she will not think you are loyal to her; but she will turn to strife and hatred, and unless you quickly take care, she will have the poison ready. If you introduce old women, and soothsayers, and prophets, and vendors of jewels and silken clothing, you imperil her chastity; if you shut the door upon them, she is injured and fancies you suspect her."[65] The list could go on. If she was beautiful she attracted lovers, while an ugly wife was easily seduced. Even if a man's wife was good and agreeable, a rare thing, he had to share her trials and tribulations in childbirth and worry when she was in danger.

Women in the Greek world were to be neither seen nor heard. They were regarded as gossipy, drunken, and immoral, as well as spendthrift. They were troublesome, but nevertheless a man needed children. The women who most often seemed to break through the barriers were the courtesans and the prostitutes, and there is a vast Greek literature about their activities. Many such women became popular heroines.[66] To enter male society, even at the level of an unequal, women had to lose status

as proper women. Even Pericles, who was not exactly a conservative in his views or in his way of life, is said to have declared that a woman should not be spoken of among men, either in praise or blame.[67] Since Pericles is usually associated with the great courtesan Aspasia, who became his mistress and lovingly bore his child, it appears evident that the Greeks had not gone very far toward the emancipation of women. Though there are many mentions of women in surviving inscriptions, most of them picture women as wives and mothers,[68] and it was as mothers that the Greeks most honored women.[69] It was for her biological function and not for her personality that woman was accepted. It was the Greeks, after all, who found philosophic and scientific reasons to justify the subjugation of women, and although Plato seemingly put in a slight dissenting vote, even he turned out to be against equality. It was the Greeks who relegated women to the house, kept them confined, and only allowed them to go out for religious festivals. The ubiquity of such festivals might well indicate that the Greeks, who drew such strict barriers over sex roles and assigned such a confined role as a model for women, needed periods in which the barriers were removed. Apparently the Greeks recognized this need themselves: Philostratus, in describing the rituals involved in some festivals, said that the image or person impersonating the god was accompanied by a numerous train in which girls mingled with men because the festival allowed "women to act the part of men, and men to put on women's clothing and play the women."[70] Some of these festivals were fairly exuberant, if not irrational, and this would fit in with the findings of I. M. Lewis, who has argued that in societies dominated by men, women find their compensation in demonic possession.[71] Though such possession is mostly subconscious it has to include an element of consciousness in order to alleviate the repression. Women, however, cannot go very far since if the male is too frequently provoked his reaction is to repress the female behavior. The Greeks recognized the dangers of female hysteria but adopted a male remedy and tried to keep women in control. Greek women, in fact, were little more than childbearers. Even romantic love was oriented more toward a male object than a female one. If society in the Greek period was undergoing transition, and men were hunting for new answers, as some have said, it seems clear that women were the early victims of a search for new solutions. The Greeks not only excluded women from assisting in the search but also regarded them as a source of many of their problems.[72]

4 / The "Rise" of Women and the Fall of Rome

The rise of the comparatively backward and inconsequential people from the village of Rome to eventual control of the Mediterranean seaboard is one of the great success stories of all history. Ultimately this story of triumph became one of tragedy as Rome entered into a period of decline. Since that time the fall of Rome has been the subject of all kinds of sermons, with each pulpit interpreting the cause of Roman success or failure to suit its own moral. Inevitably women have been accorded a good share of the blame for the Roman fall, and moralists of today continue to use Rome as an example to women who want or demand something more out of life than subordination to their husbands.

An example of such thinking is a 1968 study by Charles Winick on desexualization in American life. Winick argued that Rome provided the "most tantalizing example in history of a rigid and polarized culture that became more sexually blurred." His implication was quite clear: Americans must take care not to follow the path of Rome, something he felt was a real danger as more and more women assumed roles and performed tasks previously reserved for men. Winick, to his credit, made some qualifications and indicated that no single cause could entirely explain Roman decline. Nevertheless, he still concluded that the blurring of sex roles undoubtedly facilitated a "multiplicity of developments that changed the quality of life."[1]

Winick, at least in part, was following a path blazed by a somewhat earlier investigator, the anthropologist J. E. Unwin. Unwin, as indicated above, argued that the cultural conditions of any society at any time seem to depend on the amount of its mental and social energy, and this in turn seems to depend "upon the extent of the compulsory continence imposed by its past and present methods of regulating the relations between the sexes."[2] He then argued that "no society can display productive social energy unless a new generation inherits a social system under which sexual opportunity is reduced to a minimum."[3] Unfortunately, at least for those who advocate emancipation of women, Unwin believed the only way in the historical past that sexual opportunity had been reduced to a minimum was by the adoption of "absolute monogamy," a marriage relationship in which a husband had absolute power over his wife and children. According to this thesis the advance of society demanded that women be subordinate.

Unwin's ideas have been picked up and advocated by people as disparate as Winick and Pitrim Sorokin. Sorokin was convinced that a disorderly sexual life undermined the physical and mental health, the morality, and the creativity of its devotees, as well as the society in which there were any number of such individuals.[4] Inevitably the example given of a state where women gained freedom is Rome, and the decline of Rome is then attributed to this freedom. Any advocate of equal rights for women has to come to terms with what happened in Rome, and though this task sounds simple, it is not.

There are several obstacles, the most serious being that almost everything in the past has been written by men, not by women. Male writers have most often pictured women when they departed from the norm, when they became notorious, and only rarely when they fulfilled their expected role of wife and mother or sister. Notoriety, however, is relative, and many of the Roman writers seem to have had "tabloid mentalities."[5] They picked up and accentuated the deviant behavior and passed over that which was not headline news. Coupled with this nose for the scandalous was an obsession, present in the Roman writers from third century B.C. onward, that their own times were periods of moral degeneracy as compared to an earlier, more heroic age. Thus they pictured the women of the past as exhibiting spectacular virtue, in fact superhuman virtue, and used these mythical paragons as an example for their own "degenerate age." This attitude also forced them to exaggerate misdeeds of their own age and to use one or two exceptions from which they made generalizations that simply were not valid. Inevitably there is the danger that modern readers will take them at their word and, like

a Winick, a Sorokin, or an Unwin, believe everything they said and draw morals for our own time from extremely misleading source material.

Historians in the past did not make the task of the moralist an easy one since they ignored such aspects of Roman life as courtship, marriage, and childbearing. As late as the 1960s, J. P. V. D. Balsdon, in his study of Roman women, could write: "Intriguing as ancient Roman women may have been, they are the subject of no single work of deep and learned scholarship in English or in any other language. . . . A number of books have been written which give biographies of the most notable, or the most notorious, ladies of the imperial court but nobody, I think, has combined a historical account of Roman women, notable and notorious alike with a general description of woman's life in ancient Rome."[6]

This lack of scholarly study, which is just beginning to be remedied,[7] left all participants in the debate free to generalize and to arrive at their own conclusions without any attempt to gather together a picture of the whole. To draw such a picture it should be kept in mind that the Romans were essentially conservative. In spite of the glories of their empire, they looked back on an idealized, re-created past that never had existed. They extolled the moral outlook of the rural primitive city-state of a legendary Rome where conduct had been regulated by *mos maiorum*, respect for the customs of the ancestors both in private and in public life. To men with such attitudes, change, particularly in the relationship of the sexes, was a sign of decay. Inevitably women were pictured in unflattering colors when this was perceived as taking place.

The best way to convey the Roman attitude is by examining the Roman writers themselves, and one of the best sources for both attitudes and information is the historian Livy (d. A.D. 17). Livy told us that he deliberately set out to record the great achievements of the Romans, the sovereigns of the world, and to teach future generations by examples of noble conduct and virtue among their ancestors. Livy sincerely believed that no other people in history had such a long period of integrity or honor, and inevitably he tried to contrast the past virtuousness with what he regarded as the self-indulgence and corruption of his own time. In his preface, Livy wrote: "I hope everyone will pay keen attention to the moral life of earlier times, to the personalities and principles of the men responsible at home and in the field for the foundation and growth of the empire, and will appreciate the subsequent decline in discipline and in moral standards, the collapse and disintegration of morality down to the present day. For we have now reached a point where our degeneracy is intolerable—and so are the measures by which alone it

can be reformed."[8] It should perhaps be added that Livy was writing during the lifetime of Augustus, an epoch now regarded as the "Golden Age" of Rome. This was followed a short time later by the period that the eighteenth-century historian Edward Gibbon, famous for his book *Decline and Fall of the Roman Empire*, called the most happy and prosperous age in all of human history.[9] Quite clearly Livy was a pessimist, but it is this attitude that has so influenced most commentators on the status of women.

Livy's stories (they seem to be more legend than history) emphasized the old virtues: courage against odds, soldierly obedience, individual heroism, simplicity of manners, *gravitas* (dignity and seriousness), *pietas* (loyal, respectful feelings toward the established moral order), and in the case of women, virtue and submissiveness. Inevitably many of his tales sound like that of George Washington and the cherry tree, symbolic of an ideal with which he wished to indoctrinate his readers but not necessarily true. It should also be said that in spite of these limitations Livy is still one of the best and most reliable guides to Roman history.

If Livy's attitude reflected that of the dominant Roman class, and there is no reason to doubt that it did, then any change in what the mythological status of women had been would be regarded as a threat to the moral structure of Rome, even if that mythological woman had never existed. In their study of the sociology of sex differentiation the Vaertings hypothesized that a sex which had regarded itself as dominant would tend to see any increase in the power of the opposite sex as a threat to the very fabric of society.[10] Without subscribing to all their ideas, we can agree that this particular thesis seems to have applicability to Rome, since Livy and other masculine writers inevitably tended to see their society as threatened by any slight change in the status of women, and even by the most charitable measure they have to be labeled as misogynists. It is their misogynistic views, however, that appear so often in explanations for the decline of Rome.

Coupled with a respect for a legendary and mythical past was the ability of the Romans to engage in self-deception, perhaps inevitable in a people who, though they conquered the Mediterranean world, always argued that they went to war reluctantly and not with any imperialistic gains in mind. Even after the conquests and booty of an empire brought them great riches, they liked to believe that they were living a very simple life. Their definition of what constitutes a simple life seems quite incredible to most modern readers. This can best be illustrated with a description by the first-century A.D. philosopher Seneca of what

he called a simple pastoral trip. In his letter recounting the trip Seneca expressed himself as quite proud of the utter simplicity in which he traveled and emphasized how he roughed it by taking only one carriage load of slaves, sleeping on the ground with the Roman equivalent of air mattresses, and taking only an hour to prepare the "simple" noonday meal.[11] The Romans were also extremely patriotic, tending to think of Rome as embodying all virtues and of other peoples as inferior. Even the sophisticated Cicero (d. 43 B.C.) claimed that after the Romans had surveyed all other peoples, they would find that "there is no social relation among them all more close, none more dear than that which links each one of us with our country. Parents are dear; dear are children, relatives, friends; but one native land embraces all our loves; and who that is true would not hesitate to give his life for" our native land?[12] Anything that was extraneous, that threatened to undermine the Roman concept of the past, was dangerous, a basic threat to existence. Women who attempted to challenge the old ways were a threat to Rome, regardless of the fact that the mythological old ways had never really existed. Since the Roman experience has been so influential, it means that whenever women attempt to change their status to work for equality, part of the mythology they have to fight is the burden of the fall of Rome, a story written for the most part by men, and with a misogynistic view of the female sex.

Rome itself was very much a man's world. Its government was run by men, for men, and its history was written by men, for men. Like Greek women, Roman women were to be wives, mothers, and daughters, but they were always to observe decorum and never gain notoriety, except for their virtue. In fact, until fairly late in Roman history women even lacked individual names in the proper sense of the term. Claudia, Julia, Cornelia, and Lucretia were merely family names with a feminine ending, like calling a girl whose family name was Drew, Drusilla. Sisters had the same name and could be distinguished from one another only by the use of such identifying terms as the "elder," or the "younger," or the "first," or the "second." In the not uncommon case of marriage between paternal cousins, mothers and daughters would have the same name. No doubt this led to considerable confusion, but the Romans apparently were unconcerned, since it would not have taken any great genius to think up the idea of giving every girl a personal name, as was done with boys.

In point of fact the whole Roman system was designed to suggest that women were not, or ought not to be, genuine individuals, but only a fraction of a family, specifically anonymous and passive fractions. The

virtues stressed were decorum, chastity, gracefulness, an even temper, and the ability to bear children. Inevitably all of this was seen from a male point of view, as even a woman's tombstone testifies: "Friend, I have not much to say; stop and read it. This tomb, which is not fair, is for a fair woman. Her parents gave her the name of Claudia. She loved her husband in her heart. She bore two sons, one of whom she left on earth, the other beneath it. She was pleasant to talk with, and she walked with grace. She kept the house and worked in wool. That is all. You may go."[13] Girl children who died young were not even listed on their mother's tombstone.

Roman tradition emphasized the family, but family did not mean the same thing to the Romans as it does to us. Originally the term included all persons under the authority of the head of household, all descendants from a common ancestor, all one's property, as well as all of the servants of the household. The emphasis was on a power structure and not on biology or intimacy. The head of the family was the *pater familias*, the father of the family. He had absolute and uncontrolled power over his wife, his sons and daughters, his son's wives and children, his slaves, and property. In effect women in the family relationship were little more than another piece of property.

With such a masculine orientation it is not surprising that the Romans would manage to exclude women from any active role in the legends of their founding. It is true that Aeneas, from whom the Romans claimed descent, was the son of the goddess Venus, but there were no recognizably human female ancestors who were given much formal recognition. It was the descendants of Aeneas, Romulus and Remus, who founded Rome. The only female involved in their lives, however, was a wolf (*lupa*), and it was the she-wolf which gave them their earliest tastes of mother love. It is worthy of comment that the word *lupa* can mean prostitute as well as wolf, but the Romans chose to extol the animal female over the human. From at least as early as 296 B.C. there has been a monument in Rome of children being suckled by a wolf, and this symbol has continued to be observed by the Romans up to this day. The implications seem clear. Any real change from the unseen and unknown woman to a real live one with ambitions, frustrations, hopes, and desires caused trouble to the Romans.

Women, however, were needed as sexual mates, if only to give birth to children so that Rome could grow. Unfortunately, Romulus and Remus, who founded the new colony of Rome in 753 B.C., had not brought any women with them. Moreover, their new neighbors were reluctant to give their daughters in marriage to the young men, who had apparently

acquired a reputation as being uncouth barbarians. To solve the problem the founders of Rome decided to hold a feast for all the neighboring peoples. At a signal from Romulus every Roman seized the most attractive woman he could find and hurried her away while the other guests, unprepared for such an assault, either fled or were killed.

According to tradition, again recorded by males, the Romans treated the young women, mostly Sabines, with great delicacy for the night. The next morning the captives were awakened to hear a lecture by Romulus on the superiority of the marriage institutions that he proposed for his new state. A woman, he explained, was to be under the absolute power of her husband, and if she was unfaithful or took to drinking (an activity that might lead to unfaithfulness), she would be punished. The sole judges of her activities were to be her husband and her male relatives. However, if a wife observed decorum, respected her husband, and bore him children (preferably male), she was to be regarded as mistress of the house during her husband's lifetime and he would keep his interference in the household to the minimum. If he died before she did, she was to share his property with the children, or if there were no children and he had made no other disposition of his property, she inherited the whole of his estate. The Romans then took their captives to wife.

The Sabines in the meantime had returned home, armed themselves, and taken the offensive. After a series of encounters the Sabine women, now pregnant, intervened to separate the combatants on the grounds that they had lost one set of husbands and did not want to lose another. Peace was made, with the Sabines and Romans joining together to form a single community. In return for the loyalty of their newfound wives, the Romans are said to have promised never to make them grind corn or cook for them, a promise that if ever really made, was soon forgotten.[14]

Though women in these didactic stories occasionally give back as much as they receive, the main thrust is to emphasize the loyalty of women to their husbands and families. This point is effectively illustrated by the legend associated with the rape of Lucretia, an extremely significant event in Roman history since it was this rape that led to the overthrow of the hated Etruscan monarchy and the establishment of the Roman Republic. In Livy's story the incident began with a bull session among citizen soldiers who were temporarily stationed about twenty-three miles from Rome. The discussion apparently became increasingly misogynistic, as it often does in such situations, and only Collatinus held that his wife would be hard at work, anxiously awaiting his return. None of the others believed him, and to prove him wrong several of the

participants, including Sextus Tarquinius, the son of the Etruscan king, as well as Collatinus, rode back to check on their wives. They first spied on the wife of Sextus and found her at a splendid banquet. They then went to investigate Lucretia, wife of Collatinus. They found her spinning away with her handmaidens, anxiously awaiting her husband's return. Sextus paid off on the wager they had made, but, now thoroughly enamored of Lucretia, he decided to pay her a visit himself. Lucretia, who knew him as a kinsman of her husband, welcomed him to the house, as was the tradition. In the dead of night he entered her chamber with a drawn sword, demanding that she sleep with him. When she refused he threatened to kill not only her but a male slave as well and to leave both bodies naked in her bedroom in order to prove to the world that he had caught her in the act of adultery. Since as a male kinsman he had the right to kill an adulterous female relative, Lucretia yielded to his wishes. When Sextus rode off the next morning Lucretia quickly summoned her husband and father. They found her in an agony of sorrow for having betrayed them, and after telling them what had happened and why she had to submit, she enjoined them to avenge her dishonor and then stabbed herself to death, the only suitable ending for a wife who had disgraced her husband. Her body was carried to the Roman forum, where the account of her death so inflamed the Romans that they successfully rebelled against the king.[15]

Most other stories told about women in early Rome emphasize the same kind of concern for their virtue, their self-sacrifices for their menfolk and for the Roman state. Women in 390 B.C. are said to have given their hair for bowstrings when the Gauls besieged the city, and this event was commemorated by a statue erected to a bald Venus (Venus Calva).[16] Roman women at a later date are also said to have presented the state with their gold ornaments and other jewels in order to bribe the invading Gauls to quit the siege of their city.[17]

The purpose of such stories was quite obviously to impress a later generation with the docile and virtuous women who were their ancestors. Whether they were based upon truth or entirely upon myth is unimportant. It was the ideal that the Romans wanted to inculcate. The unreality of this ideal was exemplified during the second Punic War (218–201 B.C.) when Hannibal invaded Italy. In their determination to defeat Hannibal the Romans turned to consulting oracles, trying to perform any religious or magical ceremony that would lead to a change in their fortunes. One prophecy foretold that Hannibal would be forced to leave Italy if the cult of the Great Mother (Magna Mater) was imported from Asia Minor to Rome. The Romans, never ones to be satisfied with

half-steps, took action to bring the statue of the goddess to Rome from Asia Minor. The ship carrying the goddess ran aground near the mouth of the Tiber River, and in spite of all their efforts, the Romans were unable to move the boat. At this juncture Claudia Quinta stepped forward and proclaimed that the boat would follow her if her chastity, about which there perhaps had been some speculation, was unsullied. Then calling to the ship to follow her, she marched into Rome. Miraculously the ship followed her, emphasizing again that in Rome, at least as far as females were concerned, chastity was the only power that really counted.[18]

Roman history becomes somewhat more believable at the beginning of the second century B.C., and from this time on it seems that women were less compliant and much more lifelike. It was from this time also that the Roman misogynistic attitude began to grow and spread, although it is only by comparison with the earlier mythological period that there can be said to have been any radical change in the relationship between the sexes. There were some minor changes. The so-called free marriage had developed, and some have equated this with growing female emancipation. These marriages, however, were not free in the sense that a wife had the free choice of a partner, but rather the marriages were free from some of the ancient rituals and formalities. Moreover, the wife retained some kind of control over her property after marriage, but this control was always under the supervision of a male guardian. Previously the wife had passed out of the authority of her father and owed almost total submission to her husband, but under the new conditions her father, by giving her some property, could give her some independence. Husbands could also give their wives property, a practice that was encouraged by the fact that a wife could not be sued in court since a woman had no standing before the law. Such practices protected many a Roman investment. Marriage was still negotiated by the heads of the families, and girls could be married as soon as they reached the age of twelve. Divorce and remarriage were also possible under free-marriage contracts, although the woman could not take any legal punitive action against an unfaithful husband, whereas a husband could against such a wife.[19]

As the riches of conquest and empire flowed into Rome, many well-to-do Romans began decorating their wives and daughters with visible signs of their wealth. Some wives even became rich in their own right. With their new wealth a few of the previously repressed wives and mothers were less willing to be the docile and meek creatures they had been taught to be. Inevitably some tried to assert an independent personality. Nevertheless, there was a growing denunciation of women by

those male writers who believed that the only true state of female existence should be a masculine-dominated one. It seems that the more insecure the male feels vis-à-vis the female, the more power he attributes to her, although in the light of historical reality, he has greatly overestimated the real power of women.

The most obvious male reaction to a change in woman's state is seen in a diatribe of Cato the Censor at the beginning of the second century B.C. Cato, to put it charitably, was a Roman reactionary. As a stern upholder of Roman morals he felt that woman's place was in the home, cowering before her husband, and he did not accept any of the newfangled notions about women's rights for which some men argued. He particularly opposed the repeal of the Oppian laws, which had passed in 215 B.C. during the stresses of the second Punic War. Among other things the law had forbidden women to use ornaments, wear multicolored dresses, or ride in chariots. When discussion over repeal of the law started in 195 B.C. many women demonstrated in the forum in favor of repeal. Cato, naturally, led the unsuccessful fight to have the law retained; the speech that he gave on the occasion was re-created by the historian Livy. It was standard practice for classical writers to use speeches to convey an idea, and while the words may not have been Cato's they undoubtedly represented the thoughts of a great many men of his day:

> If each of us citizens, had determined to assert his rights and dignity as a husband with respect to his own spouse, we should have less trouble with the sex as a whole; as it is, our liberty, destroyed at home by female violence, even here in the Forum is crushed and trodden underfoot, and because we have not kept them individually under control, we dread them collectively. . . . For myself, I could not conceal my blushes a while ago, when I had to make my way to the Forum through a crowd of women. . . . Our ancestors permitted no woman to conduct even personal business without a guardian to intervene in her behalf. . . . Give loose reign to their uncontrollable nature and to this untainted creature and [you cannot] expect that they will themselves set bounds to their license; unless you act, this is the least of things. . . . It is complete liberty or, rather complete license they desire. If they win in this, what will they not attempt? . . . The moment they begin to be your equals, they will be your superiors. . . .[20]

This fear of women, whether real or imagined by Cato, is an important factor in assessing woman's place in Rome, since the so-called new

woman became the scapegoat for much of Roman criticism and has led many modern writers to overemphasize the independence of woman and ultimately to equate some lessening of restrictions against women with equality. Roman women never achieved equality and in fact never approached it. Any slight gain was the subject of such diatribes that careless readers of the classics might think that Roman women had actually gained some power.

In spite of Cato's diatribe, the Oppian laws were repealed, but the criticism of women continued. Sallust (d. 35 B.C.) claimed that "women offered their chastity for sale,"[21] while Horace chimed that marriage became defiled as maidens learned the art of love and sought out lovers at the expense of their husbands.[22] Part of the difficulty in assessing these writings is that the sources themselves are misleading. No Roman woman ever wrote anything, at least that has survived. Though many Roman women (especially of the upper classes) were literate, nothing they might have written is extant today. For example, Cicero (d. 43 B.C.) wrote to his wife and daughter, but no letter that they wrote to him exists today. Some seven women were included among the correspondents of Pliny the Younger (d. c. A.D. 114), but only his letters and not their replies survived.[23] Moreover, most extant information is of the upper and not the lower classes. Poorer women may well have had somewhat greater freedom than their upper-class sisters, but this can only be conjectured. By the end of the second century a large proportion of the free population was being drawn from ex-slaves, and if nothing else the experience of the slave women with their male masters would have been enough to give them, as well as their menfolk, a somewhat different attitude toward the accepted, traditional, upper-class values. Add to this such things as economic necessity, slum conditions, the fact that their work was serious, and not a pastime, and it seems reasonable that they might well have different attitudes toward men and men different attitudes toward them.[24]

Since the literature was inevitably written from a male point of view, it seems natural that women were blamed for many of the ills of society. Any historian of the last years of the Republic would be forced to note that divorce was quite common, but it does not necessarily follow from this that women were to blame. *Marriages de politique* in fact were almost the norm among the upper-class men ambitious to move ahead. Men chose, or youths had chosen for them, wives who would bring a rich dowry or bring advantageous connections. There is little to indicate that women had much say in the matter. In the first century B.C., for example, the generals Sulla and Pompey each married five times. Sulla,

seeking to attach Pompey to his cause, persuaded the young man to put away his first wife and marry Amelia, Sulla's stepdaughter, who was already pregnant by an earlier husband. Caesar later married his daughter, Julia, to Pompey as part of the triumviral alliance that he made with Pompey and Crassus. Augustus, who was greatly concerned with Roman "immorality," used his daughter Julia as a fisherman uses bait, marrying her in turn to each of his chosen heirs. Undoubtedly such practices weakened marriage as an institution, but rather than face the base cause, the Romans complained of female immorality and misogynistic historians and poets romanticized a past where female virtue alone had mattered and a woman such as Lucretia would kill herself because she had betrayed her husband.

Once Augustus had consolidated his power at the end of the first century B.C. he took steps to reintroduce the morals of a fabled antiquity. In a series of laws he tried to make certain that all men between twenty-five and sixty and all women between twenty and fifty should be married. Mothers of three or more children were granted greater independence in the administration of their property, while fathers of three or more children were privileged to advance more expeditiously through the necessary stages for a public career. Bachelors were penalized, as were childless widows and divorcées.[25] The masculine orientation of the legislation, with the exception of the penalties imposed on bachelors (which were never enforced), is evident from the fact that it apparently never entered Augustus's mind to include the abolition of concubines, mistresses, and brothels, an end to sleeping with one's female slaves, or a redefinition of adultery to extend it to extramarital intercourse by a married man, or even to prohibit politically motivated marriages as necessary to his program of moral regeneration.

Even under Augustus the slave woman who attracted her master had little choice, if he was married, but to become his mistress, or one of his many mistresses. Most slaveholders had slave women, and some of the women even earned their freedom by serving their masters. Cato, the guardian of public morals mentioned earlier, was greatly surprised to find that his son and daughter-in-law were irritated by the fact that he had kept a slave woman as a mistress while his wife was still alive. This, after all, was a matter of custom, not of morals. When Cato's contemporary Scipio Africanus died, his bereaved widow enfranchised his favorite slave woman and even found a freedman to marry her. Since marriage was supposed to be along class lines, and brides were supposed to furnish dowries, there were a great many relationships that were not legally classified as marriage. Concubinage was especially popular with

soldiers, who were forbidden to marry during their service, and with women who could not raise the dowry to become wives. Concubines, however, were found at all levels of the social ladder. For example, the emperors Vespasian, Marcus Aurelius, and Antoninus Pius all took concubines after their wives had died. Marcus Aurelius claimed he did so because he did not wish his children to suffer from a stepmother, although in his *Meditations* he had written that he was most happy he had managed to avoid overlong contact with his grandfather's concubine. Commodus at the end of the second century rid himself of his wife, but rather than marrying again took a concubine. The emperor Constantine was the son of his father's concubine Helena, and his father, Constantius, probably was the son of the concubine of his father. Noble women, however, were not free to engage in such illicit relationships, since the Romans practiced a double standard. A Roman woman who wanted to free a slave in order to marry him was forbidden to do so unless she herself had recently been freed and her prospective husband had been a slave with her. The emperor Septimus Severus forbade such alliances altogether.[26] Nevertheless there undoubtedly were a few freewomen who lived in concubinage with slaves, since the Senate in A.D. 52 passed a law reducing a freewoman to slavery if she lived in concubinage with a slave without his master's knowledge; if the master approved she was debased to the rank of freedwoman (that is, ex-slave). The children of such unions were in either case to rank as slaves.[27]

Some of the moralists who try to equate women of today with those of ancient Rome tend to argue that women in Rome began to assume roles that previously were filled by males. There is, however, no evidence for this. Throughout Roman history it was woman as wife and mother whom the Romans extolled, and it was only through her informal power that a woman gained a place in Roman society. It can be argued, nevertheless, that when woman's formal power is greatly limited, as it was in Rome, then her informal power will grow. Informal power, however, means that a woman has to work through someone else, rather than in a direct way. During the first and second century A.D. there seemed to be many women who did exercise this kind of power, but they were never free to act in their own names and they suffered condemnation for their lust for power. This does not mean that women were usurping roles reserved to males but only that they were utilizing their own positions to manipulate their husbands and sons. How much manipulation took place is unclear since some of the misogynistic writers of the past (as well as the present) tended to paint them in extremely bad light, even when the data do not support such a portrait. The wife of

Augustus, Livia, seems to have had considerable influence over him, and Claudius, one of his successors, seems to have had great difficulty with his wives. One of them, Agrippina, who was also his niece, was so anxious to have her son (by another husband) succeed Claudius that she allegedly had him killed. Though Agrippina did exercise power through her son for a time, as soon as he tired of her he had her executed.

The real place of woman is evident from a discussion carried on in the Senate during this same period. The debate was over allowing wives to accompany their husbands when they left Rome for an administrative post, something that traditionally had not been allowed. Here the role taken by Cato in an earlier period was assumed by Severus Caecina, who argued that there was great wisdom involved in the earlier tradition of leaving the wife behind. He said that if a wife was allowed to accompany her husband she would insist on being entertained in peacetime and if war did break out she could only interfere with its efficient conduct. The trouble with women, he claimed, was not only that they were weak, but if discipline over them was the least bit relaxed they were also inclined to be cruel and to scheme to get power in their own hands. In fact, he added, if women were legally allowed into the provinces there would not be one government but two, the second controlled secretly by the wife. The senators, to their credit, ignored his arguments by pointing out that even though women were naturally weak, this was only added reason why they should not be deserted by their husbands where they could become victims to the temptations of their own flesh and the lusts of other men.[28]

If women never competed with men, from where did the myth of the power of women come? The answer to this question seems to be, from the literary misogynists such as Juvenal, who wrote in the second century A.D. Juvenal sincerely believed that all women were lustful and anxious to dominate men. Conjugal love for him was synonymous with submissiveness by the husband, and it inevitably led to henpecking. "If you are honestly uxorious and devoted to one woman, then bow your head and submit your neck ready to bear the yoke. Never will you find a woman who spares the man who loves her; for although she be herself aflame, she delights to torment and plunder him." Women not only browbeat their husbands but if allowed they would display unwomanly tendencies by entering traditional masculine preserves either directly or indirectly. Juvenal alleged that they surreptitiously planned their own legal cases, practiced fencing, attended political meetings, spoke boldly to public officials, and worst of all even affected learning. "I hate a woman who is for ever consulting and pouring over the 'Grammar of

Palaemon,' who observes all the rules and laws of language, who like an antiquary quotes verses that I never heard of, and corrects her unlettered female friends for skips of speech that no man need trouble about: let husbands at least be permitted to make slips in grammar." Juvenal simply did not like women, and even the perfect woman who might be beautiful, charming, rich, fertile, of noble descent, a chaste wife, a prodigy as "rare upon the earth as a black swan," he found distasteful simply because who could endure a wife that possessed all perfection? His whole sixth satire was a catalog of female vices.[29]

That Juvenal justified his own hostility toward women by disparaging them, however, is no reason why moralists of today need to adopt his attitudes as historically accurate descriptions of women. It would seem natural that a society which denied women any role but wife and mother would justify the subjugation of women by insisting that they were weak in mind and character, incapable of directing themselves. On a deeper level, the man who does so has to allay his fear that woman is naturally more powerful than man (perhaps an inheritance from his biological dependency during infanthood) by reassuring himself of her unimportance in the more important affairs of the world. Juvenal is a good example. There were undoubtedly scheming women in Rome, but it was only through manipulation that a woman could operate on the larger scene at all.

It is not only satirists such as Juvenal who give such a sad picture of women but the lyric poets of the first century who popularized the concept of romantic love. These writers managed to make their love affairs sound full of misery and paint their women as in the long run unworthy of male affection. Though their sentiments were in part directed by convention, their choice of a mistress rather than a wife and mother as the subject of their poems permitted them an overt expression of hostility that would not have been acceptable in marriages. The Clodia of Catullus, the Nemesis of Tibulus, and the Cynthia of Propertius are all berated for their faults, and from these mistresses the authors generalized about women. Their conclusion was that love (and women) inevitably brought misery to men.[30]

A possible explanation for this can be found in the philosophical poet Lucretius, who was writing at about the same time as the erotic poets. Lucretius, who agreed that love made one miserable, had a rational solution, namely, the eradication of love. The first sign of love had to be lanced with quick incisions; the best way to free a male of the course of the disease was to destroy the romantic overestimation of his beloved. In effect Catullus, Tibulus, and Propertius were all doing just that, at-

tempting to deny that women even in love had any real reason for asserting any control over man. Lucretius went so far as to say that in the rare case that a mistress might be faultless, unlikely but not impossible, a man could still free himself from the pangs of love by reflecting that in her physical nature his love object was not different from all other women. Still he ended with a charitable acceptance of woman, that if the lady was good-hearted and void of malice, it was up to the man to accept her imperfections, though he should continually remind himself of these so that she could not get too great a hold on him.[31]

Ovid, another contemporary, built up the charms of love and women in his *Art of Love*, but in his *Remedies of Love* he showed how to counteract the attractions of a mistress, however lovely. Though Ovid claimed to preserve the illusions of a woman's beauty to enhance the delights of love, his *Remedies* indicated a real delight in ridiculing and degrading women. His evaluation of women was entirely consistent; though women might have been attractive, they were frail, foolish, and greedy, and their lust was uncontrollable. A man always had to be extremely wary of them.[32]

Inevitably Romans came to think that man would be better off if he were free of woman. Soranus of Ephesus, one of the most famous of Roman physicians of the second century A.D., argued that "permanent virginity" could be healthful and that intercourse was harmful in itself.[33] This attitude was picked up by the Christian writers, who were even more misogynistically inclined than the Romans. With such attitudes, it was perhaps inevitable that Roman women were blamed, without much justification, for all of the ills of Rome.

One area in which women had considerable say, however, was religion. Though only the Vestal Virgins, the guardians of the state hearth, and the priestesses of Ceres, the goddess of agriculture, were part of the state religious heirarchy, which was dominated by men, women played a large part in some of the oriental mystery cults imported into Rome. This was particularly true of the cult of Isis, which established itself in the second century B.C. Isis not only incorporated into herself many of the female gods of the Greek and Roman pantheon, she also incorporated or assimilated the powers traditionally attributed to some of the male gods, such as dominion over thunder and lightning, winds, and the sky. She was the creator of the universe, the inventor of alphabets, the patroness of navigation and commerce. She was a healer of the sick and promised resurrection to her devotees after death. Isis was also a wife and mother, and her statues with the infant Osiris were everywhere. Although she had particular appeal to women, she came to be wor-

shiped everywhere in Rome except among the army, where the masculine god Mithra had more appeal.

There was also a pro-woman side to Rome since Romans as a culture group were much less misogynistic than the Greeks. In fact, compared to women in Greece, women in Rome were emancipated. They did not need to go veiled, they were not entirely isolated from their husbands' company, and they could even enjoy the company of the opposite sex. Women could go out of the house to shop, to visit the baths, to pay social calls, to worship at temples, and to attend a public function. During the Republican period men and women were allowed to intermingle at the games in the circus and in the amphitheaters, but later they were forced to sit apart in separate blocks of seats. Some women, probably widows, engaged in business, and there were a few women physicians, probably midwives or with practices limited to the treatment of other women.

In today's world the furnishing and decorating of a house is usually regarded either as the wife's responsibility and interest or as a shared responsibility with her husband. In Roman times furniture was a male extravagance, and wives preferred to see the money spent on jewels for themselves. Ordinary housewifely chores were done for most Romans by slaves, and it was necessary to go to a very low level in society to find a housewife, as the term is defined today. Before the second century B.C. the wife is said to have baked the bread, but after this time bakeries were started, and in the richer houses chefs became the norm. The mistress of the house undoubtedly supervised the menu and oversaw the household slaves. There was even a sex differentiation in attitudes on drinking, something that women of the better classes were cautioned to avoid. Dislike of an intoxicated woman was almost an obsession with the Romans, who appear to have been extremely fearful of a woman's loss of control.

It was as wife and mother that the woman had a place in Roman society, and as the mother of sons that she earned her reputation. The Romans seldom vilified respectable mothers, but they took out their hostility toward the female sex on their mistresses, the objects of their erotic love. Romantic love was considered degrading since it brought men into the irresistible power of women—something to be avoided at all costs. Hence the hostility in the erotic poets. The Romans were much too male-centered to allow themselves to fall under the sway of any woman, at least publicly, and erotic love had to be separated from conjugal love. When a satirist like Juvenal takes on women in general, it is easy for modern moralists who are perhaps paternalistically oriented

to see all women as at fault and to claim that there was confusion of sexual roles in ancient Rome. This obviously was not the case, and there is no real evidence for such a statement. Women might have been unhappy in Rome, but they quite clearly knew their place. A few might have rebelled, but even they had to rebel through males. The most powerful women in Rome, the four women named Julia who were the power behind the throne at the beginning of the third century A.D., all had to depend upon their sons for their influence. Rome was a man's world and women never mounted much of a threat to the citadel of masculine prerogatives. Rome fell, but women had little to do with the fall, or for that matter with its climb to prominence. They gave birth to sons who fought and died, and they shed tears and suffered, perhaps they even attempted to use "feminine wiles" once in a while, probably even successfully. Nonetheless they clearly realized, and their menfolk always emphasized, that Rome was a man's world and women's purpose was to serve men.

5 / Christianity, Sex, and Women

Christianity has been one of the dominating forces in shaping Western civilization. It has permeated our institutions, given us the moral basis for our laws, and formed our ideals, and until recently the church itself controlled our education. Though Christians have always been split into different groupings, and these have a considerable variation in doctrine, all look with reverence upon the teachings of Jesus and the interpretation of these teachings that appears in the various parts of the New Testament and in the early church fathers. Attitudes expressed in these sources about women were bound to effect Western attitudes, even though the reality of a particular society or culture may have led to variations.

Traditionally Christianity has been regarded as a religion of love and charity, but it is equally a religion of asceticism and renunciation of the things of this world. Asceticism quite early was equated with sexual celibacy, and at times the sexual aspects of holiness have seemed to eclipse all other issues. Morality, in fact, became identified with sexual purity, a definition that has not quite been lost in our day. St. Athanasius went so far as to claim that the appreciation of virginity and of chastity was the supreme revelation and blessing brought into the world by Jesus.[1] Sexual continence became both one of the chief virtues and one of the chief doctrines of the Christian faith, the first and indispensable condition of righteousness.[2] Tertullian argued that a stain upon one's chastity was even more dreadful "than any punishment or any death."[3]

The Subordinated Sex

Sex in the early Christian church was usually equated with women, and again it was women who were looked upon as the source of all male difficulties. The problem was accentuated because in his Sermon on the Mount Jesus had stated that "every one that looketh on a woman to lust after her hath committed adultery with her already in his heart,"[4] which was interpreted to mean that even the stirrings of sexual feeling were sinful. To put it simply, women kept reminding men of sex desires that they tried to forget. As St. John Chrysostom put it: "How often do we, from beholding a woman, suffer a thousand evils: returning home, and entertaining an inordinate desire, and experiencing anguish for many days. . . . The beauty of women is the greatest snare."[5] Sometimes it almost seems as if the church fathers felt that woman's only purpose was to tempt man from following the true path of righteousness. Though the demands of sexuality vary greatly from individual to individual, and some men and women can remain celibate without great cost to their personalities, others have a much more difficult time. Many of the church fathers seemed to find it difficult to follow their ascetic ideals and obviously felt the task would have been somewhat simpler if women did not exist. Though it is possible to sympathize with these ascetic-minded and sexually tormented men who blamed all their difficulties on the female, Christianity would probably have had a somewhat different attitude toward women if women themselves had had a major role in formulating Christian doctrine. It is possible that they would have blamed men for their sexual difficulties, but even if this was not the case, Christianity might have had less of a tradition of misogyny.

Though religion is usually regarded as representing man's striving toward the better life and higher good, man has always had a tendency to identify his own attitudes with those of the gods. The nature of the human hand in the formulation of Christian attitudes toward women is evident when it is emphasized that Jesus, who is regarded by Christians as the messiah, was never reported by any writer of the canonical Gospels as having derogatory attitudes toward women. There is, for example, no warning from him about the wiles of women, no intentional reference to them as inferior creatures. We know that women formed an important part of his following, although in the Gospels most of the women remain anonymous. In his dealings with women Jesus refused to be bound by the shackles of petty convention. For example, he discussed his mission with a Samaritan woman at the well even though it was considered improper for him both as a Jew and a male to converse with her because she was a hated Samaritan and an inferior woman.

When his disciples heard of the conversation they marveled that "he talked with the woman: yet no man said, What seekest thou? or Why talkest thou with her."[6] Several women emerge in greater focus, including the two sisters, Mary and Martha, and Mary Magdalene, the reformed prostitute.[7]

One critic of the traditional position of women in the Christian church emphasized that though there is no recorded speech of Jesus concerning women, in those "passages describing the relationship of Jesus with various women, one characteristic stands out starkly: they emerge as persons, for they are treated as persons, often in such contrast with prevailing custom as to astonish onlookers."[8] Another writer has gone so far as to claim that Jesus not only gave women an important place in his kingdom, but also recognized that their faith, purity, and tenderness were to be the fountains of spirituality.[9] From a cursory reading of the New Testament it appears that women in fact played an important part in the emerging Christian church. They were among the earliest and most faithful converts,[10] they displayed charismatic gifts,[11] they devoted themselves to charity,[12] dispensed hospitality,[13] labored in the tasks of evangelism,[14] and imparted instruction in the faith.[15] Some of these tasks, such as extending hospitality, were the traditional roles of women, but in other respects women seem to have assumed new importance.

Biblical specialists usually emphasize that Jesus himself, at least from his extant teachings, did not proclaim a new code of sexual conduct or a new idea of sexual relationships, but was building upon the Jewish code of the time. This is also true of his statements on marriage and divorce,[16] although he attempted to apply the same standards on adultery, divorce, and remarriage to men as traditionally had applied to women. The nature of this departure from the norm is evidenced by the fact that his disciples complained about the severity of this teaching and contended that it might be better for men not to marry if it was enforced. Jesus replied in a somewhat ambiguous way. "All men cannot receive this saying, save them to whom it is given. For there are some eunuchs, which were so born form their mother's womb; and there are some eunuchs which were made eunuchs of men: and there be eunuchs, which have made themselves eunuchs for the kingdom of heaven's sake. He that is able to receive it, let him receive it."[17] This statement has been the basis of the Christian doctrine of celibacy and a mandate to observe a self-imposed continence. Occasionally in the early Christian period it was interpreted literally. Origen, for example, castrated himself.[18] There were others who followed this practice, but by the fourth century

such acts of self-mutilation had been forbidden by the church councils.[19]

In spite of the fact that the teachings of Jesus might have offered a higher conception of woman and given new meaning and potential to the relationship between man and woman,[20] they were soon modified to conform to the traditional views that society had of women. Woman's new assertiveness, or at least her prominence, created tensions between the progressive and reactionary elements in early Christianity, a tension that was only relieved by the reassertion of the traditional masculine view of the position of women. Even taking the most positive view of the statements about women contained in the writings of the various evangelists and church fathers, it would seem that they believed woman should be confined to her traditional role in the house, in the family, and in the church, but in no case was she to assert herself as an equal. Though there was a recognition that women were equal in spirit to men, this fact was usually relegated to the background, and the emphasis was on keeping them in their place here on earth. Thus while women were recognized as "joint heirs of the grace of life," they were also called the "weaker vessel who were to remain in subjugation to their menfolk."[21] While there was "neither Jew nor Greek," neither "bond nor free," neither "male nor female," in the Kingdom of God,[22] man was the image and glory of God. Women on the other hand were "the glory of man. For the man is not of the woman: but the woman of the man. Neither was the man created for the woman; but woman for the man."[23]

Women were forbidden to teach in the church[24] and were ordered to keep silent. If they had questions or wanted to learn anything, they were to ask their husbands at home.[25] In their homes they were to learn in all quietness and subjection, making sure that they did not usurp authority over the man.[26] There were almost continuous admonitions for women to obey their husbands.

Wives, submit yourselves unto your husbands, as it is fit in the Lord. Husbands love your wives, and be not bitter against them.[27]

Wives, submit yourselves unto your own husbands, as unto the Lord. For the husband is the head of the wife, even as Christ is the head of the Church: and he is the savior of the body. Therefore as the church is subject unto Christ, so let the wives be to their own husbands in everything. Husbands, love your wives, even as Christ also loved the church, and himself for it.[28]

Likewise, ye wives, be in subjection to your own husbands; that, if any obey not the word, they also may without the word be won by the conversation with the wives.[29]

Woman was, after all, the creature who had beguiled Adam into transgression, although it was said that sin would be redeemed in childbearing if all women continued in faith, charity, holiness, and sobriety.[30] It was wicked women who had provoked God to send the flood,[31] and St. Paul felt that their seductive powers were so great that they could cause even angels to sin.

Quite clearly men would be better off if they could ignore women altogether. St. Luke said that a man must hate his own wife and children in order to be a disciple of Jesus,[32] although other gospel writers tended to use a term that can be translated as "leave" rather than "hate."[33] This might only mean that a person must sacrifice everything, even spouse and children if necessary, to achieve salvation, but it also indicates a growing trend toward asceticism, since it was widely construed to apply equally to women. Adding further ambiguity was the statement about the second coming, "Woe unto them that are with child, and to them that give suck in those days."[34]

St. Paul emphasized the higher good of celibacy:

Now concerning the things whereof ye wrote unto me: It is good for a man not to touch a woman.

Nevertheless, to avoid fornication, let every man have his own wife, and let every woman have her own husband.

Let the husband render unto the wife due benevolence: and likewise also the wife unto the husband. . . .

For I would that all men were even as I myself. But every man hath his proper gift of God, one after this manner, and another after that.

I say therefore to the unmarried and widows, It is good for them if they abide even as I.

But if they cannot contain, let them marry: for it is better to marry than to burn.[35]

Some modern commentators, anxious to defend Paul from charges of misogynism, have gone so far as to claim that he advocated an ethic of mutual obligation in sexual relations. Instead of regarding coitus as a detached and peripheral venereal function involving little more than an exercise of the genital organs, it is said he insisted that it was an act

which, by reason of its nature, engaged and expressed the whole personality in such a way as to constitute a unique mode of self-disclosure and self-commitment.[36] While occasionally emphasizing this rather mystical aspect of sexual intercourse, St. Paul quite clearly regarded celibacy as an ideal and marriage and sexual intercourse as reluctant concessions to human frailty. Though marriage was not sinful, married people had "trouble in the flesh: and are overly concerned with worldly things."[37] Nevertheless, he held that forbidding a person to marry constituted heresy,[38] emphasizing that marriage was in honor among all.[39] The most misogynistic statements in the Scriptures appear not in the epistles of Paul but in the Apocalypse, the author of which saw the procession of the redeemed as a company of virgins "not defiled with women."[40] St. Paul, however, gave unprecedented emphasis to the sin of Adam and Eve, although this might have been due in part to his own belief that without the Fall there would have been no need for redemption by Jesus. Still it was woman who was at fault, since "Adam was not deceived, but the woman being deceived was in the transgression."[41]

The hostility with which some of the early Christians looked upon sex is indicated by the fact that only unmarried Christians could be baptized into the Syrian church.[42] There were even some bishops who advocated compulsory continence,[43] but in general rationality seems to have prevailed, if only because it was difficult to deny the positive statements about marriage in the Bible. Since marriage had been instituted and blessed by God, as well as sanctified by Jesus, it could not in itself be either impure or evil. In fact, in the Epistle to the Ephesians, which probably reflected the thoughts of the misogynistic St. Paul, marriage was regarded as "the great mystery" by which Christ's union with the church was signified.[44] The solution of the dilemma of asceticism vis-à-vis the worldly marriage was to recognize marriage as good but to claim celibacy as a higher good. Through this concept of the good versus the better, the church fathers managed to uphold the superiority of the virgin state and the higher merit of continence.

Some have tended to put the blame for misogynistic attitudes that appear in Scriptures and in the church fathers upon Paul, but this is much too simple an answer. Paul appears to have been a fairly open-minded man who preferred celibacy for himself, recognized that marriage might be the way of God, and felt that women were essential for propagation of the species, but rather wished that they were not around. In fact the general tenure of early Christian views would probably best be summed up in the words attributed to Methodius (c. 280), bishop of Olympus, who felt that while women were the daughters of Satan, it

was man's Christian duty to take them out of the clothes of sin and lead them on the right path, preferably that of virginity. Methodius was only the first orthodox Christian to regard virginity as the highest state.[45]

Religious teachings do not usually appear in a vacuum and Christianity was but one of several competing religions in the Roman empire. It survived perhaps because it had greater truth, but also because it had greater insights into human needs and eventually had the strongest political backing. Generally the writers of the Patristic period emphasized asceticism, which included sexual continence. This demand must have struck a responsive chord in Western intellectual thought, or else there would not have been such widespread agreement. The trouble with ascetic life is that man is often reminded of his sexual urges by women, and inevitably Christian asceticism was associated with misogynism, if only because men wrote the religious literature. Perhaps the most remarkable manifestation of sexual asceticism in the early church was the phenomenon known as *syneisaktism* (also *agapetae*), or spiritual marriage. This was the cohabitation of the sexes under conditions of strict continence. A couple often shared the same house, the same room, even the same bed, but yet the parties conducted themselves as if there were no sex difference.[46] In part this was an attempt to show that one could withstand temptation at closest quarters, but while the spirit was strong the flesh was often weak. Inevitably this led to further denunciations of women. Where did these concepts of sex as evil come from, and what were their implications for attitudes toward women?

Christian concepts came not only from the teachings of Jesus but also from Jewish, Roman, and Greek beliefs. Much of the New Testament and many of the works of the early church fathers were written to refute certain pagan ideas or to explain how Christianity fitted in with pre-Christian concepts. In the process Christianity became much less dependent upon its Jewish background and adopted more of the ideas and attitudes of Greece and Rome. As far as sex was concerned some scholars have gone so far as to argue that Christianity sexually was orphaned from Judaism prior to its coming of age, and it was this sudden independence that made it so vulnerable to hostile views of the body and misogynistic attitudes toward women.[47]

Emil Brunner, one of the most influential theologians of the twentieth century, held that the conception of sex as something that was low and unworthy of intelligent man penetrated the early Christian church from the Platonic-Hellenistic ideas floating around the Mediterreanean world. The concept was in absolute opposition to the biblical idea of creation.[48] Brunner felt that the major task of the modern generation of

scholars should be to take up opposition to what he felt was the false, non-Christian view of marriage, of sex, and of women, which has dominated and still dominates much of Christian thinking. Morton S. Enslin put it more succinctly: "Christianity did not make the world ascetic; rather the world in which Christianity found itself strove to make Christianity ascetic."[49]

The key to these concepts was the dualism that developed in Greece as the old Olympic gods proved unacceptable to enlightened persons. This was further accentuated by the political failure of the Greek world, which culminated in the Roman conquest. In their disenchantment with this world and in a search for certainty the Greeks turned to other-worldly asceticism. In their search they tended to ignore man in the flesh and to look upon him as a soul lost and imprisoned in a body. This dichotomy between spirit and flesh became more and more influential in the pagan world, and as this dualism seeped into the emerging Christian religion, it broke down the psychosomatic characteristics of the biblical view of man. One Christian scholar claims that it contaminated Christianity, "sterilized its sense of creation, perverted its confession of evil, and limited its hopes of total reconciliation to the horizons of a narrowed and bloodless spiritualism."[50] Inevitably it also led to somewhat extreme misogynistic views.

Scholars have traced the origin of these concepts to the cult of the god Dionysius and the legendary Orpheus, although today there is still considerable confusion about the relationship of the Orphic cult with Dionysius. The story itself is simple. Orpheus was the famed musician who so charmed Hades, the god of the underworld, that he was allowed to bring back his wife Eurydice from the dead providing he did not look back. The temptation proved too much for him, and when he did look back Eurydice had to return to Hades.[51] This simple myth was grafted onto the cult of Dionysius and resulted in a religion that taught the possibility of attaining immortality. This, however, required purity both in ritual and as a way of life. Within each individual was a divine soul undergoing punishment for sin. Immortality consisted of loosing the soul from its bodily prison. In effect there was a concept of soul and purity on the one hand and body (or material) and evil on the other.

The Orphics erected a theology that emphasized this twofold nature of man, good and evil. To realize eventual divinity men and women had to cherish and cultivate the divine and purge away the evil. The purpose of life on earth was to suppress the evil and achieve the good by periodic rituals, the nature of which is unknown to us today, but most important, by living an Orphic life.[52] Life entailed a conflict between an es-

sentially "higher" and an essentially "lower" nature, a radical departure from traditional Greek religious and moral thought, which emphasized that the difference between virtue and vice was one not of kind but of degree and direction.

The Orphic mysteries were never incorporated into the state religions of classical Greece, but they exercised considerable influence on those aspects of Greek thought that most influenced Christianity. Though Greek attitudes toward women have already been examined, this other aspect of Greek thinking was important in the context of Christianity because it was here that it had its greatest influence on modern attitudes. The line can be traced from the Orphics, to the Pythagoreans, to some teachings of Plato, to the neo-Pythagoreans and neo-Platonists in Alexandria, and then into Christianity and its rival religions.

Pythagoras taught that the universe was ultimately divisible into two opposing principles, the Limited and the Unlimited, and this was reflected in the opposition of light to darkness, odd to even, one to many, right to left, male to female, good to bad, and so forth. Limited, light, odd, male, good were all in the same category, while unlimited, dark, even, female, bad were in another. Women in the dualistic thought had already been identified as evil. Salvation to the Pythagoreans could only be achieved through *catharsis*, which required the observance of rigid taboos. The soul, the higher principle, was imprisoned in a mortal body that was governed by evil passions. Humans must not, however, be slaves of their own bodies but must improve and save their souls by escaping from the domination of flesh. Sexual consummation was considered the prime pandering to the indwelling Furies, and every passion, every symbol, related to it had to be repudiated. Though Pythagoras himself did not advocate total abstinence, one of his fifth-century B.C. disciples, Empedocles, did.[53] This and similar denunciations have led scholars to conclude that sexual asceticism not only originated in Greece but also was carried by "a Greek mind to its extreme theoretical limit."[54] The implication is also evident that the Greeks held that women were inferior not only from a scientific view but also from a religious view.

Plato, whose attitudes toward women have already been discussed, rejected the cultic aspects of a religion but elevated the dualism inherent in the Orphic cult and Pythagoreanism into philosophical ideals. He postulated two universal principles, Ideas and Matter, which he equated with the intelligible and the sensible worlds. Ideas were eternal and immutable, present always and everywhere, self-identical, self-existent, absolute, separate, simple, without beginning or end. They were com-

plete, perfect existence in every respect. Matter or the material world of sensible objects existed only so far as it caught and retained the likeness of the idea, but in any case was almost always an imperfect imitation. The soul, an immaterial agent, was superior in nature to the body and was hindered by the body in its performance of higher psychic functions of human life. Reality for Plato had two components, the changeable world of bodies that man could know through sense perception and the Ideal, the timeless essence or universal realities, which could be known only through the *nous*, the mind of the soul that perceived it. Though the soul had been born with true knowledge, the encrustation of bodily cares and interests made it difficult to recall the truth that was innately and subconsciously present. Love also was conceived in dualistic terms, the sacred and the profane, the one occupied with the mind and character of the beloved, the other with the body. It was only through the higher love, the nonphysical, that true happiness could be found. True love was the mutual attainment of the self-mastery that cured the disease of physical craving. Physical love was inferior to true love, and copulation itself lowered a man to the frenzied passions characteristic of beasts.[55] This is the essence of Platonic love, and the implication is clear that true lovers would be celibate.

The center of Greek philosophical thinking and speculation moved from Athens to Alexandria, and it was an Egypt that the fullest expression was given to this growing asceticism and misogynism went from philosophy into the various competing religious creeds. One of the transitional figures was the philosopher Philo, the Alexandrian Jew born in the last quarter of the first century B.C. Philo accepted the Jewish concept of the divine command to procreate and replenish the earth, but he held that the only goal of marriage was to procreate legitimate children for the perpetuation of the race. Those who had intercourse for pleasure were compared to pigs and goats.[56]

In spite of his need to justify marriage, Philo thought that the highest nature of man was sexual. It was only the irrational part of the soul that contained the categories of male and female and existed in the realm of the sexual. It was the original sin of Eve and of Adam that had resulted in sexual desires, and this marked the "beginnings of wrongs and violations of the law." Philo defined the female as inferior to the male since the female represented sense perception, the created world, while the male on the other hand represented the rational soul. Progress meant giving up the female gender, the material, passive, corporeal, and sense-perceptible, for the active, rational, incorporeal, more akin to mind and thought. Woman could become most like the male by remaining a vir-

gin, and the words *virgin, virginity, ever virginal* occur continually in Philo's references to women.[57]

Philo himself seems to have had no immediate disciples of any note, although he had great effect on Christian thinking. More immediately influential were the neo-Pythagoreans and neo-Platonists, who taught that redemption was a flight of the soul from the fetters of the body and the senses. Though they did not necessarily advocate celibacy, they insisted that sexual relations be motivated not by the promptings of nature but only by a regard for propagating the species. A neo-Pythagorean treatise of the first century B.C. stated, "We have intercourse not for pleasure but for the purpose of procreation." Sexual organs were given to man only for the "maintenance of the species" and not for sensual pleasures.[58]

Numenius of Apamea, a second-century A.D. writer, illustrated the ability of the Alexandrian scholars to patch together various philosophic and religious teachings into one system. Numenius taught that Pythagoras and Plato were interpreters of a kind of universal wisdom that could be found in the teachings of the Brahmans, the Magi, the Egyptians, and the Jews. With him dualism was carried to its logical conclusion. God, representing good, the ideal, was so high and so remote that he was out of contact with the world as man knew it and in fact had nothing whatever to do with its creation. Instead the universe was the work of a "second god," derived from an inferior deity, while the universe itself was a third god. Thus there were really three gods, the father, the creative agent generated by him, and the creative world. The second and third gods both had dual natures since they contained matter and spirit. Matter was the evil principle that opposed the divine soul. Salvation represented an escape from the corporeal and sensible existence, a reabsorption of the soul into its divine source. This was accomplished by the means of a series of reincarnations, but in the meantime humans were to cultivate their reason in order to commune with God. Individual salvation consisted in the abandonment of sexual activity, which act of renunciation served to liberate the soul from passion and thereby gain mystical ecstasy.[59]

The correlation of religion with philosophic thought becomes even more apparent in the writings of Plotinus, who lived and wrote in the third century A.D. Plotinus taught that the goal of life was to merge with the universal spirit. The path of redemption was long and gradual, but in the end the soul would be united with the divine in an indescribable ecstasy. To prepare for this ultimate union required long and rigorous discipline, both moral and intellectual. The core of human virtue lay in

detachment from worldly goods, from evil, which required an indifference to the caresses and stings of material life. Once this "apathy" from the material world was attained the soul was free to turn its attention upon the intelligible world, to identify with the path toward Divine Reason on which truth could be found.[60] Abstinence from sex was one of the requirements, and Porphyry, a disciple of Plotinus, condemned sexual intercourse under any condition.[61]

Christianity and other religions of the time were greatly influenced by such teachings. Since Christianity was competing with various other redemptive cults for supremacy, it was influenced by what its rivals said or taught, either positively or negatively. Within any particular Christian community the attitudes toward sex and women seemed, in fact, to be dependent upon the practices of its leading rivals, and sexual concepts ranged from permitting copulation if motivated by a desire for children to an outright demand for celibacy of all church members. At times it seemed that Christians tried to gain status if not adherents by outdoing the pagan rivals at ascetic practices.

As far as sexual practices and attitudes toward women were concerned, the most influential rival of Christianity was Gnosticism and its offshoots. Like Christianity it represented a syncretism of various religious and philosophical movements and was both pre-Christian and Christian, independent or yet still dependent upon Christianity. Scholars feel that much of the New Testament was written in reaction to the influence of Gnosticism, and the earliest sources of Gnostic teachings are the writings of the early Christians who militantly opposed the rival movement. Central to Gnostic speculation was the conception of the dualistic world so essential to the Alexandrian philosophical and religious teaching. Humans had elements of both good and evil, of the spiritual and the material in them, and the key to salvation was the escape of the spirit from its material body. To escape required a stringent asceticism, in particular an abstinence from sex. This has led some writers to label Gnosticism a special mixture of Christian theology and sexual morality,[62] although there were variations in Gnosticism and some Gnostics went so far as to say that no human action was subject to moral law because it only involved the material body.

The Gnostics looked to various teachers, including Simon, Saturninus, and Marcion. The interrelationships between Christianity and Gnosticism are evident from the fact that Simon Magus was preaching in Samaria when St. Peter was there.[63] In the Apocalypse there is a fierce denunciation of the Nicolaites, who were seen by the second-

century Christians as Gnostics.[64] One of the most important of the
Gnostic leaders was Marcion, a church reformer who after being excom-
municated by the Christian church in Rome in A.D. 144 set up a com-
peting organization and hierarchy. Clement of Alexandria (second cen-
tury) reported that to the Marcionites nature was evil because it had
been created out of evil matter and that they abstained from intercourse
and marriage.[65] Sex, evidently, was associated with evil, as was the
whole process of reproduction and growth. Marcion was accused by the
Christians of denying the very birth of Jesus in order that he might not
have to admit the flesh of Jesus.[66] Instead Marcion portrayed Jesus as
descending from heaven as a fully formed adult without undergoing
birth, boyhood, or temptation.[67]

Another Gnostic leader, Saturninus, believed that God had fashioned
two kinds of people: the wicked and the good, with men representing
the good and women the evil. Satan, the god of evil, advocated marriage
and reproduction as a means of continuing evil, and through this,
women, the evil, were able to dominate men. Jesus had come to restore
the spark of godliness in man, to destroy the works of the female, to
bring marriage and reproduction to an end.[68] The evilness of women
was a consistent theme in ascetic Gnosticism, although Gnosticism
had another strain. Some Gnostics felt that they were not bound by the
ordinary law of men but instead were free to go nude, commit adultery,
and engage in other sexual activities with impunity. Still another group
believed that they had the power to commit sin because of their per-
fection.

Christians as a whole rejected this so-called immoralist school of
Gnosticism, but they were strongly influenced by the ascetic one. One
of the transmitters of this Gnostic concept was Justin Martyr, a convert
to Christianity. He described approvingly a Christian youth who asked
surgeons to emasculate him as a protection for bodily virtue and
pointed with pride to those Christians who renounced marriage in order
to live in perfect continence.[69] He associated virtue with sexual absti-
nence and argued that Mary was undefiled, conceived as a virgin, and
was the antitype to Eve, the wicked woman, with whom he associated
sexual intercourse.[70] His disciple Tatian, the leader of a group of Chris-
tians known as the Encratites (the self-controlled), taught that marriage
was corruption and prohibited sexual intercourse, intoxicants, and
meats to his followers.[71] He referred to wedlock as a "polluted and foul
way of life" and urged the faithful to replace the tree of carnal appetite
with the tree of the cross.[72] Tatian's greatest influence was on the Syr-

ian church, which apparently never considered him a heretic, and it was probably from his teachings that Christians in Syria seemed to believe that Christianity could only be compatible with a life of virginity.[73]

Inevitably, with such attitudes toward sex, the Gnostics had a low opinion of women, with whom they associated sex. In the Gnostic Gospel of Thomas, it was held that women could only be saved by becoming men or at least asexual creatures. Women were held by the Gnostics not to be worthy of becoming Christians, unless they became males: "For every woman who makes herself male shall enter the kingdom of heaven."[74] This was usually interpreted to mean that women could only be saved by denying their sex, remaining virgins.

By the end of the second century Gnosticism was generally looked upon as a distorted expression of Christianity. The organizing ability of the more orthodox Christians had begun to win the war between the conflicting groups. By insisting upon the importance of the community as opposed to individuals, by emphasizing the scriptural antecedents of Christianity, yet incorporating pagan philosophy, Christianity eventually succeeded in overcoming Gnosticism and other rivals. In the process, however, the Christian church became thoroughly Hellenized and its attitudes toward sex came to be more like those of the ascetic Gnostics than those of the more earthly Jews. Inevitably women were the victims.[75]

Clement of Alexandria, while recognizing that women were endowed with the same human nature as men and capable of attaining the same degree of perfection, taught that men were usually better at everything than women.[76] He also emphasized the importance of continence in marriage and urged that intercourse be undertaken only for purposes of procreation.[77] This was a somewhat more moderate stand than the one taken by Tertullian, an avid opponent of the Gnostics, who stopped just short of condemning intercourse and seemed to be uncertain why God had ever permitted it.[78] He undoubtedly felt, as did Athenagoras, that while Christians might have to have children it was best if they experienced no desire at all.[79]

Tertullian requested all women to remember that each one of them was an Eve, the devil's gateway, the unsealer of the forbidden tree, "the first deserter of the divine law; you are she who persuaded him whom the devil was not valiant enough to attack. You destroyed so easily God's image, man. On account of your desert—that is, death—even the Son of God had to die."[80] Though Tertullian was married, he was deeply sorrowful that this was the case. In attempting to dissuade his wife from remarriage if he should predecease her, he felt her only possible motives

for wanting to be married were her natural lust or her desire to rule another man's household and to spend her husband's hard-earned money.[81] He urged women to refrain from enhancing their appearance, to conceal and neglect any signs of natural beauty. Physical beauty was not a crime, since it came from God, but it was to be feared. Every woman should wear a veil or else all men would be put in peril by the sight of her.[82] Ultimately Tertullian was not accepted as an official church father, but his influence was greater than that of many of the more orthodox.

A good Christian girl was to be kept in strict seclusion until the time of her marriage,[83] and this meant that women as a whole were denied opportunities for education and excluded from active participation in church affairs. St. John Chrysostom argued that man was ordained to regulate woman and his duty was to mold and form her while she was young and tame her so that she would later submit and obey.[84] He cautioned fathers to keep their sons away from all women, except possibly some charmless old maidservant, and to take as much care to shield a young man from a young woman as a child from the fire.[85] He felt that it was the female sex that had caused David's adultery and Solomon's apostasy. If any man stopped to "consider what is stored up inside those beautiful eyes and that straight nose, and the mouth and the cheeks, you will affirm the well-shaped body to be nothing else than a white sepulchre; the parts within are full of so much uncleanness. Moreover when you see a rag with any of these things on it, such as phlegm, or spittle, you cannot bear to touch it with even the tips of your fingers, nay you cannot even endure looking at it; you are in a flutter of excitement about the storehouses and depositories of these things."[86]

Though marriage had been instituted by God for the generation of children it was a concession to the inordinate desires of fallen humanity and a refuge for those weaker souls who could not bear the discipline of celibacy. The church fathers never hesitated to remind their readers that marriage at best was a painful affair, with the trials of pregnancy, the pains of childbirth, the anxieties of parenthood, and the distractions brought about by wives, children, and family life. Gregory of Nyssa in the fourth century dismissed marriage as a sad tragedy.[87] St. John Chrysostom did much the same thing.[88]

St. Jerome, the one church father who seemed to enjoy the company of women, argued that there could be no cause for shame in associating with the sex from which the Virgin Mary had come. He enjoyed teaching the Gospel to women and had several women as close friends, but his admiration had limits and was restricted to virgins and widows,

women who were only spiritual companions. He expressed active distaste for women as sexual objects. His views on marriage appeared in an oft-quoted passage: "I praise marriage and wedlock, but I do so because they produce virgins for me. I gather roses from thorns, gold from the earth, the pearl from the shell."[89] He saw nothing attractive in motherhood and considered pregnant women a revolting sight. He could not imagine why anyone would want a child, a brat to crawl upon his breast and soil his neck with nastiness.[90] St. Ambrose called marriage a galling burden, urging all those contemplating matrimony to think about the bondage and servitude into which wedded love degenerated.[91] In sum the fathers argued with monotonous regularity that the wedded state was not as good as the single, and since it was women who made it so difficult for men to be single, women themselves were a problem.

With the Gnostic threat on the wane, Christianity should have been able to reassess its position and tone down some of its more misogynistic and antisexual statements. This did not happen. In the first part of the fifth century Christianity, at least Western Christianity, put renewed emphasis upon ascetic ideas toward sex. This was due mainly to the influence of St. Augustine, who was responding to a new threat to Christianity, Manicheanism, a kind of Gnostic synthesis. Manicheanism was based upon the teachings of the prophet Mani (A.D. 216–77), who lived and was crucified in southern Babylonia. Mani incorporated the teachings of the Gnostics, the Christians, the Zoroastrians, and the Greeks, and his teachings spread rapidly. Like Gnosticism, Manicheanism was a dualistic religion in which there was a struggle between Light and Darkness, between good and evil. Originally, the Manicheans believed, the two realms had existed without intermingling, but history began when the Prince of Darkness, attracted by the splendor of the light, invaded the Kingdom of Light. In this original invasion the forces of light had been vanquished, then eaten by their opponents. In this way light had come to be imprisoned in the material world of darkness. The God of Light had rescued primordial man from this condition, but man still retained a mixture of light and darkness. Adam and Eve were the result of a union between a son and daughter of the Prince of Darkness. Adam, however, had more light than Eve. Recognizing the miserable state of man, the God of Light had sent Jesus in the form of the Incarnate Word to warn Adam that Eve was the tool of darkness, and as a result Adam refused to sleep with her. The powers of darkness countered this refusal by teaching Eve the necessary witchcraft by which she seduced Adam so that he became her mate and together they propagated

the world. Jesus had been sent again to accomplish the redemption of the Elect. Procreation was an act of evil since it kept the light imprisoned. The purpose of man was to gain the light, and light could be released by eating bread, vegetables, or fruit containing seeds, since the light was in the seed. The seed of man also contained light, but sexual intercourse between male and female chained the soul to Satan, denying it progress into the Kingdom of Light. Marriage was a sin, procreation the defiling birth of the divine substance. Sin consisted both in the overt act of sex and in the impulse to have sex.[92] The true Manichean remained celibate, observed strict vegetarianism, never engaged in trade, never killed anything. Not all adherents of Manicheanism, however, were expected to follow its rigid principle, only the Elect. Below the Elect were the Auditors, who as yet could not contain themselves but in the meantime supported the Elect. There was also a third group, the completely sensual members of society who, totally lost in wickedness, rejected the gospel of Mani.

St. Augustine was an adherent of the Manichean religion for some eleven years but never reached the Elect stage, in part because of his difficulties with sex. He remained an Auditor, living with a mistress, uncomfortable about his inability to control his lustful desires. Though he eventually rejected Manicheanism, his writings still conveyed the idea that sexual intercourse was the greatest threat to spiritual freedom. "I know nothing which brings the manly mind down from the heights more than a woman's caresses and that joining of bodies without which one cannot have a wife."[93] St. Augustine, however, could not quite reject marriage since it clearly had biblical sanction. He solved his dilemma by equating original sin with concupiscence (the unbidden motion of the genitals) and venereal emotion. This allowed him to hold that the act of coitus in theory was good, since it was of God, but also to claim that every concrete act of coitus was intrinsically evil and every child was literally conceived by the sinful actions of its parents. Marriage had only been sanctioned by God to moderate venereal desire, which it did by diverting it to the task of procreation. Intercourse for any other purpose was a sin.[94] Celibacy was the highest good. Intercourse was little more than an animal lust and only justified by procreation, and then only in marriage.

Since the church fathers were male, and many of them became conscious of the physical desires of their bodies when in the presence of women, misogynism became ingrained in Christianity. Marriage and motherhood were recognized, but they were not as important as the

women who denied their sex. It was woman as virgin, as a sexless crea-
ture, who was most admired. The ideal woman was a virgin, detached
from the world, preoccupied with spiritual things. She

> fasts, maintains vigils, meditates on the Scripture. Her attire is
> mean, poverty is the way of her life. She is joyous but has the gift of
> tears. She is simple but prudent. She is serene and innocent and
> sweet. From her interior purity, recollection, and devotion emanate
> the sweet odor of prayer and good works. . . . Everything about her
> exterior manner bespeaks her angelic holiness—her dignified bear-
> ing, her modest decorum, the comely pallor of her sober counte-
> nance, the pure, virginal blush of her modesty, the chaste restraint
> of her downcast eyes, and the silence of her closed lips. When
> obliged to speak, her voice is gentle, her words prudent. If she must
> walk among men, she walks as through a desert, oblivious to all
> about her.[95]

Undoubtedly such a life is possible for a few women, just as celibacy
is desired and accepted by some men. The problem was that this was the
standard applied to everyone, and quite simply most of us fail to meet
these standards, even some who have striven mightily to do so. It is
when the male who is striving to be chaste becomes conscious of wom-
en's power to arouse his sexual desires that he is most likely to lash out
at them, to blame them for his own failings. Inevitably Christian teach-
ings became misogynistic to a degree unequaled in the Western world
before or since, although there was always the mitigating factor that
Christians had to admit women as spiritually equal to men. The antag-
onism to the female reached the point that some felt it necessary to
question why Jesus had associated with such a wicked and inferior sex.
The acceptable answer to this query was that if Jesus had refused, the
sin-laden female could never have hoped for redemption.

Christianity was a male-centered, sex-negative religion with a strong
misogynistic tendency. The very fact that it was male-centered and sus-
picious of sex led it to a suspicious attitude toward woman as any kind
of sexual creature. Christianity almost went so far as to adopt the view
that sexual life was unclean but ultimately managed to repress those
elements that overstressed this point of view. These ideas of the early
Christian fathers about the evilness of sex and the dangers of women
were carried over into the mainstream of Western thought. While the
ordinary Christian man seldom achieved celibate life, he nevertheless
was influenced by this negative attitude toward sex and tended to regard
those who could repress their sexuality with awe and wonder and indi-

rectly to blame on women his own inability to do so.[96] Women them-
selves tended to feel inferior and to believe that the only way they could
approach the male level of rationality was to deny their sexuality. Early
Christian literature has a number of stories about women who in their
attempts to repress their femaleness lived and died as men and achieved
sainthood in the process.[97] Inevitably, when a woman was intelligent or
rational or had any of the other attributes associated with being male,
she was described as having a masculine mind rather than a weak
female one. Those women who did not repress their femaleness at least
on some level were the source of the problems because they were the
tempters of the male. It was not woman as a mother who achieved the
highest respect in Christianity, although there was always the example
of Mary, but woman as "man," as an asexual, virginal creature. This
Christian attitude was added to the concept of the general inferiority of
women that prevailed throughout the Mediterranean world. The result
was not only to classify women as inferior to men upon scientific and
philosophic grounds but to set them apart legally and socially as in-
ferior, and with Christianity to recognize them as morally inferior.
Though Christianity always recognized that the soul of the female had
the potential of being equal to the male, on this earth at least women
were quite clearly below the level of men.

6 / Byzantium: Actuality Versus the Ideal

In spite of the extreme misogynism of the church fathers, attitudes toward women probably changed for the better in the transition to the Christian Roman empire from the pagan Roman empire. This contradiction emphasizes an essential difference between Christianity as an ideal and Christianity as reality. When Christianity became first a legal religion and then the official religion of the Roman state, it had to deal with the problems of power. As part of the establishment it could still work for change, but if it was to remain in power it could no longer attempt to deny the right of the establishment to rule.

Early Christians had regarded themselves more or less as sojourners on earth, unconcerned with the problems of power. Some Christians even regarded the imperial Roman government as the work of Satan, although the majority probably accepted it as ordained of God. All, however, viewed it as an external power alien to themselves. When the government became Christian, or at least Christian-oriented, Christians found themselves in a dilemma as they attempted to reconcile the obligations imposed by participation in government with their personal belief. Christians placed in a position of secular authority had to face moral problems that they had not been prepared to face, since official obligations required them to act in ways contrary to Christian beliefs. In the fourth century, for example, St. Basil held that Christianity was incompatible with military service and any soldier who killed a man in the course of duty was to be regarded as excommunicated for at least three years.[1]

Rome, however, was faced with powerful military pressures, and no Roman government would countenance the excommunication of its soldiers by officially subsidized clergy. Moreover, the army itself was a potent political force and included vast numbers of men, many of whom wanted to believe in the Christian god. The result was compromise. By the fifth century, Innocent I, bishop of Rome, ruled that people who had to execute citizens in their line of duty should not be excommunicated since the powers of the state "had been granted by God and the sword had been permitted for the punishment of the guilty."[2]

As Christianity made its adjustment to the realities of power, it also provided an alternative in the form of monasticism for those who felt that any kind of compromise with secular government was dangerous to the soul. Monasticism, which developed in Egypt in the third century A.D., was a logical extension of the emphasis upon asceticism and celibacy so evident in early Christian life. It allowed the institutionalization of the higher ideal of celibacy and at the same time permitted ordinary Christians to have families and deal with the secular world, content in the belief that they were doing their best.

Monasticism also had important implications for women, since originally it started out as a lay movement, open to men and women alike. The acceptance of holy orders, an act that was first restricted to men, was regarded by many if not most of the early ascetics as a hindrance to a monastic career. This meant that within the monastic movement both men and women were equal, and both could inflict upon themselves austerities to rival the sufferings of the martyrs of the past. Some of the early monks and nuns tried to emphasize their ascetic abilities by living together, but as monasticism became more and more organized there was a strict separation of the sexes. Organization also implied that certain social ideals, such as charity, were incumbent upon those who embraced the ascetic ideal. Women in convents were allowed to give free rein to their organizing abilities with comparatively little masculine interference. Thus the convent became the major institution outside of the home in which women could exercise authority, and not surprisingly a number of women managed to leave their imprint upon history from the seclusion of the convent.

Equally important in forming attitudes toward women was the fact that when Christianity became part of the Roman state, it found itself conforming to Roman law. Roman law stated that woman had the right to own property and her property was not to be confused with that of her husband. She was also qualified to serve as a guardian in her own right. In the Greek East, the adoption of Roman law had made an essential distinction between the women of ancient Athens and the Byzantine

women, while the possibilities of economic independence gave them somewhat higher status. This does not mean, however, that women were equal to men; they were still very restricted in their activities. In the Eastern Roman or Byzantine Empire, no respectable woman ever appeared unveiled in the streets, and even in her house she never dined with a stranger. Nor did she enter into the presence of a strange man except silently and with downcast eyes. Nonetheless, by emphasizing the spiritual equality of women, the Christian church offered a way for Byzantine women to be active in society through ministering to the poor and the unfortunate. Still, a Byzantine emperor could write, as Leo VI (A.D. 886–917) did,

I have never understood how the ancients came to accept women as witnesses or how they could have failed to consider the obvious fact that it is disgraceful for the women to expose themselves to the gaze of men and that decency and propriety for a woman consist in avoiding such encounters. How could they permit women to be summoned as witnesses when this often results in their mingling with large crowds of men and using their tongues in an irreverent way totally improper for their sex? This question, as I have said, has always perplexed me. . . . We uphold the custom which, rectifying the errors of the law, denies women the right to give evidence. We hereby give this custom legal force and forbid women's evidence to be taken in matters connected with contracts. But in purely feminine affairs, where men are not permitted to be present—I refer to childbirth and other things which only the female eye may see— women may testify.[3]

The interaction of Roman Law and Christian tradition can be illustrated in the matter of divorce and remarriage, a subject on which the church fathers had strong opinions. In general the Christian church took over the pre-Christian Roman marriage rites with only slight changes. Episcopal approval was not necessary for marriage, nor was there any necessity for any ecclesiastical rites or blessings. Traditional ceremonies remained the same, save for the omission of the auspices of the augurs and similar more obvious aspects of paganism. The church orders contained no Christian marriage rite, nor was there any reference to one in the literature of the period. Even in the western part of the empire, where the church had somewhat greater say over such matters, it was not until the ninth century that there was any detailed account of the rite of Christian matrimony. At that late date it was still identical with the old nuptial ceremony of pagan Rome, except for the substitution of eucharist for pagan sacrifice and divination.[4]

Since marriage was essentially a civil affair, a contractual relationship established by consent, it was voidable like any other contract.[5] Divorce was a private act, not particularly juridical, although it did have to take place in the presence of seven adult citizens. Usually divorce was by mutual agreement, but a man could divorce his wife without her consent for quite arbitrary reasons.[6] Though some Christian emperors tried to restrict the wide grounds for divorce, both husband and wife still retained considerable freedom to separate themselves from their marriage contracts.[7] Generally the church condemned remarriage during the lifetime of the partner dismissed,[8] but this was not written into law, and if the example of the emperors has any merit, they were unable to enforce any such prohibition. Christianity also quite clearly developed and institutionalized a double standard. Concubinage, for example, was recognized.[9] St. Basil of Caesarea held somewhat reluctantly that greater indulgence ought to be shown toward the husband who strayed from his marriage vows than toward the wife.[10] In fact, the husband who failed to divorce an adulterous wife and also neglected to prosecute her paramour could be charged with the crime of pandering. The wife had no such right.

One other factor, however, seemed to strengthen the position of women, namely, the power of the empress. The Roman Empire in the third and fourth centuries had suffered from a series of military usurpers. Perhaps in an attempt to lessen the possibility of usurpation, the empress in the Byzantine state was given special powers. She had to be specially crowned and acclaimed, and many of the court and imperial ceremonies could not be conducted without her presence. Technically there was no constitutional bar to a woman acting as ruler in her own right, although most women who served as head of the state acted in the name of their sons. The exception was the empress Irene (797–802), who deposed and blinded her own son in order to rule. She was called by the masculine term *emperor* in official documents, but there apparently was no constitutional bar to her rule. Her ultimate failure was due more to her ill health than her sex. Later two other empresses, Zoe and Theodora, jointly exercised sovereignty for a brief period in the eleventh century. When Zoe appointed Constantine IX Monomachus as emperor, the two ladies turned over power to him, but after his death and that of Zoe, Theodora herself returned to full power.[11]

One of the most remarkable women was another Theodora, the wife of the emperor Justinian in the sixth century. Theodora's great notoriety is dependent almost entirely upon an account of her by the historian Procopius, who tried to blacken her character in no uncertain terms. His portrait of her has been called the most scandalous record

ever left by any notable historian of the past,[12] and apparently there was no love lost between Procopius and the empress. He indicated that she had started out as a prostitute, and though she was not a particularly good flute player or harpist, or even a trained dancer, she proved effective as a burlesque comedienne.[13] After her marriage to Justinian, Theodora settled down into respectability, but Procopius still resented her. Her moment of greatest power came during the Nika riots of January A.D. 532, which almost cost Justinian his throne. In this crisis Theodora addressed the mobs, calming them down. Procopius did not preserve her speech but reported the essence of it, and it is indicative of attitudes toward women in general that Theodora started out by stating that many would feel it was wrong for a woman "to put herself forward among men or show daring where others are faltering." Though conscious of woman's place, Theodora argued that the present crisis made such questions irrelevant and that during such a period of peril even a lowly woman had to make the best of the immediate situation.[14]

In spite of their comparative emancipation, the empresses lived in separate quarters from their menfolk, and the same pattern of segregated living was true on lesser levels of Greek life. The exception might be the peasant women, whose houses were not large enough to permit rigid segregation. The empresses were kept cloistered in the *Gynaeceum*, guarded by armed eunuchs, and other than their immediate family only women, eunuchs, and priests were permitted to visit them. When they appeared in public they were veiled to keep them from being seen. Within the *Gynaeceum* women were free to act as they chose, and the sanctity of their quarters from male invaders, even the emperor, is illustrated by the case of Anthemius and Theodora. Theodora's greatest disagreement with Justinian was over the question of whether or not the Monophysites should be treated as heretics. Justinian, who considered himself a theologian, regarded the Monophysites, the forerunners of the modern Copts, as heretical and had deposed one of their powerful sponsors, Anthemius, the patriarch of Constantinople. After his deposition Anthemius disappeared, his whereabouts unknown; twelve years later, when Theodora died, Anthemius emerged from the empress's quarters, where Theodora had kept him hidden among her women.

Unmarried girls, at least from the more well-to-do families, were kept in strict seclusion, and most never saw their husbands until their marriages. Mothers of sons inevitably had considerable say in choosing wives for their offspring. It was not uncommon for the empress to choose a wife by holding a bride show. When the empress Irene, for example, decided to find a wife for her son, Constantine, she sent mes-

sengers up and down the empire seeking out desirable girls of a specific age, height, and size in shoes. Why the shoe size was so crucial is unknown, but this particular episode might have served as a basis for an early version of the Cinderella story. Whether the power of the empress vis-à-vis the emperor was matched by the power of ordinary women and their husbands is perhaps debatable, but in all cases it was woman as mother who was highly respected.

One of the most celebrated encomiums to motherhood in all literature is that by Michael Psellus, an eleventh-century Byzantine historian. He gives us a unique and charming picture of family life. His mother is pictured as a high-minded, hard-working woman of strong principle who governed her house, her parents, her children, and her husband with relentless but kindly exactitude. She lulled her children to sleep with biblical tales and refused to allow them to be terrified by stories of demons and hobgoblins with which the servants attempted to frighten them. Though averse to displays of affection, she would kiss them tenderly when she thought they were asleep. Her dominating energy marked her son throughout his life.[15] Psellus's mother is unique among the women for whom records exist, but probably a great many other Byzantine women had similar influence on their children. It was perhaps because of his admiration for his mother that Psellus emphasized the importance of the empresses in molding character.[16]

Intellectually also the Byzantine women seem to have been somewhat more important than women of earlier times, because of their position both in the convent and in the imperial court. One of the first women intellectuals was Eudocia, wife of an Athenian teacher, who had studied rhetoric, literature, philosophy, astronomy, and geometry. She wrote poetry and even made a public speech to the Senate. Her sister, Pulcheria, also had a reputation as a learned woman. Damascius, a Syrian who lived in the sixth century, dedicated one of his books to his pupil Theodora, whom he called learned in philosophy, poetry, and letters. In the ninth century there was the learned nun Cassia (also called Cassiana or Kasia), to whom verbal tradition ascribes several poems. The empress Eudocia Macrembolitissa, wife of the eleventh-century emperor Constantine X, is also credited with several poems and learned treatises. There were others, but all of them were apparently privately tutored, since there is no mention of girl pupils in any of the schools.

A most remarkable woman intellectual was Anna Comnena, the daughter of Alexius I, the emperor who ruled in Constantinople during the time of the First Crusade. It is in the writings of Anna, called by some the greatest woman historian, that we find how much women

themselves had adopted the idea that they were inferior. Though by denigrating other women Anna may have had an unconscious desire to exalt herself by contrast, it seems more likely that she was merely reflecting the prevailing masculine opinion of women. Anna believed that women were best at serving as mourners, where their liability to tears and other emotions served as an attribute. Women were also good as penitents, but on most other matters the woman most likely to succeed was the woman who best acted and thought as a man. In speaking of the empress Irene's fears, for example, Anna said that even though the empress was terrified, she "kept her fear in the recesses of her heart, and showed it neither in words nor in gestures. For she was *manly* and staunch in mind, like that woman sung of by Solomon in Proverbs, and showed no *womanly* and cowardly feelings, such as we mostly see *women* experience when they fear something alarming."[17] Most women, according to Anna, were leaky vessels who could not be trusted to keep the secrets confided in them by their husbands. Her ideal woman was someone like her mother, who preferred not to appear in public but rather to stay at home, read the books of the saints, do good deeds, and perform acts of charity.

> And when she had to make herself public for some urgent need as Empress, she was filled with modesty and straightway blossomed out in a blush on her cheeks. The wise Theano (pupil of Pythagoras) on one occasion, when her forearm had been bared and some said to her in jest, "Beautiful in the forearm," she replied, "But not in public." So the Empress my mother, image of dignity, resting place of holiness, not only did not love to make her forearm and glance public but did not even wish that her voice should be sent forth into unfamiliar ears. Such a great and wonderful portent of modesty was she. But since, as they say, "not even the gods fight against Necessity," she was compelled on the Emperor's frequent campaigns to go with him. For on the one hand her innate modesty tended to keep her inside the Palace, and on the other hand her devotion to the Emperor and burning love to him drove her all reluctant out of the Palace for various reasons, and first because the disease of the feet [gout] which had attacked him required the greatest care.[18]

When her mother was serving her last hours as empress, Anna was particularly proud of the way she acted in keeping her feminine weakness in bounds. "Always in former perils also the Empress had a manly mind, but especially on this occasion did she play the man. Though deeply moved by the feeling of grief, she stood like an Olympic victor

wrestling against those keenest pains. For she was pierced in soul and troubled in heart by the sight of the Emperor's state, yet she braced herself and stood firm against trials. And though she received mortal wounds and the pain of them entered into her marrow, yet she resisted."[19] The ideal wife was one with feminine soft-heartedness combined with the manly qualities of watchfulness, sharpness, and activity and one who remained steadfast in faith, willing to offer good counsel. It was the woman with the manly mind Anna admired, but she believed that even the best of women could only be lesser men. Still, she felt that there were compensations for this biological inferiority in woman's position as mother, and her account is full of the influence of mothers and the devotions of their sons, even those sons who became rulers.[20]

Anna Comnena is important because she wrote down her attitudes toward women in such detail. For most of the earlier eras covered in this study, there are records of what men felt about women, and sometimes what men thought women felt about themselves, but women writers who left extant works about their feelings were almost nonexistent. It becomes significant, if also somewhat disappointing, to note that Anna's attitudes toward women seem not to have differed from the attitudes of the men around her. She seems to have accepted all of the stereotypes of her culture in regard to women. When she wanted to bestow the highest praise on a woman she called her manly—not womanly. All of the bad qualities seem to have been the feminine ones, whereas the good qualities were masculine. Moreover, she seems to have accepted without question the helpmate role of the ideal woman.

Anna's attitude was not an isolated one, and numerous later women held similar attitudes. This is an indication that women themselves were an important force in their own repression. Women have been convinced of their own inferiority and of the inferiority of others of their sex, and these prejudices remain deeply ingrained. Even when the work of men and of women is of identical quality, women tend to value the work of men more highly. In a 1968 study conducted by a group of psychologists, college girls were given a set of six short scholarly articles to rate. The names of the supposed authors of the articles were so manipulated that for each article half of the subjects thought the author was a man and the other half believed it was a woman. For example, half saw the name of John T. McKay on the first article while the other half saw Joan T. McKay. The subjects were asked to rate the authors for writing style, professional competence, professional status, and ability to sway the reader. Invariably, articles that carried the names of male authors were rated significantly higher. The researchers compared the ratings to see if

the subject matter of the article might make a difference, since it was hypothesized that in those fields traditionally regarded as female, women authors might be more readily accepted. Only in one of the fields, art history, did the articles supposedly written by female authors rate slightly higher than the ones labeled with male names. In dietetics, education, city planning, linguistics, and law, male authors received significantly higher ratings.[21] The women evaluators were unwilling to accept other women as equal to men, even in those fields where women outnumbered men, such as dietetics and education.

In a similar study another group of female college students was shown a series of modern paintings for evaluation. Again half of the group saw a brief biographical sketch listed under a male name while the other half saw a similar sketch under a female name. Those pictures with a man's name attached were judged better than the others unless the painter in the biographical sketch was presented as a top winner of an art contest; only in this proven situation were the "women's" paintings judged equal to the "men's."[22] Though the seventies saw considerable change, women still tend to undervalue themselves.

Why do women so consistently devalue their own performance and believe the cultural stereotypes about their inferiority to men? This is not an easy question to answer, but the question itself has important implications for this book. It seems likely that some of the same dynamics are involved in this type of prejudice as are demonstrated in other kinds of prejudice. Other minority group members, for example, also tend to adopt the attitudes of the dominant group toward themselves. Gordon W. Allport in his study of prejudice called this phenomenon "identification with the aggressor."[23] In a study of similar attitudes among Jews the phenomenon was labeled "self-hatred" by Kurt Lewin.[24] This apparently deep tendency for minority group members to endorse negative stereotypes about themselves is the mechanism that supports the power of any dominant group in a society, in this case, males, and prevents rebellion of the inferior minority (majority?), women. To be effective in preserving the status quo, the stereotype must include a belief that the minority group is incapable of rebellion or other independent action. This is obviously what has happened to women in the past, and Anna is one of the first witnesses we have to this phenomenon.

A historian cannot easily answer how the stereotype of female inferiority was established in the first place. Once instituted, the stereotype continued to be accepted by women because of the rewards society gave to those women who did not quarrel with it. Women, for

example, have been protected and have not needed to take part in major decision-making activities. This avoids conflict, and it is much easier for a woman to live with a man who feels that she is inferior if they both agree on that point. When the minority group member disagrees about his or her own inferiority, conflict is likely to follow, and the laws and institutions were designed to punish the women who did not go along. Identification with the aggressor at least helped to create stability in a household or society. It might well be that this was the only way women could keep their sanity in a society that treated them as second-class citizens.

Ordinary people do not think through their reasons for adopting an attitude or even critically survey the attitudes they hold. They acquire their attitudes in the socialization process, most of which occurs in childhood years. This means that those who rear the young hold great power over attitudes, and since women have always had some hand in this activity they turn out to have been an effective force in creating negative stereotypes about themselves. Children acquire an image of themselves in their early years, and usually well before the age of five they have a clear idea of their sexual identity, as well as some idea about their social status in the society. This self-image includes not only the facts about who they are but the evaluative overtones of that identity. Giving strength to such a hypothesis is a significant body of research about traditional racial attitudes of young children. Though much of this research was done when discrimination was much more severe than it has since become, both white and black children have tended to consider black children inferior, just as men and women have considered women inferior.[25] The "black is beautiful" movement of the seventies lessened racial prejudices, and the campaign for the Equal Rights Amendment lessened some of the stereotypes about women, but radical changes are difficult to bring about.

This was effectively illustrated in 1983 when a black woman won the Miss America contest. Blacks took this as a slight step forward in public attitudes but pointed out that the winner met the traditional Caucasian standards of beauty and lacked those characteristics that anthropologists have used to distinguish the Negroid from the Caucasoid races. On the other hand, militant women's groups no longer boycotted the beauty contest, as they had done earlier, but they remained unhappy at what they regarded as sexist exploitation even though the contest had modified its rules. Changes do occur if pressure continues to be exerted, but change is not easy, and negative self-images of a minority such as blacks (or in the case of women, the majority group) are arrived at

111

through the socialization process, which is not easy to change. No pressure for change existed in the Byzantine Empire.

Thus, Byzantium, though it incorporated Roman legal ideas, adapted and modified them to conform to many of the traditional Greek attitudes toward women, and these were reinforced by some of the Christian teachings. The misogynism so inherent in the church fathers was toned down, but it continued to break through, as in Procopius's denunciations of the empress Theodora. Women had their separate sphere of influence in which they had considerable independence, but though this sphere was important, women in general felt that it offered a lesser role than the one men played. Anna Comnena is one of the first recorded witnesses to woman's belief in her own inferiority, and while Anna believed that women had special compensations, her emphasis on manly women and manly qualities makes it clear that at best she still saw women as inferior.

Before examining Western Christian attitudes toward women, it is necessary to look at a segment of the Roman Empire that by the end of the seventh century had fallen sway to a newly emerging religious identity, that of Islam.

7 / Sex Is Not Enough: Women in Islam

If Christianity is classified as a sex-negative religion then Islam must be regarded as a sex-positive one, but with strong misogynistic tendencies. In fact, the change in attitudes toward sex changed neither the attitudes toward women nor their status. In comparing Christianity with Islam it becomes evident that regardless of what a religion teaches about the status of women, or what its attitudes toward sex might be, if women are excluded from the institutions and positions that influence society, a general misogynism seems to result. In spite of some generalized statements in the Koran about sexual equality, women in Islam were subjugated and regarded as inferior beings.

Before the appearance of Muhammad and the rise of Islam in the seventh century A.D., the Arabs were a male-centered tribal people who practiced polygamy and held women to be inferior. In spite of the reform of Muhammad, this attitude remained. Islam had no organized priesthood, and the lack of an all-male priestly caste in theory should have permitted greater influence for women. It did not. This is because the legal interpreters of Islam were primarily men, and prophecy, leadership in public prayer, and saintship were in general reserved for men. Though in early Islam it was regarded as incumbent upon every Muslim man and woman to seek learning, any woman who tried to do so soon attracted the hostility of learned men who looked upon scholarship as their own prerogative. Some later Muslim commentators even went so far as to argue that most of the inhabitants of Hell were women because

of their unbelief, in spite of the fact that such teachings were contrary to the Koran.[1] In many areas of the Islamic world women were even prevented from attending the mosque or permitted to attend only under conditions where men could not see them.

Richard Burton, the nineteenth-century explorer and linguist who translated the *Thousand and One Nights* into English, argued that women in Arab countries had legal rights in inheritance and in law that were not given to English women until 1882.[2] From this he argued that women in Islam had higher status than in the West. Burton was wrong on both accounts. First, he managed to ignore most of the legal changes in women's status that had taken place in England earlier, and second, he assumed that legal protection implied greater equality as well as higher status. The Islamic legal guarantees simply meant that Islamic women had certain rights that men could not take away from them. Burton made such a statement because he assumed that "women all over the world are what men make them," a belief that no feminist could accept since until and unless women can "make themselves" there can be no semblance of equality. To exercise this kind of influence women have to have access to decision-making, influence-generating institutions in society. In Islam they never had such influence, and they lacked even the convent, which gave women some independence in the West. The masculine bias inherent in Islam was evidenced by the fact that even sex was defined primarily from a male point of view. Woman was a sexual object of the man as well as a somewhat helpless pawn to her own passions. The prophet Muhammad himself emphasized this in his supposed advice to his male followers: "Coition is one of the causes of the preservation of health. Let him among you who is in a condition for having sufficient copulation marry; marriage gives moderation of the gaze and more obligatorily turns one away from incest and adultery."[3]

Almost up to the birth of the Prophet (c. A.D. 570), the Arabs were classed as a preliterate people, though there had been a great outpouring of poetry in the sixth century. This first great age of Arabic literature seemed to spring into existence almost overnight without any precursors and involved complex and elaborate meters. Later the extant poems were committed to memory, transmitted by oral tradition, and ultimately written down in the Muslim era. Though modern critical research makes it evident that numerous modifications were made to bring these poems into accord with the spirit of Islam, it is perhaps significant that women in them remained very much erotic creatures.

According to tradition many of the early poems were hung up in the

Ka'ba, the holy of Arabic holies, from whence they were called *Mu-allaqat,* literally the "hung up" or "suspended" poems. The oldest and most famous of the poets in the *Mu-allaqat* group was Imru'-al-Qays, whose description of the erotic female creature seemed particularly attractive to the men of his time.

> I twisted her side-tresses to me, and she leaned over me; slender-waisted she was, and tenderly plump her ankles, shapely and taut her belly, white-fleshed, not the least flabby, polished the lie of her breastbones, smooth as a burnished mirror. She turns away, to show a soft cheek, and wards me off with the glance of a wild deer of Wajr, a shy gazelle with its fawn; she shows me a throat like the throat of an antelope, not ungainly when she lifts it upward, neither naked of ornament; she shows me her thick black tresses, a dark embellishment clustering down her back like bunches of a laden date-tree—twisted upwards meanwhile are the locks that ring her brow, the knots cunningly lost in the plaited and loosened strands; she shows me a waist slender and slight as a camel's nose rein, and a smooth shank like the reed of a watered bent papyrus. . . .[4]

This erotic portraiture of women was carried over into Islam, but it was a very limited concept. For example, the interest of the poets was on the object of woman rather than on the emotional experience with her. Moreover, the amatory prelude so touching and colorful at first sight was actually limited to less than half-a-dozen motive sequences, each with its own phraseology and imagery.

The woman was always of high social status in tribal society and by and large conformed more to the fleshy females of the age of Rubens than to modern American concepts. When the poet spoke of love inevitably it was of bygone days and lost hopes. Later Islamic social custom supported this same kind of female impersonality, since a family would feel disgraced if one of their womenfolk was mentioned by a poet as the object of his affections. It was bad manners to use other than fictitious names in erotic verse, however modest. Slave girls might be named but ladies never. The rigor of convention was occasionlly relaxed, but just when a victory for genuineness in the portrayal of passion and affection seemed near, a fatal tendency toward rhetorization always set in and stifled the warmth of personal feelings.[5] In essence, then, it was the female as an erotic creature, with sex-positive tones, that captured the Arabic and later the Islamic imagination; woman as an individual remained unimportant.

Islamic literature represents an amalgam of Arabic, Jewish, Greek,

Roman, Persian, Babylonian, and Indian source materials, but a unique Arabic literature resulted that was united by the spirit of Islam as a whole. The key to any understanding of attitudes toward women is the revelations of God (Allah) to the prophet Muhammad that compose the Koran. Like Judaism and Christianity, Islam emphasized that men were in charge of women because God "made the one of them to excel the other, and because they spend of their property [for the support of women]. So good women are the obedient, guarding in secret that which Allah hath guarded. As for those from whom ye fear rebellion, admonish them and banish them to beds apart, and scourge them. Then if they obey you, seek not a way against them."[6] Nevertheless, women were erotic creatures, continually giving trouble to man. To avoid this Muhammad advised them to lower "their gaze and be modest, and to display of their adornment only that which is apparent, and to draw their veils over their bosoms, and not to reveal their adornments save to their own husbands or fathers or husband's fathers, or their sons or their husband's sons, or their brothers or their brothers' sons or sisters' sons, or their women, or their slaves, or male attendants who lack vigour, or children who know naught of women's nakedness. And let them not stamp their feet so as to reveal what they hide of their adornment."[7] When male visitors came into their homes, women were advised to stay behind a curtain, both so that their guests could remain pure in heart and so that the women themselves could remain pure.[8] Women were only allowed to speak freely with their male kinsmen, other women, or slaves; when they went out of their homes they were to draw their cloaks close around them in order that they be neither recognized nor annoyed.[9] Traditionally this provision has been interpreted to justify the veiling of women, although some dispute this. The whole body of a free woman was regarded as pudendal; no part of her was to be seen by anyone except her husband or close kin.[10] Men were advised never to look at the body of a strange woman but only her face, hands, or feet.[11]

Where early Christianity considered marriage good but celibacy better, Islam accepted marriage as the highest good, ordained by God: "He created for you helpmeets from yourselves that ye might find rest in them, and He ordained between you love and mercy. Lo, herein indeed are potents for folk who reflect."[12] Or again: "He hath made for you pairs of yourselves, and of the cattle also pairs, whereby he multiplieth you. Naught is his likeness; and He is the Hearer, the Seer."[13] Muhammad went so far as to state that marriage was incumbent upon all who possessed the ability,[14] and many should "marry of the women, who seem good to you, two or three or four; and if ye fear that ye cannot do

justice [to so many] then one [only] or [the captives] that your right hand possess[es]. Thus it is more likely that ye will not do injustice."[15] Women, like other property, were to be treated with care and kindness, and Muhammad regarded a virtuous wife as a man's best treasure.[16]

Obviously these verses reflect a male point of view. Women were recognized as sexual companions for the male, and it was quite permissible for pious Muslims to praise God for having created women in all their beauty. It was God who formed the female body with all the charms that awakened desire, who made woman's hair so silky, who made the precious curves of her breast. Though Muhammad emphasized that both men and women could achieve paradise, even the portrait of paradise seemed to reflect masculine wish fulfillment rather than any sign of equality for the female. The good Muslim in paradise would enjoy the society of ever virgin houris, dark-eyed damsels with swelling breasts and shy, retiring glances. Paradise was also material. Its inhabitants reposed on luxurious couches, were clad in the richest raiment, enjoying exquisite food, drinking from gold and silver vessels, smelling heavenly scents, and quaffing celestial wine.[17] According to Islamic tradition many men had reached perfection, but only four women had,[18] although Muhammad himself stated that there were several women who were outstanding.[19]

On earth, where God had made man superior to woman, women were to be subject to their nearest male relative, whose right over them was similar to his right over any of his other property. In Islamic tradition the wife's honor was in the hands of her husband, and it was his business to see that she was not violated. Women were meant to be guarded, and if a man failed in his duty it was not necessarily the woman's fault if she strayed from the straight and narrow. There were few legal sanctions to enforce the subservience of a wife to her husband, but custom itself emphasized that this was the normal and honorable way of life for a woman. If a man from another tribe seduced a married woman, he committed no unlawful or dishonorable act; poets in fact constantly boasted of their stolen loves.[20]

Sexual intercourse was a good religious deed for the Muslim male. The Koran stated that women were a field for men to cultivate, and men were advised to cultivate them as often as they would.[21] Men were cautioned, however, to seek women out for "honest wedlock," not debauchery.[22] Women also had rights, and in this respect Muhammad initiated far-reaching reforms. Since these rights, nonetheless, were guarded by institutions from which women were excluded, it was not too difficult to manipulate Muhammad's teachings against them. Muhammad, for

example, emphasized that women were to be allowed to keep their rights to their dowry,[23] that all wives in a multiple marriage were to be treated equally, and that it was forbidden to turn away from one, leaving her in suspense.[24] This has usually been interpreted to mean that coitus interruptus or other forms of birth control were not to be practiced without the woman's consent. Muhammad also stipulated that wives and daughters were to inherit, but the portion of a male child was to be twice that of the female, indicating his own attitudes toward women as lesser beings.[25] Wives were allowed to leave legacies,[26] and no man could inherit a woman's estate against her will.[27] Divorced wives (divorce for men in Islam was easy) were allowed to keep their dowries. A former husband was not supposed to impede their remarriage.[28] Widows who had been in mourning for four months and ten days could remarry.[29]

No legal age was set by Muhammad for marriage, but as a general rule girls were not to be handed over to their husbands until they were fit for intercourse. A man who had intercourse with a girl before she had menstruated was subject to punishment.[30] Marriage (*Nikāh*) literally meant sexual intercourse, although it was also used in the Koran to mean contract. If there was doubt about a girl's readiness for marriage, two matrons were appointed to examine and report on her. Usually a girl was married at twelve or thirteen; a girl of nineteen was already regarded as an old maid. In most cases the bridegroom was older than the bride.[31]

Divorce, for the male, was easily arranged. For a woman it was difficult. A man could divorce a wife twice and take her back once, but before he could marry her for a third time she had to be married and divorced (or widowed) from another husband. After a divorce a woman was to wait until three successive menses had passed to leave her divorced husband's house. This waiting period was to ensure that she was not cast onto the streets pregnant. If she was pregnant her husband was supposed to take care of her until after the delivery. Usually he kept any male children, but she usually kept the female. If it was mutually agreeable to a husband and his former wife, she could remain in his house after divorce. If she was sent away her husband had to restore her dowry. In those cases where the woman had persuaded her husband to divorce her, however, the husband could claim part of her dowry.[32] If a husband divorced a wife before the marriage was consummated he had to return her dowry and pay half of the marriage fee agreed upon.[33]

Traditionally it is accepted that Muhammad limited the number of wives to four, although Muhammad himself married several wives, probably fourteen in all, and several prominent early rulers of Islam also

had more than four. This was in part because the Koranic prohibition of
four was not so clear-cut, and also because no limit was ever set on the
number of concubines. The essential difference between concubinage
and marriage was that marriage entailed a union with a freewoman
while concubines were slaves. To marry a slave it was necessary that she
be emancipated. Concubines, however, were not to be selected from
married women unless they were captives.[34]

Muhammad's first wife, Khadijah, was a widow around forty years
old, and when he married her he was twenty-five. Their relationship was
very close and at her death Muhammad seemed inconsolable. His
friends advised him to marry again in order that he might more easily
overcome his grief, but the prophet was reluctant to do so. Finally he
married Ayesha, a young girl of six or seven. It was said that just watch-
ing the girl play with her dolls proved a consolation to the prophet. The
marriage was not consummated for several years. Most of his other
wives Muhammad took for political reasons, formalizing in the process
alliances with tribes and cementing their support. Many of the wives
were widows for whom marriage provided a kind of social security. Tra-
dition has it that Muhammad was scrupulously fair with his wives,
sleeping with each in rotation. The fact that all of his children save one
were by his first wife indicates either that most of the prophet's wives
were past the childbearing age or that the prophet himself was troubled
by impotency, had become sterile, or perhaps had his mind on other
activities.

It was Ayesha who, once she grew into a happy, fun-loving woman,
gave Muhammad the most trouble. She remained his favorite, but this
status did not exempt her from criticism. Stories about her abound, and
they often are not favorable to her. According to tradition some of the
gossip about her even influenced concepts in the *Koran*. For example,
when she accompanied Muhammad on his campaigns, she observed
purdah by being carried in a heavily curtained litter so that no man
could gaze upon the wife of the prophet. Tradition has it that on one
occasion Ayesha vanished from her litter and was nowhere to be found
when the caravan arrived at its stopping place for the night. The next
morning she arrived with a handsome young soldier, a fact that caused
considerable tongue-wagging among the faithful. She reported that dur-
ing a rest stop she had gone to perform her ablutions but after returning
to the hoogah noticed she had left her jewelry behind at the well. With-
out thinking to tell anyone she ran back to the well in order to retrieve
it, but before she returned the expedition had moved on. She then
waited for someone to come back and rescue her; soon after the gallant

119

young soldier had appeared. Few of Muhammad's followers believed her story, and various derogatory rumors about her character circulated through the camp. Muhammad defended her, thundering against her accusers: "Why did they not produce four witnesses? Since they produce not witnesses, they verily are liars in the sight of Allah. Had it not been for the grace of Allah and His mercy unto you in the world and the Hereafter an awful doom had overtaken you for that whereof ye murmured. When ye welcomed it with your tongues, and uttered with your mouths that whereof ye had no knowledge ye counted it a trifle. In the sight of Allah it is very great."[35] Thereafter to accuse a woman of adultery it was necessary to produce four witnesses, something that was unlikely to happen with any great frequency. Without four witnesses such an accusation amounted to slander, a crime, and the gossip quickly ceased. The requirement for four witnesses entered into the Koran and became a safeguard for Muslim women, although some later commentators held that a husband could meet the requirement by swearing four times. Ayesha never forgave those who failed to accept her innocence, among whom apparently was Ali, Muhammad's son-in-law and one of his successors. She later conspired to bring about the ruin of Ali and his family and the murder of his two sons, Hassan and Husein, and helped split Islam into two major camps, the Sunni and Shiite. While Ayesha's escapade was still fresh in people's minds, the principal parties in the spread of gossip against her were punished with eighty lashes.

One of the contradictions of the Muslim attitude about the sexuality of women is that female circumcision is widespread in the Muslim world. Since Islam teaches that the clitoris is the source and well of all passion in women, the excision of the clitoris is quite obviously a deliberate attempt to make women less sensuous. One modern male Sudanese writer justified the practice on the grounds that "circumcision of women releases them from their bondage to sex, and enables them to fulfill their real destiny as mother. The clitoris is the basis for female masturbation; such masturbation is common in a hot climate; the spiritual basis of masturbation is fantasy; in fantasy a woman broods on sexual images; such brooding inevitably leads a woman to spiritual infidelity, since she commits adultery in her heart, and this is the first step to physical infidelity, which is the breaker of homes."[36] Clitoridectomy was never common to all of Islam and in fact was mainly confined to the northern and eastern parts of Africa, namely Egypt, Ethiopia, and the Sudan. In the past decades there has been great agitation by women in these and other countries to eliminate the custom. Egyptian women especially have taken a leadership role. The Muslims practice male cir-

cumcision as well, but the erotic effect of male circumcision is much less than female. The excision of the clitoris apparently does not remove all ability to have an orgasm but it makes it next to impossible unless intercourse is carried out for a long time. This has apparently led women to encourage their husbands to use hashish and other such drugs to slow down their performance.[37] The Koran itself does not provide for female circumcision, but neither does it provide for male circumcision. Both are accepted in the Islamic world, and male circumcision is considered obligatory for a pilgrimage to Mecca; doubtful pilgrims are sometimes inspected to see that they meet the requirement.

As far as reproduction itself was concerned, Muhammad recognized that there was both a male and a female element, with the vaginal secretion equated with the semen of the male. He taught that the sex of the child depended upon which one of the parents had the stronger seed. If the female had the stronger seed the child was female; if the male, a male child resulted. Occasionally, though one seed determined the sex, the other seed was strong enough to affect the individual characteristics.[38] Not surprisingly this belief had important implications for the attitudes a father would hold toward his children. Male children would be proof that the man dominated the woman, a desirable characteristic in Muslim society. Thus sons were very much more desired than daughters, if only to prove the masculinity of the father.

One of the institutions that relegated women to an inferior position in society was the harem. Scholars today do not agree when the harem system and the seclusion of women came to exercise such great influence in Islam, but it seems to have developed fairly early. Many of the interpreters of the Koran were men from Persia, where women had long been secluded, and their authority in Islam probably made itself felt fairly early. The Greeks also secluded their women, and Christian churches of the East still separate men and women, as did Judaism, so that it is perhaps going too far to overemphasize the Persian influence. By the time of Hārūn al-Rashīd, a century and a half after the death of the prophet, the harem system was fully established. In fact it was so widely accepted that pious visitors to other lands were shocked when they saw free social intercourse between men and women.[39] Harem intrigues furnished a major theme in Islamic history because women in the harem could gain status if their sons emerged as rulers. Thus almost anything they did to encourage the advancement of their sons could be justified. The harem had strong political overtones and was not merely a romantic menage of women.

The Subordinated Sex

It was women's very position as sexual objects that caused so much trouble in Islam. As Vis, the heroine of an Islamic romance, was made to confess by her male author:

in women desire is stronger than modesty and wisdom. Among created beings woman is imperfect, and in consequence capricious and of ill repute, hazarding this world and the next for the sake of a moment's desire, losing all reason when her desire is fulfilled. . . . Many wiles are within a woman's skill, but she is ever disposed to accept fair words from a man. Man instinctively sets a thousand traps through which his desire will be fulfilled: always, woman is the game he hunts, and it costs him small pains to run her down. . . . Then the wretched woman is contemptible in the eyes of the man who has seduced her, and who now turns away from her.[40]

Numerous sayings indicated a gut-level hostility to the "weaker" sex:

I have not left any calamity more detrimental to mankind than woman.

A bad omen is found in a woman, a house, or a horse.

Look to your actions and abstain from the world and from women, for verily the first sin which the children of Israel committed was on account of Women.

Countering these were ambiguous statements such as

The world and all things in it are valuable, but more valuable than all is a virtuous woman.[41]

Not any woman but a virtuous woman, one who had been seen only by her husband and male relatives, one who in effect bought the idea that women were inferior creatures: "If you have a daughter, entrust her to kindly nurses and give her a good nurture. When she grows up, entrust her to a preceptor so that she shall learn the provisions of sacred law and the essential religious duties. But do not teach her to read and write; that is a great calamity. Once she is grown up, do your utmost to give her in marriage; it were best for a girl not to come into existence, but being born she had better be married or buried . . . as long as she is in your house, treat your daughter with compassion."[42] Muslim men were cautioned about women and told that God would "reward the Muslim who, having beheld the beauties of a woman, shuts his eyes." They were warned not to visit the houses of their men friends when "they are ab-

122

sent from their homes, for the devil circulates within you like the blood in your veins. It was said 'O Prophet in your veins also.' He [Muhammad] replied, 'My veins also. But God has given me power over the devil and I am free from wickedness.' " Some teachers went so far as to advise two women not to sit together "because the one may describe the other to her husband, so that you might say the husband has seen her himself."[43]

The devotional literature of Islam prepared for women urged them to help their neighbors in need, to spin for their own husbands and make clothes for their children, to remain obedient always to their husbands, never to be angry with their menfolk and if their husbands were angry toward them to try to appease them, not to go out without their husbands' permission, not to uncover themselves to anyone but their husbands, and to always beatifically smile at their husbands and never deny them their sexual privileges.[44] The ideal woman in fact

speaks and laughs rarely, and never without a reason. She never leaves the house, even to see neighbours of her acquaintance. She has no women friends, gives her confidence to nobody, and her husband is her sole reliance. She takes nothing from anyone, excepting her husband and her parents. If she sees relatives, she does not meddle with their affairs. She is not treacherous, and has no faults to hide, nor bad reasons to proffer. She does not try to entice people. If her husband shows his intention of performing the conjugal rite, she is agreeable to his desires and occasionally even provokes them. She assists him always in his affairs, and is sparing in complaints and tears; she does not laugh or rejoice when she sees her husband moody or sorrowful, but shares his troubles, and wheedles him into good humour, till he is quite content again. She does not surrender herself to anybody but her husband, even if abstinence would kill her. She hides her secret parts, and does not allow them to be seen; she is always elegantly attired, of the utmost personal propriety, and takes care not to let her husband see what might be repugnant to him. She perfumes herself with scents, uses antimony for her toilets, and cleans her teeth with *souak* [i.e., the bark of the walnut tree]. Such a woman is cherished by all men.[45]

On the other hand the contemptible woman was garrulous, fond of gaming and jesting, constantly laughing out loud, always running to her neighbors, meddling with matters that were of no concern to her, plaguing her husband, leaguing herself with other women against him, playing the grand lady, accepting gifts from everybody. Also despised was the

woman who was somber, frowning, light-headed in her relations with men, contentious, fond of talebearing, unable to keep her husband's secrets, prolific in talk.[46]

These same values appeared in that vast catalog of Islamic attitudes and beliefs known as the *Thousand and One Nights*. Women in the *Nights* appeared to be either, on the one hand, governed by impulse, blown about by passion, stable only in instability, constant only in inconstancy, falsely ascetic, perfidious, and murderous, or on the other extreme, dutiful daughters, devoted wives, perfect mothers, saintly devotees, or model lovers. The whole basis of the *Nights* was women's perfidy. Shah Zaman Samarkan received an invitation to visit his older brother, the emperor Shahryar. He departed almost immediately, but halfway through the night he remembered he had forgotten something and hastened back alone. He found his wife making love to a cook. He killed them both, then proceeded on his journey, troubled by his wife's perfidy. When his brother Shahryar went out to hunt, Zaman stayed behind accidentally, looking down into the courtyard of the harem. He found that only ten of the twenty women in the harem were really women; the rest were men. They immediately paired off as soon as the king had left. The queen herself kept a lover hidden in the tree. The moral obviously was to "Rely not on women; / Trust not to their hearts, / Whose joys and whose sorrows / Are hung to their parts! / Lying love they will swear thee / When guile ne'er departs. . . ."[47] Shahryar solved his problem by inventing a new mode of marriage. Every day for three years he took a new virgin as wife, deflowered her at night, then decapitated her at dawn. This went on till the city was all but empty of nubile girls. Finally Scheherazade, the daughter of his wazir, volunteered to marry him. In order to preserve herself from beheading Scheherazade told her husband an incomplete story, which she finished the next night, then started another. In the process of telling her tales for a *Thousand and One Nights* Scheherazade became the mother of three boys. When she concludes she requested that her children be brought to her and then said: "O King of the age, these are thy children and I crave that thou release me from the doom of death, as a dole to these infants; for, if thou kill me, they will become motherless and with none among women to rear them as they should be reared."[48] The king immediately pardoned her because he had found her chaste, pure, ingenuous, and pious. The story ended happily with Zaman marrying Dunyazad, Scheherazade's sister.

Throughout the *Nights*, women were pictured as followers of impulse. They were called offal, but as Scheherazade stated, it was not the

case that "women are always bad." A feature of the stories about women was their combination of sensuality with genuine affections. The good girl might be chaste but she knew that sexual pleasures were good, and she spoke with a frankness that is sometimes alien to the West. Burton quotes a Muslim contemporary of his as stating that the Arabs think that when a man has a precious jewel "tis wiser to lock it up in a box than to leave it about for anyone to take."[49] This in essence reflects a typical Islamic view, a sex-positive one. Women like jewels are admired and sought after but should be protected and guarded lest they be stolen. They are property, valuable property, but really not persons, and must not take upon themselves the prerogatives of persons, who are after all exclusively male.

Farīd ud-dīn 'Attār, a biographer of Sufi saints, included the life the learned woman follower of Sufism, Rābi'ah, in his account but felt he had to justify himself. "If anyone should ask me why I note her amongst the ranks of men, I reply that the master of all prophets has said, God looks not to your outward appearance. Attainment of the divine lies not in appearance but in [sincerity of] purpose . . . it is possible to learn some of the truth of religion from one of her handmaidens. Since a woman on the path of God becomes a man, she cannot be called a woman."[50] There are a few women saints in Islam, but their place in the pantheon is not as strong as it is in Christianity. There were also some early women intellectuals, such as Shuhda bint al-Ibari, "the pride of womankind," whose reputation rested on her knowledge of *hadīth,* the collection of the teachings of Muhammad in which Ayesha also played an important part. By the tenth century, however, the woman scholar was no more. Though indirectly women in the harem and behind the throne exercised influence, it was rarely acknowledged outside. Sitta Zubayda, wife of Hārūn al-Rashīd, acquired such renown that the faithful erroneously believed a tomb was built to mark her remains. Somewhat later the mother of Caliph Muqtadir, an incompetent, ruled the empire in her son's name, but the names of such women appeared infrequently enough to excite comment when they did. In both of these cases it was woman as wife and mother who was important, and the Muslim mother probably had considerable influence in the home, particularly over her children, her servants, and her slaves, but not necessarily over her husband.

In general Islamic literature made no mention of any grand loves where a lone woman ruled the lover, and the lyric poets knew nothing of the idealized heroines of Western romantic poetry. There were, of course, such verses as Omar Khayyam's famous one: "A Loaf of Bread

beneath the Bough, / A Flask of Wine, a Book of Verse—and Thou / Beside me singing in the Wilderness— / And Wilderness is Paradise enow."[51] The beloved, however, was nameless and could have been male or female. There was another aspect of Islam that had implications for attitudes toward women, namely the concept of unattainable love, where the lover was a martyr of love; in this genre the chaste lover who died of or for his love gained paradise. This concept was a unique contribution of Islam and had great influence on Western chivalric literature.

Particularly influential in propagating such an ideal were the teachings of the Arab mystics, the Sufis.[52] Some sects of the Sufis taught that femininity and saintliness were related because "woman is considered in many instances holy, as being the mother of mankind, carrying no arms, and often suffering beating, baking the bread, and entering the oven."[53] Often among the Sufis, the mystical love of the universal self was expressed in masculine and feminine terms, with God being expressed in feminine form.

> Until then I had been enamoured of her, but when I renounced
> my desire, she desired me for herself and loved me,
> And I became a beloved, nay, one loving himself; this is not like
> what I said before, that my soul is my beloved.
> Through her I went forth from myself to her and came not back
> to myself: one like me does not hold the doctrine of return.[54]

The beauty which inspired love, though expressed in beings of flesh and blood, was the beauty of divinity; love itself passed beyond the impulses of flesh and the heart to become a spiritual discipline and one of the paths that led to mystical union. The erotic metaphors employed by the Islamic poets, particularly of the so-called Medinese school, were strikingly akin to those used by the romantic poets of the later Middle Ages. Though undoubtedly many of the Arabs who followed the ideal like their Christian counterparts were not averse to actual physical love, it was chaste love that was the most consuming and most desirable. Courtly love was a delicate game, and the play was more important than the goal.[55] Women's sexuality kept men from realizing their ideal of chaste love, and rather than blame their own sexuality, they inevitably blamed women.

The inferior position of women was effectively demonstrated by Islamic folklore about the evil eye. As befit a society that put a premium upon men, the evil eye was more attracted to boy babies than girls. Thus the way for boy children to avoid being harmed by the evil eye was to be dressed as girls. Though this might have had some traumatic effect on

126

the males, they could always emphasize that they were better than mere girls. The purdah requirements of Islam also encouraged the appearance of numerous male transvestites who in public acted the parts of women on the stage or danced at formal occasions. Thus we have the spectacle of a society that prized women as sexual creatures, denying them the chance to really appear in public as such. Women had to be protected from themselves and were much too valuable a property to be put into the public arena—this in spite of the fact that Muhammad himself had forbidden women's clothes to men and condemned men who put them on.[56] The male-run society would rather put men into women's clothes than run the risk of women assuming any real importance, even as sexual creatures, outside of the home. Those women who did appear in public were regarded as prostitutes, that is, a special class of women whose mission in life was to entertain the male. When the duke of Holstein entered the provincial capital of Qazvin in 1637, he was met by "fifteen young women, well mounted, very richly clothed in many kinds of velvet with base of gold, wearing necklaces of great pearls, ear pendants, and many rings. They had their faces bare, contrary to the custom of honest women in Persia. Thus we soon knew, both by their resolute mien and by what we were told, that these were the principal courtesans of the town, come out to meet us and entertain us with their music."[57]

But Islam also had some of the same ambivalence about courtesans as the West. While prostitutes could engage in a great many more activities than "good women," they were exposed to general social and literary hostility. Moreover, many of the more powerful Muslim individuals were far less inclined to turn to prostitutes than their Western counterparts, since they had harems of their own to contend with. It was these very institutions, however, that necessitated prostitution, since so many women were drawn off into harems or to serve as concubines that prostitutes were the only female companions many men had.

In sum a positive attitude toward sex was not enough to change negative attitudes toward women. The more sexually secure Muslin writers did not differ in essentials in their attitudes toward women from the sexually fearful Christian church fathers. With purdah, polygamy, concubinage, and the harem there was both a shortage of women for the majority of males and a real lack of opportunity for men to become acquainted with anyone of the opposite sex, other than their mothers or sisters, and even then the conditions were often not conducive to establishing close relationships. When men raised in these conditions grew into positions of control in Islamic institutions, their own repressive

ideas grew and became dominant. Women had no effective voice in countering them. There was no institution woman could call her own, and all she could be was the myth of the male creation, a sexy, senseless creature who made an interesting and troublesome possession but was necessary to have children.

8 / On the Pedestal: The Beginning of the Feminine Mystique

Early medieval society popularly has been broken down into three groups: those who fought, those who prayed, and those who worked. Since women were regarded as unable to fight, were prohibited from the priesthood, and only seldom were allowed into the monastic life, the only thing they could do was work; even in this, however, they were subordinate to their menfolk. Nevertheless, toward the end of the Middle Ages women, or at least aristocratic women, also became love objects, and this development of the chivalric love mystique as much as anything else ultimately led to a different attitude toward women. Even then it had to go through several phases and well into the period of modern history before any meaningful attitudinal change resulted.

Medieval society in the West represented a fusion of Roman, Christian, and Germanic attitudes and institutions, but the addition of the German element did not necessarily lead to any improvement in the status of women, nor to any radical change in attitudes. This is important to emphasize because our first literary description of the German woman is misleading. Our source for the misinformation is the Roman historian Tacitus (c. A.D. 55–117), a conservative who was unhappy with the changing family structure in Rome and with Roman morals in general. To him German women served as an example for their Roman sisters to follow. He emphasized their subservience to their husbands and

rhapsodized over their virtue and purity, pointing out the rarity of adultery among them.[1]

Whether Tacitus was recording reality or creating a new mythology of the perfect woman has often been debated, but the evidence would seem to support the latter. German women may well have been more virtuous than Roman women at the time of Tacitus but this was not because they were made of finer fabric. It was because the consequences of any misstep were so disastrous. Germanic custom gave the husband the right to execute a wife and her lover if she was caught in an adulterous relationship, and it was the duty of all male relatives to protect the virtue of their female ones. Female chastity had property value, and women were, to put it simply, the property of their menfolk. They were always under the protection of some male: father, brother, son, or some other near male relative. Theoretically the justification for this was the physical inferiority of the female. Since woman was held to be constitutionally unable to bear arms it was felt essential that she be protected by a relative who wore a sword and could draw it if necessary to defend her.

That this might be necessary is evident from some of the provisions of the various Germanic legal codes. The laws of the Alemanni, for instance, provided that if a man met a freewoman in the country and deprived her of all that she wore above the waist, he had to pay a penalty of six *solidi*. If he stripped her entirely, the fine was doubled, and if he raped her, he had to pay forty *solidi*.[2] Women were particularly valued for their childbearing capacities. The same *wergild*, two hundred *solidi*, had to be paid for killing a man or a woman, but if the woman was of prime childbearing age, that is, between puberty and age forty, then her worth tripled to six hundred *solidi*. The code estimated six hundred *solidi* to be the equivalent of three hundred cattle or fifty male horses, and so severe was the penalty that provisions were made for paying it in installments extending over three generations.[3] Probably the emphasis on women's reproductivity helped foster acceptance of a concept of feminine passivity and dependence, particularly in the upper classes, where women were not expected to perform physical labor as they had done in earlier Germanic society. The growing stereotype of women as helpless creatures provided justification for the sexual double standards and subjection of women to their husbands, principles that were incorporated into the Germanic law codes.[4]

At first a woman could not appear in the judicial assembly and could not inherit in her own right, and if she inherited through others, she could neither administer nor dispose of her property without permis-

sion of male guardians.[5] Later women under some conditions were able to appear in court, to make contracts, and even to make wills in the manner of men. They could also own property although their ability to freely dispose of it was limited, since such an action would conflict with family rights. Nonetheless, they could have some say in what was going to take place. The Germans followed the custom of *mundium* (from *munt*, meaning hand), which meant that when the woman passed from her father's house she came into her husband's hand, and he then exercised control over her. She took his name, lived according to his station, acquired his nationality and his domicile. She also lost all right to inherit from her relatives, although she might have been given a share of the inheritance as a dowry. The husband had the right to beat his wife, and this was true throughout the medieval period, but he was not supposed to mutilate or kill her. The only limitation on a wife's submission to her husband was her need to observe her duties to God; in theory no husband could force a wife to act contrary to the Christian religion. In all other matters, however, the husband was almost the sole judge of her action.

In spite of these obstacles a significant number of women managed to become politically powerful, probably more than ever before in history, although the inevitable result was resentment. In the Anglo-Saxon kingdom of Wessex, for example, Eadberg, the wife of Beorthtric, so antagonized her subjects that the title of queen was abolished. Instead, after her reign the king's wife was known as the Lady, and his mother, "naturally but perhaps less happily, as the Old Lady."[6] Even when women began to gain more rights, there was almost a total lack of statute law and only very little interpretative legal writing dealing with their status. This was because, according to the standard text on English law, "private law with few exceptions put women on a par with men; public law gives a woman no rights and exacts from her no duties, save that of paying taxes and performing such services as can be performed by deputy."[7] A woman could never be outlawed because she was never in the law. She could, however, be declared a waif, and this waiving of the law had most of the effects of outlawry since it removed all the protections she had under the law. Even in private law her position was not as good as it might appear since the law demonstrated a preference for males over females in the right of inheritance, as well as in most other matters. Even when women were given the theoretical right to inherit, only a few became major landowners. In the *Domesday Book*, the census of English property compiled by William the Conqueror in

the eleventh century, only a minute proportion of place names, some thirty in the more than ten thousand, bore names that indicated they were held or had been held by women.[8]

Another way to examine the status of women and societal attitudes toward them was their position in marriage. In general it was not particularly high. A wife was expected to be chaste, but she had no control over her husband, and the marriage could be easily dissolved if he wanted. Concubinage was widespread and polygamy was not unknown. Several of the early Frankish kings were polygamists,[9] and one of them, King Clotaire (d. 561), who had seven wives, was married to two sisters at the same time. The sixth-century Gregory of Tours explained that this had come about because Inagunda, Clotaire's first wife, had approached her husband about her unmarried sister Aregunda: "My lord hath done with his handmaid according to his pleasure, and taken her to his bed; now to make my reward complete, let my lord hear the proposal of his servant. I entreat him graciously to choose for his servant my sister an able and rich husband, that I be not humbled but exalted by her, and thus may give thee yet more faithful service." Clotaire, in order to please his wife, summoned his sister-in-law and after looking her over decided that rather than finding a husband for her he would marry her himself. He reported his decision to Inagunda: "I have done my best to procure for thee the reward which thy sweetness asked of me. I sought a man wealthy and of good wit, whom I might give in marriage to thy sister, but I found none better than myself. Know therefore that I have taken her to wife, which I believe will not displease thee." As a devoted wife should, Inagunda meekly replied: "Let my lord do that which seemeth good in his sight; only let his handmaid live in enjoyment of his favour."[10]

Charlemagne, the most famous of the Frankish rulers, managed to have either two or four wives at the same time, as well as a number of concubines. Charlemagne also refused to allow his daughters to get married, on the grounds that he "could not part with their company. . . . What he found charming in one was the sweetness of her voice, in another the freshness of her smile, in this one the grace of her bearing, in that one her rebelliousness." It might well be, however, that Charlemagne was fearful that the would-be husbands of his daughters would become powerful by marrying them and eventually challenge his power. At any rate he had no objection to their establishing informal alliances, and several of his grandchildren were born out of wedlock.[11] Still, in spite of these examples, there were some women who exercised consid-

erable power and influence. Gregory of Tours gives details about several such women.

The problem of a religious vocation for women proved a troublesome question in the masculine-oriented society of the fourth and fifth centuries. Many of the early women who turned to the ascetic life had been forced to disguise themselves as men in order to follow their vocation.[12] This changed as convents were founded, but comparatively few women ever had the opportunity to choose a religious vocation. Girls were commonly married at thirteen or fourteen and widows were expected to marry again without undue delay. Still, there were exceptions, and medieval society found it necessary to make provisions for girls who could not or would not marry and for those powerful widows who did not want to marry again. The main purpose of the convents, however, was to provide a retreat for the widows and daughters of the great; only a few lesser women entered them in the medieval period. It was in the convent that women were most free of male domination, although it was not easy for society to accept this. The Frankish King Clotaire II (584–629), for example, felt compelled to warn his subjects that

> no maidens, holy widows or religious persons who are vowed to God, whether they stay at home or live in monasteries, shall be enticed away, or appropriated, or taken in marriage by making use of a special royal permit. And if anyone surreptitiously gets hold of a permit, it shall have no force. And should anyone by violent or other means carry off any such woman and take her to wife, let him be put to death. And if he be married in church and the woman who is appropriated, or who is on the point of being appropriated, seems to be a consenting party, they shall be separated, sent into exile, and their possessions given to their natural heirs.[13]

Some of the most famous names in early English and Frankish monastic history were nuns of royal descent, Hilda at Whitby, Etheldreda at Ely, Radegunde at Poitiers, Bathild at Chelles, and there is no doubt that they were masterful and formidable women. Even though they were nuns such women never forgot that they belonged to a ruling class. Often these early nunneries had colonies of monks attached in order to provide the necessary sacraments and temporal administration, but both the male and female communities were ruled with an iron hand by their abbesses.[14]

In theory convent life was a means by which women could deny their sex and thus follow the suggestion of some of the church fathers that

they become more like men. It was much more difficult for a woman to become a nun than a man a monk, with the result that compared to the number of men who took monastic vows only a handful of women managed to do so. Many of the convents seemed to be a place for older rather than younger women, and even the famous convent at Arles founded by Caesarius, bishop of Arles (501–73), refused for a time to admit a woman until she was in her fortieth year.[15]

One of the most famous convents in the early medieval period was that of Gandersheim, founded in the middle of the ninth century by the duke of Saxony, whose progeny eventually became holy Roman emperors. Duke Liudolf, the founder, was persuaded by his wife to establish the convent; all of his daughters were attached to it, at least for a time, and one of his daughters, Hathumod, was its first abbess. As the dukes of Saxony rose in power and influence, they continued to send their daughters to be educated at the convent, and for a time it was probably the center of female learning in western Europe. Gandersheim was a free abbey; that is to say, its abbess held it direct from the king and her rights of overlordship extended far beyond the walls of the convent; she had her own law courts and sent her own men at arms into the field. She even had the right to a seat in the imperial diet, and coins bearing her portrait are extant. Some of the nuns were quite exceptional women. Probably the most famous was Hroswitha (c. 932–1002), one of the few early medieval female writers whose works survive. Hroswitha was a poet, as well as a dramatist, although her plays were obviously written more to be read then acted. She claimed Terence as her master, but she used him as a base for moral contrast rather than for his literary style. Where Terence's comedies almost invariably dealt with the frailty of women, Hroswitha just as invariably emphasized her heroine's heroic adherence to chastity. Though her six plays varied somewhat in their story line, the motive was always to glorify uncompromising fidelity to the vow of virginity. As suited a woman of that period, Hroswitha began by apologizing for writing at all:

Although prosody may seem a hard and difficult art for a woman to master, I, without any assistance but that given by the merciful grace of Heaven (in which I have trusted, rather than in my own strength), have attempted in this book to sing in dactyls. I was eager that the talent given me by Heaven should not grow rusty from neglect, and remain silent in my heart from apathy, but under the hammer of assiduous devotion should sound a chord of divine praise.[16]

Yet if my work is examined by those who know how to weigh things fairly, I shall be more easily pardoned on account of my sex and my inferior knowledge, especially as I did not undertake it of my own will but at your [her abbess] command.[17]

To you, learned and virtuous men, who do not envy the success of others, but on the contrary rejoice in it as becomes the truly great. Hrotswitha [sic], poor humble sinner, sends wishes for your health in this life and your joy in eternity. . . . You have, however, not praised me but the Giver of Grace which works in me, by sending me your paternal congratulations and admitting that I possess some little knowledge of these arts the subtleties of which exceed the grasp of my woman's mind. . . .[18]

In short, a woman might well write but she had to be properly humble about it and not pretend to be equal to the male, even though in her own mind she might be.

The period of Hroswitha's residence at Gandersheim represented a peak of women's influence in monastic life, and during the eleventh and twelfth centuries convent life entered a period of decline. The institution of double monasteries, particularly the influential position of women in them, came under attack, and the new and exacting conception of monastic duty associated with the Cluniac reform movement gave emphasis to the priestly role of monks. Though there were hundreds of monasteries founded or associated with Cluny, only one of them was for women. This was at Marcigny, and it was founded specifically to provide a retreat for women whose husbands had become monks. These women were not to direct their own affairs, which were under the direction of a prior appointed by the abbot at Cluny.

In spite of the attempts to limit women's independence in convents, the religious revival associated with the twelfth century led to thousands of women attempting to take orders or to follow the life of a dedicated, chaste bride of God. The Premonstratensians in particular attracted such large numbers of women that the clergy grew fearful. By the end of the twelfth century the general chapter of Premontré had decreed that no more women were to be admitted into the order, and one of the abbots, a certain Conrad of Marchtal, put the reason for rejecting women in these words: "We and our whole community of canons, recognizing that the wickedness of women is greater than all the other wickedness of the world, and there is no anger like that of women, and that the poison of asps and dragons is more curable and less dan-

135

gerous for men than the familiarity of women, have unanimously decreed for the safety of our souls, no less than for that of our bodies and goods, that we will on no account receive any more sisters to the increase of our perdition, but will avoid them like poisonous animals."[19]

The Cistercian reform movement also attracted large numbers of women, largely to the discomfort of its great champion, Saint Bernard of Clairvaux (1090–1153). St. Bernard saw every woman as a threat to his chastity and worried about the vast and nameless dangers in the easy association of men and women, even those committed to a religious life. "To be always with a woman and not to have intercourse with her is more difficult than to raise the dead. You cannot do the less difficult: do you think I will believe that you can do what is more difficult."[20] A number of Cistercian convents, nonetheless, were founded, but since they had no formal place in the organizational structure of the order, the nuns had considerable freedom. Some nuns went so far as to hear confessions and preach in the pulpit, much to the scandal of the male clergy. Fearful about what such strong-willed nuns might try to do next, the general chapter of the Cistercian order finally drew up regulations insisting that the so-called Cistercian nuns receive no visitors without permission and make their confessions only to a confessor appointed by the supervising abbot, and also prohibited the establishment of any more nunneries. The nuns objected to this high-handed way of attempting to limit their independence, and in the period 1242–44 there was a series of rebellions against such attempts to curtail their independence. The abbess and nuns of Parc-aux-Dames in northern France, for example, shouted and stamped and walked out of the chapter house when the official male visitors told them of the recent legislation. Though there was an attempt to discipline the ringleaders of this female rebellion, some of the most offensive passages in the legislation were eventually rescinded, and the popes themselves recognized the religious life for women.[21]

Still, criticism continued from the more misogynistic writers. Women, it was alleged, contributed to indiscipline and were unable to regulate their own religious lives. In the view of most male writers, the only possible role for women was one of attachment to existing male orders, but these orders often did not want them and were increasingly reluctant to provide pastoral care and administrative oversight. Although many orders ultimately accepted women's "auxiliaries,"[22] it was in this setting that the movement known as the *beguines* appeared, a women's religious movement independent of any male impetus or direction. The name *beguine* had been attached to the movement by its

opponents in a smear campaign to link its adherents with the Albigensian heretics, but it proved difficult to make the charge of heresy stick. (An alternative etymology favored by the Belgian *beguines* is that the name came from their first patron, Begga, sister of Gertrude of Nivelles, the founder of the great canoness institute of Andennes.) The movement, which began in the thirteenth century, originally had no organization or constitution, promised no benefits, sought no patrons, and insisted that its adherents continue their ordinary work in the world. Many of the women lived in their family homes, others lived together in houses, but it was not where they lived but how they lived that the *beguines* thought was important. Historians tend to agree that the movement was primarily urban and was probably influenced by the fact that in many of the medieval cities at that time there were significantly more women than men owing to the large number of men who followed religious vocations and the male mortality figures associated with war and work. The unmarried and widowed women in these cities individually were often unable to fend for themselves, but collectively they could, and it was this group that was attracted to the *beguines*. Normally the *beguines* renounced marriage and took an oath of chastity, but the oath was not irrevocable and it was possible for a *beguine* to later change her mind and be married. The main theme of the *beguine* was dedication to God, though this entailed not only prayer but work. It was essential that the women devote time and energy to doing good work in the hospitals, in homes for the elderly, or in weaving and embroidery, as well as in praying and meditating. There was a strong ecstatic and visionary aspect in the *beguines*, but there was also a kind of naive sexuality. The *beguines* as a group were not particularly learned and in fact did not concern themselves with such matters, but instead contented themselves with living "religiously." Nevertheless, some of them composed hymns, prayers, and poems that give insight into their beliefs, and a few, such as Mechtild of Magdebourg and Hadewijch, rank with the best of scholars. The erotic nature of their religious commitment might be demonstrated by the following poem about the conflict between soul and body, a poem on a par with similar erotic religious poetry by males.

> My body is in great distress.
> My soul is in highest bliss,
> for she has seen
> and thrown her arms around
> her Loved One all at once.

Poor thing,
she is distressed by him:
he so draws and delights her,
she cannot withhold herself,
and he brings her into himself.

Then the body speaks to the soul:
"Where have you been? I cannot bear it any more."
I want to be with my beloved;
You will never enjoy me any more—
I am his joy; he is my distress—
Your distress is, that you can no longer enjoy me:
You must put up with this distress
for it will never leave you.[23]

The *beguines* were often associated with the friars, the Franciscans and Dominicans, whose orders were also founded in the thirteenth century and who proved to be their chief supporters. As the *beguines* grew in numbers, however, the church attempted to bring them into organized religious life, and again the criticism against them was their refusal to follow the traditional role of women in religion. A Council of Vienne in 1312 makes this clear:

We have been told that certain women commonly called Bequines, afflicted by a kind of madness, discuss the Holy Trinity and the divine essence, and express opinions on matters of faith and sacraments contrary to the catholic faith, deceiving many simple people. Since these women promise no obedience to anyone and do not renounce their property or profess an approved Rule, they are certainly not "religious," although they wear a habit and are associated with such religious orders as they find congenial. . . . We have therefore decided and decreed with the approval of the Council that their way of life is to be permanently forbidden and altogether excluded from the Church of God. . . . In saying this we by no means intend to forbid any faithful women from living as the Lord shall inspire them, provided they wish to live a life of penance and to serve God in humility, even if they have taken no vow of chastity, but live chastely together in their lodging.[24]

Soon afterward the *beguines* were forced to integrate into orders approved by the pope, and by the fifteenth century those women living under the cloak of religion without a definite rule were sought out and

their convents destroyed. The *beguines*, however, left a charitable heritage in the vast number of hospitals and homes for the aged that existed into modern times.

The often expressed ambiguity and even hostility to women in religious life was symptomatic of the position of women in secular life. From the information we can gather about the feudal noble in the medieval period it would seem that his chief interest was in his fief (his land), which he had built up or maintained. His great desire was to have an heir worthy to succeed him in his estates, and it was a common belief that a father's traits would be passed on to his heir. It was probably this belief that influenced the laws to regard a wife's adultery, particularly with a social inferior, as a heinous offense. Cowardly and weak barons were believed to be the products of their mothers' adulteries with lesser men. Even if the woman committed adultery with a social equal the biological theories of the day held small hope for the offspring of such unions. This was because it was believed that a child was produced from the merging blood of fathers and mothers. If the wife committed adultery a third element would be added, with the resulting offspring a mixture of the legal father, the mother, and her lover and bound to grow up to become a worthless man not fit to be an heir. The confused concepts about sex were even more obvious in the treatment of sexual relations between Jews and Christians. The law for German Jewry stipulated: "If a Christian lies with a Jewess, or a Jew with a Christian woman, they are both guilty of superharlotry, and they shall be laid one upon the other and be burned; for the Christian has denied the faith."[25] This was one of the rare instances in which the male was punished equally with the female. This kind of thinking strengthened the traditional inclination on the part of the nobles to demand virginal brides, although this never prevented an ambitious noble from marrying a rich widow.[26]

The need for a wife to provide an heir led childless nobles either to dissolve unproductive marriages or to bring in another wife. During much of the medieval period the Christian church fought the customary law that allowed men to divorce their wives with ease, but it was not until the eleventh century that there was any degree of success. Concubines were endemic in the early part of the Middle Ages, and this was perhaps inevitable in a time when wives, particularly noble wives, were chosen for their family connections, marriage portions, and ability to give heirs. Beauty, charm, or compatibility rarely entered into the matter. Inevitably, a nobleman was inclined to satisfy his lust where he found the process most pleasant, and concubinage was a matter of course. Male adultery did not have the same social or biological im-

plications as female, and the result was a large number of bastards, some of them quite famous, such as Charles the Bastard and William the Bastard, who are better known as Charles Martel and William the Conqueror. Quite simply, women as individuals were not particularly important to the males, and the term *love*, in our sense, was almost totally absent in the early medieval period. The favorite stories of the nobility were not of how a man married or failed to marry a woman but how a holy man went to heaven or how a brave man went to battle. The *Song of Roland*, one of the earliest *Chansons de Geste*, reflected this attitude in its coverage of Alda, the betrothed of Roland, who was only briefly mentioned. Roland and his loyal supporters killed mountainous heaps of Muslims, but eventually he too was killed, and Charlemagne, his lord, returned to France in sorrow. When Charlemagne entered his palace,

> Alda, a lovely maiden, comes to him there.
> She asks the king: "Where is the chieftain count,
> Roland, who swore that I would be his wife?"
> Charles, as she speaks, is overcome with grief;
> Tears fill his eyes, he pulls at his white beard:
> "Sister, sweet friend, I can't bring back the dead.
> But I will give you one better in his place.
> You'll marry Louis—that's all that I can do—
> He is my son, and he shall rule my realm."
> Alda replies, "Your words seem to me strange.
> The saints and angels, and God above forbid
> That I live on when Roland has been slain!"
> Her color fades, she falls down at Charles' feet,
> And dies—may God have mercy on her soul!27

Quite clearly she was of marginal interest. Roland did not think about her on the battlefield and her figure was shadowy; Charlemagne, recognizing her right to a husband, promised her even a better one. The deepest signs of affection in the poem, as well as in the similar ones, appeared in the love of man for man, the mutual love of warriors who died together fighting against odds, and the affection between the vassal and the lord or within the church, between two clergymen, usually an older and a younger.

The feudal male was chiefly absorbed in war and the chase. His wife bore him sons, his mistresses satisfied his momentary lusts, but beyond this women had no particular place in his life, and he was not particularly interested in them as individuals. When they appeared in the

feudal literature, at least in the literature prior to the twelfth century, they were pictured either as sex objects or as noble and virtuous wives and mothers, nursing their children, mourning their slain husbands, and exhorting their sons to brave and often cruel deeds. If they dared to confront a male in any other role they were resented and vilified. One of the chansons dealing with the adventures of the sons of Garins indicates how Garins's son Girart was affronted by the boldness of a woman. Girart, who became a loyal knight of Charlemagne, was to be rewarded for his services by being given the widowed Duchess of Burgundy as a wife, a step that would make his heirs dukes of Burgundy. Before the marriage was finalized, however, Charlemagne himself visited the widow and was so impressed with her and her property that he decided to take her for his own wife. The duchess, in spite of Charlemagne's great reputation, preferred the younger and handsomer Girart, and when he came to see her she had the temerity to request that he hurry and marry her, else there would be a long dispute with the king. Girart replied: "Our age begins to be a dreadful one when women go asking men to marry them! On the faith I owe to God, who has us all to save from predition, from this day onward two years shall pass before I am seen marrying either you or anyone else. So, hunt for another husband—if you can find one. You will never have me, and I tell you that to your face. Do you doubt me?"[28] The duchess prayed to God to give her Girart as husband, but without his positive reaction in demanding her as wife she had to become the wife of the emperor Charlemagne. Inevitably Girart was upset at her perfidy, but Charlemagne appeased him by giving him the city of Vienne. When Girart went to the bridal chamber to give his thanks for this fief, Charlemagne was already in bed, and when Girart bent over to kiss the foot of his emperor, the duchess, now queen, still enamored of Girart, extended her own from beneath the covers, so that he kissed it instead. This, when it became known, was regarded not as a sign of affection but as a personal insult to Girart, and he went to war with Charlemagne over the matter. The storyteller, naturally, blamed all of Girart's difficulties on the Duchess of Burgundy, rather than on his hero's arrogant rudeness.

Sex, nonetheless, was of interest to the feudal noble, and in the epics there were often beautiful and sensual young girls of exalted rank, both Muslim and Christian. Muslim princesses were generally much more suitable for such poems because they not only could rescue their handsome Christian captives from their fathers' dungeons but could eventually become converted. The baptism of a fair Saracen gave scope to some of the best lyrical efforts of the poets, since the lady could be

undressed and her charms and their effect on her knightly sponsor described in great detail, all with the pious and worthy object of recounting a solemn religious ceremony. There were also a fair number of nubile Christian girls in this literature, which considerably upset Leon Gautier, one of the nineteenth-century historians of chivalry, who was firmly convinced that the feudal epics mirrored medieval life and yet also was convinced that no proper French girl would act in the way described in some of the epics. He satisfied his conscience by holding that the authors of such poems had very little knowledge of young girls.[29] Without maligning the virtuous character of French medieval womanhood, we can readily conclude that the poets were dealing not so much with reality as with male erotic dreams. The medieval knight, no less than the modern male, thought erotic thoughts and dreamed erotic dreams, but the medieval knight was nothing if not practical. Only rarely were any of these Christian girls married to the knights on whom they lavished their favors, but instead they were either deserted or passed on to secondary characters. Even fiction seemed to emphasize that marriage was quite a different matter than erotic dreams.

Tied into this concept of erotic thought was the legendary *jus primae noctis* or *droit du seigneur*, stories of which have intrigued the male imagination since medieval times. In popular theory, the *jus primae noctis* was the right of the noble knight to spend the first night with the brides on his estates. Known under various terms, *culagium, jambage, cuissage, gambada, derecho de pernada*, and less accurately as *jus cunnagii, jus cunni, jus coxae locandae, jus coxae luxandae*, it has often been the topic of popular literature, from Voltaire to Sir Walter Scott to George Bernard Shaw. The stories were probably derived from references to *culagium*, which was a request for permission to marry. This required that a *marchet* or *merchet* (also *marchetta, marquetta*), a fine, be paid. The fine had originated from the fact that a woman moved into the house of her husband, leaving the jurisdiction of one noble for another. Since such a move technically deprived the lord of part of his property, his human stock, he required indemnification for this loss. Even within a manor it was customary to have the lord's permission to marry, and this often also entailed a fine. In addition, in some dioceses the husband had to pay his bishop or ecclesiastical authority for the privilege of sleeping with his wife on the first night or first few nights of their marriage. This, however, was not so much a compensation for the relinquishment of a right but payment for a dispensation, since the medieval church urged newly married couples to observe chastity on their wedding night and set three nights of chastity as an ideal. In effect, the fine

was a sort of penance for not observing the rules. Kings Philip VI and Charles VI of France both made efforts in the fourteenth century to induce the bishops of Amiens to give up the custom of demanding a fine for granting every newly married couple permission to have conjugal intercourse during the first three nights of their marriage.[30] Some authorities, however, persist in arguing that in some areas there was also legal justification for the *jus primae noctis* and that it was a holdover custom from pre-Christian Europe. One center of the controversy is the Celtic populations of Europe, particularly Scotland, where the *Chronicle* of Boece reported that King Ewen III (about A.D. 875) established the right of *jus primae noctis:* "Ane othir law he maid, that wiffs of the commonis sal be fre to the nobilis; and the lord of the ground sal have the madinheid of all virginis dwelling on the same." Boece, however, wrote at the beginning of the sixteenth century and his history included many fabulous narratives, of which this was probably one. There are, nevertheless, some authors who believe the account. One investigator concluded: "After weighing all the evidence, it is difficult to avoid the conclusion that the *Jus primae noctis* was the custom, at any rate in some parts of Scotland, in early times. There is no authority to the contrary, nor have any facts inconsistent with such a right ever been advanced by those who challenge it."[31]

In spite of such arguments, it seems to us that legal stipulations about the "right of the first night" probably did not exist. In practice, however, many lords did claim such rights, since the legend reflected an attitude toward women not far removed from the actual position of many women. In the early medieval period the status of many women was little above that of slaves, and like slaves, they could be violated more or less with impunity by their lords. Even when slavery declined, as it did in the later medieval period, the more powerful often had sex with the less powerful without paying much attention to legal niceties. Since the family of a woman intimate with a king often gained influence and power, some considered it an honor to be the king's mistress, or a king's whore, and while the honor was somewhat less for being a mistress to lesser nobility, there was still prestige attached to the position. The mother of a royal or noble bastard stood to gain too much to reject the advances of a lord or a prospective lord, and even if she herself might suffer, her family could benefit. A lascivious lord, or even a lascivious abbot, and these also existed, quite clearly could have the pick of a whole flock of possible companions without resorting to any legendary right of the first night.[32] As far as noble women were concerned, one of the fundamental tenets of feudal law was that the lord would respect

the wife of his vassal, and several kings, including John of England, got into trouble when they attempted to ignore such prohibitions.

The Middle Ages were contradictory, and while women themselves were often treated with little respect or devotion, this was not true of the Virgin Mary. During part of the Middle Ages the exaltation of Mary reached such an extent that she became almost the fourth person of the Trinity, and in the popular mind she incorporated the Trinity. In the early Middle Ages there was a tendency to frighten men into heaven, and in the process God became almost a relentless prosecutor, while Jesus became Christ the Judge. There was an obvious need for a mediator, and it was Mary who assumed the role. She was the grieving, sorrowful mother, sorry that her children had strayed but loving them still, regardless of what they had done. In the eyes of most men Jesus was too sublime, too terrible, too just, to be dealt with effectively, but even the weakest of humans could approach his mother, and she could exercise her influence on her son. A Franciscan author of the fourteenth century compared the intercession of Mary with the intervention of a queen. When a man seeks to turn aside a king's anger, this writer said, "He goes secretly to the queen and promises a present, then to the earls and barons and does the same; then to the free men of the household, and lastly to the footmen. So when we have offended Christ, we should first go to the Queen of heaven and offer her, instead of a present, prayers, fasting, vigils, and alms; then she, like a mother, will come between thee and Christ, the father who wishes to beat us, and she will throw the cloak of mercy between the rod of punishment and us, and soften the king's anger against us. . . ."[33]

The medieval Mary, however, remained very feminine and was very much a noblewoman, with womanly moods and caprices. She loved grace, beauty, ornament, her toilette, robes, and jewels, and she demanded attention. She protected her friends and punished her enemies. Though Mary was always important in medieval Christiandom, some see her as a Christian counterpart to the pagan Isis, and the statues of Mary and Jesus were originally often the same ones representing Isis and Horus. It was with the monastic revival of the eleventh century that she moved to the forefront. This emphasis on Mary then coincided with antagonism to women in the religious life, and one of the great advocates of the Virgin was the very same St. Bernard who basically was so hostile to women. The Cistercian order, founded in 1098, put all of its churches under the special protection of the Virgin, and the result was a vast number of cathedrals dedicated to her, including Notre Dame de Paris (Our Lady of Paris). According to a twelfth-century tradition,

which the artist Murillo later utilized as a subject for a famous painting, St. Bernard, a leader of the Cistercians, was once praying before the statue of the Virgin when the image, pressing its breast, dropped on his lips three drops of the milk from the breast that had nourished the Savior. Thereafter Bernard was devoted to the Virgin. It was not only the priests and the poor who asked for her assistance but also the nobles. Her attribute was humility; her love and pity were infinite. "Let him deny your mercy who can say that he has ever asked it in vain" was the prayer, and apparently few ever did. Though a woman and not a warrior, she protected warriors, and the favorite battle cry of each side in the various wars of the latter Middle Ages was to Our Lady, Notre Dame. The "Fighting Irish" of Notre Dame emphasize this contradiction on the football field today. St. Bernard, although condemning womankind, chanted hymns to her:

> O saviour Virgin, Star of Sea,
> Who bore for child the Son of Justice,
> The source of Light, Virgin always
> Hear our praise!
>
> Queen of Heaven who have given
> Medicine to the sick, Grace to the devout
> Joy to the sad, Heaven's light to the world
> And hope of salvation;
>
> Court royal, Virgin typical,
> Grant us cure and guard,
> Accept our vows, and by prayers
> Drive all griefs away![34]

Not only was the Son absorbed into the Mother, or represented as under her guardianship, but the Father fared no better, while the Holy Ghost nearly disappeared. Some of the poets regarded her as the temple of the Trinity, the church itself, and in the building of a church the Trinity as represented by the triple aisle was absorbed in her. Undoubtedly part of this elevation of the Virgin was due to a masculine tendency to feminize things such as ships, institutions such as the church, and buildings such as cathedrals. The priest was married to the church, and it was much easier to visualize this in feminine form than in masculine, but the interesting thing is that women as a whole benefited so little from this emphasis upon Mary.

In fact the very opposite tended to be the case. The growth of a roman-

tic and devotional literature extolling women only strengthened the belief in the moral and social dangers of feminine wantonness. The emphasis on virginity tended to create in many minds an almost hysterical aversion to the state of matrimony. In the devotional literature it was Mary as Virgin who was elevated. Though she was a mother figure, she was also an immaculate mother figure who not only remained a virgin but had herself been conceived without sin, which, in medieval terminology, meant without intercourse. Women might be of the same sex as Mary but they were also the same as Eve, and it was as Eve that woman kept reminding the religious man of his sinfulness, of his desire to have sex. Lust itself was a sin, and sexual intercourse, except for the purpose of procreation, was regarded by the church as a sin equal to murder and heresy. Some of the early penitentials, guidelines for giving penances, went so far as to prohibit intercourse between married couples during and shortly after menstruation, on Sundays, feast days, and in any other position but face to face.[35] Woman made man aware of his bodily responses. "He who loves a woman in his mind shall seek pardon from God; but if he has spoken [to her], that is, of love and friendship, but is not received by her, he shall do penance for seven days."[36] As the medieval church put more and more emphasis on celibacy for the priesthood, women came to be more and more condemned. Part of the reason for this was that though some men apparently came easily to the celibate life, many found it a traumatic experience to fight off sexual temptation. This was woman's fault: "If a presbyter kisses a woman from desire, he shall do penance for forty days. Likewise if a presbyter is polluted through imagination [has orgasm] he shall fast for a week."[37] Even close association could lead to a need for penance:

But if one of the clerical order is on familiar terms with any woman and he has himself done no evil with her, neither by cohabitating with her nor by lascivious embraces, this is his penance: For such time as he has done this he shall withdraw from the communion of the altar and do penance for forty days and nights with bread and water and cast out of his heart his fellowship with the woman, and so be restored to the altar. If, however, he is on familiar terms with women and has given himself to association with them and to their lascivious embraces, but has, as he says, preserved himself from ruin, he shall do penance for half a year with an allowance of bread and water, and for another half year he shall abstain from wine and meat and he shall not surrender his clerical office; and after an entire year of penance, he shall join himself to the altar. If any

cleric lusts after a virgin or any woman in his heart but does not utter [his wish] with lips, if he sins thus but once he ought to do penance for seven days with an allowance of bread and water. But if he continually lusts and is unable to indulge his desire, since the woman does not permit him or since he is ashamed to speak, still he has committed adultery with her in his heart. It is the same sin though it be in the heart and not in the body; yet the penance is not the same. This is his penance: let him do penance for forty days with bread and water.[38]

With such fear of women ingrained in the clergy, it was perhaps inevitable that the clergy would condemn them, while at the same time admiring them through the Virgin. The contradictory nature of these feelings is demonstrated by the fact that the height of Virgin worship came in the thirteenth century at the same time that clerical celibacy became the norm of the church. The elevation of the Virgin could only be accomplished by comparing her with the characteristics of ordinary women, and the more she was exalted, the more ordinary women failed to come anywhere near the ideal and the more they could be condemned for their failures.

As the Wife of Bath in Chaucer's *Canterbury Tales* says: "By God, if women had but written satires / Like those the clergy keep in oratores, / More had been written of man's wickedness / Than all the sons of Adam could redress."[39] It was the male view that appeared in writing, particularly in clerical literature, so much so that the Wife of Bath claimed that she could find no cleric who would speak well of women. Salimbene, the thirteenth-century Franciscan, collected several sayings about women in his autobiography, and some of these phrases were published by G. G. Coulton, who felt they were typical of medieval clerical attitudes about women:

With flames of fire doth a woman sear the conscience of him who dwelleth by her.

Where women are with men, there shall be no lack of the devil's birdlime.

Wouldst thou define or know what woman is? She is glittering mud, a stinking rose, sweet poison, ever leaning towards that which is forbidden her.

Woman is adamant, pitch, buckthorn, a rough thistle, a clinging burr, a stinging wasp, a burning nettle.

Man hath three joys—praise, wisdom, and glory: which three things are overthrown and ruined by woman's art.

What else is woman but a foe to friendship, an inevitable penance, a necessary evil, a natural temptation, a coveted calamity, a domestic peril, a pleasant harm, the nature of evil painted over with the colours of good; wherefore it is a sin to desert her, but a torment to keep her.

Woman was evil from the beginnings, a gate of death, a disciple of the servant, the devil's accomplice, a fount of deception, a dogstar to godly labours, rust corrupting the saints; whose perilous face hath overthrown such as had already become almost angels.

Lo, woman is the head of sin, a weapon of the devil, expulsion from Paradise, mother of guilt, corruption of the ancient law.[40]

This from a man who worshiped the Virgin Mary and had many women under his spiritual guidance.

The official attitudes of the church can be found in the writings of the great thirteenth-century doctor of the church, St. Thomas Aquinas who Christianized Aristotle and in the process gave Aristotelian assumptions new power and influence. Aquinas approached the subject of women from the point of view of one who believed in clerical celibacy and held that virginity was preferable to marriage. From this it almost inevitably followed that "venereal pleasures above all debauch a man's mind," and nothing "so casts down the manly mind from its height as the fondling of a woman." To love a woman too ardently, even if she were one's own wife, constituted adultery to the good Saint Thomas.[41] Still he recognized that women were human and had a right to exist, although he felt a need to justify their existence, since according to Aristotle woman was only a "misbegotten male," and "nothing misbegotten or defective should have been in the first production of things." Aquinas here felt that Aristotle was wrong. Woman, he argued, was not misbegotten but included in nature's intentions in order to continue the works of generation. She was, however, naturally subject to man. "For good order would have been wanting in the human family if some were not governed by others wiser than themselves. So by such a kind of subjection woman is naturally subject to man, because in man the dis-

cretion of reason predominates." Woman in fact had been created as a helper to man, "not, indeed, as a helpmate in other works, as some say, since man can be more efficiently helped by another man in other works; but as a helper in the works of generation. . . . Among perfect animals the active power of generation belongs to the male sex, and the passive power to the female. . . ." This was why the first woman was created from man, rather than following the normative principle of generation and having man born of woman. Thus just as "God is the principle of the whole universe, so the first man, in likeness to God, was the principle of the whole human race. . . . Secondly, that man might love woman all the more, and cleave to her more closely, knowing her to be fashioned from himself. . . . Thirdly, because . . . man is the head of woman . . . it was suitable for woman to be made out of man. . . . Fourthly, there is a sacramental reason for this. For by this is signified that the Church takes her origin from Christ." But why was woman created from Adam's rib? "First, to signify the social union of man and woman, for the woman should neither use authority over man, and so she was not made from his head; nor was it right for her to be subject to man's contempt as his slave, and so she was not made from his feet." By delegating the power of gestation to females, God also left men freer to pursue a higher aim, namely, intellectual tasks.[42]

Aquinas's chief purpose was to incorporate the concepts of Greek science and philosophy into Christian thinking, and in this he also had to come to terms with Greek biology. Aristotle, for example, had said that the father provided a child's soul while the mother supplied only formless matter. Christians, on the other hand, believed that the soul came from God, and this belief would have left the earthly father with no contribution at all. To solve this problem St. Thomas concluded that "the father is principle in a more excellent way than the mother, because he is the active principle, while the mother is a passive and material principle. Consequently, strictly speaking, the father is to be loved more . . . the mother supplies the formless matter of the body; and the latter receives its form through the formative power that is in the semen of the father. And though this power cannot create the rational soul, yet it disposes the matter of the body to receive that form."[43] St. Thomas had observed that women often led men to lust, and this led him to wonder whether the tendency of women to adorn themselves constituted mortal sin. He concluded that a married woman might adorn herself somewhat to please her husband, "lest through despising her he fall into adultery," but for a woman without a husband to do so only

gave lustful pleasure to men who saw them. Thus "if women adorn themselves with the intention of provoking others to lust they sin mortally; whereas if they do so from frivolity, or from vanity for the sake of ostentation, it is not always mortal, but sometimes venial. And the same applies to men."[44] St. Thomas, however, recognized the right of people to distinguish their estate by their clothing and also to disguise a disfigurement. When a costume or disguise went to excess, became fantastic, or excited lust, then it was to be regarded as sinful.

Even an unadorned woman had dangerous seductive properties, and medieval clerics attempted to overcome their desires by denying that the female body was attractive at all. A thirteenth-century writer compared a woman who let herself be seen by men to a person who uncovered a pit for people to fall into: "The pit is her fair face, and her white neck, and her light eye, and her hand, if she stretch it forth in his sight . . . all that belongs to her, whatsoever it be, through which sinful love might the sooner be excited."[45] Moreover, a woman who either consciously or unconsciously tempted a man to sin should be held responsible for his lost soul on the day of judgment. Nevertheless, women should remember that their bodies were hardly enticing: "What fruit doth thy flesh bear in all its apertures? Amidst the greatest ornament of thy face; that is, the fairest part between the taste of mouth and smell of nose, hast thou not two holes, as if they were two privy holes? Art thou not formed of foul slime? Art thou not always full of uncleanness? Shalt thou not be food for worms?"[46]

Johann Herolt was a fifteenth-century Dominican and only one of many[47] who believed that women were more likely to suffer the fires of hell than men because

> most women belie their catholic faith with charms and spells, after the fashion of Eve their first mother, who believed the devil speaking through the serpent rather than God Himself. . . . Even nowadays, the most part of women imitate Eve in pride and unbelief; for it is well known that a girl of nine years old will go more curiously apparelled than a boy of eighteen; and when she is too old to dare to adorn herself, then will she follow pride and vainglory in tricking out her daughter or her niece. So also will she busy herself more than a man in unbelief and enchantments; for any woman by herself, knows more of such superstitions and charms than a hundred men.[48]

Why did women put up with such libelous characterizations? Probably because they did not know the full extent of them. Clerical mi-

sogyny was often intended only for clerical listeners, and public statements on the subject were uttered only by some of the more extreme members of the celibate priesthood.[49] The church leaders had to keep in mind that occasionally women, too, might have money or power and therefore be able to endow convents, monasteries, churches, or colleges. While women might be more susceptible to sin than men, they could not be condemned entirely, and in their public utterances some clerics exercised considerable caution. Humbert de Romans, a thirteenth-century master general of the Dominican order, for example, left a sermon that he intended as a model for other friars to use when they preached to women. It gave a somewhat different view of women than usually expressed by clerics, although it too existed in the early church. He said that

> God gave women many prerogatives, not only over other living things but even over man himself, and this (i) by nature; (ii) by grace; and (iii) by glory. (i) In the world of nature she excelled man by her origin, for man He made of the vile earth, but woman He made in Paradise. Man He formed of the slime, but woman of man's rib. She was not made of a lower limb of man—as for example of his foot—lest man should esteem her his servant, but from his midmost part, that he should hold her to be his fellow, as Adam himself said: "The Woman Whom Thou gavest as my helpmate." (ii) In the world of grace she excelled man, for God, Who could have taken flesh of a man, did not do so, but took flesh of a woman. Again, we do not read of any man trying to prevent the Passion of Our Lord, but we do read of a woman who tried—namely, Pilate's wife—to dissuade her husband from so great a crime because she had suffered much in a dream because of Christ. Again, at His Resurrection, it was to a woman He first appeared—namely, to Mary Magdalen. (iii) In the world of glory, for the king in that country is no mere man but a mere woman is its queen [Mary]. It is not a mere man who is set above the angels and all the rest of the heavenly court, but a mere woman is; nor is anyone who is merely man as powerful there as is a mere woman. Thus is woman's nature in Our Lady raised above woman's in worth, dignity, and power; and this should lead women to love God and to hate evil.[50]

Even when the clergy spoke favorably of women, however, they emphasized that women were always to be subject to men. "Woman is subject to man on account of the frailty of nature, as regards both vigor of soul and strength of body. After the resurrection, however, the dif-

ference in those points will be not on account of the difference of the sex, but by reason of the difference of merits."[51] It was this state of subjection that kept women from holding the priesthood. "Since it is not possible in the female sex to signify eminence of degree, for a woman is in the state of subjection, it follows that she cannot receive the sacrament of order."[52] A man's duty was to provide for the things of the house, and it was woman's duty to attend to the affairs of the family of the house. As an Italian writer of the fourteenth century in his advice to women put it: "The seventh commandment is that thou shalt not do any great thing of thine own accord without the consent of thy husband, however good reason there seem to be unto thee for doing it: and take care thou dost on no account say to him, 'My advice is better than thine,' even though truly it was better, for by so doing thou couldst easily drive him into great anger against thee and great hatred."[53] In this respect royal women were not different from lesser women, secular writers not much different from clerical. Louis IX (1214–70), the saintly king of France, wrote to his daughter, Isabella, queen of Navarre, on the role she should play: "Dear daughter, because I think you hearken more to my words than anyone for the love you bear me, I propose to give you some advice. . . . Accustom yourself to confess frequently and select always confessors of holy life and good education. . . . Obey your husband humbly and your father and mother also in all that is pleasing to God. You must give to each of them your due for the love that you have for them and still more you should do it for the love of Our Lord."[54]

Though the typical woman was probably wife and housekeeper, subject to her husband, marriage was not the lot of every woman in the Middle Ages. In many areas of Europe, if not all, adult women were in excess of men. Though medieval population estimates were often inaccurate, there is some indication of sex ratios in the fourteenth- and fifteenth-century censuses taken in some of the German towns. Frankfort, for example, had 1,100 women for every 1,000 men in 1385, and Nuremberg in 1449 had 1,246 women for 1,000 men. Though the figures might be misleading, since many widows from the country retired to the towns, the various wars and feuds took a higher toll of males than females. The vast number of unmarried clergy and monks helped create a surplus of unmarried women, since there were only comparatively few nuns, most of whom were from aristocratic families. Particularly important, if the research about women, anemia, and mortality cited earlier in this book is correct, was the improvement that took place in diet in the later medieval period, which tended to increase the survival chances for

women. There were also economic prohibitions to marriage, because even on the lowest level of medieval society there were women without husbands, some of them widows but many of them simply never married.[55] This unmarried status was not the economic obstacle it later became, since there was plenty of work to do on estates and women engaged in almost every kind of argricultural labor, with the exception of plowing. Though the tasks assigned to women varied from manor to manor and within the manor according to their status, they always had control of the dairy, the poultry, and the vegetable garden. In the cities, also, they carried on a variety of trades. Most craft guilds had provisions for widows to follow their husbands' occupations, and some occupations were reserved to women. Throughout Europe they dominated the manufacture of beer and many of the processes of textile manufacture. In fact, the very word *spinster* would indicate that spinning was not only the regular occupation of all women but also the habitual means of support for many of the unmarried. Still, many craft regulations excluded females, and when they did work they often did so at wages lower than men's.[56]

Nevertheless, Roman and Germanic tradition had always been opposed to confining women in a harem under the custody of servants, and regardless of their economic status women always had considerably more personal freedom than their sisters in the East. Even though the noblewoman was completely subject to her husband, she was still mistress of the household. She supervised the performance of household tasks, and the younger children received their training from her. When the nobility of Europe went forth to do battle it was their wives who managed their affairs at home, superintended the farming, interviewed the tenants, and saved up money for their husbands' next expedition. A good and loyal wife was the best and strongest support a man away on a crusade or a war could leave behind. She not only administered his estates but also provided hospitality for wandering travelers, and her ability to be mistress at home was probably an influential force in helping change some of the literary portraits of women.

Literature is molded by the type of audience it has. In much of the past the audience that counted most was male. It was the men who had the money to hire poets to sing their praises and to recount the epic stories of war. When written prose developed it was usually men who were literate, since so many obstacles were put into the path of women who wanted to be educated. During the Middle Ages the most literate group was of course the clergy, and in their literature women, as indicated, had very little place. Women, even if they could not read, could

still be patrons of literature, and this right of patronage led to the development of romantic love.

Sidney Painter speculated that the whole thing started one day when a hungry minstrel who was wandering about the duchy of Aquitaine came to a castle where he hoped that his tales of battles and his tumbling tricks would earn him a good dinner. The lord of the castle, however, was absent, and the lady who acted as his hostess found his endless stories of battles rather tiring and boring and could care less for his tumbling. It somehow occurred to the poet that his stay in the castle would not be very long, nor would his meals be particularly enjoyable, unless he managed to gain her attention. Being very inventive, he composed a song in praise of the lady's beauty and virtue and described their effect on him in rather glowing terms. Naturally, he found that the lady was quite pleased, and she rewarded him with a better bed and more ample food. Soon other minstrels followed his example, and it was not long before the baronial halls of southern France were ringing with songs in praise of ladies who were able to dispense lavish hospitality, and any lady who did not have a minstrel singing her virtues felt definitely out of fashion. On this scene came William IX, count of Poitou and duke of Aquitaine, who thought such songs might prove a pleasant accompaniment to his numerous triumphs over feminine virtue and a way in which he could entertain his companions. The duke's accounts of his amorous adventures not surprisingly proved as interesting to his friends as his stories of battles, and with the example of a powerful prince who ruled a third of France, the fashion grew and expanded. Those barons who were unable to sing or write could hire someone to do so.[57]

Scholars have spent a good deal of time and energy in trying to trace the sources of romantic love to Islamic lyric poetry, to Greek Platonism, to Ovid—apparently all contributory factors—but the ability of women to act as patrons was probably the cement that bound together these various elements. Romantic love was associated with knighthood and chivalry, and in poems and literature love was pictured as a despairing and tragic emotion that drove the lover to accomplish great deeds of derring-do for his beloved and the Christian God. In theory, true love was unattainable love; that is, it was not to be consummated by sexual intercourse. In fact, the female object of the love was usually married to a man other than her beloved. This theory undoubtedly reflected the real situation of the noble ladies who acted as patrons. Adultery probably occurred in some cases where reality coincided with theory, but the medieval poet usually condemned any such amorous interludes. The

theory of romantic love espoused first by the eleventh-century French poets eventually spread throughout Europe and "effected a change which has left no corner of our ethics, our imagination, or our daily life untouched and . . . erected impassable barriers between us and the classical past or the Oriental present."[58] Our code of etiquette, with its rule that women always have precedence, is based upon the concepts of romantic love, and the concept of the gentle courteous male, the housebroken male if you will, is part and parcel of the whole tradition. In a sense romantic love represents a break from the Christian tradition, which emphasized that all love, or at least any such thing as passionate love, was more or less wicked unless it was directed to God. Thus it does not seem to arise so much from the worship of the Blessed Virgin as it does from a parody of the religious teachings of the Middle Ages. It is also an important contribution to giving women a sense of self, a sort of reification of women. Perhaps this is why so many women contributed to the literature as troubadours, as patrons, and as actual writers.

In the chivalric literature love was the emotion produced by the unrestrained adoration of a lady. Love might be rewarded by smiles, kisses, or still other favors, but the presence or absence of these was not supposed to have any effect on the love itself. The male in love lost interest in food and drink, scarcely noticed whether it was hot or cold outside, and concentrated every fiber of his being on his love for his lady. Love encouraged the development of *preux*, skill and knightly honor, and made a cowardly man valiant, a brave man braver. In fact, according to the chivalric literature, it was even doubtful whether a man who did not adore a lady could ever be a true knight. Though a woman could not fight, she gave man courage, skill, and honor—in short, she had ennobling qualities. Thus was born the myth of feminine mystique that raised woman to a pedestal. The true lady was a sort of passive goddess who was adored whether she wished to be or not, and while the knight was expected to serve his adored one with every fiber of his body, the service primarily consisted of fidelity and worship. Love was not to be mutual. The lady might or might not reward him, but at first in any case she was not to feel any great passion. She was a vision of love, and like the Virgin Mary she was unattainable.[59]

There were, however, some modifications in this ideal during the course of the later Middle Ages. As troubadour poetry moved northward, sexual intercourse became an integral and sometimes necessary part of the conception of love; knights also felt called upon to make themselves attractive to ladies. How often did the love end in ultimate consummation? The answer was dependent on the poet's or hero's sta-

tus. When the poet was a great lord he was undoubtedly rewarded by sharing the bed with his lady love; if he was just a humble knight praising the wife of a great baron, he kept his distance.

One of the great patrons of the chivalric poets was Eleanor of Aquitaine (c. 1122–1204), one of the most remarkable women in medieval history. She was the granddaughter and heir of Duke William of Aquitaine, who helped formulate the concepts of chivalric love, and her possession of Aquitaine made her the most desirable of brides. She became the wife first of Louis VII, the king of France, and then, after her divorce, of Henry II of England. She was the mother of Richard the Lion-Hearted and King John of Magna Carta fame, but even she could not exercise power directly, only through attempting to manipulate the men around her. She spent most of the last part of her life in enforced confinement while her husband spent his time with his mistress. Even queens had to know their place, and it was Eleanor's misfortune that she did not.[60] Eleanor's position as patroness of the new romantic concepts of love and womanhood was assumed by her daughters, Marie, countess of Champagne, and Alix, countess of Blois. The *minnesingers* of Germany and the poets of Italy spread the concepts eastward and southward. The original ideas were refortified by the translation of Ovid's *Ars Amoris* into the vernacular by Chrétien de Troyes, one of the great poets of the new love lyrics. A philosophy of love developed and the new amalgam appeared in the writings of Andreas Capellanus, a member of Marie's household, and author of *The Art of Courtly Love*.

Love to Andreas was a passion that came from looking at and thinking too much about the body of a member of the opposite sex; it could only be satisfied by embracing and fulfilling love's commands, in other words, by sexual intercourse. Love, however, was still separate from marriage. Marriage was a contractual obligation, while love was entirely voluntary. True love might well become adulterous, but it need not end up that way. The fact that he might really be sanctioning adultery or at least fornication troubled Andreas, and his book is full of ambiguities. How much his concepts might have modified attitudes toward women is evident from the last section of his book, entitled "The Rejection of Love," which is little more than a diatribe against the female sex. Why he wrote the book if he felt this way is unclear, but he cleansed his hands of all blame when he concluded by saying that it was all woman's fault that she was so sexual, and she, not man, should take the blame.[61] Andreas's concept of love was, nonetheless, limited only to the upper classes. It was very unlikely, he wrote, that the lower classes would have the necessary virtues for love. If a man desired a peasant woman so

strongly that he could not resist temptation, Andreas felt that he should rape her on the spot, since a courteous approach would only be wasted on a woman who could not possibly feel love.[62]

The dualism so evident in Andreas appeared also in the thirteenth-century classic *The Romance of the Rose*, written by Guillaume de Lorris and Jean de Meung. Within a framework of courtly love, the poem contained a satire on women's artifice, folly, and greed, although in this case the two contradictory elements were contributed by different authors. In the original segment of the poem, by Guillaume de Lorris, the poet was conducted to the Palace of Pleasure, where he met love and her companions Sweet-Looks, Riches, Jollity, Courtesy, Liberality, and Youth, who spent their time in dancing, singing, and other amusements. Eventually the poet reached a bed of roses; while he was attempting to pluck one, an arrow from Cupid's bow pierced him and he fell fainting to the ground. Upon his recovery he found himself alone, far removed from the rose bed, and he set out on a quest to find his beloved rose. Just as he again found it and touched it with his lips, he was taken prisoner and the key to the castle door was given to an old hag. As the poet was mourning over his fate the original poem ended. In the second part, Jean de Meung then mounted his vendetta against women, and it is at least worthy of note that he chose to express his misogynistic ideas within the framework of a romantic allegory.[63] Woman might well be placed on a pedestal of love, but her position at best was rather precarious.

The Romance of the Rose represented a kind of reaction to the sensuousness of some of the romantic literature. A century later, with Sir Thomas Malory's *Le Morte d'Arthur*, the classic summary of the Arthur legends and romantic love, virginity was firmly in the saddle. Malory emphasized that the sin that prevented some Knights of the Round Table from achieving a vision of the Holy Grail was desire for women. Only Sir Galahad and Sir Percival were "like maidens clean and without spot," while one other, Sir Bors de Banis, had only once trespassed and after that had "kept himself so well in chastity that all is forgiven him."[64] In the course of the quest, two of the successful knights, Percival and Bors, were tempted by devils in the guise of beautiful women, and Percival punished himself for almost yielding by stabbing himself deeply in the thigh. Galahad, however, was not even tempted, presumably because he was so pure and holy that he was immune to sexual attraction. In the end, after the destruction of the Round Table, all the surviving knights became hermits, a development that perhaps can be regarded as a symbolical rejection of women. Malory continually

showed women ruining men. Morgan le Fay, for example, tried to destroy her virtuous and devoted brother, King Arthur, as well as to undermine virtue in general. Morgan hated all men, but particularly Arthur because he was the most eminent of her kin; she stole his sword, replaced it with a brittle replica, and sent him a mantle intended to burn him to death. She also tried to lead Lancelot and Tristam, the best of knights, into fatal ambushes. Guinevere, the wife of King Arthur, through her spiteful behavior to Lancelot brought about the ruin of the Round Table.[65]

In the fourteenth-century story of *Gawain and the Green Knight*, it was also woman as temptress who emerged, indicating that in spite of the chivalric ideal the view of women was slow to change. Gawain had managed to pass a whole series of tests of his courage and chastity, in part through the gift of a life-saving girdle by the wife of his host. He felt guilty for concealing this gift from his host, who in fact had ordered his wife to tempt Sir Gawain. It was the woman who was blamed for all Sir Gawain's troubles, and he departed with a burst of invective:

> But no marvel it is for a fool to act madly,
> Through woman's wiles to be brought to woe.
> So for certain was Adam deceived by some woman,
> By several Solomon, Samson besides;
> Delilah dealt him his doom; and David
> Was duped by Bath-sheba, enduring much sorrow.
> Since these were grieved by their guile, 'twould be great gain
> To love them yet never believe them, if knights could.
> For formerly these [men] were most noble and fortunate,
> More than all other who lived on earth;
> And these few
> By women's wiles were caught
> With whom they had to do.
> Though I'm beguiled, I ought
> To be excused now too.[66]

Even in the Robin Hood literature it was a woman who was to blame for Robin Hood's death. Robin Hood, seeking help from his cousin, the prioress of Kirkly Abbey, was bled to death by her, and by the time he realized what was happening he was too weak to escape. He managed to blow a blast on his horn and Little John came running, begging for permission to get revenge by destroying the nunnery. Robin Hood as he lay dying forbade this, since he had never hurt a woman in his life.[67] Women were to be protected, but they could not be trusted. A true lady

was a fine creature, but one never found out who was a true lady until too late.

Late medieval literature in fact retained a full quota of misogynous portraits of women. One of the most virulent assaults upon women was by John of Salisbury, who collected almost every possible example of troublesome women in history, mythology, and literature, from Diana, goddess of the hunt, to his own time. John considered hunting self-indulgent and vicious, and he claimed that the Greeks had made a woman its patron only because they did not wish to degrade their gods by making them sponsors of such a pastime. Cleopatra was another one of his subjects, and he regarded her suicide as a worthy death for a poisonous courtesan who tried to corrupt the character and virtue of noble men. John felt that though matrimony might be justified because it excused lustful pleasure, in all cases single loneliness was much better than marital bliss.[68] Women were frivolous, passionate, cruel, and immodest.

Although John was a cleric, this was not just a continuation of clerical misogyny, since most books were produced by antifeminist writers. It might even be that books were regarded by some as a replacement for women. Richard de Bury, the fourteenth-century bishop of Durham, said that woman, whom men should "flee more than the asp and the bailisk," made it plain that "we [books] alone of all the furniture in the house are superfluous and complains that we are worthless for any service of the household. Soon she advises that we be exchanged for costly caps, for muslim and silk, for twice-dyed purple, for robes, and silver-colored furs, and for wool and linen. . . ." Nonetheless, it was only books that could offer salvation, and not women.[69] Women merely distracted men from the higher causes. Walter Map (fl. 1200) in his *Courtiers' Trifles* attacked marriage with a vengeance. "Even the very good woman, who is rarer than the phoenix, cannot be loved without the loathsome bitterness of fear and worry and constant unhappiness . . . and many maladies interrupted by the alternation of health are less painful than one illness which affecteth us with incurable pangs. . . . My friend, may the omnipotent God grant thee power not to be deceived by the deceit of the omnipotent female, and may He illuminate thy heart, that thou wilt not, with eyes bespelled, continue on the way. . . ."[70]

The late Middle Ages were caught up in contradictions. Officially, at least by the clerical and scientific writers, it was accepted that sex was bad and that sexuality was sinful. This worked against women, since males—especially clerics—often thought of sex when they looked at women. Yet at the same time the cult of courtly love, emphasizing the

erotic, was elevated, and the idea that the love of woman was the force that improved man's character and elevated his spirit was advanced. Unfortunately, love also led to sex and even to adultery, and this was always the fault of women. Undoubtedly many women had negative attitudes toward sex, but only rarely did they put the blame for sexuality on men as men tended to blame women. Women were praised on the one hand and damned on the other. They were the butt of satire, some of it good-natured and some of it malicious: "For take my word for it, there is no libel / On women that the clergy will not paint, / Except when writing of a woman-saint, / But never good of other women, though."[71] This is the complaint of Chaucer's Wife of Bath. Women were still essential if a man was to have children, and economically wives in most cases were not only helpful but also an asset. Still, marriage at best was a kind of partnership, and partnerships often prove troublesome. In a society in which marriage was rated as the second-best thing, as it was in the medieval period, it would seem that large numbers of men might rebel against the limitations put upon them by marriage and blame much of their difficulty on their wives, particularly on wives who did not keep their place. The ideal wife appeared in the story of Griselda, recounted by Chaucer in English, by Boccaccio in Italian, by Petrarch in Latin, and probably elsewhere. Though such a person as Griselda never existed, she was the ideal by which other wives were measured, and inevitably all came up short, subject to criticism. The theme of the story was simple. A nobleman, anxious to continue his line, hunted for a wife. He examined all prospects but finally agreed to marry one of his own serfs, Griselda, providing that she would promise to cheerfully comply with his every wish and never show the slightest dissatisfaction. She agreed, and much to his surprise she became a model wife, pleasing him in every way and fulfilling all her duties and functions. He, nevertheless, continually tested her submissiveness. When she gave birth to a daughter he told her that he must have the child killed. The pluperfect Griselda replied: "My child and I are your possession / And at your pleasure; on my heart's profession / We are all yours and you may spare or kill / What is your own. Do therefore as you will." Though pleased with the answer, he had the child removed. Griselda never even sighed, although she did beg the man who came to take the child to bury the little body unless her lord objected. When she gave birth to a second child, a boy, he too was taken away. Again Griselda remained calm and peaceful, adhering to her husband's orders. Still he was not satisfied. To test her yet further he announced to her that she must go back to her father, since he had decided to take another wife. Griselda obediently

responded: "My lord, I know as I have always done / That, set against your high magnificence, / My poverty makes no comparison. / It cannot be denied, and I for one / Was never worthy, never in my life, / To be your chambermaid, much less your wife." After she cheerfully returned to her father's hovel, her husband was satisfied with her true obedience. He finally revealed to her that his new bride was really her daughter, that her son was also alive, and she remained his wife. He had just devised these innocent schemes to test her.

> On hearing this Griselda fell in a swoon
> In piteous joy, but made recovery
> And called her children to her and they soon
> Were folded in her arms . . .
> "All thank to you, my dearest lord," said she,
> "For you have saved my children, you alone!
> Were I to die this moment I have known
> Your love and have found favor in your sight,
> And death were nothing, though I died to-night. . . ."[72]

Griselda has to be an exaggeration, but the medieval male believed in the subjugation of women. Philippe de Novaire, a thirteenth-century writer, held that women "have a great advantage in one thing, they can easily preserve their honour if they wish to be held virtuous, by one thing only. But for a man many are needful, if he wish to be esteemed virtuous, for it behoves him to be courteous and generous, brave and wise. And for a woman, if she be a worthy woman of her body, all her faults are covered, and she can go with a high head wheresoever she will; and therefore it is in no way needful to teach as many things to girls as to boys."[73] Philippe then logically concluded that it was not necessary to teach girls to read. Virtue and virtue alone counted. Fortunately, not all agreed with him, and several men were strong advocates of literacy for women.

Chaucer's Wife of Bath was the opposite extreme to Griselda. In the prologue to her tale, Chaucer revealed that she had had five husbands. Her first three, all since dead, had been chosen because they were old and rich and she rather quickly had gained their love and their property. Once she gained mastery she did not even have to bother to be nice to them, although she treated them with affection when they gave her presents. Her fourth husband, a rake, had been a mistake, but she had managed to cure him by making him jealous. Her last husband, and the one with whom she was still living, she had married for love. He was much younger than she and also at first had proved to be difficult, but

she had found his weakness when she had pretended to be dying after he had hit her. In effect, a determined woman could find the weakness of any man. After telling about herself in the prologue, the Wife of Bath recounted the adventures of a knight who set out to find what women really wanted most. Though some had responded to the knight that women wanted wealth and treasure, others jollity and pleasures, some gorgeous clothes, others fun in bed, and still others to be gratified and flattered, he himself had discovered that what women really desired was "the self same sovereignty / On husbands as they on those that love them, / And would be set in mastery above them; / That is your greatest wish."[74]

There was, however, a limit to how far medieval misogyny could go. This was simply because though the clerics might condemn women, and the secular writers might make ribald jokes about them, the church still recognized that sex existed, and heterosexuality was much preferable to homosexuality. Helping to emphasize this distinction was the revival of Platonism in the late medieval period. To Plato and the neo-Platonists love was the desire of beauty; it began on the individual level, extended to a recognition of the kinship of all physical beauty, and concluded with the recognition that beauty was an intangible spiritual essence. Love in effect was a means of achieving the highest spiritual cognition. Plato, however, had conceived of love primarily as between two men or between a man and a youth, and this to the medieval church was anathema. When the study of Plato was intensified in fifteenth-century Italy, many writers were concerned with avoiding the charge of homosexuality. They could do this either by attributing only an intellectual and moral fervor to those who loved members of the same sex or by attributing to women, not men, the personal beauty that excited men to love and impelled the lover to seek the higher forms of beauty.[75] If these were the alternatives the course of the Christian church was clear. The contradictions of medieval views of sexuality were never more evident than in the fact that it was the church's very antisexuality and fear of sex that led Christianity to elevate women. The more materialistic concepts of courtly love were reinforced with the spiritual aspects of Platonic love. It was through the ennobling love of woman that man could attain the contemplative state that led by degrees to a desire for things divine. Still, the argument could not be carried too far, and Leon Battista Alberti (c. 1390–1472) could still write that women were "crazy and full of fleas."[76]

Even while chastity came to be emphasized, there was still considerable mistrust of women, and it was during the fifteenth century, the so-

called Renaissance period, that chastity girdles appeared. If it was the virtuous woman who was going to be admired, some husbands were going to take all efforts to ensure the chastity of their wives and daughters, even if it meant enclosing them in barbaric contraptions. How widespread such contraptions were is debatable, but the first authenticated picture of one dates from 1405. It is believed that they reached the height of their development in Italy and existed there for several centuries.[77] Women had to be controlled, whether in chastity belts or otherwise, and the fourteenth-century Geoffrey, the knight of La Tour-Landry, in a book compiled for the instruction of his daughters, held that a gentleman in a rage could strike his wife. He kept emphasizing to his daughters to take "hede how all good women owe to be humble, curteis, and seruisable vnto her hosbondes."[78] Bourgeois literature, which had not yet incorporated the chivalric ideas, was essentially misogynistic, and the henpecked husband was a suspiciously favorite theme.

Perhaps the only way the picture could be changed was for women themselves to write from their point of view, and women wrote very little. Heloise in her love letters to Abelard was perhaps an exception, but when most women did write they either ignored the topic of woman's place or accepted the male stereotypes.[79] Countess Beatrice de Die and Marie de France, both poets, were not misogynists, but they did not picture women in their work any differently than did male poets. A major medieval exception to this statement was Christine de Pisan, a fifteenth-century woman who might be regarded as an early feminist voice. Christine, at best, was a cautious advocate of woman's rights, careful not to antagonize the male. Instead of trying to argue that women were equal in intelligence, culture, or education to men, she accused those who attacked women as guilty of ingratitude. After all, she pointed out, woman had been the ever present servant of man, the nurse of infancy, the mourner at his burial, and his true helpmate. To call such a servant faithless, cruel, inconstant, vain, and worthless was not only rude but also demonstrated a lack of common courtesy. Moreover, it was poor logic to lump all women together. Some were bad, just as some men were bad, but some were good, and men unfortunately labeled all women as one group. She emphasized that God had created woman in his own image and had chosen her to be the mother of Jesus while an ordinary man had not been chosen as the father. Woman was made of finer material than the simple dirt out of which man had been created, and this obviously meant that woman was more noble than man. Woman was also created in Paradise, whereas man was not. She

cited a whole series of women, from Medea to Dido to Penelope, who remained constant to their men even when the men had deserted them. For these reasons, as well as others, men should prize, cherish, and love women. No man could be without a mother; it was women alone who were the mothers, as well as the sisters, daughters, and friends of man. While she admitted that she was only a woman and not particularly important, she could claim the right to defend her sex on the grounds that a small knife could make a big hole in a sack and a very small rodent could assault and put a lion to flight. Christine also argued that women should be educated; no amount of learning could ever prove injurious to a virtuous woman. She would concede, however, that woman's education should be different from man's because there were sexual differences, and women should not be expected to occupy all the positions of men.[80] This moderate attack was the first assault by a woman on the misogyny of the Middle Ages and one of the first to survive from any period.[81]

There were a few men who sided with Christine. At first glance her most unlikely ally was Giovanni Boccaccio, whose *Decameron* sometimes seemed to be a catalog of cuckolded husbands and scheming wives. Boccaccio, however, also wrote *De Claris Mulieribus* (*Concerning Famous Women*), a collection of biographies of some 104 women, the first collection of women's biographies ever written. It was from the pages of Boccaccio that Christine took some of her ammunition to deal with the misogynistic critics of women. Though Boccaccio's stories covered all types of women, from those who betrayed and tricked men to those who served their menfolk loyally and devotedly, the emphasis was more on the latter than the former. Boccaccio, nonetheless, was still somewhat ambivalent about the female of the species. The highest praise he could offer to woman was to call her "manly," and he used the adjective repeatedly. Women to become great had to overcome the obstacles of their bodies, because nature had not created them equal to men. He recognized that women could become great scholars, rulers, and painters, and he encouraged them to do so, but he also feared that they would encroach on the rights of men.[82] Ambivalence, however, was better than hostility, and Boccaccio represented a step forward over most of his contemporaries.

Women for the most part were still regarded as inferior to men at the end of the Middle Ages, as they were at the beginning. Leon Battista Alberti summed up the expected role of women in the fifteenth century:

The character of men is stronger than that of women and can bear the attacks of enemies better, can stand strain longer, is more con-

stant under stress. Therefore men have the freedom to travel with honor in foreign lands, acquiring and gathering the goods of fortune. Women, on the other hand, are almost all timid by nature, soft, slow, and therefore more useful when they sit still and watch over our things. It is as though nature thus provided for our well-being, arranging for men to bring things home and for women to guard them. The woman as she remains locked up at home, should watch over things by staying at her post, by diligent care and watchfulness. The man should guard the woman, the house, and his family and country, but not by sitting still. He should exercise his spirit and his hands in brave enterprise, even at the cost of sweat and blood.[83]

In spite of Alberti's view, it seems clear that attitudes toward women were undergoing some modification at the end of the medieval period. The change, however, was ambiguous, as is indicated by the growth of romantic love. There was a tendency to place some women on a pedestal, restricting this elevated position to the most noble women and denying it to women of the lesser classes. Attitudes toward women were still tied up with attitudes toward sex, but the church recognized that sex was part of human existence and vastly preferred that its members engage in heterosexual rather than homosexual activities. Quite clearly women remained subordinate to men, although the nature of this subordination was being redefined to meet changing conditions. The vast majority of women, even those such as Christine de Pisan, who challenged some of the masculine assumptions, were primarily mothers, and it was either as mothers or as chaste exemplars of virtue that women had respect. Though few women probably enjoyed the pedestal that the concepts of romantic love put them on, most of them thought that at least temporarily it was better than the gutter, and the myths of the female mystique appealed to them. The difficulty with the pedestal, however, was that it was hard to remain there without falling.

9 / The More Things Change, the More
They Remain the Same

\mathbf{I}f the view of women during the medieval period was heavily colored by a clerical emphasis on the need for celibacy, it would seem logical that the appearance of Protestantism, with its denial of the virtue of celibacy, would lead to a change in attitude toward women. Logic, as should be evident by this point in the book, has had little place in man's attitudes toward women, and though the advent of married clergy probably curtailed some of the worst excesses of clerical misogyny, it did little to elevate the status of women. At the same time, it restricted women's choice of alternative careers by eliminating the convent, one of the few institutions where women had considerable independence of action. One observer, G. Rattray Taylor, in his sometimes brilliant but always highly opinionated study entitled *Sex in History,* went so far as to label the advent of Protestantism a "desperate attempt by patrists to restore patrist ideals."[1] This seems to be an exaggeration, although it is true that Protestants in general condemned the courtly lover's worship of women as disgusting effeminacy.

Most of the leaders of mainstream Protestant thought, from Martin Luther to John Calvin, regarded the physical superiority of the male as a sign from God of man's superiority in the household. They looked upon the husband-father as the ultimate authority within the home, the breadwinner, the pastor and priest to the family. It was only by submission to her husband that a woman could atone for Eve's transgression.[2]

The More Things Change

Martin Luther, who was often rather earthy in his expressions, and whose *Table Talk* was more or less accurately recorded by various disciples, put the matter of women's submission rather bluntly: "Men have broad shoulders and narrow hips, and accordingly they possess intelligence. Women have narrow shoulders and broad hips. Women ought to stay at home; the way they were created indicates this, for they have broad hips and a wide fundament to sit upon [to keep house and bear and raise children]."[3] Luther regarded marriage as an effective means of curing sin, although women were necessary in other ways as well. He wrote: "Many good things may be perceived in a wife. First, there is the Lord's blessing, namely offspring. Then there is community of property. These are some of the pre-eminently good things that can overwhelm a man. Imagine what it would be like without this sex. The home, cities, economic life, and government would virtually disappear. Men can't do without women. Even if it were possible for men to beget and bear children, they still couldn't do without women."[4]

After his break with Rome, Luther gradually arrived at the conclusion that clerical celibacy was wrong because it had originated from what he regarded as the false belief that divine favor could be won by performing self-imposed tasks. The key to his religious thought was that salvation came from faith, not good works, and thus chastity, which had been regarded as a good work, could no longer be so regarded. For Luther the gift of continence came only from God. Luther was positive that sex in and of itself did not involve man in any more sinful conduct than other potentially sinful acts. Wedlock, in fact, was God's gift to mankind, a state of life approved by God and possessing the authority of his sanction. Marriage was inherent in the very nature of man, had been instituted in Paradise, confirmed by the Fifth Commandment, and safeguarded by the Seventh. It was a true, heavenly, spiritual, and divine estate.

Once Luther arrived at an idea he tended to act upon it, and so at forty-two he married the ex-nun Katherine von Bora, who was then twenty-seven. Sören Kierkegaard, the great theologian of the nineteenth century, said that Luther might as well have married a plank as Katherine, since he felt that Luther had nothing more in mind by his marriage than to demonstrate his approval of clerical marriage. Any woman might have suited his purpose, and Katherine's only claim to fame was that she was Luther's wife.[5] In part because of Luther's garrulousness, and in part because Luther took to marriage like a duck to water, we know something about Katherine. Luther put strong emphasis upon marital love, upon the home as a school for character not only for chil-

dren but also for the husband and wife as well. Though Luther was always the magistrate within his house, he recognized the difficulties of two human beings living together as man and wife and came to marvel at the patriarchs who had been able to stick out marriages that lasted for several hundred years. He once wondered how often Eve must have said to Adam, "You ate the apple," and Adam had retorted, "You gave it to me." He could feel only compassion for Abraham, who in his old age was caught in a crossfire between two jealous women, and he sympathized with the blind Isaac who had nothing to do in his declining years but listen to the wrangling of Rebecca with the wives of Esau.[6] Luther still had a somewhat jaundiced view of the female, but in many ways he looked upon the opposite sex as a kind of friendly rival and he lacked the fear of some of his clerical predecessors. He wrote:

> When one looks back upon it, marriage isn't so bad as when one looks forward to it. We see that our mothers and our fathers were saints and that we have the divine commandment, "Honor your father and your mother." When I look beside myself I see my brothers and sisters and friends, and I find that there's nothing but godliness in marriage. To be sure, when I consider marriage, only the flesh seems to be there. Yet my father must have slept with my mother and made love to her, and they were nevertheless godly people. All the patriarchs and prophets did likewise. The longing of man for a woman is God's creation—that is to say, when nature's sound, not when it's corrupted as it is among Italians and Turks.[7]

> You can't be without a wife and remain without sin. After all, marriage is an ordinance and creation of God. Therefore it is not Satan's idea when a man desires to marry an honorable girl, for Satan hates this kind of life. So make the ventures in the name of the Lord and on the strength of his blessing and institution.[8]

Men, no matter how antagonized they might be by the female, should always keep in mind that women are also God's creation. Luther felt called upon to upbraid the archbishop of Mainz, who had been quoted as condemning the "stinking, putrid, private parts of women." "That godless knave, forgetful of his mother and his sister, dares to blaspheme God's creature through whom he was himself born. It would be tolerable if he were to find fault with the behavior of women, but to defile their creation and nature is most godless. As if I were to ridicule man's face on account of his nose! For the nose is the latrine of man's head and

stands above his mouth. As a matter of fact, God himself must allow all prayer and worship to take place under this privy."[9] Luther, in general, was opposed to ridiculing women in public. "Girls and women ought not to be censured in public pamphlets, even if there is reason to suspect them, but ought to be rebuked in private or reported to the magistrate. There are many imperfections in the female sex—as the proverb puts it, 'If all girls are good, where do wicked women come from?' " In the privacy of his own home, however, he sang some words of caution about beautiful woman, since "A red apple may look good and inviting, / And yet worminess hide: / So a girl with the worst disposition / May be pretty outside." Though Luther felt that there were defects in everything, the poets, having learned from experience, could still only lament that woman was such a "weak vessel."[10]

The good wife was the one who kept her place. In a sense, Luther sounds like a broken record, repeating the stereotypes of the past: his statements about Eve remind one of statements Hesiod made about Pandora. For example, after an argument with his wife, whom he called Katie, he stated: "You convince me of whatever you please. You have complete control. I concede to you the control of the household, provided my rights are preserved. Female government has never done any good. God made Adam master over all creatures, to rule over all living things, but when Eve persuaded him that he was lord even over God she spoiled everything. We have you women to thank for that! With tricks and cunning women deceive men, as I, too, have experienced."[11] In the home the husband should be master over his womenfolk, although he could delegate certain tasks to his wife in order to devote himself to higher and more important things.[12] Luther regarded himself as master in his own home, at least most of the time, was quite possessive of his wife and children and also rather happy and content. "I am rich, God has given me my nun and three children; what care I if I am in debt, Katie pays the bills. . . . George Kark has taken a rich wife and sold his freedom. I am luckier, for when Katie gets saucy, she gets nothing but a box on the ear."[13] Luther strongly believed that women were inferior to man. This belief was a contradiction, since he also believed that there was a universal priesthood of all believers and that God did not distinguish between men and women in this respect. He still, nonetheless, excluded women from the ministry on the grounds of the necessity for preserving order and decency and because of the inferior aptitudes inherent in the female sex. He recognized, however, that exceptions might be made in time of necessity.[14] Luther was willing to make an occa-

sional exception, but women in general were inferior to the male. This might be regarded as a slight gain for women, but any concessions to women were to be made on male terms by the men themselves.

John Calvin put less emphasis upon the subordination of women than Luther did, and he also put less emphasis upon their tasks as child-bearers. Instead he taught that the primary purpose of marriage was social rather then generative. Woman had not been created simply to be man's helper in procreation, nor was she just a necessary remedy for his sexual needs caused by the corruption of human nature by the Fall; rather, the female had been created as man's inseparable associate in life as well as in the bedchamber.[15] Calvin agreed that the Scriptures emphasized males instead of females, but questioned whether it should be concluded that "women are nothing." Instead, he held that generally women were included under the generic term "men," and it was obvious that men could not have children without women. Though the family name rests in the possession of the males rather than the females, Jesus himself was born from a woman.[16] Nevertheless, Calvin held, as did Luther, that the subjugation of woman to man was part of God's law, so much so that a woman was not to leave her husband even if he was of a different religion from her or even if he beat her. In 1559 Calvin wrote to an unidentified woman:

> We have a special sympathy for poor women who are evilly and roughly treated by their husbands, [but] because . . . of the tyranny by the Word of God, [we cannot] . . . advise a woman to leave her husband, except by force of necessity; and we do not understand this force to be operative when a husband behaves roughly and uses threats to his wife, nor when he beats her, but [only] when there is imminent peril to her life, . . . we exhort her . . . to bear with patience the cross which God has seen fit to place upon her; and meanwhile not to deviate from the duty which she has before God to please her husband, but be faithful whatever happens.[17]

Woman's mission in life, according to Calvin, was to be a mother, and it was this special ministry, which prevented her from assuming positions in the church, that in turn deprived her of authority to preach publicly. Ultimately Calvin concluded that a woman should not be allowed to speak in the church, to baptize, or to offer, and she could not claim for herself the function of any man, much less the priest. Calvin said he was well "aware of the answer of those who think otherwise: that there is a great difference between common usage and an extraordinary remedy required by dire necessity. But since Epiphanius declares

that it is mockery to give women the right to baptize and makes no exception, it is clear enough that he condemns this corrupt practice as inexcusable under any pretension."[18] We know little about Calvin's wife, Idelette, except that he had a high opinion of her. When she died he wrote to a friend: "I have been bereaved of the best companion of my life, who, if our lot had been harsher, would have been not only the willing sharer of exile and poverty, but even of death. While she lived, she was the faithful helper of my ministry. From her I never experienced the slightest hindrance."[19]

Thomas Hooker, the American Puritan and follower of John Calvin, went much further than Calvin in expressing his feelings about women: "The man whose heart is endeared to the woman he loves, he dreams of her in the night, hath her in his eye and apprehension when he awakes, museth on her as he sits at table, walks with her when he travels and parlies with her in each place where he comes. . . . That the husband tenders his spouse with an indeared affection above all mortal creatures: This appears by the expressions of his respect, that all he hath, is at her command, all he can do, is wholly improved for her content and comfort, she lies in his bosom and his heart trusts in her, which forceth all to confess, that the stream of his affection, like a mighty current, runs with full tide and strength. . . ."[20]

The Calvinist acceptance of woman depended on her knowing her place in a male world. When it appeared that two queens, Mary Tudor and Mary Guise, might rule in England and Scotland, and that these two women were also Catholic, the Protestant misogyny that lay under the surface burst into the open. Probably the most notorious attack on women by the Protestant reformers of the sixteenth century was that issued by John Knox under the title "The First Blast of the Trumpet against the Monstrous Regiment of Women" in 1558. Knox, who was living as an exile in Calvin's Geneva, wrote that to promote a woman to a position of rule, superiority, or dominion, over any city, realm, or nation, was repugnant not only to nature but also to God. Not only, he claimed, had God deprived woman of the right to any such authority or domination, but man himself had seen why this denial of female rule was necessary. "For who can denie but it is repugneth to nature, that the blind shall be appointed to leade and conduct such as do see? That the weake, the sicke, and impotent persons shall norishe and kepe the hole and strong? And finallie, that the foolishe, madde, and phrenetike shal governe the discrete, and give counsel to such as be sober of mind. And such be al women, compared unto man in bearing of authoritie. For their sight in civile regiment is but blindness; their strength, weaknes;

their counsel, foolishnes; and judgment, phrensie, if it be rightlie considered."[21]

God had plainly denied woman any authority over man, although Knox recognized they did have certain legal rights to inheritance. This right, however, even in the case of queens, could never be construed as the right to rule.[22] Knox had projected a second and third blast of his trumpet against women, but these were never written, probably because some of his more prudent colleagues persuaded him that a female ruler sympathetic to Protestantism (Elizabeth I) might soon ascend the throne of England. Knox never recanted his views on women and later, after Elizabeth was on the throne, he wrote to her minister William Cecil giving reverence for the miraculous work of God in comforting his afflicted by such an "infirme vessell," namely a female ruler. Knox was willing to support Elizabeth's right to rule only if she would confess that the "extraordinary dispensation" of God's mercy had made lawful unto her that "which both nature and Godes lawe denye" to other women.[23] These attitudes made him *persona non grata* to Mary Queen of Scots, although he was not alone in his hostility to female rule. Two of his colleagues, John Ponet and Christopher Goodman, wrote tracts with similar themes.

Even the "defenders" of rights for women found it hard to justify the right of a female to rule. John Aylmer, for example, who wrote a refutation to Knox, maintained not that women were fit to rule but only that God occasionally chose to work his way through a weak instrument. If God chose to place in authority a "woman weake in nature, feable in bodie, softe in courage, unskilfull in practise, not terrible to the enemy, no shilde to the frynde," it was because God could work through the weak as well as the strong, through a woman as well as a man. Even though women might occasionally rule, however, Aylmer held that they could never be ordained as clergy because the female lacked the mental and mortal virtue indispensable for a clergyman. In general, Aylmer regarded women as "fond, folish, wanton, fibbergibbes, tatlers, triflers, wavering, witles, without counsell, feable, careless, rashe, proude, deintie, nise, talebearers, eavesdroppers, rumor raisers, evell tonged, worse minded, and in every wise doltified with the dregges of the Devils dounge hill."[24] Excluded from this general category of females was Elizabeth, whom he praised lavishly, if only because at the time he very much desired a career in the church of England. As Katharine M. Rogers, in her invaluable study of misogyny in literature, remarked, "It is not hard to see, however, why she kept him waiting a long time for his bishopric."[25]

Separate and distinct from the Lutheran wing and the Calvinist wing of Protestantism was the Anglican, the success of which ultimately was due to the policies of Queen Elizabeth. Nevertheless, the Anglicans made but few concessions in their attitudes toward women. William Tyndale (d. 1536), who died long before Elizabeth ascended the throne, insisted upon women's subordination in marriage. Women, he held, were put under men in order to keep female lusts and wanton appetites under control. Later, however, Thomas Becon paid tribute to woman's wisdom and prudence and to her competence, while Jeremy Taylor in the seventeenth century went to some effort to disassociate himself from those morose cynics who deemed women unfit for man's friendship. Still, the Anglican writers with almost uniform monotony expounded the basic principle of male headship and credited men with superior understanding and reasoning. Women, on the other hand, were said to have been so constituted that they required guidance, control, and protection. "They are intrinsically inferior in excellence, imbecile by sex and nature, weak in body, inconstant in mind, and imperfect and infirm in character; yet in spiritual capacity it is allowed they are equal to their lords, having 'as good an interest in the promise of God, and as fair a title to that eternal life which the divine grace bestows upon us.'"[26] The subordination of women was regarded as inherent in nature itself, an integral part of the divine hierarchical ordering of the universe, proof of which could be found in the nature of the feminine defects, namely, the action of God in creating woman after, out of, and for man and the fact that women first fell into sin. The good woman was the wife who was ever vigilant in conforming to the wishes of her husband, diligent in the discharge of wifely duties, compliant in manner, interested in domestic affairs, ready to obey, and always good-humored. Any wife should be treated by a husband as he would treat a child, which a woman was at heart, and his control over her was to be paternal and friendly, not magisterial or despotic. By delegation from him woman was to have authority over the nursery and over the offices of domestic employment.[27]

Those women who did speak publicly on religious issues were usually rebuked by the males. For example, when Katherine Zell, whose ex-priest husband was one of the leaders in the Protestant movement in Strasbourg, defended the right of priests to marry, she was immediately reminded of St. Paul's injunction for women to be silent in the church. Katherine, however, knew her Bible and she effectively replied: "I would remind you of the word of this same apostle that in Christ there is no longer male nor female and of the prophecy of Joel: 'I will pour forth my

spirit upon all flesh and your sons and your daughters will prophesy.' I do not pretend to be John the Baptist rebuking the Pharisees. I do not claim to be Nathan upbraiding David. I aspire only to be Balaam's ass, castigating his master."[28] Another woman, Argula von Grumbach, defended Luther by writing a letter of protest to the faculty at the University of Ingolstadt. She, however, immediately adopted the humble demeanor of a proper woman: "I am not unacquainted with the word of Paul that women should be silent in church but, when no man will or can speak, I am driven by the word of the Lord when he said 'He who confesses me on earth, him will I confess and he who denies me, him will I deny,' and I take comfort in the words of the prophet Isaiah, 'I will send you children to be your princes and women to be your rulers.' "[29]

Protestantism, by its emphasis upon the Scriptures, encouraged women to read, and the development of the printing press in the fifteenth century further stimulated literacy in both men and women and made reading material far more accessible. The greatest gains in equality appeared in some of the minor Protestant groups. Many of these were much more willing to accept women on the basis of near equality than a Luther or Calvin. John Comenius, a seventeenth-century minister of the Church of the Brethren (Moravian church), sympathized with women's complaint that they had to live under the rule of men even though they formed one-half of the human race. He felt that neither sex should try to rule the other, although he believed that men should rule the community and women the home, and this might mean that women sometimes would also have dominance over men. He could see no good reason why women should be excluded from the pursuit of knowledge and argued that women were often endowed with a greater sharpness of mind, as well as capacity for knowledge, than men. He also wanted them to be well educated, since the more learning they had stuffed into their minds "the less will the folly that arises from emptiness of mind find a place."[30]

Catholicism reaffirmed the doctrine of clerical celibacy in the sixteenth century, and though there was a series of rather remarkable women religious leaders, there was little change in the clerical attitude toward women. This lack of change is most evident in the writings of St. Theresa of Avila (1515–82), one of the most remarkable women of any period. In spite of her sainthood she once retorted that the "very thought that I am a woman is enough to make my wings droop."[31] Like her famous predecessor, St. Katherine, she wondered whether St. Paul was right in his misogynistic dismissal of women, and through her mystical vision she felt that she arrived at new truths. She held that while

the church should be guided by the teachings of St. Paul, all the Scriptures should also be followed, and if this occurred there would be a radical change in attitudes toward women. St. Theresa recognized the physical weakness of women as compared to men but stated that it was not enough to justify their subordination.

> When thou wert in the world, Lord, thou didst not despise women, but didst always help them and show them great compassion. Thou didst find more faith and no less love in them than in men. . . . We can do nothing in public that is of any use to thee, nor dare we speak of some of the truths over which we weep in secret, lest thou should not hear this, our just petition. Yet, Lord, I cannot believe this of thy goodness and righteousness, for thou art a righteous Judge, not like judges in the world, who, being after all, men and sons of Adam, refuse to consider any woman's virtue as above suspicion. Yes, my King, but the day will come when all will be known. I am not speaking on my account, for the whole world is already aware of my wickedness, and I am glad that it should become known; but, when I see what the times are like, I feel it is not right to repel spirits which are virtuous and brave, even though they be the spirits of women.[32]

In spite of such rejoinders, clerical attitudes changed but little. Cardinal Cajeta (1469–1534), the sixteenth-century commentator on St. Thomas Aquinas, expressed agreement with the great doctor's view on women, although he did admit that there were many things that a woman might do better than a man. St. Ignatius Loyola (1491–1556), the founder of the Jesuits and one of the leaders in the Catholic reform movement of the sixteenth century, thought he detected a similarity between women and Satan: "The enemy conducts himself as a woman. He is a weakling before a show of strength, and a tyrant if he has his will." The Spanish Dominican Dominic Soto (1495–1560) held that the female sex was a natural impediment to the reception of holy orders and, after echoing St. Paul's views on women, added that nature demonstrated that it would be absurd for women to hear confessions, for even if by chance there were some women who were prudent, the female sex in general manifested a poverty of reason and a softness of mind.[33]

The best they could do was go along with St. Francis de Sales (1567–1622), who, in his *Introduction to the Devout Life*, urged men not to be provoked by the weakness and infirmities of the bodies and minds of their wives but instead to preserve a tender, constant, and heartfelt love. "Woman was taken from that side of the first man which was nearest

175

his heart, to the end that she might be loved by him cordially and tenderly. The weakness and infirmity of your wives, whether in body or in mind, ought never to provoke you to any kind of disdain, but rather to a mild and affectionate compassion. God has created them such, to the end that they should depend upon you and you should receive from them more honor and respect. It is also that you should have them for your companions in such manner that you should still be their heads and superiors." He cautioned wives to "love tenderly and cordially the husbands whom God has given you, but with a love respectful and full of reverence. God indeed created them of a sex more vigorous and commanding and was pleased to ordain that the women should depend upon the man, being bone of his bone and flesh of his flesh, and that she should be made of a rib taken from under his arm, to show that she ought to be under the hand and guidance of her husband. All Holy Scripture strictly recommends this submission to you. . . ."[34]

In spite of the assaults of Protestantism upon Catholicism, or perhaps because of them, the Catholic church attempted to limit women's careers in the religious life by imposing strict enclosures upon all religious women, forbidding them to enter the world in the fashion of the Franciscans or Jesuits or Dominicans once they had taken their vows. These prohibitions, which probably were originally promulgated against the *beguines* in the thirteenth century, were renewed in the sixteenth century at the Council of Trent and confirmed by Pope Pius V, who held that women who took solemn vows must accept cloister. Not all women were willing to abide by such strictures, but few were able to overcome them. Angela Merici (1474–1540), the founder of the Ursulines, insisted during her lifetime that her followers not be bound by the cloister, wear a habit, or even live together. Their only vow was to be one of chastity, and her followers were to live a life of consecrated virginity while laboring as apostles in the world. After her death, however, church officials forced her companions back into the old monastic mold. A similar fate was imposed upon the Sisters of Visitation, established by Francis de Sales and Jeanne de Chantal. Only St. Vincent de Paul seems to have been successful in having the order he founded break away from the past strictures; his Daughters of Charity became particularly influential in the emergence of modern nursing.[35]

The extent of clerical hostility to any change in the role of women within the Catholic church is evident in the case of Mary Ward (1585–1645), the founder of the "English ladies." A Catholic in Protestant England, Ward wanted her ladies to work in the world, conducting schools for girls, subject only to the pope, independent of all other bishops and

176

men's orders. For her time she was a strong advocate of greater freedom for women, and she planned to teach girls Latin as well as various secular subjects up to this time reserved largely for men. She wrote, "There is no such difference between men and women that women may not do great things, as we have seen by the example of many saints. . . . For what think you of this word, 'but women'? As if we were in all things inferior to some other creature which I suppose to be man. . . . And if they would make us believe we can do nothing, and that we are but women, we might do great matters."[36] She was, however, a far cry from being a revolutionary. She accepted the duty of wives to submit to their husbands, believed that men were to be head of the church, and agreed that women could not administer the sacrament or preach in public churches; the clergy, nonetheless, still condemned her. Some of the Catholic leaders in England wrote to Pope Gregory XV in 1621 in an effort to have her congregation dissolved on the grounds that women were "soft, fickle, deceitful, inconstant, erroneous, always desiring novelty, liable to a thousand dangers." They claimed that such weaknesses were accentuated in Ward's case because she would not submit to cloister and insisted on her rights, as well as that of her followers, to speak freely on spiritual matters. This led to erroneous teaching by her female followers; moreover, their ability to travel freely and visit the homes of the faithful could only cause a scandal, while their apostolic work would make them the subject of ridicule. Ward appealed to Pope Urban VIII in 1624, who ordered her case reviewed by a board of cardinals. The board concluded that it was doubtful any organization of women such as she contemplated could do any good. Her order was suppressed in 1629, and when she disregarded the order of the suppression because she thought that it had been falsified, she was arrested as a heretic and schismatic. The wording of the bull suppressing her order, issued by Pope Urban VIII, effectively reveals the clerical attitude: "Certain women, taking the name of Jesuitesses, assembled and living together, built colleges, and appointed superiors and a General, assumed a peculiar habit without the approbation of the Holy See . . . carried out works by no means suiting the weakness of their sex, womanly modesty, virginal purity . . . works which men most experienced in the knowledge of the sacred scriptures undertake with difficulty, and not without great caution."[37] In short, religious attitudes toward women did not change much during the rise of Protestantism or the coming of Catholic reform. Protestantism, by emphasizing the virtue of marriage, had eliminated some of the clerical misogyny, but a woman, whether she was Protestant, Catholic, Jewish, or Muslim, was not to assert any

authority over the male. She was clearly subordinate, even if by some chance she might even become a ruling monarch.

Although religious officials had not basically changed their view of women during the sixteenth and seventeenth centuries, there were quite radical changes in education, particularly concerning the importance of female education. These changes were the result not so much of any change of attitude toward women as of a change in the concepts of education. During much of the medieval period the aim of education had been religious, to train priests and theologians. This concept was modified somewhat in the twelfth and thirteenth centuries by the development of universities, but the students in such institutions, even those studying medicine and law, were still regarded as clerics. Throughout much of Europe almost any male charged with a crime could claim benefit of clergy, and if he could read Latin he was entitled to be tried under church law instead of secular law. Since women were prohibited from becoming clerics they were automatically eliminated from any possibility of attaining a university education. The development of professionalization in the university thus excluded heretics, schismatics, and Jews, as well as women, from becoming lawyers or physicians, and this had long-run implications for the status of women, since increasingly the professions moved into the universities, and without the opportunity to attend such schools women were severely handicapped.[38] Girls in the later Middle Ages, however, could attend "song" schools, schools run by "chantry" priests who were paid to say masses for the dead and who usually ran a school on the side. Girls were also taught by casual tutors, but they were excluded from the formal grammar schools that were regarded as preparatory schools for the university. If parents or guardians wanted their daughters to learn more than simple reading they had to hire tutors; this sometimes caused difficulty, as the famous love affair between Héloïse and Abelard exemplified. In the larger noble households girls were sometimes taught by chaplains, but their learning took place in their home and the emphasis was on matters of domestic utility, including the teaching of manners, the enhancement of personal beauty and charm, and how to dress well. In theory women who wanted to have more education might turn to a convent, but increasingly there was suspicion about educated nuns and few dared to go beyond elementary Latin. In fact, it came to be assumed that nuns did not know Latin, with the result that visiting bishops talked with them in the vernacular.

Though Protestantism by its emphasis on Scriptures probably gave

some impetus to education for girls, and the invention of the printing press made reading much more important, the key to the change was the growth of humanism, an intellectual movement that started in Italy during the fourteenth century and from there spread throughout much of Europe. At this time Italy politically was overshadowed by the growing states to the north and west of it, while the papacy, the medieval glory of Italy, was located at Avignon in what is now France. In these circumstances the Italians turned to their past glories and rediscovered their Roman heritage. To restore the magnificence of Roman culture, the virtue and power inherent in Rome came to be the inspiring aim of the Italians. They regarded themselves as the true possessors of the culture not only of Rome but also of Greece, and they avidly sought to import the classical concepts into their own day. This effort was marked by an assertion of individuality, an emphasis upon *virtu*, manly self-expression and virtuosity, activities that Jacob Burckhardt said led to the Renaissance.[39] During the process of reviving the glories of the past the nature of education was changed, since the humanist scholars came to believe that the secret of the wisdom of Alexander or the virtue of a Trojan lay in the way they had been educated in their youth. Education was thus the key to virtue, and as this concept caught the fancy of the Italian ruling classes, humanists came to be in great demand as teachers, both for boys and girls. Though at first educated girls were few, attitudes gradually changed until by the sixteenth century the education of woman was an important subject, both for literary discussion and in actual practice.

Some observers of the Italian Renaissance have much exaggerated this new emphasis upon female education. Burckhardt, for example, held that "women stood on a footing of perfect equality with men." Such a statement must be regarded as strictly ahistorical, although Burckhardt undoubtedly meant something different by equality than might be accepted today.

There was no question of woman's rights' or female emancipation, simply because the thing itself was a matter of course. The educated woman, no less than the man, strove naturally after a characteristic and complete individuality. The same intellectual and emotional development which perfected the man, was demanded for the perfection of the woman. Active literary work, nevertheless, was not expected from her, and if she were a poet, some powerful utterance of feeling, rather than the confidences of the novel or the

diary, was looked for. These women had not thought of the public; their function was to influence distinguished men, and to moderate male impulse and caprice.[40]

Women, at least upper-class women, might well have become somewhat better educated in the Renaissance than earlier, but they had to be careful not to assert themselves very much. Probably even more important than the humanist emphasis on learning in encouraging education for women was the fact that women played an important role on the political scene in the sixteenth century in their own right. That they were able to do so is indicative of some change in societal attitudes. Earlier women like the empress Matilda, mother of Henry II of England, and Eleanor of Aquitaine, his wife, had tried to rule independently of their husbands, but they had been severely handicapped and in the long run unsuccessful. At the end of the fifteenth and beginning of the sixteenth centuries, however, there were a number of women who were important as rulers in their own right or as regents. Isabella of Castille was a queen of Spain, while in England Mary and Elizabeth were reigning monarchs. In France Catherine de Medici fought like a tiger to see to it that her minor sons succeeded to their inheritance. The influence of these women rulers is evident from the fact that they were instrumental in forcing a reassessment of education of women. Catherine, the wife of Henry VIII, hired her fellow Spaniard, Luis Vives, to serve as tutor for her daughter, Mary. In an effort to prove his qualifications Vives wrote *Instruction of a Christian Woman* (1523). Vives stated that while Xenophon, Plato, and Aristotle had said many things about a woman's function, and saints such as Cyprian, Jerome, and Augustine had discussed maids and widows, he was the first to really write a treatise on female education.[41] Though Vives perhaps exaggerated his own importance in the area, since Francesco Barberino, for example, had written a treatise on the subject in the thirteenth century, Vives marked a new beginning for what came to be a long tradition.

By no stretch of the imagination could Vives be called a feminist. A girl, he felt, should be taught to read in order to study holy books, but she should also learn the domestic arts, needlecraft, spinning, and weaving, in order to better serve her parents and her husband. Though Vives believed that intelligent girls should go on to study, he felt their field should be severely restricted: "Let a woman learn for herself alone and her young children, or her sisters in the Lord. For it neither becometh a woman to rule a school, nor to live amongst men, or speak abroad, and

shake off her demureness and honesty. . . . Therefore, because a woman is a frail thing, and of weak discretion, and that may lightly be deceived . . . a woman should not teach lest when she hath taken a false opinion and belief of any thing, she spread it unto .the hearers, by the authority of mastership and lightly bring others into the same error, for the learners commonly do after the teacher with a good will." Good Christian women were to be secluded from the world for fear that they would develop a taste for misbehavior; they should be taught by example never to use unclean words or uncomely gestures; and they must not be allowed to read romances written by idle men, but only uplifting kinds of literature. Vives seemed to believe that if a woman was left to herself she would instinctively read dangerous nonsense, and thus it was essential for girls to go to wise and learned men for guidance. He held that unmarried virgins were to pass their time in company of other girls, reading and discussing holy books, resisting the temptation to talk about feasting and dancing. No girl should be encouraged to sit alone in her room and muse, for although her thoughts at the outset might be good and pious, a "woman's mind is unstable and abideth not long in one place."[42]

Royal princesses were special women, requiring special treatment, and Vives made a *Plan of Studies* for the young princess Mary. He felt that she should study all that was best in classical literature, from Plato to Cicero and Plutarch, the works of the Christian fathers, and also the writings of some of his contemporaries, particularly Sir Thomas More and Desiderius Erasmus, his friends. Both More and Erasmus were important in helping to modify societal attitudes toward educated women. More was the father of three daughters who were probably the most learned women in England. He carefully supervised their education, and during his various absences from home corresponded with their tutors. He wrote to one of them: "It mattereth not in Harvest Time whether the Corn were sown by a Man or a Woman, and I see not why Learning in Like Manner may not equally agree with both Sexes: for by it Reason is cultivated, and as a Field, sown with wholesome Precepts, which bring forth good Fruit."[43] More's daughter Margaret, who married William Roper, was said to have acquired a "perfect mastery of Greek and Latin," together with some knowledge of philosophy, astronomy, physics, arithmetic, logic, rhetoric, and music. Though More's example had great influence upon both Vives and Erasmus, others felt that allowing women to study Latin and Greek would encourage them to become too independent. Richard Hyrde (or Hart), another one

of the tutors that More hired, argued that this could not possibly be true because English and French literature had the same kind of information as Latin and Greek, but not everyone believed him.[44]

Erasmus went further and argued that learning was not particularly dangerous to the moral fiber of a woman; instead, the real dangers were idleness and triviality of interests. A girl cooped up with a "foolish and empty-headed" woman was more likely to learn mischief than if she read good books, and those men who felt that a learned woman was twice a fool were themselves ignoramuses. A learned woman would make a better wife than an ignorant one, since intelligence implies reason and there is nothing so hard to control as ignorance, where reason and argument are of no avail. Erasmus, unlike some of his contemporaries who thought as he did, gave few rules for the education of girls, partly because as a celibate priest he had little experience upon which to draw, but also because he felt that circumstances varied from individual to individual. The first duty of an educator was to train his students, male or female, to exercise their free will to make rational choices in the affairs of life. He compared educated women with uneducated woman, much to the advantage of the former. The uneducated women began their day

> with hair-dressing and rouging; formal attendance at public worship follows, for the sake of seeing and being seen: then comes breakfast. Gossip and the lightest of "literature" fill up the morning until dinner. The afternoon is occupied by promenades, and, for the young people games sadly lacking in decorum. Then more gossip and supper. It is no better when the family moves to the country, where amid idle days, the crowds of retainers, lackeys, and serving-girls, is a standing influence of evil. How different is such an environment for a young girl from that careful supervision which Aristotle commands.[45]

Richard Mulcaster, the first headmaster of Merchant Taylors' School in London, agreed that both young boys and girls should be educated, but he, like most of those who advocated education for girls, believed that boys should have priority. This was because the "male is more worthy, and politikely he is more employed," and the bringing up of young maidens, "in any kynd of learning, is but an accessary by the waye. . . ."[46] Most educational writers held that the purpose of female education was to inculcate in women a love of goodness, particularly of chastity, and a hatred of evil. They should be taught "reading well, writing faire, singing sweet, playing fine," but they were not to be regarded

as professional, only "honest perfourmers and vertuous livers." Some of
the male writers wondered if women should be taught to read at all,
since there were dangers in books, and most of those who did believe
that girls should read felt that their reading should be censored. In gen-
eral, girls were to be closely confined to the home, where they could be
kept away from public entertainments, and some went so far as to urge
that they be kept from windows in order that they not see the evil of the
world. Though it was necessary for girls to venture outside occasionally
for various purposes, such as going to church, it was recommended that
they be escorted by older persons who would try to select the nearest
and shortest ways possible without encountering the reality of evil. In
every way they were to be guarded from learning unclean words, acquir-
ing uncomely gestures, or making lascivious movements of the body.
The first things to teach girls were submission and obedience. Educa-
tional theory did not divide women into two groups, the ruler and the
ruled, as it did men, but instead held that all women were to be ruled.
While books addressed to boys were filled with discussions of various
occupations, those aimed toward a female audience recommended only
one occupation, housewifery. The purpose of education for a lady was to
ensure proficiency in domestic affairs, to give her moral and religious
training to help her remain chaste and obedient and run a well-managed
household. The so-called female virtues of chastity, humility, obe-
dience, constancy, patience, piety, temperance, kindness, prudence in
household management, and fortitude under affliction were empha-
sized. Someone has called these the Christian virtues. If this were true
the virtues most admired in males were the pagan ones, namely self-
expansion and realization. The male was to develop to the utmost every
power he had and direct every action to enhance his authority. Women
were to suppress and negate themselves. Women were also urged to
marry early in order to increase their chances of being virgins at mar-
riage, but also to curtail their opportunities for education and to force
them to turn to the problem of attending to children.[47]

A significant portion of sixteenth- and seventeenth-century literature
dealt with what the French call *Querell des femmes,* or the debate over
woman. In a sense this was a continuation of the medieval discussion
associated with chivalric love, but it received new emphasis with the
publication of Baldassare Castiglione's *Book of the Courtier* in 1528.
The influence of the book may be gauged from the fact that one hundred
printings were made in the sixteenth century and it was translated from
Italian into Latin, German, Spanish, English, and French during this
same period. The end of the second section and the whole of the third

were devoted to the questions of what woman was, what her essence was, what her destiny was. The book was in dialogue form and included a discussion between Count Gaspar Pallavicino and Agostino Fregoso, who generally represented the standard misogynistic views, and Giuliano de Medici, who defended the fair sex. Fregoso and Pallavicino argued that women were very imperfect creatures, inferior in every respect to man, whose only destiny was to guarantee the continuation of the human species through childbearing. Since woman was all body, whoever possessed a woman's body was master of her mind, and feminine sexual morals were bridles imposed upon them by men in order to ensure the legitimacy of their children.

Giuliano replied to all of these arguments.

> For just as no one stone can be more perfectly stone than another as regards the essence of a stone, no one piece of wood more perfectly wood than another—soe one man cannot be more perfectly man than another; and consequently the male will not be more perfect than the female as regards its essential substance, because both are included in the species man, and that wherein the one differs from the other is an accidental matter and not essential. . . . Again, if you examine the ancient histories . . . you will find that worth has continually existed among women as well as among men; and that there have even been those who waged wars and won glorious victories therein, governed kingdoms with the highest prudence and justice, and did everything that men have done. . . . Do you not remember having read of many women who were learned in philosophy? Others who were very excellent in poetry? Others who conducted suits. . . ?[48]

One of the most effective defenses of women was in Erasmus's *Colloquy* entitled "The Abbot and the Learned Lady." This was a short dialogue between Antronius, an abbot, and Magdalia, a learned lady. Antronius, who was visiting in the lady's apartment, remarked that the room was unbecoming both to a "young miss and a married woman" because it was so "filled with books." Magdalia asked him whether he had ever seen books in a lady's house before:

> Antronius: Yes, but those were in French. Here I see Greek and Latin ones.
> Magdalia: Are French books the only ones that teach wisdom?
> Antronius: But it's fitting for court ladies to have something with which to beguile their leisure.

Magdalia: Are court ladies the only ones allowed to improve their minds and enjoy themselves?

Antronius: You confuse growing wise with enjoying yourself. It's not feminine to be brainy. A lady's business is to have a good time. . . .

Magdalia: What if I enjoy reading a good author more than you do hunting, drinking or playing dice? You won't think I'm having a good time?

Antronius: I wouldn't live like that.

Magdalia: I'm not asking what you would enjoy most, but what ought to be enjoyable. . . .

Antronius: You strike me as a sophistress, so keenly do you dispute.

Magdalia: Isn't it a wife's business to manage the household and rear the children?

Antronius: It is.

Magdalia: Do you think she can manage so big a job without wisdom?

Antronius: I suppose not.

Magdalia: But books teach me this wisdom. . . .

Antronius: I've often heard the common saying, "A wise woman is twice foolish."

Magdalia: That's commonly said, yes, but by fools. A woman truly wise is not wise in her own conceit. On the other hand, one who thinks herself wise when she knows nothing, is indeed twice foolish.

Antronius: I don't know how it is, but as packsaddles don't fit an ox, so learning doesn't fit a woman.

Magdalia: But you can't deny that packsaddles would fit an ox better than a miter would fit an ass or a swine.[49]

There were other defenders. Henry Cornelius Agrippa von Nettesheim published a defense of women in 1529. He recognized that there were differences between men and women but argued that these were only physical, and because the soul had no sex, there could be no difference in this respect. Although he granted that women occupied a decidedly subordinate position in society, he said that this subjection was proof not of the incapacity of women but rather of the usurpation by men of women's natural right. Little more could be expected of women who were shut up in the house from the time they were born, given nothing serious or worthwhile to do, treated as if they were inca-

pable of a real action, forced to make the needle and thread their sole occupation.[50]

Women, however, could also speak for themselves. One of the leading literary figures of the sixteenth century was Marguerite de Navarre, author of the *Heptameron*. Marguerite also composed a book of letters to defend her sex against unjust charges, and though her defense of women is no longer extant, it was analyzed by Pierre de l'Escale in 1612, and from his summary we can get the basis of her ideas. Marguerite held that woman was the masterpiece of God since she was formed after man and was God's last work. Because women had intuitive powers lacking to men they were also more intelligent, and woman should have been able to command more effectively because she was more willing to listen and was therefore more reasonable. In fact, Marguerite held that women had originally commanded men until men had usurped power, an argument that made her an early advocate of the theory of matriarchy. Inevitably, however, those who wanted to compliment Marguerite on her intelligence and ability held that she had a manly heart in a woman's body and that she surpassed the rest of her sex in intelligence.[51]

The great feminist of the period was Marie de Gournay (1565–1645), one of the intellectual leaders of France during her lifetime and friend and correspondent of most of the major literary figures, particularly the great Michel de Montaigne. Marie fought hard for the emancipation of women and against the conviction that women were inferior to men. She entered the battle for women's rights in 1594 and continued in it up to her death. She personally suffered more than most other women of her time because she refused to follow the custom of submissiveness for women but instead openly displayed her learning, both in her writings and in her social contacts. Inevitably she also alienated many women, particularly those "ladies" who were becoming important for their salons, where they invited leading intellectual figures to discuss the issues of the day. These women, though important societal figures, had different aims in life than Marie. Marie felt that the salon ladies strived only to perfect the social graces and to act in the proper submissive role of women as helpmates for the more superior males. Marie, however, could not condemn them, since she believed that women by their early environment, habit, and the climate in which they lived could do little else. It was this condition she worked to change. The human animal for her was neither man nor woman, and although there were physical differences these were only for purposes of propagation. She emphasized this by the statement that "nothing so resembles a male cat on the

window sill as a female cat." Her own feelings of alienation appear in the introductory sentence to one of her books: "Happy are you, Reader, if you do not belong to this sex to whom all good is forbidden, since to us liberty is proscribed . . . so that the sole joy and sovereign virtue allowed us is to be ignorant, to play the dullard, and to serve."[52]

Renée of Ferrara, daughter of King Louis XII of France, put the prejudice toward women rather bluntly: "Had I had a beard I would have been the king of France. I have been defrauded by that confounded Salic law." This was a reference to a fourteenth-century interpretation of an ancient Frankish law that prevented women from ruling in France. Even when women did get to rule, as they did in England, they had difficulties. Such simple things as marriage caused difficulties in a period in which women were legally and conventionally subject to men. For a queen to marry meant conferring kingship either upon a native social inferior or upon a foreign equal. To do the first was to compromise internal peace, and to do the second, was to jeopardize national independence. In England Queen Elizabeth evaded the dilemma by remaining single, but her half-sister Mary fell into the marriage trap. By the Act of Succession that placed Mary upon the throne she was to be succeeded by her sister Elizabeth if she died without heirs. Since Elizabeth was the daughter of Anne Boleyn, whom Henry had married at least in part to get a male heir, and this marriage had forced a break with Rome, it was essential that Mary have an heir in order to make certain that Catholicism was maintained in England. There were, of course, other ways of preventing Elizabeth's succession, and some of them were contemplated by advisers to Mary, but Mary would have no part in them. The only impeccable and infallible way to retain Catholicism and prevent Elizabeth from succeeding was for Mary to have an heir. For her husband she chose King Philip of Spain and of the Netherlands, a somewhat natural choice because the Tudors and Hapsburgs had long been allies, and England's commercial interests were closely tied to the Netherlands. Mary recognized this and the marriage agreement stated that if Mary and Philip had a male child he would be Philip's heir in the Netherlands and Burgundy as well as Mary's in England, an arrangement that would give the English political control over an area to which they were strongly tied commercially. Great care was taken in drawing up the marriage agreement in order to ensure Mary's rights. Though Philip was called king of England and was to assist in the government, Mary alone was to bestow and only Englishmen were to be appointed to fill offices in church and state. If Mary died without an heir Philip had to renounce all claims to the English throne.

00:00:05# The Subordinated Sex

In spite of such safeguards, as well as the potential advantages to England of control over the Netherlands, Mary's marriage was greeted with considerable hostility. Hatred of the foreigner was particularly rampant at this time in England, and much of the success of Henry VIII had been due to his ability to exploit and foster such hatred. Even while the treaty was under negotiation there was a rebellion led by Thomas Wyatt, whose motives were in part religious (hostility to the return of the Catholic faith) but mostly political (the threat of a Spanish king). Mary managed to put down the rebellion and her throne was saved by the loyalty of the citizens of London, but the hostility to Philip remained. Some of this hostility was transferred to Mary herself by her executions of Protestants who refused to accept her Catholic appointees, and though the numbers were not great in total the average of some ninety a year caused increasing antagonism toward her. The growing domestic discontent was further complicated by Mary's involvement in the wars of her husband with France, which led to the loss of the last British outpost, Calais, on the European continent. Unfortunately, also, Mary, in spite of all her ambitions for the future and her genuine affection for her usually absent husband, proved unable to conceive a child. The first English experiment with a woman ruler proved to be little short of disastrous.

Elizabeth, on the other hand, was much more successful. In fact, she turned out to be a political genius, and much of her success was due to her ability to remain unmarried, not subordinate to a husband. It was not enough to remain unmarried; Elizabeth also had to avoid having an illegitimate child. Her ability to do this meant either that she was sterile or that she remained a virgin, since there were no effective birth control pills and abortion was dangerous. Her countrymen believed she remained a virgin, a belief commemorated in the American state of Virginia and its offshoot West Virginia, dedicated to the virgin queen. Though it seems clear that Elizabeth, with the example of her sister Mary before her, had probably decided not to marry, she did not publicly commit herself to spinsterhood, and for some twenty years she was one of the most courted women in all history.

It is indicative of the way in which women have been regarded that even as late as the nineteenth century there were some "historians" who felt that, judging from Elizabeth's success, she must have been a man in disguise. These people argued that Elizabeth, following the execution of her mother, was more or less neglected, isolated from the court, and lodged in the countryside. Here she became ill and died, but her guardians, fearful of telling the king of the death of his daughter, and

knowing that he probably would not recognize her anyway, scoured the countryside for a replacement of the right age. Unable to find a suitable girl child they utilized a boy. This, it was said, explained Elizabeth's somewhat masculine features in her old age, including a tendency to baldness, as well as her "masculine ability" in ruling. Naturally it explained her reluctance to marry.

Though it is easy to be cynical about the reputed intellectual accomplishments of the rich and powerful, Elizabeth obviously was intelligent. She had a very real love of learning and was from all evidence very learned in her own right. She must be regarded as one of the great rulers of England; her abilities were early attested by her teacher, Roger Ascham, who wrote to a friend that it was difficult to say

> whether the gifts of nature or of fortune are most to be admired in my distinguished mistress. The praise which Aristotle gives wholly centers in her; beauty, stature, prudence, and industry. She has just passed her sixteenth birthday and shows such dignity and gentleness as are wonderful at her age and in her rank. Her study of true religion and learning is most eager. Her mind has no womanly weakness, her perseverance is equal to that of a man, and her memory long keeps what it quickly picks up. She talks French and Italian as well as she does English, and has often talked to me readily and well in Latin, moderately in Greek. When she writes Greek and Latin, nothing is more beautiful than her handwriting. She delights as much in music as she is skillful in it. . . . I am inventing nothing, my dear Strum; there is no need.[53]

The success of Elizabeth leads one to question how many other able women were denied chances to succeed. The numbers must have been legion. Elizabeth's reign, however, led to little change in the status of women, although it seems likely that at least some women wondered whether it was not unreasonable to subject themselves to such stringent male controls while a queen was ruling England. There was considerable controversy over the nature of women's role, which perhaps grew out of Elizabeth's reign,[54] but women remained firmly under the control of their husbands. The legal status of women in England is evident in the case of Frances Coke, younger daughter of Sir Edward Coke, the famed champion and exponent of the common law. Frances was a daughter of Coke's second marriage, to Elizabeth Haton, which was not a particularly happy alliance. Coke, anxious for support at court, arranged for Frances, then fourteen, to marry Sir John Villiers, the eldest brother of the king's favorite, the duke of Buckingham. Villiers unfortu-

nately was mentally defective and inclined to spells of insanity. Lady Elizabeth felt that her daughter could expect a better match and tried to secrete her in a cousin's house. Coke, however, seized Frances by force, and when her mother attempted to complain about his conduct to the Star Chamber, she found herself put into custody, unable even to attend her daughter's wedding. Frances's husband took the name of Lord Purbeck after the property he hoped to receive from his wife, but apparently he had other things wrong with him than defective intelligence. When Frances gave birth to a child, she was suspected of adultery and was sentenced to pay a heavy fine, sent to prison, and made to do public penance wearing a white sheet. She eventually managed to escape her imprisonment, but her money and property went to her husband.[55]

If women were asserting themselves somewhat more during the sixteenth century, which is at least debatable, the self-assertive woman and even the educated one faced growing hostility in the seventeenth. King James I of England, for example, was particularly hostile to female pretensions. When a learned young lady was presented to him at court with a comment on her ability in Latin, Greek, and Hebrew, he is said to have replied: "But can she spin?" In 1620 he urged the clergy of his kingdom to "inveigh vehemently against the insolence of our women."[56] James was also known for his belief in witchcraft, which in some ways seemed to institutionalize a fear of women.

The period from 1485 to 1750, in fact, was the great age of witchcraft, and Europe went berserk in seeking out witches. Some areas were worse than others. In general, the witchcraft trials were restricted to France, Germany, Scotland, England, and to some extent Italy. Holland, the Scandinavian countries, Ireland, and Spain were virtually free from the delusion, as was most of eastern Europe. Until almost the thirteenth century the official position of the Christian church was that acts associated with witchcraft were all illusions or fantasies originating in dreams and that belief in the actuality of witches was a pagan and heretical custom. This idea was challenged in the writings of St. Thomas Aquinas, who held that even though witches might be illusions or dreams they were no less real. The key document in changes toward witchcraft, however, was a papal bull of Innocent VIII in 1484 designed to assist in eradicating witchcraft in Germany. Appointed to carry out the search for witches were two Dominicans, Heinrich Kramer and Jakob Sprenger, who between them wrote a manual, *Malleus Maleficarum*, or the *Hammer of Witches*, first printed in 1486. The manual had the merit, or perhaps fault might be a better term, of codifying all the folk belief about black magic and witchcraft into church dogma, and

in the process it opened up the floodgates of hysteria. Before 1520 the book had gone through thirteen editions, and it continued to be published during the sixteenth century. The authors argued that witches were more likely to be female than male, because women knew no moderation whether in goodness or in vice, and they quoted a whole catalog of church fathers and other misogynistic writers to prove that women were the sources of all evil, that they had defective intelligence, inordinate passions, and weak memories, and that they tried to dominate men.[57]

The root of the fear of witches lay in the social tensions of the time, marked by the growth of heresy, by the appearance of Protestantism, by challenges to old defined dogmas, but also by the changing social scene in which women were challenging some of the old assumptions. Witchcraft could explain not only what seemed mysterious and dangerous but also even the odd and the deviant. One reason that Joan of Arc, for example, was condemned was that she wore men's clothing and fought like a man; such a form of deviant conduct could only be due to witchcraft. Once the Protestant movement appeared, both Catholics and Protestants turned to hunting witches with equal abandon. In a sense the belief in witches was a clerical phenomenon foisted upon a somewhat reluctant public, and it reflected all the hostilities of the clergy, including their traditional misogyny. When the new science of Galileo, Kepler, and Newton effectively challenged some of the basic assumptions upon which Christianity said witchcraft worked, both the fear of witchcraft and the power of the clergy were weakened.[58]

Though both men and women could be witches, it was women by far who were most often accused. In England six times as many women were indicted as men, and contrary to popular impression, twice as many married women were charged as were spinsters or widows.[59] Germany suffered the most from the persecution; some 100,000 of its people were executed, the vast majority of whom were women. In 1631 Cardinal Albizzi on a trip to Cologne wrote: "A horrible spectacle met our eyes. Outside of the walls of many towns and villages, we saw numerous stakes to which poor, wretched women were bound and burned as witches."[60]

Reginald Scot, an Englishman somewhat skeptical of the theories about witches, in 1584 tried to explain why women were found to be witches more often than men. It was, he wrote, because

they have such an unbridled force of fury and concupiscence naturally that by no means is it possible for them to temper or moderate

the same. So as upon every trifling occasion, they (like brute beasts) fix their furious eyes upon the party whom they bewitch. Hereby it comes to pass that women having a marvelous fickle nature, when grief so ever happens to them, immediately all peaceableness of mind departs; and they are so troubled with evil rumors, that out go their venomous exhalations, engendered through their ill-favored diet, and increased by means of their pernicious excrements, which they expel. Women are also (it is said) monthly filled full of superfluous humors, and with them the melancholic blood boils; whereof springs vapors, and are carried up, and conveyed through the nostrils and mouth, etc., to the bewitching of whatsoever it meets. For they belch up certain breath, wherewith they bewitch whomsoever they list. And of all other women, lean, hollow-eyed, old, bettlebrowed women are the most infectious.[61]

How much the threat of being accused as a witch kept a woman in her place is difficult to determine historically, but there was a concerted effort in the seventeenth century to reassert masculine prerogatives. In England this appeared most obviously in the Puritan marriage relationships. Though the wife was the husband's friend and companion, she was also his servant, deriving her authority from him. The nature of the wife's subordinate status in Puritanism has been the subject of much discussion,[62] mostly erroneous, but the best literary representation of this tendency is found in the works of John Milton. Milton, while emphasizing that the wife was something more than a sexual vessel, also claimed that she was less than a man. It was because Adam did not maintain his authority over Eve that he fell, and everywhere Milton insisted that women must be subject to man's sway.[63]

Giving further impetus to the need to keep woman in her place were the medical writings of the sixteenth century, most notably those of François Rabelais, who was a physician as well as author of the *Gargantua* and *Pantagruel*. Rabelais was expressing standard medical beliefs when he wrote that nature had placed in female bodies,

in a secret and intestinal place, a certain animal or member which is not in man, in which are engendered, frequently, certain humours, brackish, nitrous, voracious, acrid, mordant, shooting, and bitterly tickling, by the painful prickling and wriggling of which— for this member is extremely nervous and sensitive—the entire feminine body is shaken, all the senses ravished, all the passions carried to a point of repletion, and all through thrown into confu-

sion. To such a degree that, if Nature had not rouged their foreheads with a tint of shame, you would see them running the streets like mad women, in a more frightful manner than the Protides, the Mimallonides, or the Bacchich Tyades on the day of their Bacchanalia ever did; and this, for the reason that this terrible animal I am telling you about is so very intimately associated with all the principal parts of the body, as anatomy teaches us.[64]

The only way women could control this internal animal, the womb (Rabelais said it was an animal because it moved by itself), was by absorption in other activities, by subordination to the male. "I shall not go any further into this dispute. I merely would say to you that those virtuous women who have lived modestly and blamelessly, and who have had the courage to rein in that unbridled animal and to make it obedient to reason, are deserving of no small praise indeed. And I may, in conclusion, add that once this same animal is glutted, if glutted it can be, through that alimentation which Nature has prepared for it in man, then all these specialized motions come to an end, all appetite is satiated and all fury appeased."[65]

During the sixteenth century, at the same time the concept of a lady was being developed, women's clothes became more confining and limited their abilities to engage in any real activity, almost as if reality were being reshaped to conform to official attitudes. The result was that the very women who were writing and thinking the most about the role and status of women were among those who were being forced to confine themselves to corsets and limit their action by yards and yards of material. In general, prior to the fifteenth century women's costumes had followed the natural configuration of the body, with no artificial or confining shaping. By the end of the fifteenth century, however, two items of female apparel appeared that tended to limit their freedom of activity, namely the "busc" and the "farthingale," both of which were also known under various other names. The busc was an early form of corset. It was made from two pieces of linen, stiffened by paste, stitched together, and shaped to the waist at the sides. To keep the front part really rigid a piece of wood, horn, whalebone, metal, or ivory (busc was the technical term) was inserted between the layers, thick at the top and tapering toward a point at the waist. Shoulder straps were attached to hold this "pair of bodys" or stays in place since they were not shaped to the breasts, and they were laced together. The effect must have been like a tight waistcincher that also held the breasts in, since illustrations and

literary references indicate that the ideal woman in the last part of the sixteenth and first part of the seventeenth centuries was one with a small waist.

To further accentuate the waist farthingales (verdynggale) were developed. The term comes from the Spanish *verdugos* (saplings). The farthingale was basically a kind of hooped petticoat, probably originally made from saplings. At the beginning of the sixteenth century the farthingale was cone-shaped by a series of graduated hoops, giving the required shape, but it was bolstered by adding extra padding to the hips to give a more rounded shape. Some farthingales required enormous amounts of material to complete and as much as fifty yards of whalebone and buckram to construct. The difficulties of wearing one were indicated by an epigram of the sixteenth century: "Alas, poor verdingales must lie in the street, / To house them no doore in the citee made meete, / Syns at our narrow doores they in can not win, / Send them to Oxford, at Brodegates to get in."[66] The Venetian ambassador to the court of France described the French women in 1577 as having "inconceivably narrow waists: they swell out their gowns from the waist downwards by whaleboned stuffs and vertugadins, which increases the elegance of their figures. Over the chemise they wear a corset or bodice, that they call a 'corps pique' which makes their shape more delicate and more slender. It is fastened behind which helps to show off the form of the bust."[67] By the seventeenth century, the French-type farthingale had replaced the Spanish. The hooped petticoat remained tub-shaped but it was stretched out from the sides by means of a thick bolsterlike bustle commonly known as "a bum roll," a sort of doughnut open at one end and tied around the waist. Anne, the wife of King James I, wore one so expansive that she was four feet wide at the hips.[68]

With such a costume the lady became ever more handicapped in her movements, and more and more activities were denied to her. Perhaps the most ludicrous denial of rights, to our minds, was the refusal to let women play female roles on the stage. On the stage a woman was usually not a female but a male. This was not so much the case in Italy as in England, but the custom was widespread. In a sense the Europeans were simply following the Greek practice, but there were additional reasons that emphasized the subordinate and protected status of women. Modern drama originated in the late Middle Ages from two sources, from groups of strolling players who were at first officially classed as rogues and vagabonds and from church dramas. Both excluded women. Women who appeared in the strolling groups would have been despised as shameless and scorned as prostitutes, and because women could play no

active part in either the services or the offices of the church, they were usually prohibited from serving as actresses in religious drama. As the dramatic art took on new luster in the sixteenth century, men continued to play the heroines. Actors were formed into companies, each under the patronage of a wealthy member of the aristocracy, and younger boys were apprenticed to leading actors from whom they learned their art. Many of them would start out playing female roles as well as the smaller male parts. Some became quite famous for their impersonations.[69]

It seems difficult for us to imagine males playing some of the juicier female parts in Shakespeare's plays, but this was the custom and the playwrights adjusted to it. It might well be that some of the female roles were written to be more masculine than they might otherwise have been. The controversial modern drama critic, Kenneth Tynan, for example, has gone so far as to suggest that Lady Macbeth is basically a man's role, and it is a mistake to cast a woman in the role at all. This might well be another example of male chauvinism, twentieth-century chauvinism if you will, in denying that women could have or should have as dominating a personality as Lady Macbeth. We know the names of some of the men and boys who played the Shakespearean roles. The first Ophelia is thought to have been Nathaniel Field; the first Desdemona, the famous Richard or "Dickie" Robinson. Lady Macbeth was probably originally played by Alexander Cooke, and the ambitious role of Rosalind was played by Willie Ostler. Robert Gough or Goffe was the first Juliet and possibly the first Cleopatra. Perhaps the difficulty boys and men had in impersonating women in their early twenties and thirties was one reason Shakespeare's female roles were primarily for older women or young girls. The French included actresses in their dramas somewhat earlier than the English, but when a French troop with actresses ventured onto the English stage in 1632, the women were jeered and pelted with apples. It was only in the last part of the seventeenth century that female actors made their appearance in England.

In sum, though we increasingly hear the voices of women in the sixteenth and seventeenth century challenging traditional attitudes, these attitudes managed to survive the challenge. Though women emerged as powerful queens, and both among the Anabaptists on the Continent and during the Puritan Revolution in England were significant spokespersons for change, men remained in control of the institutions in the long run. Thus, while individual women might be able to break the barriers, women as a group could not. The ideal for women at the end of the seventeenth century was to be good wives and mothers, an occupation

for which girls were trained from early childhood. This is not to put down the role of wife and mother, only to indicate the limitations that women faced, since to be a good housewife then as now was not an easy occupation: it required that the woman run the house efficiently, beautify it with the work of her hands, and spiritually make it a place of peace and happiness for those who lived in it. The good housewife was to "be of chaste thought, stout courage, patient, untired, watchful, diligent, witty, pleasant, constant in friendship, full of good Neighbourhood, wise in Discourse but not frequent therein, sharp and quick of speech, but not bitter or talkative, secret in her affairs, comfortable in her counsels, and generally skillful in the worthy knowledge which do belong in her Vocation."[70] We might add that she was to be subordinate to her husband and to males in general. There had been some changes, but the more things changed the more they seemed to be the same, at least as far as women were concerned.

10 / China and India: Inferiority Is Not Only Western

$$T$$hough this book concentrates on Western civilization, it is important to realize that a belief in woman's inferiority and her subordination was not confined just to the West. This belief was present in Eastern civilization as well. To do justice to the East it would be necessary to write as lengthy a treatment as we have devoted to the West, something we cannot do in such a brief study, but some indication of Eastern positions can be gained from an overview of attitudes in India and China. The same problems of sources exist in these areas as in the West, namely their male orientation, but third world areas, particularly those areas where Westerners came as conquerors or colonizers, also pose another problem to the historian of attitudes about women. Not only are the sources themselves male-oriented, but because of their colonialist attitudes the Europeans often obscured and reshaped indigenous history to suit their own needs and in the process tended to obscure further the role of women. Though this is less true of China than of India, it is very much the case with other third world—though non-Eastern—regions like Latin America and Africa.

Women in India, as in the West, were completely under the subjugation of males. There are some indications that the level of subordination was not as severe in very early Indian history as later, and in fact some historians believe they have found evidence of an early matrilineal system. Many of the early tribes in India, for example, were named after

women, such as the Kādravey, descendants of Kadrū, the Vinateya of Vinatā, the Daitya of Diti, and the Dānavas of Danu. As in the West, some investigators have claimed that there is evidence of an early matriarchal system, since originally the female divinity, at least in some parts of India, took precedence over the male, as among the Sāktas, and in the dual form of divine names the goddess was almost always named first, as in Lakshmī-Nārāyan, Gaurī-Sankar, Rāha-Krishna. There are also surviving legends of states ruled by women, which at least indicate that the Indians did not think female rulers were beyond the realm of probability. With the appearance of the Aryans, an Indo-European speaking people, in the second millennium B.C., however, patriarchy was firmly established, and in the religious pantheon the female became, if she had not always been, subordinate to the male. She was not then, though, as subordinate as she later became.

The earliest extant literature of these Indo-European invaders is the *Veda*, and these writings indicate that women, though clearly subordinate, still held an important function in the religious rituals, a function that only gradually was taken away from them. During the Vedic period most religious rites and ceremonies were open to them, and women took an active part in the various rituals. Certain sacrifices were restricted to women. The Vedic age also produced at least a score of eminent female scholars, poets, and teachers; and a number of hymns included in the *Rig-Veda*, composed some time between 1500 B.C. and 900 B.C., were attributed to women. By the time the first Hindu law codes emerged around A.D. 100, however, women had lost more ground vis-à-vis the male.[1]

Hindu law was not based on the decree of a sovereign or political body but rather on sacred scriptures believed to be divinely inspired and unalterable. It assumed a metaphysical foundation of universal regularity and order in the whole cosmic process, and from this concept came the notion of *dharma*, which means law, religion, morality, and in effect the universal laws of nature that uphold the cosmos. The earliest and most famous of these laws was that of Manu, which dated from about A.D. 100, although according to orthodox Hindu tradition the laws coincided with the appearance of man himself. The purpose of the code seems to have been to give divine sanction to the institution of caste, to make caste supreme in India, and the Brahman supreme among the castes. In these laws women were put under the control of men:

By a girl, by a young woman, or even by an aged one, nothing must be done independently, even in her own house.

In childhood a female must be subject to her father, in youth to her husband, when her lord is dead to her sons; a woman must never be independent.

She must not seek to separate herself from her father, husband, or sons; by leaving them she would make both [her own and her husband's] families contemptible.

She must always be cheerful, clever in [the management of her] household affairs, careful in cleaning her utensils, and economical in expenditure.

Him to whom her father may give her, or her brother with the father's permission, she shall obey as long as he lives, and when he is dead, she must not insult [his memory].[2]

Men must be continually watchful of their womenfolk. "Day and night women must be kept in dependence by the males [of their families], and if they attach themselves to sensual enjoyments, they must be kept under one's control. . . . Women must particularly be guarded against evil inclinations, however trifling [they may appear], for, if they are not guarded, they will bring sorrow on two families. Considering that the highest duty of all castes, even weak husbands [must] strive to guard their wives."[3] Women by their very nature were wicked creatures.

It is the nature of women to seduce men in this [world]; for that reason the wise are never unguarded in [the company of] females.

For women are able to lead astray in [this] world not only a fool, but even a learned man, and [to make] him a slave of desire and anger.

One should not sit in a lonely place with one's mother, sister, or daughter, for the senses are powerful, and master even a learned man.[4]

[When creating them] Manu allotted to women [a love of their] bed, [of their] seat and [of] ornament, impure desires, wrath, dishonesty, malice, and bad conduct. For women no [sacramental] rite [is performed] with sacred texts, thus the law is settled; women [who are] destitute of strength and destitute of [the knowledge of] Vedic texts [are as impure as] falsehood [itself], that is a fixed rule.[5]

For women who accepted their status and obeyed their masters there were rewards.

Women must be honoured and adorned by their fathers, brothers, husbands, and brothers-in-law, who desire [their own] welfare.

Where women are honoured, there the gods are pleased; but where they are not honoured, no sacred rite yields rewards.

Where the female relations live in grief, the family soon wholly perishes; but that family where they are not unhappy ever prospers.

The houses on which female relations, not being duly honoured, pronounce a curse, perish completely, as if destroyed by magic."[6]

Yet in spite of this the slaying of a woman was not a particularly serious crime, since as Manu says, "stealing grain, base metals, or cattle," having "intercourse with women who drink spirituous liquor," and slaying a woman are "all minor offences, causing loss of caste."[7]

Other lawgivers generally reflected Manu's biases, although Yājñavalkya, who denounced Brahmanic avarice, has been regarded as less misogynistic, but only to a slightly lesser degree. Yājñavalkya also taught that the ideal woman spent all her greatness and goodness in maintaining a happy home and husband and always obeyed the men in her family. Woman's duties included these: "Learning to arrange furniture and being expert, cheerful and frugal, she should worship the feet of both her parents-in-law, and be devoted to her husband. She whose husband is away from home, should abandon playing, beautifying the body, joining societies, and festivities, laughing and going to another's home. Devoted to the pleasure and to the good of her husband, of good conduct with subdued passions, [such a wife] obtains renown in this world, and after death attains the best end."[8]

Until recently in India, it was often held that being born a girl was a penalty for some sin committed in a previous incarnation. In many areas of the subcontinent the birth of a girl was not announced, or it was merely stated that "nothing" had been born. The friends awaiting the birth of a boy then went away "grave and quiet."[9] Females were regarded as an encumbrance and a burden from birth. They were an impediment in war; they had to be protected in time of peace; they were unclean and dangerous during their menses, pregnancy, and childbirth; they had to be provided with a dowry when they married; they were of no use to anyone as widows. The father of daughters, even though his position was as exalted as a king, had to put up with insults not only from equals but from inferiors as well. Even when the father succeeded in selecting a good son-in-law, his anxiety did not end, for he still had to wait to find out whether the marriage was a happy one. Inevitably, female infanticide was practiced on a wide scale from earliest times; the casting away of children and of unmarried mothers of unwanted girl babies and the destruction of the fetus were mentioned in the Vedic texts. The

Yajur-Veda told of girls being exposed when born, a custom that continued down through the centuries with little effort to modify it. In Bengali a woman might drown her child in fulfillment of a vow; in western India female infants were strangled or smothered; among the Rajputs parents often used to kill their unwanted children, usually girls, either by refusing proper nourishment or sometimes by poisoning the nipples of the mother's breasts.[10] Those who try to find some justification for such a callous disregard of girl children indicate that perhaps it was not so much a hatred of the female sex as an anxiety to see that the daughter was well placed so that she could live in comfort and happiness,[11] but this seems a rather farfetched apology.

Women, nevertheless, had their place, and in the religious rituals of Hinduism they were indispensable, because certain ceremonies could not be performed by a Brahman unless his wife was with him.[12] She was, however, to be clearly subordinate to her husband. Unmarried daughters were to live in chastity and obedience toward their father, mother, and other kinfolk. Marriage was not only a necessity for girls but a religious sacrament as well, since it was believed that a female virgin could never attain spiritual enlightenment in this world or reach the abodes of bliss in the next. Marriages were arranged by the father, and if he died his role was to be taken over by a girl's brothers. Brotherless maidens were believed to be exposed to all kinds of danger, so that a girl with brothers was preferred as a bride.[13] The absolute necessity of acquiring a husband led Indian parents to marry their daughters at younger and younger ages and also led to a widespread discrepancy between the ages of the bride and groom. Marriage was so important to a girl that at times formal marriage ceremonies were performed over corpses of girls who had died before they had been married.

In the Vedic period, when the emphasis on marriage was not so overwhelming, girls were usually married at fifteen or sixteen years of age. By the period A.D. 500–1000 many of the writers were urging that girls be married before the age of ten, the age at which it was believed they reached puberty. Certain factions argued for even younger marriages, and five- and six-year-old brides were not unknown. Early marriages helped the parents secure a guardian for the daughter in case the father died.[14] As younger marriages came more and more into vogue, women's educational accomplishments deteriorated. In turn, this lack of education lessened women's importance in Hindu religious ceremonies, leaving them less and less independence. Inevitably, women were relegated to the home, where they were out of sight if not out of mind. While some of the girls in the cultured and rich families still acquired some

learning, it was increasingly the outcast girl who managed to maintain any degree of independence. As in Greek society when women had been so subordinated, men turned to prostitutes and dancing girls for entertainment and companionship, and India developed a special class of prostitutes to entertain the male.[15] Woman in general, however, had no independence in virtue, religion, or law; they did not even have the freedom to dispose of themselves. As one modern Hindu woman lamented, the only place a woman could be free of the male was "in hell."[16]

Often the difference in ages between a man and his child bride was very great, and it was not unusual for a man of fifty or sixty to marry a girl of five or six. Even if the husband died before consummation, which was not usually attempted until the girl was about ten, the child was regarded as a widow and could not remarry. Some children were even married in embryo. In such cases two pregnant women underwent the formalities of a marriage ceremony, and this union by proxy, providing the children turned out to be of opposite sex, was absolutely binding.

Unlike Westerners, whose attitudes toward women seem to have been at least in part motivated by a fear of sex, the Indians welcomed sex. The Hindu never regarded marriage as a condition inferior to virginity, nor was there any notion of sex being impure. Virginity had no special cult; lifelong celibacy was permitted for men, but it was never enjoined as a permanent ideal. Celibacy for women (except widows) was actively discouraged, since heaven was not open to the sacramentally unconsecrated, that is, the unwedded maiden.[17] Asceticism as practiced in India was usually a temporary discipline, a self-restraint imposed as a means of acquiring magical powers. Sex, moreover, was strongly emphasized in the outward aspects of Indian religions, such as the statues of the gods; in these anthropomorphic conceptions both female and male elements were portrayed in all their sensuousness.[18]

Intercourse was said to be performed for four basic reasons: for procreation, in which case it took place between a husband and wife; for pleasure, where an experienced woman or a professional courtesan served as the companion; for motives of power, as when a man desired to triumph over a husband through possessing his wife; and for magical purposes. In this last case the woman herself was equated with the sacred place: her hips and haunches with the sacrificial ground; the mons veneris with the altar; the pubic hairs with kusa grass; the moist labia with the soma press; the yellow vulva with prepared fuel; the red-tipped phallus with the ember; lust, with smoke; penetration, with the mystic chants; voluptuousness, with sparks; movement, with the burning heat; orgasm, with the living flame; and semen, with the oblation.[19]

This cult sexuality appeared in both Hindu and Buddhist scriptures, but it received its fullest rationale in Tantrism. The origins of Tantrism are unknown, but it dates from very early times and is the prototype of yoga and other magical techniques.

Separate from, but also allied to, mystical sex was sex for the purposes of pleasure, and there were many Hindu love texts, the most famous of which was the *Kamasutra* compiled by Vatsyayana in the fifth century A.D. According to tradition Vatsyayana remained an ascetic celibate all his life, and his work was written entirely from imagination without any personal experience. There are hundreds of other books on erotica, although few of them are available to the English-speaking reader.[20]

Just as sex asceticism in the West served to justify the subjugation of women, so did sexual liberation in India. Hinduism depicted woman as by far the more sexual of the two partners. Whether men or women enjoy sex the most has often been debated, but on this subject Hinduism offered definitive answers—it was women who did. The answer appeared most simply in the tale of a king named Bhangāsvana, who was known as a tiger among men yet was unhappy because he lacked sons. In desperation he went through a special religious ritual that served to guarantee him sons, but in the process he angered Indra, the most prominent of the Vedic gods of the heavens. Indra sought revenge, but it was not until Bhangāsvana had had one hundred sons that the god was able to find a means of punishing the king. Indra's chance came when the king became lost while hunting; Indra gradually led the king to the shores of a beautiful lake where, weary, he stopped to bathe in what proved to be magical waters. When the king emerged he found that he no longer had the body of a man but that of a woman. Though ashamed at his condition he (or now she) went back to the city and reported to her numerous wives, sons, and subjects what had occurred. Unable to be king any longer she retreated to the forest, taking up life as a companion to a holy hermit. As his mistress she soon bore as many sons as a woman as she had begotten as a man.

Indra, ever observant but still angry, felt that the ex-king had not suffered enough for his impiety in making such a sacrilegious sacrifice. As further punishment Indra hit upon the idea of having the two sets of sons of the woman-king fight against each other until they all were killed. The death of all her sons set the ex-king to weeping and wailing so loudly and piteously that even Indra was moved to have pity. He revealed himself to the woman and asked a paradoxical question: Which of the sets of sons that had been killed would she choose to have live again if she had the choice? The ex-king replied that she would prefer to

have the sons she had borne as a woman because a woman "cherishes a more tender love" than man, and it was for mother's love that she wanted her sons. Impressed by the answer, Indra not only granted the wish but also restored to life both sets of sons. Indra then asked the ex-king which sex she would be if she had a choice of remaining a woman or being changed back into a man. She chose to remain a woman because the "woman has in union with man always the greater joy, that is why . . . I choose to be a woman. I feel greater pleasure in love as a woman, that is the truth, best among the gods. I am content with existence as a woman."[21] In effect, women, though subjugated to men, have the consolation of sex to keep them content.

There are numerous stories in Hindu scriptures that further amplify the sensuality of women and the satisfactions of sexual pleasure for them. Ila, who was both a man and a woman during alternate months, spent his/her time as a woman in sexual pleasure, while her/his time as a man was spent in pious ways and thoughts.[22] In the *Rāmāyana*, one of the great epics of Hinduism, the insatiability of women in love appeared in the story of the woman who exhausted her husband as well as the ascetic who had taken her away from him.[23] There is an old Hindu proverb that says that woman's power in eating is twice as great as that of a man, her cunning or bashfulness four times as great, her decision or boldness six times as great, and her impetuosity or delight in love eight times as great.[24] It was commonly accepted that without sexual enjoyment a woman would pine and ache. But love was not only a tonic for a woman, it also had noble meaning, since it filled her whole being, making her steadfast and faithful, and as it grew ever deeper, it strongly mingled with the altruistic.

Though emphasizing woman's sensuality and need for love, Hinduism also limited its direction by stressing that the greatest joys of love for women were found within the bonds of marriage. Love could blossom anywhere, but it was only in the garden of wedlock that the full depth of the glowing colors and innermost perfumes was revealed.[25] Early Vedic writings seemed to hint that a certain amount of promiscuity might have once existed,[26] but if so it did not linger on into recorded history. According to Hindu tradition the blind seer Dīrghatamas ordained that woman was to have only one husband as long as she lived, and if he died, she was not to remarry. If a woman went to a man other than her husband, she lost caste, as did an unmarried woman who prostituted herself.[27]

Hindu writings portrayed woman in the most favorable light, either as a sensual sexual creature or a devoted wife and mother. This contrast of

burning sensuality and devoted mother was perhaps a reflection of the dualism that seems to be inherent in Indian thought. It has been said that nowhere in any area of the world has woman as loving wife and tender mother been more extolled or appreciated,[28] and even the misogynist Manu said that where women were not honored all other religious deeds were barren.[29] The *Rāmāyana* reported that at first all beings were alike in stature, sex, speech, and so on, but then the Maker made a distinction, taking the best from all beings, out of which he shaped woman. Good women could not be soiled or spoiled and like the pearl could be found in the most sordid of environments. On the other hand, there were passages that painted woman as the sum and substance of all that was evil. When the divine wise man Narada attempted to find the cause of evil in the world, he found that women inevitably were its basis. Women lacked the moral bonds of men, and even when they found rich and worthy husbands, they threw themselves into the arms of bad men as soon as they had a chance. A woman who remained faithful to her husband did so only because she did not have a chance to stray or because no other man could be found who was willing to woo her. Women were envious of youth and other women and continually in need of love. Women were death, the wind, the underworld, the ever burning entrance to hell, the knife edge, the snake, the fire; woman was each of these and she was all of them. While there were good women, the glorious ones, the mothers of the world, they were more than balanced by the evil ones, who loved no man with whom they united.[30] The deception of woman was a continuing theme in Hindu literature.

There are other strains in Indian thought, particularly that represented by Buddhism, which was founded in India by Buddha in the fifth century B.C. Scholars prefer to call Buddhism a system of morality or ethics rather than a religion, since its essential concern is with moral precepts by which men should live. There was nothing in his life that would indicate that Buddha set out to reform Hinduism, but many of the doctrines he promulgated were contrary to basic Hindu beliefs. As far as women were concerned Buddha emphasized their equality with men, and although their activities were in general confined to domestic, social, and religious functions, their status was considered in theory as equal to that of men. Among the followers of Buddha the birth of girl children was not looked upon with despair and matrimony was not held before them as the end of their existence. Women were regarded as individuals in command of their own lives, and not just chattels to their husbands.[31] Buddhism, however, in spite of its great contribution to India, was submerged into Hinduism within India itself, although it exer-

cised great influence outside that country. Though in some areas in India Buddhist ideas lingered on to elevate the status of women, in general the Hindu concept of woman as somewhat of a lower animal than man remained dominant. Sikh and Parsee concepts were also different from Hindu, but it was the Hindu influence that dominated India.

Nowhere was the concept of the inferiority of women more exemplified than in the custom of suttee, the Hindu rite of suicide of widows by self-immolation. The word itself is said to be derived from Satī, wife of Siva, who committed suicide because her husband had been insulted by her father. The term was extended to mean the "true" wife who remained faithful to the memory of her husband by not marrying again, and eventually it came to mean the rite by which a widow committed herself to the flames of the pyre on which the body of her husband was cremated.

There has been considerable speculation about its origins, since there were apparently no clear references to it in the Vedic literature. The one line in the *Rig-Veda* that has sometimes been held to justify the custom has been shown by scholars to be a later interpolation. The interpolation, however, was important, because by changing the Sanskrit word *agre* to *agneh* a sentence was changed from "Let the mother advance to the altar first," to "Let the mothers go into the womb of fire." Max Müller, the great nineteenth-century Anglo-German Orientalist and comparative philologist, called this change of text "perhaps the most flagrant instance of what can be done by an unscrupulous priesthood." The custom of suttee, however, was not established by this change of text, only encouraged, and it seems clear that by the time the modification in the scripture took place the custom must already have been in vogue in order to require scriptural justification.[32] The first instances of suttee were recorded in the Indian epics, and when the Greeks of Alexander the Great visited India in the fourth century B.C. they found suttee already being practiced in the Punjab. By the first or second century A.D. the rite had gained the support of some of the lawgivers, who declared it a meritorious act on the part of the widow. By the sixth and seventh centuries the life of a widow apart from her husband was being unequivocally condemned as sinful, and she was urged to mount the funeral pyre with him. Though the rite was probably at first restricted to the wives of princes and warriors, it also spread to other groups in society. Two kinds of suttee were distinguished; the *saha-marana*, or co-dying, in which a widow burned herself on the same fire as that on which her husband's corpse was cremated, and the *anu-marana*, in which the woman delayed her death for some reason but died on a pyre lit with embers preserved

from her husband's cremation. This second type of suttee usually took place only if the widow was in an impure state at the death of her husband. Impurity could result from menstruation, in which case a week was to pass after the cessation of the period before she could commit suttee, or from pregnancy, and then suttee was to be delayed until two months after the birth of the child. Suttee involved a rather elaborate ceremony. The woman was given a ceremonial bath, and then, dressed in her finery and ornaments, she accompanied the body of her husband to the cremation ground. Since it was believed that the woman who died in suttee would have access to the spheres of heaven she was entrusted with messages to carry to deceased relations. Arriving at the pyre, she gave away her ornaments, which were kept by the recipients as precious mementos of her sacrifice. She then mounted the pyre and sat beside the corpse, placing her husband's head on her lap, after which the pyre was lit. Since many women would have second thoughts about their self-immolation as the flames approached, special precautions were taken to prevent them from jumping from the fire. Often the pyre was laid in a pit from which there was no escape, or the widow was tied to logs or chained to stakes. Sometimes when they still tried to escape they were hit on the head or pushed back with poles. Apparently also some women were drugged.

The custom was particularly prevalent in northern India, where the ritual took on staggering proportions, since polygamy and concubinage were the norm among the upper classes. It was not unknown for several hundred women, wives, concubines, daughters, and devoted female servants to burn themselves to death when their master died. During the period of Muslim domination in India there was an attempt to prevent suttee by instituting a permit system based on a declaration by the widow that she of her own free will wished to become a *satī*, but few women could resist making such a declaration under pressure of their relatives. Being descended from a woman who committed suttee or being related to one was considered a great honor. The Portuguese in their areas of control managed to eliminate suttee after 1510 by taking action against all relatives and bystanders in any suttee ritual. The British took no action in their areas at first, although they did keep records, so that we have some idea of how prevalent the custom was in certain parts of India. In Bengal between 1815 and 1828, for example, the British recorded some 5,100 cases of suttee; in Banaras, 1,150; and in Patna, 700; as well as hundreds of others in other parts of India. In 1829 the British finally classified suttee as a homicidal act, but the practice was slow to die out.

The Subordinated Sex

Scholars have advanced various reasons for suttee, and all indicate the subordinate and subjugated position of women in India. Edward Thompson went so far as to argue that suttee was an inevitable consequence of the Hindu premise that "the husband stands to the wife in place of the Deity." Inevitably it became a mark of female devotion. There was also the fact that male vanity was involved. There was a half-felt belief that a man's possessions could be sent with him for use in the next world if they were burned or buried with him. His wife or wives and other women being his chief possessions, they should obviously be dispatched to the next life. There was also a kind of male jealousy at the thought of leaving a beautiful woman behind after death for others to enjoy, and the fear that one's widow without the necessary supervision might misbehave and bring disgrace to the family. There was the very real fact that relatives were reluctant to be burdened with the responsibility of having to support a widow and were happy to have her out of the way. The ancient Greeks believed that the Hindus had instituted suttee to prevent a wife from poisoning her husband, since she would have to die with him as well.

Why would women follow through and commit suttee? Undoubtedly, many of them believed that it was essential they do so. There was also the dread of being a widow in Hindu society, probably the most unfortunate character in the whole range of Hinduism. To the orthodox family, at least in medieval India, a widow was ill luck incarnate. If she was young and childless she was even more calamitous than if she had children, since as a husbandless, barren, menstruating female, her presence brought contamination, the sound of her voice was a curse, her glance was poisonous, and her very existence was perilous. She was treated as a thing apart, as if she were already dead. Since remarriage was an impossibility, those widows whose parents would not take them back or who had no other means of support were destined for the streets, a not particularly pleasant existence. It took a long time for conditions to change in India, and as late as 1948 a survey showed that the age of widows ranged between eight and fifty-four, with the average being close to twenty, evidence of continuing child marriages. Some 16 percent of the widows had not had their marriages consummated, and another 14 percent had lived with their husbands for no more than a year. The average period of married life was seven years.[33]

To summarize, Hinduism started out with a higher status concept for women than any of the other world religions, but because of conquests by foreigners, the growing rigidity of the caste system, and the increas-

ing emphasis on marriage for women, women became more and more subordinated to men. Hinduism ultimately failed to recognize any life for women other than marriage. Though the freedom of the prostitute was limited in many ways, the more successful and powerful had far more personal freedom than the ordinary wife or mother. Often, however, prostitution was forced upon women. A woman who was supposed to perform suttee and failed to do so often had to turn to prostitution in order to support herself; young girls could be sold into prostitution; and for a woman without a husband there was often no other alternative.

Chinese history covers the same period of time as the whole of Western civilization, and obviously over a span of four thousand years there were some differences in attitudes toward women. As in the West, however, regardless of time or dynasty, in China women have been regarded as inferior to men. Some observers have even said that women as a group were treated even more unjustly in Chinese society than Western,[34] but it seems likely that most such Western observers have not really paid attention to how women were regarded in the West.

In the earliest periods of Chinese history, prior to 1100 B.C., women may have been held in more esteem than later, just as was the case in India. This is perhaps demonstrated by the fact that the family organization, and even the sexual morality, of the early Shang people was very loose, and there are even indications that a kind of matriarchy existed.[35] Again, matriarchy is much too strong a term, since what evidence there is tends to show the existence of matrilineal descent and matrilocal practices rather than matriarchy. Several attitudes that later had great influence on Chinese attitudes toward women can be traced back to these early periods of Chinese history. Some of the earliest surviving texts, for example, described woman as the initiator of sex, with the male as a mere student, and throughout Chinese society this seems to be one consistent measure of attitudes toward women. The more puritanical periods in Chinese society coincided with greater hostility to women, while in the more relaxed periods in which sexuality was more openly accepted women tended to be regarded with slightly less hostility. Women throughout Chinese history were revered as mothers, and the Shang character for woman emphasized the large breasts of the pregnant woman. Men on the other hand were represented as a piece of cultivated land, emphasizing the male function of tiller of the land and provider for the family.[36] Women were also associated with the color red, which among other things stood for sexual potency, creative power,

and happiness, whereas white, the color coupled with the male, was the color of death, impotency, and negative influences. The symbol for family was also closely linked with women and birth.

Later the various alchemical treatises of the third century A.D., which probably reflected earlier beliefs, also credited woman's essence, the Yin, with special rejuvenating and strengthening power.[37] At the same time the Yin was subordinate to the Yang. The Chinese taught that the interaction of the Yin and Yang produced everything in the universe. Yin was the negative principle corresponding to shade, darkness, the moon, water, weakness or yielding, depth, and all things feminine. Yang, the positive principle, corresponded to light, brightness, the sun, strength, fortitude, and all things masculine. One was passive, the other active; one submissive, the other dominant; and though they were antithetical to each other, each was indispensable and necessary. In theory husband and wife, as Yang and Yin, were equal, but man's superiority over woman was clearly accepted.

This subordination was expressed under the principle of the "three dependencies": (1) dependency upon the father when a girl was young, (2) dependency upon the husband after marriage, and (3) dependency upon the son after the death of the husband. A woman could never act autonomously. On her wedding day her parents gave her their final instruction, encouraging her to be "respectful and cautious" and not to "disobey" her husband. The husband's authority replaced the father's, and the husband was regarded as ruler over his wife in much the same way as a king over his minister or the father over a son.

Within the family woman's right to rule the household was recognized, but she ruled it for the benefit of her husband. Care of the children, cooking, washing, sewing, cleaning, and directing the maidservants were all inside tasks and in the final analysis were services performed for her husband. Apparently few women worked regularly in the fields, even among the peasants, although they probably joined in for harvesting. Many women were attached directly to the great households, doing various sorts of work, including silk culture, which was regarded as a woman's task. Here they were at the mercy of those above them, and this meant that the lord of the household had a perfect right to use them as he pleased. Women in such households were known as *ch'ieh*, a word that later came to mean concubine. If one of them bore their master a child this improved her status, and a male child of such a woman could even be made his father's heir, although this was not usually the case. Probably the institution of concubinage grew from such a custom, yet generally such women were regarded as little more than a

means of amusement. One early prime minister was praised for his honesty and frugality with the statement that "his concubines never wore silk and his horses never ate millet."[38]

Throughout Chinese history women were accustomed to living in considerable seclusion and proper women were not usually seen at public ceremonies, although they were sometimes placed behind a screen so that they could observe without being seen. Symbolic of this subordination was the later *fu* character for woman, which was a combination of the characters for female and broom and implied both to serve and to submit. Since no family could have two authorities, the woman had to submit to her husband. After his death, her son or some other male member of the husband's family succeeded to this position, and although a mother or grandmother was senior to her son or grandson, she could never become the family head. As an ancient proverb stated, "If a hen rules at morning the family comes to an end."[39] It was as an old woman, however, that the woman probably received the greatest respect and exercised the greatest authority.

The Chinese family included several generations occupying the same dwelling, living under the authority of the eldest generation and holding goods and property more or less in common. Though the authority of the male head of such families was virtually absolute, almost that of life or death, the authority of his wife was second only to his, and she exercised great influence over her daughters-in-law. If she outlived her husband, her influence increased. As one historian has written, the "authority of the old woman of position in China is a thing which defies definition."[40] Filial piety was regarded as the chief of Chinese virtues, and no son was supposed to turn against his mother. Particularly difficult was the position of daughter-in-law in such families, since she was clearly subordinate to her adopted parents; a scolding by a daughter-in-law could result in the death penalty if the parents of her husband lodged a complaint with local authorities.[41]

Like Western society, Chinese society also had a double standard in which adultery by the husband was regarded as a mere peccadillo, if that, while adultery by a wife could be punished by death. The Chinese woman had practically no right to seek a separation or divorce from her husband, although he could divorce her for any number of reasons: disobedience to his parents, barrenness, adultery, jealousy, incurable disease, loquacity, and theft. If, however, she had no close relatives to receive her, or if she had worn mourning clothes for three years for the husband's parents, or if her husband had been poor at the time of the marriage and had since become wealthy, she could not be divorced. Di-

vorce, even when permitted, was a drastic solution, and often a man simply took a concubine and more or less ignored his wife. In fact, in the eighth century A.D. it was held that a man whose wife had failed to give him a son and heir could be punished unless he took a concubine. This was because the lack of a son might force the discontinuance of the worship of his ancestors. A wife could do little about such actions except perhaps feel sorry for herself. There is an early poem from the Chow dynasty, first millenium B.C., expressing the feelings of a supplanted wife:

> You feast with your new wife,
> And think me not worth being with. . . .
> My person is rejected;
> What avails it to care what may come after. . . .
> You cannot cherish me,
> And you even count me as an enemy.
> You disdain my virtues,
> A pedlar's wares which do not sell. . . .
> Feasting with your new wife,
> You think of me as a provision [only] against your poverty.
> Cavalierly and angrily you treat me;
> You give me only pain.
> You do not think of the former days,
> And are only angry with me.[42]

If a wife came from a powerful family, she could appeal to her family for support, but in general, polygamy and concubinage were widespread, at least among those who could afford the practices.

Not all women submitted meekly to the taboo that forbade them to take part in public affairs. The *Odes of Yung* included a poem about a woman who, involved in the disaster of her state, correctly saw the course that might have saved it but was prevented from acting because people would have dismissed her recommendations as only from a woman. "Ye great officers and gentlemen, / Do not condemn me. / The hundred plans you think of / Are not equal to the course I was going to take."[43] Probably, however, if she had been more discreet in her recommendations they might have been accepted, since various Chinese biographies of women indicated that they often saved their menfolk from disaster by giving them timely advice.[44] Several bronze inscriptions also tell us that the wives of kings and other rulers sometimes held the reins of power while their husbands were away on military expeditions.[45] There were even a few women rulers, such as the empress Nēe Lü in the

second century B.C., who ruled after the death of both her husband and her son. Nevertheless, the general opinion of woman as ruler or royal adviser was low. Moralists had little good to say of women but rather delighted to tell of kings and princes who meet their doom through feminine intrigue. One of the worst things that could be said of a man was that he followed "the words of his woman."

> A wise man builds up the wall [of a city],
> But a wise woman overthrows it.
> Admirable may be the wise woman,
> But she is [no better than] an owl.
> A woman with a long tongue
> Is [like] a stepping-stone to disorder.
> [Disorder] does not come down from heaven;
> It is produced by the woman.
> Those from whom come no lesson, no instruction,
> Are women and eunuchs.[46]

Traditional Chinese society was deeply influenced by the teachings of Confucius and Lao-Tse, who were active about 500 B.C., and also by the teachings of the contemporary Indian thinker Buddha. Buddhism began to permeate China shortly after his death but did not arrive in force until the first centuries of the Christian era. Within India itself Buddhism was gradually absorbed in Hinduism, but in China, modified by Chinese disciples, it found new force. Each of the movements founded by these men, Confucianism, Taoism, and Buddhism, helped form Chinese attitudes toward women, but probably the dominant one was Confucianism, and it was also the most antiwoman.

Next to nothing is known about the personal attitude of Confucius toward women, although he did state that both women and people of lowly station were difficult to deal with. "If you become close to them, they turn non-compliant, if you keep them at a distance, they turn resentful."[47] The interpreters of Confucius soon worked out a rather detailed system in which the position of woman was set forth as absolutely and unconditionally inferior to that of man; quite simply she did not count. Woman's prime duty was to serve and obey her husband and her parents, to look after the household, and to bear male children. The biological functions of women were emphasized; psychological considerations were given only secondary importance. Chastity was a requisite for orderly family life as well as for the undisturbed continuation of the lineage. Inevitably, female premarital chastity assumed almost the semblance of a religious cult. To ensure the least amount of temptation

or contamination, the Confucianists advocated the complete separation of the sexes and carried this through to its most absurd consequences, even to the extent that the husband and wife were not supposed to hang their garments in the same closet. The ideal woman was one who concentrated all her efforts on her household tasks. Participation in outside affairs, especially in public matters, was abhorred as the root of all evil and the cause of the downfall of the great dynasties.[48]

A song in the *Shih Ching,* or *Book of Songs,* one of the five Confucianist classics, described the different customs observed for a newborn boy and girl, symbolizing their future status in life and the different attitudes toward the sexes:

> So he bears a son,
> And puts him to sleep upon a bed,
> Clothes him in robes,
> Gives him a jade sceptre to play with.
> The child's howling is very lusty;
> In red greaves shall he flare,
> Be lord and king of house and home.
> Then he bears a daughter,
> And puts her upon the ground,
> Clothes her in swaddling-clothes,
> Gives her a loom-whorl to play with.
> For her no decorations, no emblems;
> Her only care, the wine and food,
> And how to give no trouble to father and mother.[49]

The male child was dressed in bright clothes, for he must one day appear in court, while the woman would remain hidden from view. The bit of jade given to the boy symbolized the badge of office that he would hold as a man, whereas the loom-whorl given to the girl symbolized the work of spinning that was woman's work in life.[50]

Confucianism was fundamentally a practical philosophy adapted to a patriarchal state. Its ideas were essentially ethical, and they continued to be elaborated upon over the centuries. Eventually they gained the support of the Chinese rulers and Confucius was honored as the great sage; his creed became a kind of state doctrine. In the ideal state advocated by Confucius, marriage was insisted upon for all, and the chastity of women assumed the semblance of religious cult. Even the remarriage of widows was tolerated only at certain times and under the rule of certain dynasties, while during others the rigid seclusion of women was insisted upon and the remarriage of widows was considered a

moral crime. A woman spent her time running the home and bringing up children, and she was supposed to have little time to devote to her own education or to perfecting herself in the arts. Too much learning was considered dangerous to her virtue; it was not the function of wives to supply their husbands with intellectual or emotional companionship. When a man needed a woman to share his mental life with him or to teach him romantic love, he took her from among the courtesans. Proper women were barred from male society other than that of their own relatives.[51] They were not supposed to share men's intellectual interests, and they were strictly forbidden to meddle with male activities outside the house. Even the young daughters in upper-class families were taught only the womanly skills such as weaving and sewing and looking after the household; they were not taught reading and writing in any regular manner. In spite of this, some women managed to leave an imprint upon history.

One who did was Lady Pan Chao (d. A.D. 116), daughter of Pan Piao, a well-known writer and administrator, and sister of Pan Ku, a famous historian. Pan Chao was married as a girl of fourteen, but when her husband died young, she, as an adherent of Confucius, never remarried. Instead she devoted herself to her literary studies, in which she had been initiated by her father, and she became famous for her polished style and wide learning. When her brother died without completing his history, the emperor Ho ordered her to finish it; he also appointed her instructor to the empress. Lady Pan was no feminist but a devoted adherent of the Confucian philosophy, and she accepted the inferiority of woman to man. One of her best-known works is a pamphlet, *Nü chieh,* or "Women's Precepts." In the chapter entitled "Humility," she summarized the ideal woman:

> Let a woman modestly yield to others; let her respect others; let her put others first, herself last. Should she do something good, let her not mention it; should she do something bad, let her not deny it. Let her bear disgrace; let her even endure when others speak or do evil to her. Always let her seem to tremble and to fear. [When a woman follows such maxims as these,] then she may be said to humble herself before others.
>
> Let a woman retire late to bed, but rise early to duties; let her not dread tasks by day or by night. Let her not refuse to perform domestic duties whether easy or difficult. That which must be done, let her finish completely, tidily, and systematically. [When a woman follows such rules as these,] then she may be said to be industrious.

Let a woman be correct in manner and upright in character in order to serve her husband. Let her live in purity and quietness [of spirit] and attend to her own affairs. Let her love not gossip and silly laughter. Let her cleanse and purify and arrange in order the wine and the food for the offerings to the ancestors. [When a woman observes such principles as these,] then she may be said to continue ancestral worship.

No woman who observes these three [fundamentals of life] has ever had a bad reputation or has fallen into disgrace. If a woman fail to observe them, how can her name be honored; how can she but bring disgrace upon herself?[52]

She gave other characteristics of the proper woman:

To guard carefully her chastity; to control circumspectly her behavior; in every motion to exhibit modesty; and to model each act on the best usage, this is womanly virtue.

Man is honored for strength; a woman is beautiful on account of her gentleness.

To wash and scrub filth away; to keep clothes and ornaments fresh and clean; to wash the head and bathe the body regularly, and to keep the person free from disgraceful filth, may be called the characteristic of womanly bearing.

With whole-hearted devotion to sew and to weave; to love not gossip and silly laughter; in cleanliness and order [to prepare] the wine and food for serving guests, may be called the characteristics of womanly work.

To choose her words with care: to avoid vulgar language; to speak at appropriate times; and not to wear others [with much conversation], may be called the characteristics of womanly words.[53]

Though Lady Pan felt that girls should be educated, her whole ethical system was based on the belief that woman's place was in the home. The purpose of education was to teach girls right from wrong, but other than this defense of female intelligence, she accepted female inferiority. Women were not to assemble together in groups, nor if they traveled outside the home were they to attract attention. Lady Pan believed that a widow should not marry again because a wife could not ever leave a husband, and taking a second husband would have meant she deserted her first one.

To obtain the love of one man is the crown of a woman's life; to lose the love of one man is to miss the aim in woman's life.

For these reason a woman cannot but seek to win her husband's heart. Nevertheless, the beseeching wife need not use flattery, coaxing words, and cheap methods to gain intimacy.

Decidedly nothing is better [to gain the heart of a husband] than whole-hearted devotion and correct manners.[54]

Lady Pan's advice to women was similar to that of a whole series of manuals advising women how to behave, all of which emphasized woman's submissiveness to men. A related genre was the *Lieh-nü-chuan*, or *Biographies of Eminent Women*, the prototypes of which dated from the first century B.C. Essentially, these biographies consisted of edifying stories of women who sacrificed themselves for their husbands, virtuous widows who preferred death to remarriage, and women who when their husbands needed it gave them wise advice.[55]

How much do these reflect reality? It would seem obvious that the place assigned to woman in theory and that prevailing in practice might well be quite different. That reality might have been somewhat different is evident from a statement made by Ko Hung, a third-century philosopher, who felt that the failure of women to observe their proper place in society was leading to the decay of the family and the ruination of the state. He urged the wise men to keep their womenfolk under more effective control. He claimed that women and girls no

longer engage in spinning and weaving, they do not like any longer to make cap-tassels, they do not make hemp, but they love to gad about on the market place. They neglect the supervision of the kitchen, but devote themselves to frivolous pleasures. They go out visiting to see their relatives, they proceed there by the light of the stars or carrying torches, night after night. . . . Along the road those ladies indulge in unseemly jokes and pranks. . . . These women also make pleasure trips to Buddhist temples, they go out to watch hunting and fishing. . . . They even travel beyond the district-boundaries. . . . They proceed there in open carriages with curtains raised.[56]

Not all philosophers, however, were misogynists, and a contemporary of Ko Hung, a scholar by the name of Fu Hsüan, lamented the low status of women.

Bitter indeed it is to be born a woman,
It is difficult to imagine anything so low!
Boys can stand openly at the front gate,

They are treated like gods as soon as they are born.
Their manly spirit bounded only by the Four Seas,
Ten thousand miles they go, braving storm and dust.
But a girl is reared without joy or love,
And no one in her family really cares for her.
Grown up, she has to hide in the inner rooms,
Cover her head, be afraid to look others in the face.
And no one sheds a tear when she is married off,
All ties with her own kin are abruptly severed.
With bowed head she tries to compose her face,
Her white teeth biting her scarlet lips.
Now she has to bow and kneel times uncounted,
Behave humbly even with maids and concubines. . . .
She is blamed for all and everything that goes wrong.
In a few years her gentle face will have changed,
As her husband often goes after new loves.
While at first they were as close as shape and shadow,
Now they are as far apart as Chinese and Huns.
But whilst even Chinese and Huns do sometimes meet,
Husband and wife stay as far apart as Lucifer and Orion.[57]

This same kind of sympathetic understanding appears in Lü K'un's sixteenth-century work, *Kuei fan,* a revision of the biographies in the *Lieh-nu-chuan.* Lü K'un rearranged the categories, eliminated the section on evil women, added a few biographies of his own, and emphasized, in addition to the extraordinary fidelity or virtue of some women, the capabilities of those women who "manage matters well." He praised his heroines not for their submissiveness but for their independent thinking and for their ingenious use of persuasion. His writings also indicated that there was a new literate class of women who encouraged, if they did not demand, a more diversified portrait of women than earlier generations and male writers had provided. One authority has gone so far as to suggest that the sixteenth-century attitudes toward women in literature had so changed from the past that in these works the foundations for the "presumably revolutionary twentieth-century belief in the equality of the sexes" can be found.[58]

Because Lü K'un appealed to the emerging literate class of women, it might well be that his somewhat prowoman stance reflected women's perceptions of themselves more accurately than some of the more misogynistic literature. This only serves to emphasize just how much our

perception of women in the past is a male one. Sometimes, however, women appeared more positively in this literature as well. In part this is true of women in Taoist literature.

Taoism represented another side to Chinese life. If not basically modifying attitudes toward women, it emphasized the importance of the female principle. Lao-Tse, the great prophet of Taoism, concentrated on individual life and tranquility. He and his followers reasoned that the greater part of man-made activities had served only to estrange man from nature, giving rise to an unnatural and artificial human society with its family, state, rites, ceremonials, and arbitrary differentiation between good and bad. The Taoist philosophy advocated a return to pristine simplicity, to a golden age where people would live long and happily, where there would be no good or bad, where everyone would live in perfect harmony with nature, where the Yin and the Yang would be united. Woman was venerated by the Taoists because she was considered to be closer to the primordial forces of nature than man and because it was in her womb that new life was created and fostered. It was the female who possessed the indispensable element for achieving the elixir of life.

> The Spirit of the Valley never dies.
> It is called the Mystic Female.
> The Door of the Mystic Female
> Is the root of Heaven and Earth.
>
> Continuously, continuously,
> It seems to remain.
> Draw upon it
> And it serves you with ease.[59]

Water, the female, and the infant were Lao-Tse's symbols to Tao, and all three were passive, receptive, and quiet.

> He who is aware of the Male
> But keeps to the Female
> Becomes the ravine of the world
> Being the ravine of the world
> He has the original character which is not cut up
> And returns again to the [innocence of the] babe.[60]

Seekers after the One were to be aware of their masculine assertiveness and to keep in mind the way of women, who were passive:

The Subordinated Sex

The Female overcomes the Male by quietude,
And achieves the lowly position by quietude.[61]

Before the Heaven and Earth existed
There was something nebulous:
 Silent, isolated,
Standing alone, changing not,
Eternally revolving without fail,
Worthy to be the Mother of All Things.
I do not know its name
 And address it as Tao. . . .[62]

Though in later Chinese history this role of the primordial mother was ignored or explained away by Confucian exegesis, it remained in esoteric Taoist writing and also had considerable influence on Chinese sexual practices. Sexual activity for the Taoist was a requirement in the search for longevity and hence immortality. The object of such practices was to promote the happy union of Yin and Yang. Man could not live without woman any more than the sky could be separated from the earth. It was necessary, however, to know the proper technique, and for this several works were written on the art of the bedchamber. The contradictory attitudes toward women emphasized by Confucianism and Taoism were seemingly resolved by following the Confucian ideal regarding the social position of the sexes, but their sexual relations were governed by Taoist ideology.

The aim of sexual intercourse was to escape, to transcend the material world, and to replace the body by a heavenly and immortal substance that was nothing less than pure Yang. Even though Yin was the feminine force and Yang the masculine, both sexes had elements of each. Clearly the man had more Yang, but the female, finding herself in the passive position, had the advantage of possessing that sweet power which in Taoist theory ended up by gaining the upper hand. Thus the Taoist sex manuals often assumed an antifeminist position. They believed that the key to the One was found by storing up the male semen, and the various sex manuals instructed men how to do this but warned them not to make this knowledge available to the female. What benefited man was really injurious to woman, so he was advised to get women who were innocent of the Way and to indoctrinate them so as to ensure his sexual well-being. The man was also to absorb woman's Yin essence and at the same time give her physical benefit by stirring her latent Yang nature. According to Chinese sex literature a man's semen

was his most precious possession, the source not only of his health but also of his life; every emission of semen diminished his vital forces unless it was accompanied by the acquisition of an equivalent amount of Yin essence from the woman, which all women possessed in unlimited supply. Men only received this Yin essence from women during their orgasm; they should therefore strive to give women complete satisfaction every time they performed the sexual act. The man, however, should control his passion so that he reached orgasm only occasionally, in order to build up his Yang. If he could get his semen through mental concentration to revert upward through the center of the spinal cord into the brain, he was well on his way to becoming a sage. In effect, even the Taoists, with their belief in sex as a way to Tao, would emphasize that women be kept ignorant of the Key, since if women knew the path as well as men they would have an advantage over them.[63]

In the sixth century A.D. the Taoist communities began to organize themselves into monasteries on the line of the Buddhists, and thereafter the Taoist movement was almost entirely in the hands of the monks. It was only in isolated country districts that a married secular clergy was able to exist. For the monks marriage was forbidden, as were all forms of lewdness, but sexual union occupied too important a place in the philosophy to be condemned. In fact, there were courtesans who specialized in Taoist erotic techniques in most of the major cities, but their customers were not usually men of true religion. Increasingly the merging of the Yin and Yang was to take place within the body, with the heart and the loins representing the two principles, and the true Taoist tried to merge these vital forces, freeing himself from any dependence of any kind on others, alimentary, physical, or sexual.[64] Through this the male adherents could ignore women altogether.

Buddhism, the third of the great intellectual movements in China, never achieved the dominance that Confucianism did, perhaps because it taught that women were equal to men. The Buddhist creed of universal love and compassion, preaching equality of all beings, appealed particularly to the spiritual needs of the Chinese women, while the various female deities, such as the compassionate goddess Kuan-yin, helped them in distress and lent some color to their rather monotonous daily lives. The early Buddhist texts that were translated into Chinese, while mentioning Buddha's position on women, essentially glossed over it to avoid antagonizing what were felt to be Chinese sensibilities. Buddhism, however, allowed women to serve as nuns, and these women, who by virtue of their sex had free access to the women's quarters, were

the favorite counselors of the ladies of the household. Buddhist nuns officiated at intimate household ceremonies, such as prayer meetings for the recovery of a sick child and advising on cures for sterility, and they acted as personal advisers and physicians. They often taught young girls reading, writing, and feminine skills.

Inevitably, public opinion, as represented by the male establishment, regarded nuns and convents with disfavor, and during Ming times (A.D. 1368–1644) a series of novels and short stories painted their alleged iniquities in lurid colors, just as similar stories about nuns were circulated in the West. Even before this time a writer of the Yuan dynasty (A.D. 1280–1368) had cautioned against various women visitors to the women's quarters because they would only stir up trouble. He broke the visitors down into nine groups, three "aunts" and six "crones": "The three 'aunts' are the Buddhist nun, the Taoist nun, and the female fortune-teller. The six 'crones' are the procuress, the female go-between, the sorceress, the female thief, the female quack, and the midwife. These are indeed like the three punishments and the six harmful cosmic influences. Few are the households which, having admitted one of them, will not be ravaged by fornication and robbery. The men who can guard against those, keeping them away as if they were snakes and scorpions, those men shall come near the method for keeping their household clean."[65] In effect, almost all women visitors to the women's quarters were frowned upon, and there was an attempt to keep women in even greater isolation.

Buddha himself had originally been reluctant to allow women to serve as nuns on the grounds that it would corrupt the whole order, though finally he did so after much pleading from his mother. Undoubtedly one of the reasons for male hostility to the nuns was that the monastery offered refuge to girls who abhorred the idea of having to marry men they had never seen, as well as to those wives or concubines who wanted to escape from cruel husbands or tyrannical mothers-in-law. (Many girls, however, had no choice in the matter, and parents would often make a vow that an unborn daughter would become a nun in order to avert a calamity, or in the case of existing daughters would promise them to the monastery in order to help them recover from a disastrous illness.) The idea that women might abandon their sacred duty of propagating the family to live in self-contained communities free from male jurisdiction was also abhorrent to the Confucianists.

Buddhism probably had its greatest influence on Chinese society under the T'ang dynasty (A.D. 618–907), and during this period several women poets emerged into literary history. Not all of these poets were

222

Buddhists, however, and perhaps the two most prominent, Yü Hsüan chi and Hsüeh T'ao, were Taoist nuns.

Following the T'ang dynasty there was a strong revival of Confucianism, which undoubtedly lessened the free association of men and women. Several Confucian philosophers, such as Chou Tun-i and Shao Yung (eleventh century), borrowed concepts from Taoism and founded a syncretic system called Neo-Confucianism. They formulated a new theory on the basis of the system embodied in the *I Ching*, the ancient *Book of Changes*,[66] which was given its final form by Chu Hsi (twelfth century). He stressed the inferiority of women and the strict separation of the sexes, and this theme continued until fairly recent Chinese history. This, however, did not necessarily reduce the number of educated women, since the introduction of wood-block printing at about the same time made it somewhat easier to publish and acquire books. Women also painted, and perhaps the greatest woman literary genius of China appeared during the twelfth century, namely, Li ch'ing-chao, better known by her literary name, I-anu. Most of her poetry has been lost, and only about fifty surviving poems are definitely identified with her. These, however, serve as a mirror to the emotions of a proper upper-class woman and express her feelings at various times in her life, when her husband left home for a short period, when he was away for a longer period at an official post, and after he died. The last seems particularly moving:

> The wind has subsided, the earth is scented with fallen flowers.
> The day being late, I am too tired to comb my hair.
> His things remain, but the man is gone, and life has ceased to be.
> I want to talk but tears begin to flow.
>
> I have heard that spring is still fair at the Twin Stream
> And intend to go there, sailing in a light boat.
> But I am afraid that the skiff at the Twin Stream
> Cannot hold sorrows so heavy. . . .[67]

Increasingly, the chastity of women became a veritable cult, and women were more and more confined. The best evidence for the imposition of greater restrictions was the introduction of footbinding, a practice that made it almost impossible for women to move about without great effort. In fact, there is a Chinese verse: "Why must the foot be bound? / To prevent barbarous running around!"[68]

Scholarly opinion about the introduction of footbinding into China varies, but most would agree that it became almost standard in the

twelfth century. Chinese folklore attributed the custom to a fox who tried to conceal its paws while assuming the human guise of a Shang empress in the twelfth century and thereby set a fashion. Another semi-legendary account says it was started by this same empress, known for her small feet, which she accentuated by binding. Still another version of the story claims that the empress had a club foot that she concealed by binding and that she persuaded her husband to make compression of feet obligatory for all young girls so that she would not stand out.[69]

A Chinese historian of the twelfth century attributed its introduction to the ruler Li Yü (A.D. 961–975), who controlled one section of China prior to its reunification by the Sung dynasty. He had a favored palace concubine for whom he constructed an artificial lotus plant out of gold and on which she danced with her feet tightly bound. Her admirers said she was giving rise to lotuses with every step, and "golden lotus" became a euphemism for bound feet. In spite of the mythical aspects of such stories footbinding probably did begin as a dancing measure and was encouraged in the royal harem, and its diffusion was facilitated as a device for suppression of women. Increasingly as the Neo-Confucianists became more important, there was growing hostility to any feminine liberty and intellectual freedom, an emphasis on female chastity, and a hostility to any remarriage by women. There was also a growing belief that a woman of virtue should be a conventional lady of little talent. Though women were permitted to read proper classical works, they were discouraged from singing or writing poetry. Chu Hsi (A.D. 1130–1200), who introduced footbinding into southern Fukien, felt that it was better for a woman to starve than remarry after her husband's death, and he thought of footbinding as a "means of spreading Chinese culture and teaching the separation of man and woman." By the end of the twelfth century it had become accepted as the hallmark of gentility and correct fashion. Families that claimed aristocratic lineage came to feel compelled to bind the feet of their girls as a visible sign of upper-class distinction. The diminutive feet and hands and slender waist of the upper-class woman indicated that she was incapable of useful effort and had to be supported in idleness by her owner. Several treatises justified the practice as guaranteeing feminine chastity, since though it made women more attractive, it also made it difficult for them to leave their quarters. Gradually footbinding was transmitted from the north to the center and south of China, and the Chinese emphasized it in order to draw a clear cultural distinction between themselves and their large-footed Mongol conquerors. Soon upper-class Manchu and Korean women bound their feet, and the practice was also observed among the Jewish

colony in Honan. It remained primarily an upper-class phenomenon; women of the poorer classes were usually barefooted. Nevertheless, any family ambitious for their daughter's future bound her feet. As early as the seventeenth century various Chinese rulers tried to abolish the custom, but it was not successfully abolished until the middle of the twentieth century.[70]

In summary, women were not particularly highly regarded as human beings in China. They were admired for their beauty, and during the period of footbinding, there was a cult of foot fetishism; they were sought after as sexual mates, and they were respected as mothers. The ideal mother in Chinese literature was the mother of Mencius, a disciple of Confucius. After the death of her husband the mother of Mencius settled with her young son in a house near the cemetery, but she soon realized that she had made a mistake, because the boy at play imitated the ceremonies of burial that he saw enacted. She then moved to another house near the market, and this time to her distress she saw the boy play at buying and selling. Finally she moved to a house near a school, and there she had her reward. Her little son was soon busy imitating the learned scholars he saw about him as they applied themselves to their tasks. She emphasized the necessity of female devotion in a saying attributed to her: "A woman's duty is to care for the household and she should have no desire to go abroad."

This in essence was the ideal of the Chinese woman, sacrificing herself for her family and recognizing her subordination. If she adhered to the role she might as an old woman exercise considerable power over her family and demand filial respect from her sons and her daughters-in-law. As a child, however, she might be sold into prostitution or into concubinage, or given to a convent, or even, if it was believed that it would propriate the gods, killed. If she was born into the upper classes she was somewhat protected from such fates, but after the introduction of footbinding her life was tremendously circumscribed. Though China geographically includes a large area and there were differences in customs in various parts of China, women almost everywhere were regarded as inferior.[71]

Whether these Eastern women were any worse off than Western women at comparable stages in development is debatable. Although footbinding seems a particularly cruel form of confinement, in many ways it was not any more debilitating than the attempts of Western women to narrow their waistlines to eighteen or twenty inches, and it had the same effect of limiting women's physical activity. In fact, unless a girl began wearing corsets as a child, an act which inhibited her phys-

ical activity, she never managed to get the desired narrow waist. Obviously, however, there must have been compensations for the confinement imposed by footbinding, and women themselves, as Lady Pan so ably demonstrated, accepted the idea that they were inferior. Even the love relationship, which sometimes removes antagonism between the sexes, became increasingly restrictive as Chinese society became formalized. As Marcel Granet, the French scholar, argued: "The absence of intimacy is the dominant feature of family organization. This was a significant feature at first in the relations between husbands and wives, and between fathers and sons. It appears to become the rule for all family relations. Dominated by ideas of respect, domestic morality seems in the end to become mixed up with a ceremonial of family life."[72] Gradually a regulated system of relations developed in which the proper actions were dictated in sex and in social situations, as well as in other situations, and spontaneity became impossible. Chinese society was organized on the inferiority of women and the superiority of men. To change this, it was necessary to almost challenge the very foundation of Chinese society.

11 / Role Change and Urbanization

One of the difficulties the amateur has in studying history is the tendency to look at the past from the perspective of the present, to imagine that people lived under conditions similar to our own. Such a practice can only lead one to draw erroneous conclusions, and this is particularly true about the role and status of women. Continually throughout this book we have emphasized that women have been confined to the home, subordinated to their husbands, denied any existence apart from their menfolk. It is important to emphasize, however, that such a condition in the past would be different from a similar one today, if only because the home was such a different place. The overwhelming majority of people, probably as many as 90 percent, earned their living at agriculture and lived in a village. This meant that though women were subordinate to men they worked alongside them in the fields at crucial times, and both men and women used the home or hut as an operational base. Even in the developing cities of medieval and early modern Europe the craftsmen carried on their trades in their homes, assisted by their wives and children. Most retail shops were simply an extension of the home, and only larger enterprises occasionally had a separate warehouse.

Under such conditions women were not only useful but also essential. A wife was not only a mother and a bed companion but also an economic necessity, carrying out hundreds of tasks that assisted in bringing income to the family. Women usually had control of work such as spinning, weaving, making clothes, manufacturing beer, and so forth.

Though the ordinary woman might well cook the meals for her family, this was not a particularly time-consuming task. Meals for the ordinary person were simple and often meant little more than taking something from the ever stewing pot. There were no dishes to wash and no utensils to clean, since all but the richest ate with their fingers. Bread, the staple food in most of Europe, was not made at home by a devoted housewife but in a bakery, since the expense of having an oven in the home was beyond the means of most people. Large numbers of people had servants, although a servant might be only a child. In some cases people sent one of their children out and received someone else's child in return. The higher nobility, and the richer burgers, had several servants, and in the great houses there were a lot of servants, but most of the great houses were isolated in the countryside, and the women of such houses had little time for social affairs. Like the ordinary peasant women they had numerous tasks to perform in running the household, seeing that the wool or other material was spun, woven, and made into clothes, keeping track of the larder, making beer and cheese, and performing other such chores. Unless there were houseguests, the social season was limited, confined to a few weeks of the year, and usually meant moving to the royal court or to a nearby city. During this brief social season women as well as men could put on a display of the latest fabrics and fashions and get ideas to keep them occupied for the rest of the year. During the absence of her husband at war, or for other purposes, the wife was in charge of the household. Though women of the upper classes obviously had an easier time than those of the lower, the point to be emphasized is that women, regardless of the male attitude toward them, were essential, and the tasks they performed were as important to the economic survival of the family as those of the males.[1]

In the sixteenth and seventeenth centuries the nature and function of the nobility changed. In the early medieval period nobility had justified their existence by their military function, but with the invention of gunpowder and the development of cannon, their cavalry charges and individual prowess had become less meaningful. Ambitious kings had attempted to weaken them further because they were the greatest rivals of the kings for power. In the process the kings had turned to the developing cities for income and with this purchased soldiers and established bureaucracies that made royalty more or less independent of the nobles. The nobles, however, still existed, and it was the genius of the seventeenth-century Louis XIV to turn fighting men into courtiers, a trend that had started earlier but was now sanctioned and encouraged by the king. One of the vestigial functions of the nobility was to offer advice to the king, to attend his court, and Louis made his court such an impor-

tant event that no noble ambitious for royal preferment could afford to miss it. Louis also brought women into the royal court and, by emphasizing their social functions, gave them a new kind of importance. Historians are divided on the merits of Louis XIV as a ruler and on the benefits that the French received from his rule, but as a pattern setter and fashion innovator he was unexcelled. Though he often seems a megalomaniac to more democratic modern readers, his imperious manner and the way in which he spent his money made his court the fashion center of Europe and led all other European rulers to try to imitate it. Within France every person of importance tried to attend the king, and he made this a rare privilege difficult to achieve. Only noblemen and women could formally be presented to him, and the way in which a person was presented and the length of time the person spent with the king became a method of measuring status within France. In effect status depended upon the whim of the king. To emphasize the importance of his court Louis built a new and lavish, as well as extremely uncomfortable, palace at Versailles. It cost a fortune to build, so much that Louis tried to hide the cost from his advisers, and it has been estimated by some that six out of every ten francs collected in taxes during the later part of his reign went to support Versailles and its attendants.

From Versailles emanated the dress, manners, speech, and fashions of Europe, and though court life, because of its artificiality, must have been basically dull, no ambitious French noble or would-be noble could ignore it. Ballet, opera, drama, art, and literature were all sponsored by the court, and inevitably those who achieved the patronage of the king had their reputations made. As the court grew in size, and the king's patronage became more important, factions arose between those who received royal favor and those who did not, and between those who received more royal favor and those who received less. At the time of Louis's death in 1715, these factions were evidenced by the fact that some of the French intellectuals either preferred to work away from Versailles or were denied access to the court. After his death, the nature of patronage changed radically. His successor, his great-grandson, who took the name Louis XV, was only a child of five, in no position to serve as patron; moreover, there was a decided intellectual reaction to the policies of Louis XIV. Louis, however, had brought men and women together in a social setting, and even his detractors continued to follow the same procedure, albeit on a smaller scale. The result was the rise of the salon. Perhaps inevitably, since it was the only acceptable way in which they could express themselves, certain powerful and ambitious women dominated the salons.

Literally, a salon was a drawing room, but it came to be the term

applied to any reception at which society gathered for balls, dances, gambling, or even conversation. The purpose of a salon was nominally the pleasure of meeting congenial acquaintances, but it was also a method of displaying new fashions, new talents, and new ideas. A few women, perhaps tired of the trivia at some of the social gatherings, turned their salons into intellectual gathering places where philosophy could be discussed and important intellectuals invited. It was through such salons that the *philosophes*, the philosophers or intellectuals of France, spread their rather revolutionary ideas. Nevertheless, the purpose of such gatherings was essentially social, and even though philosophy was one of the favorite games, the interest was not in deep, detailed philosophical questions but rather in living, amusing, and fascinating discussion. Even the most serious topics almost always had a tone of artificial levity, and to be effective it was necessary to veil major thoughts in graceful conversation.

The key to a good salon was a host or hostess who could keep the conversation scintillating, introducing the right people, making the kind of statement or exclamation calculated to send the guests off on another round of discussion. Women proved particularly adept at this, perhaps because they could appeal to the mighty egos of some of their guests without threatening them as equals. Though the role of hostess traditionally belonged to women, these women made it something more than it had been in the past, and in the process influenced history. Madame de Tencin, an unfrocked nun, managed to effect the appointment of two cardinals (her brother and her lover) while running one of the most brilliant salons in Paris. Madame du Deffand, regarded by Voltaire as an equal, felt free enough to criticize Rousseau. She was also a friend of the English prime minister, Horace Walpole, who periodically escaped to France to see her. Later the illegitimate daughter of her brother, Mademoiselle de Lespinasse, usurped her place and induced many of her aunt's brightest guests to come to her salon instead. Madame Geoffrin, a member of the bourgeoisie and therefore never able to be presented at court, turned her salon into a brilliant social empire and counted among her friends the tsarina of Russia and the king of Sweden.[2]

Salons in imitation of the French sprang up in most other European countries. The sponsors of such affairs in England came to be known as bluestockings, originally a rather derogatory term that implied that persons who attended them were interested more in conversation than in dress. Though the origin of the term is somewhat debatable it is believed to have resulted from the fact that Benjamin Stillingfleet, unable

to afford the correct black silk stockings then worn by fashionable society, made do with some blue or black worsted stockings. Whether this was true or not, women who pretended to any intellectual abilities afterwards were called bluestockings. In London the major hostesses were Mrs. Elizabeth Montagu and her rivals Mrs. Elizabeth Vesey and Mrs. Frances Boscawen. London, however, never rivaled Paris in the eighteenth century, in part because London was not the intellectual center of Great Britain in the same way that Paris was of France, but also because Englishmen were more addicted to clubs exclusively composed of men. In fact, a larger number of women, known for their own intellectual accomplishments, attended the salons in England than they did in France.

In spite of the fact that the salon was widely imitated, its era was limited to a rather brief moment in the history of high society when it was fashionable to sponsor intellectual gatherings. Fashions, however, change, and women turned to other kinds of social activities, if only because the number of intellectual guests who met all the requirements was limited and only a few hostesses could compete in this arena.[3] Much of the decline, however, had nothing to do with the women involved but was dependent on the changes taking place in the eighteenth century. As the century turned from discussion to action, women found themselves losing out, and by the time of the French Revolution the salon had disappeared altogether. During the Directory period in France, at the end of the eighteenth century, there was a rather deliberate attempt to revive the salon, but the new leaders of France were unaccustomed to the refined play acting of the aristocratic society and viewed the salons more as places for ostentatious display of newly acquired fortunes or power than as centers of intellectual conversation. This same exaggerated display carried over into the nineteenth century, as women, cut off from any real competition in the world at large, attempted to make their societal activities meaningful by throwing all their thwarted energies into competition for place and status.

Since women were so important in the salons, or more probably because equality followed naturally from other ideas, the *philosophes* paid considerable attention to the position of women in society. At the core of their thought was an attempt to formulate new political and social views based on the discoveries and theories of science. They believed that societies operated in accordance with natural laws as binding as the mathematical laws governing the functioning of the universe. The key words for the *philosophes* were *reason* and *natural*, terms that they interpreted to mean that people, unmolested by arbitrary authority and

231

dependent upon their own reason and observation, could find the laws governing human nature and then act accordingly to make a better world. Without intending to be revolutionary, the *philosophes* were soon at odds with many established institutions that seemed to them to have no real reason for existing and that they felt were contrary to natural law. Society had to remove such institutions because once people found truth, they should act accordingly and live in greater virtue and happiness. To find truth it was necessary to gather knowledge, to challenge old assumptions, and to eliminate obstacles. This could best be done by education, since only through the intellect could people distinguish between good and evil, become virtuous and therefore happy.

The women's "defects" of which the *philosophes* were conscious were no longer regarded as imposed by the laws of nature but instead were believed to have been acquired as a result of the conditions under which women lived. This meant that if the conditions were changed, the shortcomings of women could be eradicated. Therefore, it was essential that women develop their native mental ability, as it was only by becoming enlightened—knowledgeable, so to speak—that they could become virtuous and shun evil. A number of the intellectual leaders of the eighteenth century spoke out on the question. Voltaire denounced the injustice of woman's lot. Diderot felt that woman's inferiority had largely been made by society. The Marquis de Condorcet in two pamphlets, *Letters of a Citizen of New Haven* and *On the Admission of Women to the Suffrage*, pleaded that women be granted equal social and political rights but felt that this step would require them to be equally educated. Without education they could only be dangerous rulers.

A change in the tone of writings about women can also be noted taking place in England at this time. Potentially the most influential writer was John Locke, who in his *Second Treatise of Civil Government* (1690) emphasized that familial power was vested in both the mother and the father, not in one or the other. He supported his position on both rational and scriptural grounds. Scripture, according to Locke, disclosed that children owed obedience to both father and mother, while reason demonstrated that the child's physical and intellectual weakness and inability to give consent put it under the jurisdiction of both parents. Unfortunately, Thomas Jefferson, who based the Declaration of Independence upon the *Second Treatise* and copied the phrase "all men are created equal" from Locke, probably did not mean what Locke had meant, that all people, both male and female, were created equal.

William Wollaston's *The Religion of Nature Delineated* included a section devoted to "Truths Concerning Families and Relations," in

which he stated that marriage involved not only the propagation of the species but also the mutual happiness of the couple. David Hume wrote on such subjects as "Of Polygamy and Divorce" and "Love and Marriage" and held that the subordination of woman was a sign of a barbarian society. Francis Hutcheson in his *Short Introduction to Moral Philosophy* published in 1747 held that the powers vested in husbands by the civil laws of many nations were monstrous. Some writers did more than talk and write; they also acted. Voltaire, for example, fell in love with the marquise du Chatelet, who "thought as I did, and who decided to spend several years in the country, cultivating her mind." He wrote that he was "tasting in absolute peace and a fully occupied leisure, the sweets of friendship and study with one who, unique among women, can read Ovid and Euclid and who possesses the imagination of one allied to the precision of the other."[4]

Nevertheless, the intellectual woman was suspect, and it was the reaction more than the revolt, if it can be called that, that set the pattern. Part of the difficulty was that, in France at least, the eighteenth century was an age of debauchery and the leader was the king of France, Louis XV. When his queen, Maria Leczinska, denied the king access to her bedchamber, the king turned to other women, and there were a succession of royal mistresses, the most famous of whom was Madame de Pompadour. Madame de Pompadour realized quite early that in order to maintain her position she had to keep the king continually distracted. To meet this need a special house in the Deer Park (Parc aux Cerfs) district of Versailles was purchased to house two or three mistresses at a time. The women (often girls) in the house lived a rather secluded life, except for visits from their patron and lover, whom they were taught was a Polish nobleman. When a girl ceased to attract the king, she was paid off with some jewels or a sum of money and married off to some discreet husband. When Madame de Pompadour died, her place was taken by Jeanne, Comtesse du Barry. During her reign as royal whore the Deer Park became less important, if only because Louis was growing old while Jeanne was still very young. With the king setting such an example, however, the rest of French society followed, and inevitably much of the sexual excess was blamed upon women. The Goncourt brothers, in their *Woman in the Eighteenth Century*, held that the influence of "women was highest" during the eighteenth century, and they claimed that in France women ruled throughout the whole century. Though the Goncourts held that it was the influence of women that had raised the cultural level of France,[5] if such an argument is accepted the implication is also clear that it was women who had caused France all its mis-

ery as well. The Goncourts, however, exaggerated the position of women in eighteenth-century France, since the only way women could effectively act was through men. There was, moreover, a new kind of hostility to women that appeared in force during the eighteenth century, different from the misogynism of an earlier period, namely, the so-called libertine literature that emphasized the sensuous and unstable nature of the female.

Several of the *philosophes* wrote erotic works that tended to put down women as victims of their passions, motivated by self-seeking, pleasure, and vanity. This fact makes one wonder how deep their commitment to female equality was, since even Denis Diderot supposedly wrote such literature in his *Bijoux indiscrets*. The most famous names in this respect, however, were Choderlos de Laclos and the Marquis de Sade in French, Casanova in Italian, and in English John Cleland, famous for his *Memoirs of a Woman of Pleasure*, or *Fanny Hill*. Laclos's *Liaisons Dangereuses* told how two young men seduced an innocent girl who then became a whore and how a young, religious matron was systematically driven to infidelity and finally to death. The Marquis de Sade went further. He believed that since a woman's sensation of pleasure in sex can be shammed, while pain cannot, pain rather than pleasure was the highest form of sexual activity for women. Nothing, to him, was so monstrous that it could not be a source of joy. Though de Sade wrote to his wife that his sole wrong in life was to love women too much, and he gave some of them wickedly triumphant roles in his novels, his feeling seems to have been quite the opposite of what he claimed. Simone de Beauvoir, for example, said that his novels effectively demonstrated the contempt and disgust that de Sade felt for servile, tearful, mystified, and passive women. She wondered whether de Sade might not have hated women so much because he saw in them his double rather than his complement and because there was nothing he could get from them. "De Sade felt himself to be feminine and he resented the fact that women were not the males he desired. He endows Durand, the greatest and most extravagant of them all, with a huge clitoris which enables her to behave sexually like a man."[6] Though Casanova has been called a skilled lover rather than a libertine, he wrote that his chief business in life was "to cultivate the pleasures of the senses." Casanova's descriptive narrative made his story something more than an account of his love affairs. It became, in fact, a valuable picture of the manner and morals of the period and perhaps, in Havelock Ellis's words, a "dignified narration of undignified experiences." John Cleland, in his erotic account of the adventures of Fanny Hill, again emphasized women as sex-

ual objects, although he managed to do so in the most chaste English, using no "vulgar" words at all.

Inevitably, when the French Revolution swept away much of the ancient regime, it also swept away what were regarded as the evils of that society. It did not, however, legally change the rights or status of women. Perhaps this was because it essentially was a middle-class revolution, respectful of middle-class institutions, and in its attitudes toward women it leaned more on Rousseau than on Voltaire. Rousseau's attitude toward the female probably was most felt in education, and this attitude in turn looked back to Fénelon, whose treatise on the education of girls had been published in 1686. That year also saw the establishment of the first boarding school for girls by Madame de Maintenon, the uncrowned queen of France, and the publication of Abbé Fleury's *De choix et de la methode des études*, which had a chapter on studies for females. Fleury, Madame de Maintenon, and Fénelon all agreed that moral and intellectual education were inseparable. There was no need for women to study the classics because then they might become bluestocking intellectuals; even a knowledge of modern language had its dangers because it might lead to a taste for novel reading, but girls should learn to read and write their own language correctly. Arithmetic was of value to a future housewife, and girls should be trained to carry the responsibilities that managing an estate entailed. Above all, girls should learn to exercise reason, because then they could be led by intelligent discussion rather than unreasoning flattery. It always had to be kept in mind that women were weaker than men: "A woman's intellect is normally more feeble and her curiosity greater than those of a man; also it is undesirable to set her to studies which may turn her head. Women should not govern the state or make war or enter the sacred ministry. Thus they can dispense with some of the more difficult branches of knowledge which deal with politics, the military art, jurisprudence, philosophy and theology. Even the majority of the mechanical arts are not suitable to them. They are made for exercise in moderation. Their bodies as well as their minds are less strong and robust than those of men."[7] Fénelon thought that girls were best brought up in their own homes although some convents might be permissible. If a girl was educated at home it was up to her mother to oversee the process, though a governess might be called upon for help. It was for this reason that he composed his treatise. He realized that a curious woman might be unhappy because of the restricted nature of her education but argued that she was wrong to be so because this meant that she did not recognize the importance of the subjects on which she was instructed.

Though St. Cyr was founded by the wife of a king, it effectively dem-
onstrated the prevailing hostilities to any education for females. In spite
of rigorous control over the girls in the school, St. Cyr, perhaps because
it was a boarding school located in Versailles, soon achieved a reputation
as a place for training royal mistresses. Though there was no truth in
such rumors, they forced revision of the curriculum, and this led to the
girls being put under even more stringent controls. In spite of such
changes the gossip continued, until in 1692 St. Cyr became a regular
Ursuline convent. Its graduates, nonetheless, were the best-educated
women in France, and St. Cyr became not only the best convent board-
ing school in France but also a teachers' training college sending out an
annual batch of graduates who became either wives and mothers or
teachers in other convent schools.[8]

It was against this background of female education in France that the
educational writings of Jean Jacques Rousseau appeared. Rousseau
thought that before progress could take place a moral revolution was
necessary, and such a revolution could only occur when government
itself had been transformed into an expression of popular will. Part of
such a revolution would establish the ideal relation between the sexes,
where men would be active and strong and women passive and weak.
Rousseau held that it was necessary that one sex have the power and the
will and the other be subordinate. He believed that those who advocated
equality of the sexes, with reciprocal duties and obligations, were in-
dulging themselves in idle declamations. To cultivate the qualifications
of the male in the female implied the neglect of those qualities that
were peculiar to her sex, and therefore he felt the process was contrary
to human nature. In his *Emile*, or more fully *Emilius and Sophia or a
New System of Education*, he argued that woman existed only by refer-
ence to man; she was made to please him and to obey him; so nature
willed it. His model of the ideal may be taken from his description of
Sophie's musical ability:

Sophie has natural talents; she feels them and she has not ne-
glected them, but not having been in a position to put much art
into their cultivation, she has contented herself with using her
pretty voice to sing in tune and with taste, her feet to walk lightly,
easily, and with grace, to make a reverence in all sorts of situations
without embarrassment or awkwardness. Otherwise, she has had
no singing master save her father, no dancing mistress save her
mother; an organist of the neighborhood has given her a few lessons
on the harpsichord in accompanying, which she has since culti-

vated by herself. At first she only thought to have her hand appear to advantage upon the lower keys; thereupon she found that the sharp dry sound of the harpsichord made the sound of the voice sweeter. Little by little she became aware of harmony; finally, in growing up, she began to feel the charms of expression and to love music for itself. But it is a taste rather than a talent; she is completely unable to decipher a tune from the notes.[9]

From the standpoint of women's rights even the women of the salon were essentially conservative; they knew their place and dared not usurp that of the male. The truly learned woman throughout the eighteenth century was an anachronism, and the accent remained not so much on knowledge as on accomplishments. Since a woman's position in society was to be a good wife, she was to be taught those things that would make a better wife: reading, writing, household management, perhaps some modern language—French if she was English, Italian if she was French—needlework in all its branches, music, and dancing. Lady Mary Wortley Montagu (1689–1762), who must be classed as a rebel against the assigned female role and who is best known for introducing smallpox inoculation into Europe, wrote in 1752 that women were "educated in the grossest ignorance, and no art omitted to stifle our natural reason. If some few get above their nurses' instructions, our knowledge must rest concealed and be as useless to the world as gold in the mind. I am now speaking according to our English notions, which may wear out, some ages hence, along with others equally absurd."[10]

There were few women like Lady Montagu. Most women appear to have accepted their status even though they might desire a better education. Hester Mulso (Mrs. Chapone), Lady Mary's contemporary, warned in *Letters on the Improvement of the Mind* against the danger of pedantry and presumption in a woman—the dangers of exciting envy in one sex or jealousy in the other, of exchanging the graces of imagination for the preciseness of a scholar. Instead of having women study the classics, she wanted them to learn to enjoy the conversation of persons of sense and knowledge. Girls should be taught history, poetry, nature, geography, chronology, moral philosophy, French, and dancing, but they had to be careful in their reading and in their conversation never to offend against propriety. Hannah More, one of the most famous of bluestockings, proved equally reactionary in her attitude to female education. Her goal was not equality with males in education but recognition of women as different, more moral, creatures than men. Her purpose was not to make scholarly ladies or female dialecticians but to raise the

moral tone of society. Though she condemned female "accomplish-ments" and the emphasis upon dancing, music, and sketching, and wanted girls to be thoroughly grounded in the basic elements, she felt that emphasis should be on the "corruption of our nature" and the in-stillation of a disposition to counteract it.[11] Girls should also be taught to be submissive, to submit to restraint, and not to carry on a dispute even if they knew themselves to be in the right. "I do not mean that they should be robbed of the liberty of private judgment, but they should by no means be encouraged to contract a contentious and contradictory turn. It is of the greatest importance to their future happiness that they should acquire a submissive temper, and a forbearing spirit."[12] A sound grammatical knowledge of English was considered essential, as well as an appreciation of the best English authors, though More feared the reading of novels. She went so far as to urge that girls not learn French, since English girls were unlikely to marry Frenchmen or live abroad, and a knowledge of the language would lead even more surely to corrup-tion than reading the English novelists. Her reputation was such that she was consulted on the education of Princess Charlotte, the daughter of George IV, and here she urged somewhat broader learning, including Latin, French, and German, but still the emphasis was on forming moral judgment.[13]

She probably would have agreed with Dr. Erasmus Darwin, the grand-father of Charles Darwin, who wrote that the "female character should possess the mild and retiring virtues rather than the bold and dazzling ones; great eminence in almost any thing is sometimes injurious to a young lady; whose temper and disposition should appear to be pliant rather than robust; to be ready to take impressions rather than to be decidedly mark'd; as great apparent strength of character, however ex-cellent, is liable to alarm both her own and the other sex; and to create admiration rather than affection."[14] In retrospect, it can be seen that More and others accepted societal definitions of women and worked to educate them within this framework.

Inevitably, any woman who went further and demanded that women be granted equality would be regarded as deviant by other women and by society as well. One woman who dared to believe in equality was Catherine Macaulay Graham, who wrote an eight-volume history of En-gland covering the reign of the Stuarts. She also achieved considerable notoriety when at the age of forty-seven she took as her second husband a young man of twenty-one. She wanted coeducation for boys and girls, to get rid of the notion that the education of females should be of an opposite kind to that of males. Instead she urged that boy and girl chil-

dren be brought up together, following the same studies and playing the same games. "By the uninterrupted intercourse which you will thus establish, both sexes will find that friendship may be enjoyed between them without passion. The wisdom of your daughters will preserve them from coquetry. . . . Your sons will look for something more solid in women than a mere outside."[15] Mrs. Graham deplored the exclusion of women from the political arena and held that once women had been educated they would give up indirect influence for rational privileges.

Her plea was picked up by her younger contemporary, Mary Wollstonecraft (1759–97), who regarded Mrs. Graham as the woman of greatest ability ever produced in England. Unhappy over the lack of any change in the rights and status of women in the revolutionary movements then convulsing Europe, Wollstonecraft wrote a manifesto for women's liberation, A Vindication of the Rights of Woman. This work, which appeared in 1792, was a passionate plea for the education of women to be improved until they became the intellectual equals of man. Wollstonecraft wanted to do for women what the French Revolution had done for men.

> Men complain, and with reason, of the follies and caprices of our sex, when they do not keenly satirize our headstrong passions and groveling vices. Behold, I should answer the natural effect of ignorance! The mind will ever be unstable that has only prejudices to rest on, and the current will run with destructive fury when there are no barriers to break its force. Women are told from their infancy, and taught by the examples of their mothers, that a little knowledge of human weakness, justly termed cunning, softness of temper, outward obedience, and a scrupulous attention to a puerile kind of propriety, will obtain for them the protection of man; and should they be beautiful, everything else is needless, for at least twenty years of their lives.[16]

She held that all the writers on female education, from Rousseau to her own contemporaries, had done little more than render women weaker and more artificial than they would otherwise have been.

> Let woman share the rights, and she will emulate the virtues of man; she must grow more perfect when emancipated or justify the authority that chains such a weak being to her duty. If the latter, it will be expedient to open a fresh trade with Russia for whips: a present which a father should always make to his son-in-law on his wedding day, that a husband may keep his whole family in order by

the same means; and without any violation of justice reign, wielding this sceptre, sole master of his house, because he is the only thing in it who has reason: the divine, indefeasible earthly sovereignty breathed into man by the Master of the universe. Allowing this position, women have not any inherent rights to claim; and, by the same rule, their duties vanish, for rights and duties are inseparable.[17]

For expressing such sentiments Mary Wollstonecraft was abused and ridiculed. Horace Walpole called her a hyena in petticoats. In spite of such attacks the work must have hit a responsive chord, since it went through three editions in a few years. Probably the greatest support came from women of the middle class who lacked the protection of an aristocratic marriage settlement and could never hope for divorce from a bad husband. Hannah More, as could have been predicted, spoke out against it: "I have been much pestered to read the Rights of Women, but I am invincibly resolved not to do it. Of all jargon, I hate metaphysical jargon: besides there is something fantastic and absurd in the very title. How many ways there are of being ridiculous! I am sure I have as much liberty as I can make good use of, now I am an old maid: and when I was a young one, I had, I dare say, more than was good for me."[18] As Doris Mary Stenton rather harshly put it, "old maids" such as Hannah More, particularly those who were well enough off to live in comfort and intelligent enough to find something to do, showed a crass indifference to the possibility of other women's suffering. Such women suffered least from the attitude of the law,[19] and, it might be added, they had the most to lose if married women achieved some of their privileges.

Wollstonecraft was not the only person who reacted negatively to the failure of the French revolutionaries to make a change in women's status. Condorcet, mentioned above, had written his essay urging the admission of women to suffrage in 1789, and in 1791 Olympe de Gouge had written a pamphlet on the rights of women. Perhaps the most significant support for Wollstonecraft's writings came from the German essayist and writer of humorous novels Theodor Gottlieb von Hippel, whose *On Improving the Status of Women*, published in 1792, might be regarded as an attempt to persuade men of the need for changes in their attitudes toward women. To this end he set out to prove that women possess the necessary reason for the proper exercise of the rights of citizenship.[20]

Wollstonecraft's and Hippel's writings loosed the floodgates for a whole series of pamphlets arguing for greater equality for women, an

issue that had become more important because of the changing role of women in society. The major factor in bringing about such a change was the industrial revolution. In simple terms this was the application of machine power to tasks formerly done by hand. In the process it removed industry from the home to the factory and lessened the economic importance of a wife. Industrialization, particularly with the development of steam power, led to a rapid growth in cities and marked the shift in the nature of the population from rural to urban. The consequences of this at first were disastrous, not so much for attitudes toward women but in the social functions of women. As industry moved into the factory, the wife of a workingman was no longer the economic asset she earlier had been, while children could prove economic disasters. Even in the upper classes woman's role changed. At the beginning of the eighteenth century the mistress of the house was actively concerned in the management and productive work of a large household, but by the end of the eighteenth and beginning of the nineteenth centuries, she had become much less important economically, replaced by a bailiff or butler. The wife of the small freeholder or tenant farmer who lost his land became dependent upon her husband, because with the loss of land went her opportunity of contributing to the resources of the family. If ultimately she became a wage earner it was at a scale on which she could not adequately maintain herself, still less contribute to the support of the family. As middle-class women found their role changing and their numbers increasing, they tended to copy the manners and accomplishments of upper-class women, but without the property rights or responsibilities such women once had. Inevitably it came to be a sign of status for a man to have a beautiful, well-dressed, and well-decorated wife, and in some ways leisured wives became a sign of success, a means of conspicuous consumption. The middle classes, though aping the pretensions of the upper classes, nevertheless retained essentially middle-class values, emphasizing that they were more moral than the upper classes. The result was the elevation of female virtue and chastity to a new dogma and a further limitation on women's activities. As women in such classes found themselves cut off from other activities, they received compensation by emphasizing the importance of motherhood and homemaking.

Medical theory supported the changing role. Out of the growing literature of female disease emerges a consistent pattern of characteristics with implications for the behavior of women, which suggests certain attitudes toward them. As biological creatures, this literature argued, women experienced crucial stages in the maturing process different

from men, which could be defined as diseased states: puberty, virginity, pregnancy, widowhood. Since most women passed through most of these stages, they obviously represented an important component of female personality. Moreover, their weakened constitution rendered women's bodies and minds particularly susceptible to disorder. Since their behavior was intimately connected with anatomical weakness, the understanding male had to take into account the fact they were women. Sensitivity to disease, for example, frequently resulted in fickleness, but because they were women they could not be held accountable for their conduct. Rather, it was simply a manifestation of their illness. Even their capacity to reason was not always reliable because of their biological rhythms. Women also often suffered from unmet sexual needs that could lead them to crave the fantastic. The medical explanation was utilized not only to explain that female afflictions demanded indulgence but to emphasize that women required male guidance and control.[21]

There was, however, a very real distinction in roles between middle-class and working-class women. The latter, for example, could work, but the former could not. This was because in England, where industrialization began, the citizens of the time were not unconscious of its effects upon the life of the ordinary person. In fact, the moralists of the period worried about the growth of illegitimacy, the increase in orphans, and the decline in sexual and other morals. Since wages originally were very low in the factories, few laboring men could support a wife, let alone a family, and there was a rapid increase in prostitution. The problem of adequate alternatives to prostitution received particular attention. John Campbell, who wrote under the pseudonym M. Ludovicus, thought that a foundling hospital should be established for young girls and other females.[22] Campbell's recognition of the economic factors in prostitution was further amplified by John Fielding, who, with his brother Henry Fielding, the novelist, founded the first police system in London. Fielding felt that the reason for the high crime rate in England was the existence of great numbers of homeless children, a situation that led boys to become thieves from necessity and their sisters "Whores from the Same Cause."[23] In order to cut down on prostitution, Fielding proposed a "public laundry," which would help "preserve the deserted Girls of the Poor of this Metropolis; and also to reform those Prostitutes whom Necessity has drove into the Streets, and who are willing to return to Virtue and obtain an honest livelihood by severe Industry."[24] Fielding wanted the girls in his laundry to learn as well as work, and part of his plan called for teaching girls under twelve to read and those between twelve and sixteen

242

the housewifely tasks of knitting, cooking, and so forth; only those over sixteen were to work in the laundry, helping to support themselves until they were married.[25]

Jonas Hanway, another reformer, felt that Fielding's idea of a laundry was not as good as his own suggestion of a factory for manufacturing carpets. He stated that the Turks had already found that carpet weaving kept the women in the harems busy, and the same occupation would work for English girls who were inclined to prostitution.[26]

It was the textile factories, however, that provided the greatest source of employment for women. Though there were many critics who opposed female employment in factories, in effect women were doing there what they had done at home. Many of the English reformers believed that those factories that provided work for women and children were doing a great service for the country as well as providing an advantage for the poor. Daniel DeFoe, best known for his *Robinson Crusoe*, explained the importance of female employment in *A Plan of the English Commerce:*

. . . a poor labouring Man that goes abroad to his Day Work, and Husbandry, Hedging, Ditching, Threshing, Carting, etc. and brings home his Week's Wages, suppose at eight Pence to twelve Pence a Day, or in some Counties less; if he has a Wife and three or four Children to feed, and who get little or nothing for themselves, must fare hard, and live poorly; 'tis easy to suppose it must be so.

But if this Man's Wife and Children can at the same Time get Employment, if at next Door or at the next Village there lives a Clothier, or a Bay Marker, or a Stuff or Drugget Weaver; the Manufacturer sends the poor Woman comb'd Wool, or carded Wool every Week to spin, and she gets eight Pence or nine Pence a day at home; the Weaver sends her two little Children, and they work by the Loom, winding, filling Quills, etc., and the two bigger Girls spins at home with their Mother, and these earn three Pence or Four Pence a Day: So that put it together, the Family at Home gets as much as the Father gets Abroad, and generally more.

This alters the Case extremely, the Family feels it, they all feed better, are cloth'd warmer, and do not so easily nor so often fall into Misery or Distress; the Father gets them Food, and the Mother gets them Clothes; and as they grow, they do not run away to be Footmen and Soldiers, Thieves and Beggars, or sell themselves to the Plantations, to avoid the Gaols and the Gallows, but have a Trade at their Hands, and every one can get their Bread.[27]

To many people it seemed evidence of a good deed if the factories would employ women and children as well as men, and several industrialists appealed to Parliament for special favors on the grounds that they employed so many women and children. One woolen manufacturer backed up his plea for privileges by claiming that his factory enabled the workers to "take their children from the highways and from their infant idleness, and bring them to wool and wheel."[28] Defoe wrote admiringly of those areas in the country that managed to enable children of four or five to earn their own bread.

In the nineteenth century, reformers, motivated by a changing attitude toward women that held that a proper woman did not work, fought to remove women and children from the factories. The factory women themselves, however, did not agree. A group of them wrote:

Living as we do, in the densely populated manufacturing districts of Lancashire, and most of us belonging to that class of females who earn their bread either directly or indirectly by manufactories, we have looked with no little anxiety for your opinion on the Factory Bill. . . . You are for doing away with our services in manufactories altogether. So much the better, if you had pointed out any other more eligible and practical employment for the surplus female labour, that will want other channels for a subsistence. If our competition were withdrawn, and short hours substituted, we have no doubt but the effects would be as you have stated, "not to lower wages, as the male branch of the family would be enabled to earn as much as the whole had done," but for the thousands of females who are employed in manufactories, who have no legitimate claim of any male relative for employment or support, and who have, through a variety of circumstances, been early thrown on their own resources for a livelihood, what is to become of them?

In this neighbourhood, hand-loom has been almost totally superseded by power-loom weaving, and no inconsiderable number of females, who must depend on their own exertions, or their parishes for support, have been forced, of necessity, into the manufactories, from their total inability to earn a livelihood at home.

It is a lamentable fact, that, in these parts of the country, there is scarcely any other mode of employment for female industry, if we except servitude and dressmaking. Of the former of these, there is no chance of employment for one-twentieth of the candidates that would rush into the field, to say nothing of lowering the wages of

our sisters of the same craft; and of the latter, galling as some of the hardships of manufacturies are (of which the indelicacy of mixing with the men is not the least), yet there are few women who have been so employed, that would change conditions with the ill-used genteel little slaves, who have to lose sleep and health, in catering to the whims and frivolities of the butterflies of fashion.[29]

Eventually, instead of abolishing the right of women to work in the factories, the English Parliament turned to regulate the conditions under which they worked. This suited the notion that women, even lower-class women, were made of finer material than men but also recognized the economic realities of female employment. Middle-class attitudes about the housewife, however, also began drifting downward into society, and in 1841 a group of factory operatives, anxious to raise their own wages and influenced by middle-class attitudes toward women, demanded the "gradual withdrawal of all females from the factories" on the grounds that the home, its care, and its employment was the true sphere of women, and women brought up in factories could not "make a shirt, darn a stocking, cook a dinner, or clean a house." They further held that the employment of women was an "inversion of the order of nature and of Providence—a return to a state of barbarism in which the woman does the work, while the man looks idly on."[30]

In spite of such criticism, the factories in the long run gave women an opportunity to move from the home and ultimately led to a shift in their outlook. Before the industrial revolution, marriage, even though it had been a kind of economic partnership, confined women to the home. With the factory system and urbanization, eventually they were brought outside the home into closer contact with other women, and this made the confining nature of the traditional home much more evident. It also further roused their antagonism toward the legal inequalities that existed. Traditionally a married woman had never possessed a legal right to her own earnings or to a share of the family wages, but in an earlier age where much of the life of both men and women centered around the home this had not been a burning issue. When a husband could take the cash wages of his working wife or daughter, however, it became a real issue and roused women to greater consciousness of their own inequalities. Factories for the most part by the nineteenth century were discriminating against married women.

Increasingly it was the single woman, not the married woman, who worked in the factory, and such a discrimination was probably accepted

by a married woman on the grounds that her earnings usually did not make up for the loss to the family resulting from the nonperformance of other domestic duties. It was only in the twentieth century, as more labor-saving devices for running a house appeared, that it became physically possible for a woman to work outside the home and still keep the home running. The exclusion of married women from the factory was also encouraged by the growth of humanitarianism, which was favored by the workers, anxious to improve their own working conditions. Since the mores of the day, following the ideas of Adam Smith, emphasized the nature of a contract freely entered into between the employer and the employee, the government found it difficult to interfere. Because women and children, however, were not fully free individuals, their employment conditions could be regulated, and this was where the factory legislation was most effective. Indirectly, of course, the male also benefited. As the middle-class idea of homemaker spread downward, it became a common assumption that a man's wages should be paid on a family basis. This further encouraged the idea that a married woman's place was in the home, and homemaking and childrearing were regarded as the economic contribution of the female. This helped stabilize the family even though it discriminated against women. Single women could work, but they also found more and more restrictions put upon the work they could do and their wages declined proportionately to those of men. Certain tasks were declared unsuitable for women because they were too heavy or required working in confined spaces that were not conducive to the best of moral behavior. Still, in a crisis a woman of the working class, married or unmarried, could work outside the home. No such outlet was permitted to the middle-class woman, who found outlets for her energies more and more restricted. The effects of this were summed up by Margaretta Greg in 1853. She wrote that a lady must be a mere lady, and nothing else:

> She must not work for profit, or engage in any occupation that money can command, lest she invade the rights of the working classes, who live by their labour. Men in want of employment have pressed their way into nearly all the shopping and retail businesses that in my early years were managed in whole, or in part, by women. The conventional barrier that pronounced it ungenteel to be behind a counter, or serving the public in any mercantile capacity, is greatly extended. The same in household economy. Servants must be up to their offices, which is very well; but ladies, dismissed from the dairy, the confectionery, the store room, the still room, the

poultry yard, the kitchen garden, and the orchard have hardly yet found themselves a sphere equally useful and important in the pursuits of trade and art to which to apply their too abundant leisure.[31]

It was from educated middle-class women, as they became more and more unhappy with their confined role in society, that the demands for female emancipation began to appear.

The new model of the genteel woman that appeared among the emerging middle classes was one where the woman did not manage an estate or closely supervise the work of her household; instead, gentility came to be associated with inactivity. Women, who were already items of conspicuous consumption, became more useless by social convention that they themselves adopted. To make matters worse, such women were not only useless; many were also uneducated and terribly bored. To compensate for this there was a growing tendency to set women apart from the rest of mankind: women were a species of men who had reached a higher moral level. They were a special creation called upon to perform a special function, motherhood—and children received more attention.

Though epidemics were still widespread and large numbers of children died before achieving maturity, the eighteenth century as a whole saw a shift in emphasis from treating them as little adults to treating them as children requiring special care. In the process the role of the mother increased in importance. Cardinal Bernis wrote during the period that "nothing is more dangerous for the morals and perhaps also for the health than to leave children too long in the care of servants."[32] The importance of the family was also increased by the growth of privacy. Until almost the seventeenth century it was rarely possible for anyone to be left alone. People lived close together, and the density of social life made isolation virtually impossible. People who shut themselves up in a room for some time were regarded as exceptionally eccentric. In the eighteenth century, owing in part to increased prosperity, the style of living changed and houses themselves were altered to establish new ways of privacy. Rooms, for example, were made independent of each other, opening on a corridor or a hallway instead of passing from one to another. Rooms also developed specialization, and the concept of comfort was born. Beds were confined to the bedroom, which was also furnished with cupboards or alcoves, often fitted out with the new toilette and hygienic equipment. In France and Italy the word *chambre* began to be used to denote the room in which one slept, as distinct from *salle*, the room where one received visitors and ate. In England, though

the word *room* was kept for all functions, a prefix was added to give precision: the dining room, the bedroom, and so forth. This specialization of rooms among the middle class and nobility confined servants to out-of-the-way quarters and required that bells be arranged in order to summon them. It became quite improper to call on a friend or acquaintance at any time of the day without warning. The proper lady had a day at home or sent formal invitations.

The greater emphasis on family life also led to an emphasis on children, and since it was accepted that the father might have to be away from home, the burden of holding the family together fell upon the mother. It was recognized that the child was not ready for life, that he or she had to be subject to a special treatment, a sort of quarantine, before being allowed to join the adults. Since the child was to be isolated from society, it seemed obvious that woman also, the natural guardian of the children, should be isolated. Motherhood was a special calling, demanding equal time with other occupations, and the tendency to put women on a pedestal that had started in the Middle Ages reached a new height.

This new elevation of woman was evident in the instructions of the Presbyterian minister Dr. Gregory to his motherless daughters, entitled *A Father's Legacy to His Daughters.*

> Though the duties of religion, strictly speaking, are equally binding on both sex, yet certain differences in their natural character and education, render some vices in your sex particularly odious. . . . Your superior delicacy, your modesty, and the usual severity of your education, preserve you, in a great measure, from any temptation to those vices to which we are most subjected. The natural softness and sensibility of your dispositions particularly fit you for the practice of those duties where the heart is chiefly concerned. And this, along with the natural warmth of your imagination, rends you particularly susceptible to the feelings of devotion. . . . One of the chief beauties in a female character, is that modest reserve, that retiring delicacy, which avoids the public eye and is disconcerted even at the gaze of admiration. . . .[33]

The capstone of gentility was the attainment of a higher moral susceptibility and delicacy in feeling. The genteel woman was to be a model of self-control, to attenuate sexual attraction as the mode of relation between the sexes, and to favor discreet withdrawal and even retreat in the face of vulgarity. Even Hannah More, the bluestocking teacher, dramatist, writer, and essayist, felt that woman's knowledge was not to be produced in some literary composition but to come out in

conduct. The ideal gentle woman would be the woman who "had been accustomed to have an early habit of restraint exercised over all her appetites and temper; she who has been used to pent bounds of her desires as a general principle, will have learned to withstand a passion for dress and personal ornaments; and the woman who has conquered this propensity has surmounted one of the most domineering temptations which assail the sex. Modesty, simplicity, humility, economy, prudence, liberality, charity, are almost inseparable, and not very remotely connected with an habitual victory over personal vanity."[34]

Chastity was the mark of the new gentility, and though chastity or the lack of it might be difficult to prove, the assumptions of chastity were not. Thus there were a lot of things that a proper lady could not or would not do. If a girl's dress was too revealing, her ornaments too provocative, her speech and gestures too bold, then some people would assume that she had lost her chastity. Appearance counted for more than reality. It was absolutely essential that a proper girl look and behave with a respectable "modesty." Since women in the wealthier classes were also relieved of all kinds of physical exertion, it was expected that their appearance would exhibit a meticulous personal daintiness, their gestures an absence of violent muscularity, and their clothes and hairdress an unfunctional fragility. This meant that even "creative" activities, the form in which women were permitted to direct some of their energies, had to be very limited. As far as music was concerned, and music was a favorite because it could be shown off best, certain activities were very unladylike. If a girl played a flute she had to purse her lips, a very unladylike gesture; this was also true if she played a horn, and the brass instruments had the added difficulty of requiring visceral support for tone quality, which meant that they were even more unladylike. The cello required a girl to spread her legs; if she played the violin she had to twist her upper torso and strain her neck in an unnatural way. The clothes of the time added to the difficulties of playing and remaining ladylike. In fact, with the exception of the harp, about the only instrument a proper girl could play was a keyboard one; the harpsichord, clavichord, or pianoforte allowed the girl to sit properly before the keyboard, arrange her clothes neatly, put a polite smile on her face, keep her feet demurely together, strike the keys lightly with no unseemly vehemence, and act gentle and genteel, an outward symbol of her family's ability to pay for her education and her decorativeness. Her abilities, which should be adequate but not professional, were signs of her family's status of life, of its striving for culture, of its pride in the fact that she did not have to work, nor did she have to chase after men.[35]

Inevitably, the life of the proper woman came to be filled with a kind of genteel idleness in which she tried to fill her time with a number of trivial occupations superficially related to the fine arts, known as "accomplishments": fancy needlework and embroidery; framing pictures in shellwork; embellishing cabinets with a tracery of seaweed, filigree, and varnish work; working with chenille, crepe, ribbon, or netting; making artificial flowers of wax or fabric; cutting out paper ornaments; drawing or painting slightly; and playing the piano adequately. When anything untoward appeared the lady was either to withdraw or, if this was impossible, to faint. There were even ways to faint elegantly:

> The eyes grow dim, and almost closed; the jaw fallen; the head hung down; as if too heavy to be supported by the neck. A general inertia prevails. The voice trembling, the utterance through the nose; every sentence accompanied with a groan; the hand shaking, and the knees tottering under the body. Fainting eventually produces a sudden relaxation of all that holds the human frame together, every sinew and ligament unstrung. The colour flies from the vermilion cheek; the sparkling eye grows dim. Down the body drops, as helpless, and as senseless, as a mass of clay, to which, by its colour and appearance it seems hastening to resolve itself.[36]

Though the prudery associated with the new gentility has often been labeled Victorianism, it predated the advent of Queen Victoria and remained a dominant theme for much of the nineteenth century. The new mystique of motherhood granted women special status but at the same time guaranteed them inferiority. Common women went to work in the factories, neglecting their families, and aristocratic women remained outside the bounds of middle-class morality; but the good woman, the true middle-class woman, as befitted her newfound moral purity and spiritual genius, had to devote herself to the task of homemaking, something that in the past had not been regarded as particularly important. Because she was pure she was also weak and had to be safeguarded at all costs from the corrupting effects of the man-made world beyond the domestic circle. William R. Taylor and Christopher Lasch have suggested that the

> cult of women and the Home contained contradictions that tended to undermine the very things that they were supposed to safeguard. Implicit in the myth was a repudiation not only of heterosexuality but of domesticity itself. It was her purity, contrasted with the coarseness of men, that made woman the head of the Home

(though not of the family) and the guardian of public morality. But the same purity made intercourse between men and women at least almost literally impossible and drove women to retreat almost exclusively into the society of their own sex, to abandon the very Home which it was their appointed mission to preserve.[37]

The burden put upon women by such an attitude was one that many of them did not want and could not bear, but the only outlet for their discontent was in church work and in literary pursuits. Religion in a sense became a justification for what they wanted to do and could not do, and even woman suffrage became a movement to raise the standards of morality by allowing the purer and finer species, the woman, to vote. Victorianism taught women to think of themselves as a special class, and having become conscious of their unique sexual identity, they could no longer accept uncritically the role definitions drawn up for them. Denied liberty, they sought power, and not infrequently the easiest way to gain power was over their children. Motherhood came to be elevated into a kind of mystique that Freud made into a kind of pseudoscientific basis of existence. Though the Victorian concept of women as wan, ethereal, spiritualized creatures bore little relation to the real world where women operated machines, worked the fields, hand washed clothing, and toiled over great kitchen stoves, it was endorsed by science and religion. Fashion materially assisted by keeping women in bustles and hoops, corsets and trailing skirts, and other items of clothing in which they remained encased throughout much of the period. The ideal waistline came to be the span of a man's two hands, and since few women could achieve this naturally they did so by tight lacing. The feminine delicacy that was so much admired was at least in part due to constricting corsets, rather than being visible evidence of the superior sensibilities, the "finer clay" of which women were made. Women who were not delicate by nature became so by design. Women themselves came to believe in their own special genius, and those who did not conform were usually ostracized. The world came to be made up of good girls and bad girls. The bad girls represented sexuality, the good girls purity of mind and spirit, unclouded by the shadow of any gross or vulgar thought. The largest collection of bad girls was the prostitutes, and they were thought to have had poor moral inheritance. The literature of the time, particularly the novels, represented sexuality as dangerous and evil, thereby reinforcing respectable young women and anxious wives in their moral code of chastity and virtue. With overpowering mothers who were brought up as young girls to fear sex, the nineteenth-

century home often became a nest of psychological difficulties that have not yet disappeared.

Since women, in spite of their sensibilities, were reading in increasing numbers, it became essential that their reading material be controlled. By the end of the eighteenth century it was assumed that most fiction was much too indelicate for women, who had to be shielded from the grosser facts of life. Even Aphra Behn, the late seventeenth-century writer usually regarded as the first professional woman of letters, became suspect for the new generation of women readers. Though Behn had been considerably less ribald than some of her masculine contemporaries, the standards of Charles II's age, even in a mild form, were much too risqué for young ladies of a more squeamish age. Samuel Richardson's *Pamela*, strongly recommended as a moral tale for young girls in the last part of the eighteenth century, by the nineteenth was considered much too daring for virtuous young ladies—this in spite of the fact that Pamela was successful in fending off all assaults on her virtue until she was safely married.

Indicative of the change in literature was the success of Thomas Bowdler, a well-to-do physician who never seriously practiced medicine but did take a great interest in "good" works of nearly every kind. Bowdler was university educated and widely traveled, a man of the world who nonetheless enjoyed reading aloud the great writers to his family. He became concerned at the overt sexuality in Shakespeare, and his concern led him in 1818 to produce a ten-volume expurgated version that he felt included only what was fit to be read "by a gentleman in the company of ladies." *Othello*, however, was too much for even Bowdler's purifying activities, and he advised that this play be transferred from the parlor to the locked cabinet. Bowdler's efforts had been anticipated by others, including James Plumptre, who in 1805 published an expurgated songbook. One British writer went so far as to urge the perfect hostess to see "to it that the works of male and female authors be properly separated on her bookshelves. Their proximity unless they happen to be married should not be tolerated."38

At the same time that the concept of feminine sensibility was being refined, the concept of marriage was also changing, and this ultimately led to a different attitude toward the woman as wife—a change from being a helpmate and mother only to being a lover and companion as well. Usually this change is attributed to the movement known as romanticism, which can be traced to some of the writings of Jean Jacques Rousseau and Johann Wolfgang von Goethe. This movement reached its greatest influence in nineteenth-century Germany, whence it spread

outward. In romanticism the claims of the intellect gave way to those of passion and emotion; the critical spirit was replaced by the imaginative one, although romanticism could be better defined as a "mood" than as a movement because it is difficult to confine it to a rigid definition. The romantics reacted against the views of the *philosophes*, who they felt had overstressed the role of reason in discovering truth and had not paid enough attention to emotion. Romanticism was pro-sex in that the romantic was encouraged to go against social convention, to emphasize physical passion, to recognize the fact of sexual inconstancy, to cultivate emotion and sensation for their own sake. Put in this way the actions of the romantics were not particularly different from those of the *philosophes*, although the thought processes by which they arrived at conclusions were different. As far as marriage was concerned, the romantics held that the only true basis for marriage was a mutuality of feeling and attraction, and carried logically to a conclusion this meant the romantic union was one freely made between equals. The "inequality" of women in the marriage relationship, in fact, was one of the principal points of agreement among the romantics.

The threads of the romantic movement trace back to the chivalric epics, but added to its medieval heritage was the belief that love itself involved an intense psychological relationship as well as a physical one. The adherents revived Plato's theory that every individual was but one-half of a complete entity so that somewhere there was to be found the twin-soul, the missing half, the only person in the world who provided the full complement for one's own personality. For the romantics sex had a positive value but only if it took place within an intense psychological relationship. In fact, sexual union was illegitimate unless the lovers were joined by emotional and intellectual ties as well as physical ones. Sex was possible only with the beloved, and its purpose was to link together two individuals motivated by the highest emotions. The female partner should be, in Percy Bysshe Shelley's terms, "as perfect and beautiful as possible, both in body and in mind, so that all sympathies may be harmoniously blended, and the moment of abandonment be prepared by the entire consent of all the conscious portions of our being."[39]

Marriage relationships that were loveless and oppressive ought to be dissolved, and the German Johann Fichte went so far as to state that marriage without love should be regarded as an automatic divorce.[40] Generally the romantics would hold that once a true love was found the lovers became so perfectly united in body and soul that true love was identical with fidelity. Not all would agree that love was eternal and

immutable, and Shelley, for example, held that in the normal course of life one could fall in love more than once. "A husband and wife ought to continue so long united as they love each other: any law which should bind them to cohabitation for one moment after the decay of their affection would be a most intolerable tyranny. . . . The connection of the sexes is so long sacred as it contributes to the comfort of the parties, and is naturally dissolved when its evils are greater than its benefits."[41]

In essence the romantics were feminists of a kind. They believed that woman had been denied her humanity in a world ruled by men and that she needed to be liberated from masculine tyranny; at the same time, however, they were ambivalent about how far woman should go. This was because while they recognized the disabilities under which women lived, they still emphasized the nature of opposites in the male and female psychology. Marriage was the union of opposites, and the female complemented the male; thus if he was aggressive, she was passive, and if he was rational, she was emotional. As Victorianism settled in, the free-love aspects of romanticism were also modified, and marriage was the be-all and end-all of romantic love. The romantics were conscious of their inherent masculine bias, and some of them attempted to soften traditional sexual identities by preferring "delicate and dreamy men, free and daring girls." The German Friedrich Schlegel wondered what "is uglier than overemphasized womanliness, what is more repulsive than the exaggerated manliness which prevails in our mores, our opinions, yes even in our art? . . . Only self-reliant womanliness, only gentle manliness, is good and beautiful."[42] In his novel *Lucinda* his male protagonist says to his mistress: "We exchange roles and with childish delight try to see who can best imitate the other; whether you succeed best with the tender vehemence of a man, or I with the yielding devotion of a woman. . . . This sweet game has for me quite other charms than its own. . . . I see in it a wonderful and profoundly significant allegory of the development of man and woman into complete humanity."[43] Unfortunately, however, since sexual roles were not blurred but only exchanged, it must be assumed that they eventually reverted to their original owners, that men continued to be vehement and women yielding.

The romantics, however, did not carry every one along with their rhetoric. Misogynism remained, as is evidenced by Arthur Schopenhauer's essay "Of Women," which appeared in 1851. Schopenhauer wrote as if the romantics had never existed, arguing that women's qualities are natural and that the very naturalness of their behavior, virtues, and vices makes them inferior to men. Specifically, women are deficient in rea-

254

son, in physical strength, in love, and even in the aesthetic faculty, and each of these deficiencies has serious consequences. Woman's lesser intelligence accounts for her lifelong childishness as well as her willfulness and her lack of a sense of justice. Since she is not physically strong, she must survive by her cunning, and therefore she has become a master of pretense and lying. Her deficiency in love makes her hate her own sex and unable to love her own children on any level other than the purely instinctive one. In fact, the only thing she is really capable of loving is a man, who becomes her whole goal in life. Because she has a naturally ugly appearance and lacks any real aesthetic faculty, she cannot appreciate any fine art. In short, to reverence women in a chivalric spirit is to flout nature at every turn.[44]

Still, the romantics struck a responsive chord, and though they only rarely carried their feminist ideas to the logical conclusion of equality, they did place the ideal of romantic love within marriage and in the process emphasized the need for both psychical and physical compatibility of the marriage partners.

The fact that the romantics eventually accepted the idea that women were essentially different from men proved in the long run to be the most successful weapon that women had in demanding greater equality. If women were made of finer fabric, more concerned with morals, with man's inhumanity to man, then this allowed them to enter the political arena on these grounds. The battle for woman suffrage was fought on the grounds not of basic equality but of bringing a higher moral plane to politics. Women were active in the fight to free the slaves, in the battle to outlaw liquor, in the struggle to eliminate prostitution, and in the campaign to extend education. These were moral causes or were concerned with children and were therefore causes that women could join in and even, within the limits of the masculine prerogatives of the time, assume a leadership in. Middle-class women were expressing themselves in the arts, in literature, and in poetry, but they were not really confronting men on their own terms. Women rulers had come to be an accepted part of life, and there were a large number in the seventeenth and eighteenth century, from Maria Theresa to Catherine the Great of Russia, but they usually were allowed to rule only when the male line had defaulted.

What was taking place at the end of the eighteenth century and the beginning of the nineteenth was not a change in women's sphere but a new appreciation of female qualities. Traditionally, as this book has demonstrated, there was a female sphere that had very little overlap with the male. These spheres basically did not change until the twen-

tieth century, but what was beginning to take place was a kind of up-grading of the women's sphere, a raising of it to a higher moral and aesthetic level. This had implications for the changing nature of male-female relationships, since if women could not demand equality by coming through the front door, they could try to enter by the back, fighting on the unequal terms assigned to them by the men. Though physically this put them at a disadvantage, it probably allowed them to move forward without appearing too deviant. Though many women must have admired the freedom of a Mary Wollstonecraft, who had an illegitimate child and did not believe in marriage and taught that women were equal to men, they did so secretly, rarely in the open. Though the romantics continued to regard women as subjective rather than objective, as patient and receptive rather than volatile and spontaneous, as passive rather than assertive, as made for love and not friendship, these very qualities had gained value and could be used on the battleground for greater freedom. In short, few new weapons had been added to the female arsenal, but the nature of the tactics shifted as women became more conscious of the weakness of the male position.

12 / Women in Colonial America

\mathbf{T}he men and women who ventured into the wilderness of the American continent brought with them more than domestic animals, tools, and personal possessions; they also brought their own cultural baggage. Whether they came from France, Spain, England, the Netherlands, Sweden, or the German-speaking areas of Europe or from the various parts of Africa, they saw themselves as transplanted Europeans or Africans and tried to preserve as many of their traditions as conditions allowed. Only gradually did they develop into "Americans," but in the process, because the original thirteen colonies all came under British rule, English influence was strong. Most colonists spoke English, and their laws were based on those of Great Britain.

Life in America, however, was quite different from that in England, not only because the geography was different or because of the Indians who lived here or because of the vast variety of peoples who came to America, but because living conditions themselves were different. This affected attitudes toward women. One of the most important factors in early colonial life, for example, was the scarcity of women. Colonial documents offer an almost constant refrain about single girls finding America a paradise of bachelors eager to wed. An early Swiss settler wrote home with the advice that penniless girls ought to emigrate to America because "here men do not care for money. . . ."[1] The first permanent English settlement in Virginia, Jamestown, was an all-male enterprise. Since the Virginia company made no provisions for sexual mat-

ters the gentlemanly adventurers were left to their own devices, and though Indian women were often utilized as sexual companions, only rarely did the Virginia settlers marry them. Even before the colonists had set out for Virginia they had been warned in a sermon that just as Abraham's descendants were to keep to themselves, so the new English colonists were not to "marry nor give in marriage to the heathen. . . . The breaking of this rule, may breake the neck of all good success of this voyage."[2] This apparently did not mean, however, they could not have sex with the "heathen," and colonial records were full of such alliances. The only official marriage between Indian and European in the early days of the Virginia colony was that of John Rolfe and Pocahontas. Though this marriage was an important factor in preserving peace between the Indians and the settlers, Rolfe's own attitude toward his wife and offspring is indicated by his failure to provide in his will for his child by Pocahontas.[3]

Many factors combined to discourage formal marriage. Differences in culture played a role. That the Indians were not Christians meant that for most, marriage was unthinkable. Moreover, Indian women did not possess the skills expected of a European wife. Unless a man wanted to live on the frontier among the Indians or isolated from other settlers, an Indian wife put him at a disadvantage. She could not spin and weave the type of material to which he was accustomed, churn butter, make sausages, brew beer, make cheese, or handle housekeeping accounts. But such skills obviously can be learned. Clearly a major obstacle in the path of intermarriage with Indians, and with blacks as well, was the racial attitudes of the settlers.

The scarcity of European women caused some difficulty; many of the women who did come found so many offers that they attempted to keep several men happy, an activity much frowned upon by the authorities. The Virginia Great Charter of 1619 set up machinery so that the church could search out such "skandalous offences as suspicions or whoredomes, dishonest keeping with women, and such like."[4] In New England the most scandalous settlement was that of Thomas Morton at Mare Mount, where contacts between Indian women and colonial males upset the Pilgrim colony at Plymouth. It was ultimately destroyed by the combined forces of New England.[5] Gradually, as the colonies grew in population through natural increase as well as through immigration, overall sex ratios began to be equalized. But men continued to outnumber women on the frontier, while more settled Eastern areas would later develop a surplus of females.

Even when a scarcity of women prevailed, however, basic attitudes

remained the same. According to English common law, which provided the basis of American laws, the status of women was rather straightforward. A single woman—a *feme sole*—could own and dispose of property, negotiate contracts, make wills, and in short do much that a man could do. A married woman—a *feme covert*—was quite another matter. English law held that upon marriage a man and a woman became one person, namely the husband. All property belonged to him, including property belonging to the wife prior to marriage. Wills often specifically left to the wife her clothing and jewelry, even her wedding ring; otherwise, technically she would not have been able to claim even these things. Children were also the husband's, and in the case of separation, they remained with him. While a will often named the wife as guardian, the husband could legally bind them out or choose someone else to care for them without even consulting her. Premarital agreements could allow a woman to retain certain rights or possessions, but they were rare and usually limited to the daughters of wealthy families. Because the wife legally was not a person, she could neither sue nor be sued, and her husband was responsible for her debts. She was expected to obey her husband, and he had the right to punish her. This punishment could include beating; court records contain numerous instances of wives accusing their husbands of physical cruelty. In some cases, fines were levied against the husbands for their physical cruelty.[6]

Religious attitudes reinforced the law. New England Puritans found biblical justification for their subjugation of women in the Fifth Commandment and its reference to honoring one's father and mother. Though the commandment clearly mentioned both sexes, "father and mother" were interpreted to mean not only parents but all superiors, and since the husband was the superior of the wife by the law of conjugal subjection, as well as by nature, she had no choice but to respect his wishes.[7] The teachings of St. Paul describing the proper role for women served as the basis for many a colonial sermon. It was widely accepted that woman had been created as the helpmate for man, not vice versa, and that as a helpmate she had proved troublesome. Women, in popular belief, were the cause of the expulsion of Adam and Eve from the Garden of Eden, and women's special punishment for this action was to bring forth children in sorrow and to obey their husbands. Tied in with this was the belief in woman as temptress, and there was a deep and primitive kind of suspicion of women, which could, as in Salem, evolve into accusations of witchcraft.

Qualities to be encouraged in women were implicit in the names chosen for girl babies; although there were Marys, Marthas, and Sarahs

aplenty, there were others who went through life as Patience, Mercy, Faith, Constance, Hope, Prudence, and Charity, forever reminded of the virtues expected of them. Fortunately, the Scriptures also presented quite another picture of women, one that eased the stigma of being female. The women in the Old Testament were often pictured as strong figures, not just subordinate wives, and Christianity had always emphasized that women had souls, equal in value in the eyes of God to those of males and therefore of an "equal perfection."[8]

While a wife was to obey her husband, he also had obligations to love and care for her. Religion combined with the demands of colonial society to emphasize the importance of the family and therefore to recognize the role of woman not only as wife and mother but as teacher of her children. The Puritans and the Quakers especially encouraged the education of girls so that they could read the Bible and later instruct their sons and daughters. Some women ran dame schools in their homes with the approval of both religious and secular leaders. Although nowhere in the colonies did women receive educations equal to those given men, many in the middle and northern colonies did acquire basic reading, writing, and arithmetical skills.

Women, however, had to be cautious in their display of knowledge. When one New England woman wrote a book, her brother publicly rebuked her by stating that her "printing of a Book beyond the custom of your sex, doth rankly smell."[9] When the wife of Governor Hopkins of Connecticut became mentally ill, her insanity was blamed upon the fact that she had spent so much time in reading and writing. "If she had attended her household affairs, and such things as belong to women, and not gone out of her way and calling to meddle in such things as are proper for men, whose minds are stronger, etc., she had kept her wits, and might have improved them usefully and honorably in the place God had set her."[10]

The behavior of Anne Hutchinson (1591–1643) also provoked the wrath of the leaders of the Massachusetts Bay Colony. To be sure, men as well as women were punished in those early years of the colony for falling into the antinomian heresy—the belief that moral law is of no use or obligation because faith alone is necessary for salvation—but Hutchinson's crime was compounded because she had exceeded "woman's place." By holding meetings to discuss and interpret the sermon of the previous Sunday, she not only undermined the authority of the Puritan clergy but threatened male dominance. Such behavior, her accusers claimed, was a "thing not tolerable nor comely in the sight of God nor fitting" for women to do. When Hutchinson retorted that the Bible gave permission to teach the young (Titus 2:3–5), she was warned that such

teachings were to be restricted to teaching young women "about their business to love their husbands," not offering religious views that differed from those of the majority.[11] The violence of the Puritan response to Quakers was fueled in part by the emotions surrounding the proper role for women, since the Quakers allowed women to preach. Even the comparatively mild nonconformity of another educated seventeenth-century woman, the poet Anne Bradstreet (1612–72), provoked sharp criticism because she too ventured into an area "not fitting" for a woman. Some of the reaction to her poetry seems comprehensible only if viewed in the larger context of what that behavior implied. Bradstreet, conscious of the male hostility to the educated female, had prefaced her book:

> I am obnoxious to each carping tongue
> Who says my hand a needle better fits.
> A poet's pen all scorn I should thus wrong,
> For such despite they cast on Female wits:
> If what I do prove well, it won't advance,
> They'd say it's stoln, or else it was by chance.[12]

She pointed to Queen Elizabeth as an example of a woman who had made considerable contributions to civilization and concluded:

> Now say, have women worth or have they none?
> Or have them some, but with our Queen is't gone?
> Nay Masculines, you have thus taxt us long,
> But she, though dead, will vindicate our wrong.
> Let such as say our Sex is void of Reason,
> Know tis a Slander now, but once was Treason.[13]

Life for women in the colonies was often pictured in glowing terms, as in a flyer distributed in England claiming that "If any Maid or Single Woman have a desire to go over, they will think themselves in the Golden Age,"[14] but reality was different. Life in predominantly rural colonial America meant hardship and deprivation and drudgery for all but a very few, and the specialized labors of both men and women were essential for survival. As the Virginia company soon discovered, single males did not contribute to stability or profit in a colony. To overcome this defect, the company in 1619 sent to the colony a boatload of "purchase brides." They were but the first shipment of single women, and throughout the early years in all the colonies, but especially in the South, women came as indentured servants on their own. As was true of the "purchase brides," not all indentured servants embarked for the New World willingly, and having arrived, they found their freedom, in-

cluding their freedom to marry, severely limited. Some were bought by men desiring them as wives, others married a member of the household in which they served, but most could not marry during the period of their indenture. As a result of surreptitious liaisons or perhaps even rape, many bore illegitimate children who were often bound out without the mother's consent. Others who found themselves with child resorted to abortion or infanticide. Despite the drawbacks of indenture, however, many of the women fared well in the new land, and many of the first families of Virginia and Maryland owe their origins to them.

In some respects, women in the early colonial period enjoyed a kind of rough equality, if only an equality of continual labor. Women were needed and they were scarce: therefore they could be somewhat choosy. If a woman was healthy and strong, she had little difficulty finding a husband. Colonial records suggest that many women were tough, bawdy, and resourceful and were prized for their courage and endurance rather than for an attractive appearance or a pleasing personality. Although there was a definite division of chores by sex—with the exception of black slaves, few women regularly worked in the fields—women played an essential economic role.

Most Americans lived on farms and produced much of what they consumed and wore. On the farm the woman was responsible for the kitchen garden and the domestic animals; she prepared the food and sometimes helped to produce or gather it; she spun and wove and made the family's clothing; she churned the butter and made the cheese and beer and soap and candles; she nursed the sick with home remedies; she chopped wood and fetched water; and she bore and cared for the children. Clearly child care did not occupy a major portion of her time. In fact, to modern eyes, she might appear neglectful of her children, only half consciously caring for the little ones as she went about her chores and expecting the older ones to perform many of the same tasks as the adults. Childhood was brief, and there was little time for play. Frequent pregnancies were a fact of life, since children in a preindustrial society, even very young children, were an economic asset. Families with numerous offspring could bind them out to those less blessed. Not surprisingly, the colonial birth rate was the highest in the Western world.[15] The death rate was also high, and colonial graveyards provide poignant evidence of the many mothers who died giving birth and of the babies who failed to survive their first few years. Many speculate that such conditions often combined to discourage close and loving relationships between mother and child.

Sex under such conditions was a fact of life. Sermons, court cases,

letters, and other written accounts discuss sex with a frank and straightforward approach that shocked later generations and even surprises some modern readers. There was little privacy in the home, and children often slept in the same room where their parents did. Modesty or prudishness was not possible for most, and the attitudes that later came to be labeled "Puritan" would not have been recognized by the early Massachusetts settlers or those anywhere else in the colonies. Recognizing the importance of sex, the religious leaders of the time sought not to ignore it but to channel it through marriage into the procreation of children.[16]

Sex manuals were also not unknown. The most widely circulated manual was a collection of information and misinformation going under the title of *Aristotle's Masterpiece* or *The Complete Works of Aristotle*, which included within it *Aristotle's Last Legacy* and *Aristotle's Experienced Midwife*.[17] In spite of the use of Aristotle's name, the famed Greek philosopher had contributed nothing to the content of the work. The manual by the pseudonymous Aristotle was a miscellaneous collection of medical facts and pseudofacts gathered together in the sixteenth and seventeenth centuries. It perpetuated the myth that young women and virgins were particularly susceptible to hysteria and would be until they were married and achieved orgasm with their husbands. The book was widely printed, with each publisher varying the content slightly, but in all editions male lovers were urged to pay particular attention to the clitoris of the female. In a 1711 edition the publisher summed up the information about sex in this way:

> Thus the women's secrets I have survey'd
> And let them see how curiously they're made.
> An that, though they of different sexes be,
> Yet on the whole they are the same as we,
>
> For those that have the strictest searchers been,
> Find women are but men turn'd outside in
> And men, if they but cast their eye about
> May find they're women with their insides out.[18]

Throughout the various compilations, however, the emphasis was on marriage, and this fitted in with the colonial concern that sex was primarily to be enjoyed in marriage. Marital obligations included meeting the sexual needs of both partners, and failure to do so was one grounds for divorce in early Massachusetts. Sex outside of marriage was frowned upon, but there was a double standard inherent in colonial attitudes.

Though men might stray women were not supposed to do so, and Hester Prynne's scarlet letter was not dreamed up by Hawthorne. Women accused of adultery or fornication commonly received harsh penalties and were more often subjected to physical punishment or public humiliation than were men. However, the numerous births that, according to the records of colonial churches, took place during the first months of marriage suggest that sexual relations between young people were tacitly condoned so long as marriage followed.

Not all married women limited their sexual contacts to their husbands. Prostitutes appeared early in American history and had value in a society with such disproportionate sex ratios. In Puritan Boston, for example, the founders of Harvard worried that the students might succumb to the wiles of the town's prostitutes. Still, prostitution was regarded as a more acceptable alternative than sodomy, a catchall term that included masturbation, homosexuality, and numerous other activities. Thus it was accepted that men long absent from their wives or womenfolk could turn to Indian women or to slaves or prostitutes. Prostitutes could be punished, however, and this included stripping them to the waist, tying them to a cart, and whipping them through the village or town.[19] Cotton Mather became so concerned about public tolerance of prostitution that he organized a Society for the Suppression of Disorders in Boston and wrote a pamphlet calling public attention to the evils of prostitution.[20] Nonetheless, prostitution existed.

Life for most in colonial America, whether male or female, was a struggle in which laws and legal rights had little significance. Questions of ownership or rights to earnings seldom arose in this preindustrial society, where the entire family made up an economic unit and mutual needs bound its members together. If a woman was lucky, her husband provided for her and treated her with kindness. If he was drunken or improvident or brutal, however, unless his behavior led to court action, she had little recourse other than flight. Although newspaper advertisements for runaway wives indicate that some did escape, most did not. Divorce, although rare, did occur, especially in Massachusetts, where marriage was a civil contract. Occasionally court records reveal fines and other punishments meted out to a spouse who failed to abide by the marriage vows. In such cases a husband might be ordered to support his wife. If a wife misbehaved and her husband brought this issue to the attention of the courts, she could be physically punished, probably because women usually had no money of their own to pay a fine. Wifely "crimes" included nagging, gossiping, and quarreling, as well as more serious ones. Clearly the colonial family was not always a happy or a

peaceful one; most wives, however, had little choice but to suffer, if not always to be still about it.

In the colonies there was a more or less continually moving frontier, and frontier life demanded particular fortitude from women. Separated from friends or neighbors, they had no one to turn to for companionship or for support in times of childbirth, illness, or bereavement. Inevitably they welcomed the chance for social gatherings, although these usually combined work with pleasures, as in quilting parties. Many lived in continual fear of hostile Indians. Though colonial women early learned from Indians how to prepare unfamiliar food such as corn, in general white women (and men) paid little attention to other customs of the Indians. Undoubtedly they would have learned valuable skills if they had done so, but few of the European colonists imagined that Christians could learn much from the heathen. As relations between settlers and Indians deteriorated, women as a group proved no more tolerant or compassionate about Indians than men.

Colonial life changed as the population grew and towns developed. In some ways town life was less arduous for women. They could buy goods such as cloth, candles, and bread, and they were spared some farm-related chores. Town women, however, still worked, usually side by side with their husbands. Women were present in every colonial occupation from mortician and barber to printer and blacksmith, from cobbler to tavern keeper, from brazer and tinsmith to fuller (fulling was a step in the making of wool cloth). While some established their own businesses, particularly in fields like dressmaking or millinery, most of the independent businesswomen had taken over for absent, ill, or deceased husbands, fathers, or brothers. Maria Provost, wife of James Alexander, kept one of the largest shops in New York City. One evening in 1721 she gave birth to a daughter after having spent the day behind the counter, and the next day, with the help of her sixteen-year-old apprentice, she opened the shop and sold thirty pounds' worth of merchandise from her bed. Her husband bragged that he was very lucky to have such a good wife, who "alone would make a man easy and happy had he nothing else to depend on."[21] The fact that there were fewer women than men in most occupations is less important than the fact that women's occupational activity met community approval; society did not confine women to such occupations as midwife or nurse but left the door open for a variety of options. No one questioned, however, that marriage and motherhood were their natural roles.[22] Moreover, women labored under a disadvantage if they competed with men, and the inability of married women to make contracts or institute legal proceedings caused serious

problems when their husbands were absent. Courts occasionally decided in favor of women in these situations.

The vastness of the American colonies allowed varying norms to be followed. Among the most independent women were those on Nantucket Island, where the chief industry was whaling, an occupation that kept the men away on voyages lasting from two to five years. Inevitably, most of the island's business was handled by women. Status for a woman in circumstances like these came from her ability to make money or protect her husband's money during his absence. Under such conditions it was very difficult for a woman to be a "clinging vine," if only because, as one islander remarked, there were "no sturdy oaks" for her to cling to. Though mainlanders characterized Nantucket women as "homely and ungenteel," and their Quakerism kept their dress plain, they performed most of the tasks reserved for men in other parts of America. One preserved anecdote, perhaps apocryphal, tells the story of a good wife who while at a store decided to buy a whole barrel of flour, rather than make several trips to the store, and who then to save delivery time picked up the barrel and carried it home.[23] It was perhaps no accident that women from Nantucket later contributed disproportionately to the leaders of the women's rights movement. Lucretia Mott, one of the early feminists, and Maria Mitchell, a professor of astronomy at Vassar and militant champion of a new place for women, were both natives of the island.

One field where women enjoyed a near monopoly was midwifery. Few trained physicians existed except in the towns, and even there women dominated the practice of "obstetrics." In addition, nursing the sick or injured usually fell to the females in a household, and daughters learned remedies from their mothers. Some who developed special talents in that direction became known as doctresses. But to betray too much medical skill, whether as midwife or doctress, was to invite suspicion or even hostility, for it was commonly believed that such knowledge came from the devil. Indeed, Anne Hutchinson's success as a midwife contributed to the outcry against her.

One of the ironies of colonial America was that, in a society that accepted marriage as the destiny of women and that looked with pity and disapproval on spinsters, unmarried women enjoyed numerous advantages. Not many achieved the wealth and prestige of Margaret Brent, who was among the largest landowners in Maryland and played an important role in the early history of that colony, but colonial records are full of single women who owned land and businesses. Widows who

had been left the bulk of their husbands' estates were often among the wealthier members of a community, and if they chose to remarry could enter into premarital contracts to safeguard their belongings. The widows of poor farmers or shopkeepers did not enjoy these advantages, however, and were often forced, as indeed were widowers, into hasty remarriage.

Almost from the first European customs were modified to meet the demands of the American environment. European travelers noted the freedom enjoyed by young unmarried women and the voice allowed them in choosing husbands. The presence, especially in the South, of young women who had come without their families broke down the pattern of parental control over marriage. Relative scarcity of women in most colonies in the early years may also have afforded them more discretion in the choice of a mate, and certainly it increased their value. In the mid-eighteenth century Dr. Alexander Hamilton, a Scottish observer, reported that it was not unusual for young couples to go on long walks together and that he even went on such a hike himself with a woman companion and friends, enjoying "all the pleasure of gallantry without transgressing the rules of modesty or good manners."[24]

The American custom of dating can be traced back into the early colonial period. One observer reported that before the dangers of the wilds had been eliminated it was not unusual to see in Albany, New York, adolescent boys and girls going off on picnics together, with the young women carrying their sewing baskets and their male companions their rifles.[25] Obviously such freedom did not go without comment, and Jonathan Edwards, the Puritan reformer, for example, condemned all kinds of frolics where mixed groups were out at night.[26] Edwards was not alone. Many of the European visitors were shocked at what was permissible. The French traveler François de Chastellux observed a young man and woman holding hands and kissing in the presence of the family. He assumed that the couple were betrothed, and when he discovered that this was not the case, he marveled that it was not a crime "for a girl to kiss a young man."[27] Kissing, pinching, and fondling usually were regarded in the eighteenth century as mere flirtations, not to be taken too seriously. There were, however, limits and, to our minds, contradictions. Hannah Logan, a young Quaker, had to receive her father's permission before she could press the suit of her lover, but it was perfectly all right for the two to sit alone past midnight, embracing each "other in pure Love and perfect Confidence."[28]

One of the things that distinguished early America from Europe was

the great distances between settlements, which, coupled with a lack of hotels and restaurants, early bedtimes, and shortage of beds, meant that strangers were dependent upon individual hospitality. The result was the development of bundling, putting two people into the same bed. Lt. Thomas Anburey, stopping in a storm at a Massachusetts cabin, was offered a portion of the bed of the daughter of the house. Unaccustomed to American hospitality, the lieutenant offered to sit up all night rather than share the bed of the teenaged daughter. The father rejected this response out of hand and laughingly explained that he was not the first man Jemima had bundled with. Jemima, however, volunteered the information that he was the first Britisher.[29]

Bundling was also part of the courtship process. Marriage in the colonies usually involved a formal betrothal or precontract before the final marriage vows. This put the couple in an ambiguous position, not yet married but more than single. In several of the New England colonies, for example, sexual intercourse of a betrothed woman with a man other than her promised spouse was punishable not as fornication but as adultery, but if it took place with her betrothed the couple was punished only half as severely as an uncontracted couple for the same offense.[30] Many of the betrothed couples courted each other in bed, with a board between them for safety, although from the public confessions in the churches it seems that the board did not always work. In spite of the attempts to stamp out the custom it continued through the eighteenth century, at least until greater sophistication and more adequate housing became the norms for American opinion makers.[31] Memories of the custom, if not the custom itself, continue in the numerous traveling salesman jokes about farmers' daughters.

As the population increased and towns grew larger, the role of women changed. They became more genteel and ladylike, less free and open, more "civilized," less backwoods.[32] This process did not work to give women greater equality but to increase their subordination. Even in the earliest years on the frontier, however, the women worked hard to appear "civilized." For example, women tended to cling to the customs and dress they had always known. Rather than adopting clothing more practical to a wilderness, perhaps imitating that worn by native American women, they continued to wear the long full skirts of their mother country. Men were more adaptable, and their clothes were less likely to be European. On the frontier most women eagerly awaited news of the latest European fashions and cherished a "best" dress for special occasions. As economic differences between colonists became magnified, the more affluent followed the style of their European counterparts,

wearing the elegant hairdos, hoop skirts, and finery so popular in London and Paris. In fact, clothing seemed to symbolize women's tendency to reestablish in America the world that had been left behind.

Helping to form colonial attitudes about proper behavior for a lady were the novels or instruction books often imported from Europe, although printed in America. Romances achieved wide circulation despite concern about their ill effects on impressionable female sensibilities. Prescriptive literature met with greater approval, and the English *Spectator* and *Tatler* were widely read, as were such books as Dr. Fordyce's *Sermons to Young Women*.[33] The general tenor of the prescriptive literature was to encourage women to become ladies and to be virtuous, demure, and properly deferential to men. Letters and diaries from the period indicate that among the upper classes these teachings were carefully followed.

Not all American women became ladies, however. For those in frontier settlements life resembled that in the early colonies. Small farms still demanded the full-time labor of men and women. Even in the towns, only the well-to-do experienced the benefits, and the drawbacks, of a more civilized society, and women in these classes owed their more leisurely lives in large part to the labor of less fortunate women who worked as their servants. In the South female slaves rapidly replaced indentured servants, working both in the house and the field, often alongside the men.

Slave women were apart from the world of white women in colonial America, but they too had a different role than that of the men within the limits set by the slave owners. Probably within slavery the mother-child bond was both more sacred and stronger than the husband-wife bond, but this was a reflection of traditional African society.[34] This does not mean, however, that slavery emphasized matriarchy or that the father was not important, just that women identified more with other slave women than with slave men, just as free women identified more with other women than with men. Slave women, however, were sexually at the mercy of their masters, and this fact emphasized and exaggerated the double standard in the South. Every planter tended to regard himself as the supreme source of law in his own bailiwick, the creator of his own slave code, although the need for enforcement and requirements of the market led to development of formal codes. Still, black women suffered from being the master's unwilling sexual partners, while his wife suffered from her inability to do anything about the situation. Peter Fontaine in 1757 claimed that Virginia "swarms with mulattoe bastards."[35] Thomas Anburey, who traveled throughout much

of America during the eighteenth century, also reported seeing a number of mulattoes on southern plantations and added that many of the young women "are really beautiful, being extremely well made, and with pretty delicate features; all of which I was informed were the colonel's own. . . . It is a pleasant method to procure slaves at a cheap rate."[36] White women on the other hand were protected from the male black slave. This distinction between white women and black women was one of the factors contributing to the concept of female gentility in the South, which was different from that held in the North and West and in fact almost seems to have been a kind of guilty compensation for the greater freedom of men in seeking bedmates. W. J. Cash wrote that the southern woman became

> the South's Palladium, this Southern woman, the shield-bearing Athena gleaming whitely in the clouds, the standards for its rallying the mystic symbol of its nationality in face of the foe. She was the lily-pure maid of Astolat and the hunting goddess of Boetian hill. And she was the pitiful Mother of God. Merely to mention her was to send strong men into tears—or shouts. There was hardly a sermon that did not begin and end with tributes in her honor, hardly a brave speech that did not open and close with the clashing of shields and the flourishing of swords for her glory. . . .[37]

Such gyneolatry did not lead to political power or equality for women, but it had its compensations. The difficulty was that even though many women were satisfied with being subjugated and exalted, not all were. Men were recognized as different creatures, able to assume different tasks, but women were all set apart by biology and qualified only to be wives and mothers.

The regional and class differences in the attitudes toward women emphasize a growing shift from European concepts. Gradually the colonists began to regard the New World as their home, and the final British victory over the French in 1763 may well have resulted, at least in part, from the fact that the English colonists fought to defend what they viewed as their own land, not the colonial outpost of a far-off European power.

During the early years, when the lives of most colonists centered around the everyday effort to survive, political or legal equality generally meant little to women. But as Americans increasingly concentrated on the political and economic issues that would culminate in the Revolution, the relative position of women declined. To be sure, women as well as men on this side of the Atlantic read Locke, Condorcet, and

Montesquieu and were aware of heady new ideas about liberty and government by the consent of the governed. Some even talked about rights for women, and both John Otis and Thomas Paine openly questioned male dominance by asking whether women were not born as free as men.[38] Obviously they were the exceptions, since despite Abigail Adams's famous letter to her husband as he went off to the Continental Congress, in which she urged him to "remember the ladies," there is no indication that he or anyone else in that body was concerned with the rights of women. In fact, his reply, teasing his wife for being so "saucy," suggests that not even the respect he often expressed for her opinions could convince him to believe that she or any other woman should enjoy political rights.[39] The stirring words in the opening passage of the Declaration of Independence about all "men" being equal and having certain inalienable rights, which in modern times have been interpreted to include women, did not mean political equality for women in the eyes of their author. In answer to a letter from a young woman about just such matters, Jefferson wrote that women were "too wise to wrinkle their foreheads with politics."[40]

Such views did not prevent women from participating in the struggle with Great Britain, however. As protests against the British policies mounted, women, especially those in the towns, played key parts in organizing and enforcing colonial boycotts. Joining together as Daughters of Liberty, they vowed not to purchase British goods and worked to furnish substitutes. They concocted herbal teas and, some for the first time in their lives, turned to spinning wheel and loom to produce homespun. The letters of Abigail Adams, Mercy Otis Warren, and Judith Sergeant Murray clearly show their vital interest in the growing revolutionary excitement, and they freely expressed their views to male and female friends alike.[41] Murray, writing under the pen name of Constantia, turned out patriotic plays and articles, while Warren would later write a history of the Revolution. That Massachusetts women should be outspoken in support of the Patriots' cause is not surprising, for they had long enjoyed a position of greater equality and a higher level of literacy than women elsewhere in the colonies. Women elsewhere, however, were also active. Julia Spruill writes of southern women involved in revolutionary activity, and in Philadelphia women organized a fundraising campaign to aid Washington's army.[42]

Activity did not lead to greater political power. In fact, women technically lost some of their political rights. This happened because legally some women had had the right to vote in several of the early colonies, at least on certain issues, but lost that right around the time of the Con-

stitution. New Jersey alone retained woman suffrage, but there is little reported about this until an Elizabethtown election in 1796, when a group of conservative "widows and maids" organized by the Federalist candidate nearly defeated his opponent. The *Newark Centinel* then proudly reported that the residents of New Jersey not only preached the rights of women but also boldly pushed such ideas into practice. Apparently the New Jersey registration provisions were rather loosely enforced, and after an election in 1806 in which an assortment of women, blacks, servants, and others were herded into polling booths, the New Jersey legislature moved to restrict the suffrage to "free white male citizens," cutting out aliens, females, and blacks all together.[43] It was not until the establishment of school suffrage in Kentucky in 1838 that women once again began to regain their right to vote.

Not all colonial women favored independence; many remained loyal to Great Britain. Problems arose when a wife took a stand different from her husband's, particularly if the husband opposed the Revolution and fled, leaving his wife behind. One troubling issue was whether a woman still legally married could carry on a business in such cases. After the war, questions arose as to whether a Loyalist husband's actions should deprive his Patriot wife of a claim to his property. Whichever side a woman favored, most women felt the effects of the war.

Women accompanied the armies as wives or camp followers and helped to feed and nurse the soldiers or to act as couriers or spies. Some took part in battle, and at least one, Deborah Sampson, posed as a male and joined the army, using the name Robert Shirtliff. Sampson bound her breasts with a bandage to disguise herself and reportedly augmented her waist with padding. Though Cornwallis had already surrendered at Yorktown when she enlisted, she did see action with scattered units of British troops and Tory bandits and was wounded. When finally discovered in 1783, she was given an honorable discharge and shortly afterward married Benjamin Gannett. She received a pension for her wartime services and thus can be listed as one of the first women, if not the very first, to serve in the U.S. Army. As her story reached the public she became an object of considerable curiosity and gossip, but she also eventually came to be regarded as a kind of heroine.[44]

Despite the disruptions caused by war, the basic perception of women remained unchallenged. Under duress of war a woman might manage a business or run a farm or even accompany her husband to battle, but not even Abigail Adams or Mercy Warren questioned her primary role as lady, wife, and mother. Yet that role underwent subtle changes. Independence accelerated economic developments and focused attention on po-

litical matters, circumscribing the sphere of women more rigidly. "Republican Motherhood" became the ideal, with results both positive and detrimental for women.[45] Women came to be viewed as depositories and conveyors of public and private morality. They had moral law unto themselves. It was they who would bring forth the future leaders of the nation. While their husbands tended to the male world of business and politics, women were to manage the households, raise the children, and provide havens of stability. Men admitted that to fulfill these responsibilities, women needed education. The years following the Revolution witnessed the founding of numerous "academies" for girls. Benjamin Rush, a leading advocate of female education and a founder of Philadelphia's Young Ladies Academy, believed that only educated mothers could produce the informed citizens required for the success of the American experiment.[46] Judith Sargeant Murray strongly seconded him: "When [educated women] become wives and mothers, they will fit with honor the parts allotted them."[47] Perhaps Murray privately valued women's education for its own sake and couched her plea in language that appealed to men. Benjamin Franklin serves as a witness that this subterfuge remained necessary. Franklin advocated education for women, but as his *Reflections on Courtship and Marriage* stated, nature as well as the circumstances of life designed men for "superiority" and invested them "with a directing power in the more difficult and important affairs of life." Educated women, however, were more likely to listen to their husbands than uneducated, since they would be able to reason "with delicacy, coolness, and good temper, supported by a solidarity and strength of judgment." Franklin also held that though love might come by chance it was retained by art.[48]

Franklin was no feminist, but what might be called feminist writings were beginning to reach the United States. Mary Wollstonecraft's *Vindication of the Rights of Women*, mentioned earlier, appeared in two independent editions in 1792, one printed at Philadelphia and the other at Boston. Still a third edition appeared in 1794. The influential Philadelphia Quaker Elizabeth Drinker commented that "she speaks my mind,"[49] and several other Americans, male and female, spoke highly of the book. William Godwin's *Enquiry Concerning Political Justice and Its Influence on Morals and Marriage* was published in the United States three years after it appeared in England. Godwin, the husband of Mary Wollstonecraft, held that monogamous marriages were inconsistent with men's psychological makeup and that removing the unnecessary bindings of law and property would allow man to apply a kind of reasonable virtue and moderation of his sex life.[50] American writers

also questioned traditional views. Judith Sergeant Murray, for instance, created heroines who were always strong, resilient women. Charles Brockden Brown, usually regarded as the first professional author in the United States, believed it was unfortunate that women were too often regarded more or less as animals, existing only for the convenience of males. In his novels, such as *Alcuin: A Dialogue* (1798), he attempted to portray alternative situations where women were somewhat more equal. Brown, however, was not a feminist; he protested both the ideas and the character of Wollstonecraft, whose life-style he regarded as immoral. Probably most women agreed with him. They liked many of Wollstonecraft's ideas but were shocked by her life and her unconventionality.

Slowly, however, the seeds planted by these writers took root and, when combined with the changing roles that women found themselves in, began to bear fruit in the woman's movement of the early nineteenth century. Increasingly, women grew discontented with the limitations put upon woman's role and began to agitate and "meddle with such things as are proper for men."[51] This agitation and meddling is the subject of the next chapter.

13 / Growth of Feminine Consciousness in the United States and Movement Toward Equality

So far in this book, the male voices have dominated. Only occasionally, and generally only in more recent times, have women spoken for themselves. Even when they have spoken, their voices have often seemed muted—perhaps a reflection of their ambivalence about the role they have wanted to play. Though men in the past did occasionally speak on behalf of women, change began to occur only when women started to express their own needs and desires. A woman's movement had to be led by women. In this sense women are like other minorities in American culture, from blacks to Indians to gays. In the early stages of consciousness, outsiders can help develop public awareness of the needs of a particular segment of society, but ultimately leadership has to come from the minority group itself.

To bring about change has required an assault upon tradition, but it is a tradition that women no less than men have accepted. One of the difficulties with being subjugated and subordinated, as women in the past have been, is that there are rewards for accepting a position of inequality in society. Probably the simplest behavioral explanation of this acceptance is to regard behavior as a product of the expectations of rewards and punishments. Women who submitted to the stereotypes of the past were rewarded for their inferior position. Sometimes the reward was a direct one. Lack of power seemingly protected them from the risks

of decision making and the anxiety over punishment for wrong decisions. It may appear simpler to be relieved of these decisions. Upperclass women were also often rewarded directly for their obedience and passivity by gifts and a life of luxury. With the industrial and commercial revolution these rewards were extended along the social-class ladder to include the middle class. Women became symbols of conspicuous consumption as men flattered them, comforted them, and displayed them.

Sometimes the reward for a lack of formal power was indirect and came in the form of great informal power. In China, for example, the power of the old mother was almost absolute, and in various polygamous societies, the mother whose son reached a position of power could lord it over all the other women. Although in these instances women lacked the physical power to confront men directly, they could take satisfaction in their ability to manipulate them. Manipulation, in fact, traditionally has been the role of the subjugated, and for those who followed the rules it could be a position of considerable influence. Mary R. Beard documented just such informal power in her interesting study *Women as Force in History*.[1] Though serving as the power behind the throne is satisfying to many, it is not every person's cup of tea. It might be that in the past, when physical strength and military ability were frequently the deciding factors in any power confrontation, manipulation was the main possibility open to the ambitious woman. This does not need to be the case today, because most power is based on attributes other than physical strength. One advantage for some in the subordinate role is that status can be ascribed, and so achievement is focused on marrying the right person rather than doing things for oneself.

That few women in the past openly rebelled at their role in life does not mean that they were satisfied, since few slaves have ever rebelled on a mass scale either. As Karl Marx, the nineteenth-century theoretician of revolutions, pointed out, the lumpen proletariat, the most alienated and dispossessed class and the one with the most to gain, lacked the spark of revolution. Moreover, punishments in the past were often severe for those women who rebelled against the regulations of male-dominated society, and the rewards great for those who conformed. The most successful rebels tended to attack the edge of the glacier of prejudice, but one difficulty was that women as a group lacked organizations that could build upon progress in order to maintain the momentum of change, lacked the educational sophistication of their male counterparts, and were economically and legally limited.

The nineteenth century saw rather far-reaching changes in all of these

areas, and change in one often brought about change in another. Education is an example. Though there had been various female seminaries, and women had been taught in convent schools since the Middle Ages and often had special tutors at home, formal education for women at the college level only became available in the years after 1820, and at the beginning it was far from equal to that available to men. The Troy Female Seminary, founded by Emma Willard in 1821, and the Mount Holyoke Seminary, founded by Mary Lyon in 1837, originally aimed at preparing young ladies for their proper roles as wives and mothers or as teachers, but eventually developed into regular colleges; Holyoke still survives. At Oberlin College, which in 1833 became the first coeducational institution, female students took special "ladies'" courses and were expected to perform domestic chores.

Almost immediately the schools were faced with such major problems as what degree to confer, because some felt that it would be improper to award a woman a degree as bachelor or master of arts, both of which terms implied that the holder was male. Some institutions tried to get around the dilemma by issuing such degrees as "Laureate of Science," "Maid of Philosophy," and "Mistress of Polite Literature," but eventually most women were given the same degrees as men and the terms lost any particular association with sex. The number of coeducational schools continued to increase as state colleges and a few private ones began to admit women students, especially when the Civil War resulted in a scarcity of the male variety. But it was more socially acceptable to go to a girls' school, and in the period after the Civil War these increased rapidly, with the founding of Vassar in 1865, Smith and Wellesley in 1875, and Radcliffe and Barnard, the female annexes to Harvard and Columbia, shortly after. Though the women's colleges, particularly the counterparts to the male Ivy League ones, contributed immeasurably to gaining recognition for the intellectual abilities of women, they also set women apart as a separate class and encouraged the treatment of them as somehow of finer fabric than men. Throughout the nineteenth and well into the twentieth century, most of the women's colleges continued to emphasize that women were different from men and, in general, refused to establish any career-oriented majors except for teacher training. The president of Mills College, as late as 1950, emphasized that women had to be educated differently from men since their function in society was different.[2]

Women's colleges accepted as a given that they were not training women to compete in the marketplace with men, realizing that to do so would probably have negated what positive effect they had. Americans

believed that women were meant to be mothers, and had colleges indicated that they were training women to be anything other than good wives and mothers, they might have lost the public support they had. In fact, almost until World War II, the only way most women could have careers was to sacrifice marriage and family, to be spinsters with a profession, and this status was generally regarded as being inferior to that of wife and mother.[3] Women were insulated against the dominant masculine goals of society and shamed into forgoing careers, which supposedly attracted only neurotic women. In the process the differences between men and women were emphasized and reinforced.[4] The Marxist Freudian philosopher Herbert Marcuse, whose ideology was popular in the 1960s, held that women were less brutalized than men because economic discrimination kept them out of the competitive world and confined them to the home, where they exemplified bourgeois virtue.[5]

Often the result was to emphasize that woman's nature set her apart from men, a position advocated by what Mary Daly called the "pedestal pedlars." In this view, woman's significance was due not necessarily to her psychological, biological, historical, or social position but to her symbolic aspect.[6] Woman's vocation ostensibly was to surrender and hide; through selflessness, she achieved not self-realization but generic fulfillment in motherhood. In a sense, women were regarded as timeless and conservative by nature, shrouded in "mystery" because they were different from men.[7]

Inevitably, women who did manage to enter the professions somehow had to compete with men, and yet to be successful they had to conform—at least outwardly—to the role that society dictated for them. This ambivalent position is illustrated by the case of Elizabeth Blackwell, who usually is regarded as America's first woman physician. Blackwell was admitted to Geneva Medical College in 1847 after being rejected by twenty-seven other schools. Geneva accepted her because the faculty of the school, unwilling to antagonize her sponsor, an influential physician whose support the school needed, turned the decision over to the students, with the provision that one negative vote would deny her entry. The students—some because they saw an opportunity to embarrass their teachers, others because they saw it as an exciting prank, and a few because they believed in women's rights—voted to admit her. One student started to vote no, but the other students pounced on him and, either in real or mock fear, he changed his vote. When Blackwell graduated less than eighteen months later, in order to meet the proprieties expected of women, and unwilling to offend others at the ceremony, she refused to walk in the commencement procession;

instead she sat with the other women who had preceded the graduates into the chapel.

Blackwell's troubles did not end with her graduation. As she and the handful of other early female physicians discovered, hospitals would not admit women as interns, residents, or members of the staff. After gaining experience in a Paris clinic, she returned to New York, where she was forced to open her own hospital for women and children. Although she, as well as others in her famous family, sympathized with the women's movement, she carefully avoided controversy, undoubtedly in part at least to deflect criticism of women in the medical profession. She nonetheless wrote about her experiences and beliefs and blazed the path for others to follow.[8] By the end of the century, more women were attending medical schools than before, but most hospitals remained closed to women. Many women physicians practiced in hospitals and clinics devoted to the care of women and children. Few married, and those who did usually retired from active practice. Barred from membership in the American Medical Association, female physicians formed their own professional organizations.

Equally great opposition faced women who wished to practice law. George Templeton Strong wrote in his diary, "No woman shall degrade herself by practicing law, in New York especially, if I can save her. . . ."[9] In 1873 in *Bradwell* v. *Illinois*, the U.S. Supreme Court ruled that it was the prerogative of a state to deny an appropriately educated woman admission to the bar.[10] The privileges and immunities clause of the Fourteenth Amendment did not include in its scope the right of a woman to practice law. The second wave of women attorneys, although licensed, often did not practice as men did. Perhaps this was why a significant cadre was found in leadership positions of women's organizations, pressuring for legislative and judicial reforms that often were meant to benefit women "less fortunate" than themselves.

Even as late as 1926, when Emily Hahn graduated with a degree in engineering, women had difficulty finding work in "men's professions." Hahn herself never was hired as an engineer.[11] The relatively few women who received professional degrees were invariably held back by existing prejudices about the nature of woman's role, as well as by legal restrictions.

Faced with such obstacles, it is not surprising that many women entered professions and occupations not dominated by men. By the end of the nineteenth century, four such professions had appeared and had been quickly filled by middle-class women: nursing, social work, elementary teaching, and library work. That society did not frown on

women entering these areas was probably due to two factors. First, in a sense all of them had traditionally been women's jobs that now were becoming professionalized. And second, women could be paid less than men. Not surprisingly, each became a low-status occupation where workers were paid less than men in jobs requiring similar education or ability. Most of the women who went into these fields worked only until they married, and the rapid turnover of personnel helped to keep wages down.

In the lower socioeconomic groups, married women worked because they had to, but the better jobs were usually available just to single girls awaiting marriage. This was generally true of the two occupations in the business world that women most effectively claimed as their own: typist and telephone operator. In 1870 only seven women in the United States were classified as secretaries, but by 1950 there were over one million. The first woman telephone operator was hired in 1878, in part because women could be hired at lower wages than men. Women also took over selling jobs, particularly of women's goods, but not until the twentieth century was it considered respectable for a woman to be a saleslady in a department store. When Gilchrist Department Store in Boston hired its first woman salesclerk in 1877, people came to stare at her for several weeks. (Gilchrist's in 1972 announced that it would issue charge cards to women customers in their own names without requiring their husbands' permission—an indication that it takes a long time to modify long-standing prejudices.)[12] Women also worked in the emerging factories in the nineteenth century, but here they often ran into organized opposition from men who felt that they were cutting men out of jobs, and they were usually found in the lowest-paid factory positions. Organized labor, social feminists, and various reformers worked for legislation designed to establish certain minimum working conditions for women and children, conditions that were important in bettering the working conditions for men as well but that also limited women in the job market. Probably the majority of women who worked did so as domestics or in jobs allied to women's tasks in the home, such as laundress, cook, practical nurse, hairdresser, and so forth.

Black women had a more difficult time than white, although it was often easier for a black woman to get a job than a black man—but only as a domestic or servant. Richard Wright, a major black writer of the first part of the twentieth century, pictured the situation graphically and poignantly in one of his stories, which recounted the continued failure of a black male to get a job. In his desperation he finally dressed up in his pregnant wife's clothes and was hired almost immediately as a

domestic. He then found that he was also expected to satisfy the sexual needs of his male employer, and when he refused, he was fired.[13] Only in the 1970s did sexual harassment become a public issue.

As women gained educational sophistication and some means of earning a living independent of a man, they became more conscious of the disabilities under which they worked. Many were aware of the eighteenth-century revolutionary rhetoric in both Europe and America, which emphasized that all men had been created equal, and realized to their own growing discontent that in practice the "men" in the rhetoric meant males and not people in general. Women who protested were often, though not always, regarded as isolated individuals. Margaret Fuller, for example, an important figure in the American transcendental movement (which included such people as Henry David Thoreau, Ralph Waldo Emerson, and Bronson Alcott), in 1843 wrote her woman's rights tract, "The Great Lawsuit—Man Versus Men: Woman Versus Women." In it, Fuller portrayed the campaign for feminine equality as a divinely ordained fight to exalt the human race.[14] In 1845 her *Woman in the Nineteenth Century* emphasized women's strength and demanded that women exercise their own intellectual power in defining their place in life.[15] Serving as editor of the transcendentalist journal *Dial* and then as a reporter for Horace Greeley's *Tribune,* Fuller demonstrated that a woman could compete successfully in the world of men. Emerson himself, in addressing a woman's rights convention in 1855, noted that women had not yet expressed a wish for equal rights.[16] Emerson indicated a willingness to give them this right if they desired it, but a lone voice like Fuller's or even an organized meeting for women's rights apparently to him did not represent enough of a demand to require any change.

Woman's organizational action and participation in the United States began to increase in the early nineteenth century with the establishment of various relief societies for the urban poor, such as the New York Orphan Asylum Society run by women.[17] The Jacksonian period—marked by the separation of classes of women and of women's and men's roles—also marked the growth and diversification of women's organizations. In the years leading up to the Civil War, many women served in ladies' auxiliaries, organized bake sales, and generally stayed within a limited service role. Ladies of the period might engage in missionary societies, which offered proper ways to pass time and, despite the paternalistic attitude of the era, opened a window on worlds such as Africa and the Far East, about which these women often knew little. Religion, in fact, could be utilized both as motivation and as cover for

many women's activities. In these varied organizations, women gained in organizational experience and expertise. In the process they began to voice their own concerns more effectively,[18] and even as the women's rights activism has waxed and waned over the past 150 years, the new consciousness has continued to grow,[19] first in churches and in women's groups but then in a broader spectrum of activities.

Gradually women began to involve themselves in ventures that took them beyond what was considered their proper sphere. Often motivated by religious conviction, many joined temperance and abolition societies that in turn served inadvertently as springboards into feminism. As they sought to take a more active part in combating slavery and intemperance, they found themselves opposed by men who expected them to remain obediently in the background. Lucretia Mott discovered that even her fellow Quakers frowned on her speaking out against slavery, and Susan B. Anthony encountered similar disapproval at temperance meetings. When the Grimké sisters, Sarah and Angelina, began publicly denouncing slavery—and they were particularly effective because of their southern origins—they, too, met hostility. Catharine Beecher, while sharing their abolitionist views, criticized them for their unladylike behavior, and the Congregationalist clergy of Massachusetts chastised them in a pastoral letter. The letter especially censured them for mentioning the fact that slave women were often sexually abused by their masters and overseers, since this was a subject women ought not to talk about. Some nineteenth-century clergymen even held that it was beyond woman's capacity to speak from the platform on any subject, and when the Grimké sisters and others demonstrated that women could speak effectively, reactionary clergy retorted, as did the Reverend Jonathan F. Stearns, that the "question is not in regard to ability, but to decency, to order, to Christian propriety."[20] The Grimké sisters were not silenced by the censure of the Massachusetts Congregationalists, and Sarah Grimké went on the offensive with her "Letter on the Equality of the Sexes and the Conditions of Women." In this she held that whatsoever was "morally right for a man to do" was also morally right for a woman, something that Bible-quoting opponents found difficult to deny. Sarah Grimké admitted that by such a statement she was asking women to sacrifice the adulation, the flattery, the attentions of trifling men, but she held that this was the only way woman could elevate her own character.[21]

The experiences of women like Mott and Anthony and the Grimkés led them to a growing awareness of their own subordinate position in society, a position, as many of them noted, that was similar to that of

slaves. Sarah Douglass and Harriet Tubman were among the black women who shared these views and who would be among the early champions of women's rights. Tradition has it that Elizabeth Cady Stanton and Lucretia Mott conceived the idea of convening a women's rights meeting after the World Anti-Slavery Convention in London in 1840 denied Mott a seat as a delegate because she was a woman. The convention, held in Seneca Falls, New York, on July 19, 1848, issued a Declaration of Sentiments and Resolutions, strategically modeled after the Declaration of Independence. Paraphrasing the Declaration of Independence, it stated: "We hold these truths to be self-evident; that all men and women are created equal. . . . The history of mankind is a history of repeated injuries and usurpations on the part of man towards woman, having in direct object the establishment of absolute tyranny over her."[22] The document then went on to list specific grievances, calling for the removal of various liabilities and demanding woman's sacred right to the elective franchise. The Seneca Falls meeting launched the women's movement in the United States, and it was followed by a series of meetings in the years before the Civil War.

Men seemingly were resentful even when women banded together to collect funds for a worthy cause. In Boston, for example, the Bunker Hill Battle monument remained unfinished in the 1840s because of lack of funds. To raise money to finish it, a group of women, under the leadership of Sarah Josephus Hale, held a handicraft fair. The funds raised permitted construction to continue, but the managers of the project accepted the money only on condition that no credit be given to the women who had ignored their natural incapacity by attempting (successfully) to raise money.[23]

Men were not the only ones to cling to traditional attitudes about women. Catharine Beecher and Emma Willard may have been pioneers in women's education, but both were opposed to women taking an active part in political matters, and while Sarah Hale edited the leading women's magazine, she did not favor woman suffrage. Differences of opinion among women are revealed even more sharply where morality and sexual behavior are concerned. Mary Coffin Wright, an early feminist, attended a rural dance in 1850 and became righteously indignant because of the women "sitting in gentlemen's laps and thinking nothing of being kissed."[24] Frances E. Willard, a feminist and future leader of the Woman's Christian Temperance Union, reported that when she was at an Evanston boarding school in 1858, "a young woman who was not chaste came to college there through some misrepresentation, but she was speedily dismissed; not knowing her degraded status I was speaking

to her when a schoolmate whispered a few words of explanation that crimsoned my face suddenly; and grasping my dress lest its hem should touch the garments of one so morally polluted, I fled from the room."[25]

Still, while many women continued to adhere to what is usually considered Victorian morality, others openly questioned prevailing views of marriage and sexuality. Elizabeth Blackwell wrote that women should be educated about their sexual functions, and Lucy Stone stated that she very much wished "that a wife's right to her own body should be pushed to our next convention,"[26] a concern that is still an issue in the political arena of the 1980s.

The early suffrage movement launched by Stanton and Mott became submerged in the issues of the Civil War, but in the postwar era the ratification of the Fourteenth Amendment to the Constitution led many supporters of woman suffrage to think that things had changed. The amendment prohibited the abridgement of privileges and immunities of U.S. citizens. Susan B. Anthony, working with Missouri attorney Francis Minor, argued that all persons born in the United States were citizens, that suffrage was a right of all adult citizens, and that women as persons and citizens were therefore entitled to vote. In attempting to vote Anthony found herself placed under arrest, and in 1873 she was convicted by a federal court in New York. Other women, members of the National Woman Suffrage Association, engaged in similar attempts to vote. In 1874 Virginia Minor tried unsuccessfully to register to vote in St. Louis.[27] Because as a married woman she could not herself bring suit, her husband Francis took the case to the U.S. Supreme Court, which held that the privileges and immunities clause in the Constitution did not entitle her to vote. In effect, the Constitution had to be changed before women throughout the country would have the right to vote.

During the years following the Civil War, those involved in the suffrage movement, and in the women's movement generally, often differed over both philosophy and tactics. The American Woman Suffrage Association, led by Lucy Stone and other prewar feminists, took a relatively conservative position while continuing to advocate the vote for women. Stanton and Anthony formed the more liberal National Woman Suffrage Association and fought not only for suffrage but for other issues of concern to women, including working women. While Stanton and Anthony demanded the vote as woman's right, others justified it as necessary to influence public policy makers concerning the justice of the causes they supported. Frances Willard, president of the Women's Christian Temperance Union, was able to win over many conservative men and

women to the suffrage cause by convincing them that women voters would help to bring about Prohibition and thus to purify society.

Some of the western territories provided women with universal suffrage, although the reasons probably had little to do with female equality as such. The men of Wyoming, where women received the vote in 1869, were in part motivated by a desire to preserve the "white, rural, middle-class American virtue." This, they felt, they could do by doubling the vote of the "respectable" people who settled as family units as opposed to "undesirables," such as gamblers, hustlers, and the mentally unbalanced who were attracted to life on the frontier.[28] Women were also in short supply in Wyoming, and it was also hoped that more women would be attracted to the territory. Women, wrote one local humorist, "can give this territory a boom that will make her the bonanza of all creation." Even though equality for women probably was not the motivating factor in giving them the vote, woman suffrage did serve as a case study for those women in other states who argued that women could vote as intelligently as men. Wyoming in 1890 was admitted as a state with woman suffrage and in 1916 sent the first woman to Congress, Jeannette Rankin.

The second territory to give women the vote, Utah, faced a somewhat different situation than Wyoming, since women were as numerous there as men. Again the motivation was to gain backing for the establishment, this time the Mormon church. At least two reasons seem to have motivated the Mormons in Utah to give women the vote. The overwhelming majority of women in the territory were Mormon, whereas large numbers of men were non-Mormons attracted by the mining industry. By giving women the vote the Mormons could assure themselves of dominance. The Mormons at this time also practiced polygamy, which was under heavy attack across the country as a new form of slavery, and if they gave women the vote and the women voted to retain polygamy, the Mormons could assure a hostile America that women were not forced into polygamy. Congress, in fact, insisted in 1887 that women not be given the right to vote until polygamy was abolished. Utah restored woman suffrage in 1896 when it was admitted as a state with a provision in its constitution making polygamy illegal. Not all western states gave women the vote; California rejected it by referendum in 1896.[29]

Meanwhile, women in ever growing numbers were entering into activities outside the home. During the Civil War, northern women organized the Women's Central Association for Relief, but it was headed by a man, since it was assumed that women would be incapable of chairing

such a body. Nevertheless, the women's organization eventually led to the formation of the United States Sanitary Commission, which was an important factor in the northern victory.[30] Women in this and other war-related activities demonstrated skills and strengths that may have surprised even themselves, and not all of them returned to their prewar attitudes. Some joined the women's clubs that became popular among urban middle-class women in the last third of the century. Often beginning as literary clubs, they became increasingly concerned with issues of public interest. While most of these women combined their club work with family obligations, younger women, many of whom had attended college, found themselves unsatisfied with the conventional path leading to marriage and motherhood and searched for acceptable alternatives. The settlement house movement provided an outlet for some of these middle-class women, one that satisfied their own needs and at the same time enabled them to contribute to reforms that benefited society.

Jane Addams, who founded Hull House in Chicago in 1889, was a pioneer in the settlement-house movement. She was a major figure in most of the reform movements of the late nineteenth and early twentieth centuries, championing the rights of the poor, blacks, laborers, and women and children, and she helped to found the National Conference of Social Work. She was also active in the Women's International League for Peace and Freedom, for which work she won the Nobel Peace Prize in 1931. Only slightly less well known was Lillian Wald, the nurse and social worker who founded the Henry Street Settlement in New York and played an active role in the Progressive movement. Another woman closely connected with settlement houses was Florence Kelley. While living at Hull House, Kelley lobbied for passage of the Illinois Factory Inspection Act and then went on to serve as factory inspector. She later moved to the Henry Street Settlement and became a leader of the National Consumers' League, working for years on behalf of child labor laws, protective legislation for women, and other Progressive measures. Her belief that women needed special protection in the workplace explains her later opposition to the ERA. Jeannette Rankin, the first woman to serve in Congress, had been a social worker, as had Frances Perkins, the U.S. secretary of labor under Franklin Roosevelt and the first woman to serve in the cabinet. Not only did those involved in settlement-house work play a major role in Progressivism, they also helped to shape the policies of the New Deal.

Although most of the women associated with what was rapidly becoming the profession of social work supported woman suffrage, they

usually saw it as only one among the many issues of importance to women. Others devoted their endeavors to the suffrage cause alone. Hoping to end the divisions in the movement, the two competing suffrage organizations merged in 1890 to form the National American Woman Suffrage Association (NAWSA). Despite some successes in the West, the suffrage movement stalled in its state-by-state attack, and in 1914 the Congressional Union, a radical arm of the association, proposed the Nineteenth Amendment. A wide variety of women's groups established special suffrage committees to push for ratification, and a national campaign was organized to get women the vote, with Carrie Chapman Catt, the president of the NAWSA, coordinating the attack. She and other savvy leaders of the suffrage movement worked to win over politicians to their cause, at first with only mixed results. Although Theodore Roosevelt's Progressive party endorsed woman suffrage in 1912, neither major party did so either then or in 1916. President Wilson took refuge in claiming that such matters should be left to the states and hoped to placate women by proclaiming Mother's Day. But, as state after state granted women the vote, finally including states east of the Mississippi, Wilson wavered. The clincher came with U.S. entrance into World War I, when Catt and many other women promised "woman's" support for the war effort and Wilson announced his support for the suffrage in recognition of their contributions.

World War I did more than speed woman suffrage. The demands for workers necessitated by the absence of men in the armed services meant that women entered the paid work force in ever larger numbers, and some of the traditional barriers broke down. When the U.S. Navy, for example, ran short of male clerks and lacked appropriations for additional civilian help, the secretary of the navy, Josephus Daniels, publicly questioned whether there was any law that said a yeoman must be a man. When he found there was not, he authorized the navy to enroll some eleven thousand uniformed "yeomanettes." Other breakthroughs occurred, and although few women actually were sent to Europe, nurses, ambulance drivers, and Salvation Army "lassies" numbered among those who went.

Women also entered industry in great numbers and found themselves making grenades, collecting streetcar fares, running elevators, and washing locomotives, as well as performing scores of other jobs previously thought "unsuitable" for women. Even women who did not work for pay found new kinds of demands on their time and new volunteer tasks, such as managing many charitable organizations that in the past had been run by men. The majority of women lost their jobs or

voluntarily returned to their previous lives after the war, but many expressed an unwillingness to be relegated to a restricted list of occupations.

Meanwhile, women continued to challenge traditions and break down barriers. First the bicycle, then the automobile offered women greater personal freedom and mobility. Isadora Duncan in dance, Gertrude Ederle in sports, Amelia Earhart in aviation—all became symbols of the "new woman." Margaret Sanger's crusade for public acceptance and legalization of birth control contributed to the changing moral climate. But once again the conflicting attitudes of women themselves surfaced as older feminists like Jane Addams expressed disapproval of the short skirts, bobbed hair, and unladylike behavior of the "flappers."

Despite the surface changes, there was still a lack of equality; the mystique of woman as a finer creature held and had strong legal support. For instance, in *Muller* v. *Oregon* in 1907, the U.S. Supreme Court unanimously upheld protective hours legislation as constitutional because women were in a class of their own owing to "inherent differences between the two sexes." These differences, the Court implied, would not rationally free women from dependence upon men.[31] Various courts used the Muller decision for decades afterwards to justify sex-based discrimination as legal and still sometimes so use it. In 1937, in *West Coast Hotel* v. *Parrish*, the Supreme Court upheld a plea by a chambermaid and her husband, reinforcing the constitutionality of protective legislation for women and affirming Washington's minimum wage law for women and children.[32] In the 1970s the opposition to the proposed ERA based part of its position on the argument that the amendment, by removing such protective legislation, would work to the detriment of women.

Women began serving as officeholders as early as the 1890s. Not until the 1940s, however, were laws barring women from state office totally eliminated. Initially women were slow to become part of the partisan political scene. After successfully leading the fight for woman suffrage, Carrie Chapman Catt disbanded the National American Woman Suffrage Association to found the nonpartisan League of Women Voters, which emphasized voter education on important issues; Catt also urged women to join a major political party and ignored the National Woman's party. An emphasis on good government seemed to appeal most to women at the time.

Women voters did not really come to the fore until 1932, and by that time the Republicans had ceased to court them so ardently. Perhaps the

most exceptional women in partisan politics were Frances Perkins and Eleanor Roosevelt. Many of the women who successfully navigated the political shoals either were social workers or had started in social-betterment causes. Perkins, an early member of the YWCA, had begun her reform career in Chicago's famous Hull House under the supervision of Jane Addams. From there she moved into paid reform work, finally with the National Consumers' League, and then into a public administrative office in New York State. In 1933 she became, as noted earlier, the first woman appointed to a U.S. cabinet post. Eleanor Roosevelt's political reform career began with the Junior League, founded in 1901 to promote knowledgeable citizenship and to work for social betterment. It has been shown that the move by women into the electorate facilitated Roosevelt's victory in 1932 and that social feminism is a major link between late nineteenth- and early twentieth-century reform endeavors and the New Deal program.

Many of the reforms with which women were concerned initially dealt with children or the family, both regarded as women's special province, and it was from motivations for strengthening the family that many women first entered the political arena. Women's clubs of all kinds—ranging from the Relief Society members of the Church of Jesus Christ of Latter Day Saints to the emerging Parent-Teacher Associations to the YWCA to the General Federation of Women's Clubs—could unite to affect various political units on these key issues.

Some have called this view of women "gynocentrism," a belief that women can speak with a different voice than men. Margaret Fuller expressed this view in the middle of the nineteenth century and Charlotte Perkins Gilman at the end of the century.[33] Certainly the concern for the family, children, and other vital social issues enabled women to be key spokespersons for change in the United States. Harriet Beecher Stowe's *Uncle Tom's Cabin* was a powerful antislavery voice, while Helen Hunt Jackson's *A Century of Dishonor* and *Ramona* raised national consciousness about the plight of the Indians. Rachel Carson did the same for the natural environment in the twentieth century. The list could go on. Even when women were not in the leadership role of the various reform movements, they were the workers; and while they often seemed to defer to the men who received the recognition, without them organizations and causes would not have been so successful.

The onset of the Second World War once again opened up the industrial doors to women, and by the end of the war women were found on all levels of industry, doing tasks normally assumed to be those that only men could do. Six million new female workers entered the labor

force, another two hundred thousand enlisted in the armed forces, and thousands of nurses became commissioned officers. After the war some women returned home to have the babies and home life that the war (and the preceding Great Depression) had interrupted, but they had gained a new understanding of their capabilities that was not easy to forget. Many soon grew tired and frustrated with their homemaker role; the spokesperson for a new kind of role for women was Betty Friedan, whose *The Feminine Mystique* appeared in 1963.[34]

Middle-class housewives were not the only women whose consciousness was being raised in the 1960s. As in the pre–Civil War years, a renewed awareness of women's subordination grew out of the movement of blacks to better their own status in society, which a hundred years after the war was still that of second-class citizen. Closely connected to the struggle for civil rights, and to the student protests and the growing opposition to Vietnam as well, a new woman's movement took shape. Support came from an unexpected source when the bill that became the 1964 Civil Rights Act was amended to include discrimination on the basis of sex. This act, and the various amendments, acts, and executive orders that followed, served as a legal basis for women's efforts to obtain equality in areas such as education, employment, and credit availability. Affirmative action, and the Equal Opportunity Act of 1972, opened up new fields to women and provided a tool with which to fight discrimination in hiring, promotion, and pay.

The new phase of the women's movement sought to integrate women more effectively into the mainstream, and in 1966 Friedan, U.S. representative Martha Griffiths, and others, including Caroline Davis and Dorothy Haener of the United Auto Workers and Congresswoman Shirley Chisholm, founded the National Organization for Women (NOW). Within two years NOW had developed a network of local chapters and moved to the cutting edge of the organizational movement of women, with support from longer-standing women's organizations like the League of Women Voters and the American Association of University Women, as well as new ones such as the National Women's Political Caucus, founded in 1972.[35]

Quickly adopted as a major goal of NOW and its supporters was the ratification of the Equal Rights Amendment. The original ERA had derived from a resolution found in the Declaration of Sentiments issued in 1848, and it became a major goal of the National Woman's party, led by Alice Paul. First introduced into Congress in 1923, it was reintroduced without success in every session thereafter. Finally a revised amend-

ment was passed by Congress in 1972 and seemed at first to be on its way to ratification, but it failed, three states short, in 1982. As with woman suffrage, women led the fight against the ERA, with Phyllis Schlafly organizing the forces that resulted in defeat.

Despite the defeat of the ERA, however, feminists made many significant gains in the years after 1960. Indicative of the new consciousness of women was the appearance of women's caucuses in most major groups, the invigoration of women's studies in colleges and universities, and a consciousness of issues of special concern to women. The handling of rape cases, for example, was reformed, and laws were changed in order to facilitate prosecution of cases. The abortion issue moved from a hidden facet of society to become a major political issue, as some women demanded the right to control their own bodies, while others led the right-to-life movement.

Pay equity also moved to the forefront. In Denver, for example, a group of nurses filed in 1977 for increases in their salary. They had found that entry-level salaries for nurses were $316 less a month than for sign painters and that a Graduate Nurse I was paid less by the City and County of Denver than a Plumber I, Tree Trimmer I, Tire Serviceman I, Oiler I, Gardener Florist I, or Parking Meter Repairman I. The discrimination continued up the ladder. A director of nursing service, supervisor of 575 employees and the holder of a master's degree with more than five years' experience on the job, was paid less than the holders of any of the other 119 city job classifications that were filled entirely by men and that required the same or less combined education and experience. The nurses, utilizing provisions of the Equal Pay Act of 1963 and Title VII of the Civil Rights Act of 1964, united to file a suit, *Lemons* v. *The City and County of Denver*.[36] At the trial a conservative U.S. federal judge ruled that even though such economic discrimination did exist, it would be too costly to remedy and that in any case this type of differential pay was not prohibited by Title VII. The case failed on appeal and the U.S. Supreme Court refused to hear it. This, however, was just the first in a number of suits; the landmark decision came in 1983 in the case of *Gunther* v. *County of Washington*.[37]

In this case a group of Oregon jail matrons brought suit against the county because their salaries were only 70 percent of those paid to male correction officers. The matrons argued that the two jobs were substantially equal. The district court refused to admit evidence showing intentional sex discrimination and ruled that the two jobs were not the same. The case went all the way to the Supreme Court, which held—in effect

291

acknowledging the doctrine of equal worth—that Title VII actions are not required to meet the equal-work standard and which ordered the case to be retried. On retrial the judge ruled for the matrons.

For every step forward, there seems to be another setback. The United States Civil Rights Commission in 1985, dominated by appointees of President Reagan, rejected the concept of pay equity for U.S. employees and issued a lengthy report arguing that courts and federal civil rights enforcement agencies should define sex-based job discrimination only in terms of equal pay for equal work. Fortunately, not all government jurisdictions (including the U.S. Supreme Court) agreed and as of this writing several state, county, and city units have begun to address the problem on their own, including the city of Los Angeles and the states of New York and Washington. Slowly the concept is gaining ground. Once such efforts begin to succeed the marketplace itself might take over, but in the initial stages more effective intervention is needed.[38]

14 / Biology, Femininity, Sex, and Change

One of the arguments consistently advanced for keeping women subordinate throughout the centuries has been that their biology has preordained them to be so. The biological putdown reached its height in the nineteenth century, just at the time when women were beginning to organize effectively and demanding greater participation in public affairs as well as greater independence.

Women are biologically different from men, and the fact that they give birth to children is an important factor in the lives of most women. This often has led men to extol motherhood while putting down women in other ways. As Thomas Cobbet wrote in the seventeenth century: "Age may wear and waste a Mother's beauty, strength, parts, senses, limbs, estate, etc., but her relation of a Mother is as the Sun where he goeth forth in his might for the ever of this life that is always in its meredian, and knoweth no evening; the person may be gray headed, but her Motherly relation, is ever in its flourish. It may be Autumn yea, Winter, with the woman but with the Mother as a Mother, it is always Spring."[1]

One result of such attitudes in the nineteenth century was an attempt, by both women and men, to recast women as less sexual creatures than men, as creatures made of finer materials, silks and spices and everything nice. The result was a sexual prudery of which women were both victims and advocates. This movement did not reach all classes of society equally, but emerged first in the middle classes in England and spread to the United States and to other areas of the world

as well as to other classes. The popular term for these attitudes as explained earlier is Victorianism, so named from Queen Victoria and her supposed attitudes toward sex and morals. The fact that Victoria was a woman was used to cut off parliamentary debates on such subjects as lesbianism and homosexuality, and this same mindset made women out to be delicate, virtuous creatures who endured the sexual act out of marital duty and the inborn desire to bear children. As a mother, a woman's duty was to guard her children against impure thoughts or actions. Guidebooks for mothers told of the inevitable and horrible effects of masturbation and warned that any indication of sexual desire or curiosity in children should be immediately squelched.

The guidebooks did not describe the limitations and constraints on women that were inherent in this value system. Other writings, however, did. The early twentieth-century poet Amy Lowell commented about:

> Confounded Victoria, and all the slimy inhibitions
> She loosed on all us Anglo-Saxon creatures.[2]

For Lowell, Victoria was "all pervading in her apogee." Her English contemporary, the novelist Virginia Woolf, wrote that "a change seemed to have come over the climate of England."

> Love, birth, and death were all swaddled in a variety of fine phrases. The sexes drew further and further apart. No open conversation was tolerated. Evasions and concealments were sedulously practiced on both sides. And just as the ivy and the evergreen rioted in the damp earth outside, so did the same fertility show itself within. The life of the average woman was a succession of childbirths. She married at nineteen and had fifteen or eighteen children by the time she was thirty; for twins abounded. Thus the British Empire came into existence; and thus—for there is no stopping damp; it gets into the inkpot as it gets into the woodwork—sentences swelled, adjectives multiplied; lyrics became epics, and little trifles that had been essays a column long were now encyclopaedias in ten or twenty volumes.[3]

Including industrialization and urbanization, several factors served to bring about this change. Most of the Western world, including the United States, went through a period of rapid and unsettling change. Old values seemed threatened as government by an aristocratic elite gave way, not only in the United States but elsewhere, to relatively more democratic participation and a new governing elite—attorneys and pol-

iticians. This was government by the common man.[4] Some theorists have posited that the growing influence of the business ethic emphasized an efficiency and deferred gratification that could be translated from the economic realm to the sexual.[5] Men were supposed to store and harbor their semen. As a result, sexual activity began to be viewed in a different light. The period also saw great social mobility with vast new fortunes made by newly emerging elites, including finance capitalists. In addition, geographic mobility—a movement of people from Europe to the United States, from the farm to the city, and from the eastern United States to the West—led to the uprooting of families and the undermining of traditional authority. In the process, the family took on greater symbolic importance as the guardian of tradition and morality, and efforts to protect the family became linked with restraints on sexuality.

In retrospect there seems to have been a compulsion toward order that yielded a new emphasis on values such as "regularity, system and continuity." Old values acquired a sentimentality scarcely deserved, for example, "the touching warmth between master and slave."[6] Forgotten was the reality of slavery, the Civil War, and the terror under which many blacks lived.[7] Changes in religion also played a part in shaping attitudes of the period. Women came more and more to constitute a majority of Protestant churchgoers, and religion became increasingly feminized. Christian virtues began to be identified with characteristics usually defined as feminine, with the result that the ideal women were seen as somehow purer, more spiritual, than men. Gradually the ideal concept of women as sexless and morally superior creatures evolved, gaining widespread acceptance among the middle and upper classes. Since women naturally were sexless, the argument went, it was their duty to help men overcome their more bestial nature.

Parenthetically, this feminization of religion, if it can be called that, worked against women achieving any equality, and it has caused militant feminists of almost every generation to speak out strongly against it. Matilda Gage, for example, in 1893 attacked the first five books of the Bible as patriarchal enslavement;[8] a group of women including Elizabeth Cady Stanton in 1893 brought forth *The Woman's Bible*, emphasizing principles of equality and balance in all forms of matter and mind.[9] Mary Daly, in the 1960s and 1970s, continued the attack in a series of books,[10] and even the National Council of Churches, in 1983, went so far as to issue a nonsexist lectionary of Bible readings, changing God from a He to a One.

Still, the religious emphasis on the differentness of women from men

allowed many a pulpit orator to speak of women's moral purity as well as the threatened destruction of that purity by man's law. Women developed among themselves the expectation that they should act within the morals they guarded to ensure a harmonious world.[11] Women were not alone in this, since increasing numbers of men also shared the belief that sexual drives were something of which to be ashamed. Along with improved living arrangements, which allowed separate rooms to be built and greater privacy for each individual, came a new concern about what constituted proper behavior. Often these attitudes led to a prudery, a hypocrisy, and a rationale for action that might have been humorous had the consequences been less harmful.

By the end of the nineteenth century, suffrage advocates had shifted from the position of Elizabeth Cady Stanton and Susan B. Anthony—that the vote was a right of women as citizens—to the argument that as purer, more virtuous beings than men, women would use the vote to better the world. After several defeats in the courts and a slowdown in the rate of state adoption of the vote for women, many organizational suffragists tactically adopted the view of domestic feminism that woman's role was to be wife and mother. The argument was extended to any matter of importance to the family and hence to women, including the vote for women.[12] Opponents of woman suffrage argued that the vote would somehow destroy all that was good in women and thereby destroy the family; progress, they contended, was not all it appeared. Ratification of the Nineteenth Amendment in 1920 failed to satisfy the hopes and fears of either group.

Clearly people in the United States were ambivalent about many women's issues. Almost everyone, including most feminists, joined in reverence for motherhood. At almost the same moment suffrage agitation reached a crescendo, Americans began to celebrate Mother's Day, the result of the campaign of Anna Jarvis. It was on the anniversary of her own mother's death that, in 1908, the first Mother's Day was observed in a Philadelphia church. Observation of the event spread rapidly.

Science also entered into the change in attitudes about sexuality. One such change resulted from a better understanding of venereal disease, particularly syphilis and gonorrhea. Although syphilis had appeared in epidemic form in the sixteenth century, the full implications of the disease came to be understood only in the nineteenth century, primarily through the efforts of a U.S.-born Frenchman, Philip Ricord, who described the three phases of the disease. Because third-stage syphilis may appear as late as twenty years after the disappearance of the second stage and has many different kinds of symptoms, the difficulty in con-

necting the three stages with the one infection is understandable, particularly in the period before the germ theory of Pasteur was accepted.[13]

Failure to understand the cause of these symptoms had led many to attribute them to a profligate life. Ricord's findings revealed that syphilis could be transmitted not only to the sex partner of the syphilitic, including the wife, but to any child she might be carrying as well. As a result, much of late nineteenth-century concern about venereal disease came to be concentrated on the innocent victims of the profligate and sexually active male. The assumption was that only certain kinds of women, namely prostitutes, carried the disease and that any other woman who received it did so from a husband who had not been faithful to his beloved. Economics often played a role in this victimization by denying the woman access to treatment, let alone discreet treatment.

Also tied in with the demand for tightened sex standards was another kind of fear about overt sexuality, one that was accepted by many members of the medical profession. The sources of this anxiety can be traced back at least to the seventeenth century,[14] but the anxiety achieved both medical and public popularity through the writings of a Swiss physician, S. A. D. Tissot. Tissot taught that the human physical body suffered a continual waste and that unless the losses suffered in wastage were replaced, death would inevitably result. Normally much wastage was restored through nutrition, but even with an adequate diet the body could waste away through, for example, seminal emission or its equivalent in the female. Tissot emphasized that of all the potential losses of vital fluids, the most controllable by the individual was that of sexual excretion. Although some natural loss was to be anticipated, it was vital that the losses be utilized for the purpose that God intended, that is, procreation.[15]

Tissot's ideas were disseminated to the United States by Benjamin Rush, one of the signers of the Declaration of Independence, and later by a host of would-be nineteenth-century reformers. Sylvester Graham originally restricted his advocacy to the use of unbolted (i.e., unsifted) flour—today he is best remembered for graham crackers—but subsequently he preached that his contemporaries were suffering from an increased incidence of debility, in large part owing to sexual excess. While he realized the need for procreation, Graham told his readers that intercourse once a month was adequate and in no case should exceed once a week. This advice was restricted to married couples. Nonmarried individuals should abstain altogether, because any sexual activity would prove especially dangerous to them.[16]

Even the need to procreate was denounced by some writers. Mrs. Eliz-

abeth Osgood Goodrich Willard compared regular sexual activity to a man piling up bricks and then throwing them down or to a man beating the wind with his fist. "A sexual orgasm," she wrote, "is much more debilitating to the system than a whole day's work."[17] The mostly male medical writers recognized the sexual drive in males but wondered how nature (usually referred to as God) could have created males with such drives if sex were so dangerous. William Acton, a prominent English physician whose work was also published in the United States, argued that the danger for males had decreased because females as a group were indifferent to sex and had, in fact, been created with this indifference to prevent overuse of the male's vital sexual energy. According to Acton, only out of fear that their husbands would desert them for courtesans or prostitutes did most women waive their own inclinations and submit to their husbands' ardent embraces.[18] Acton, who also wrote on prostitution, realized that there were women more sexually active than he supposed the ordinary wife and mother to be: even though women had little need for sex, he observed, their "weak generosity" might lead them to submit to men's sexual advances.[19]

If sexual activity were so harmful, how had generations of individuals in the past managed to escape its evil and dangerous influence? Those concerned with the new "scientific findings" about sex had an answer—that the growing complexity of "modern civilization" and the higher evolutionary development of modern humanity posed special problems. George M. Beard, for example, argued that modern civilization had put such increased stress upon "mankind" that large numbers of people suffered from nervous exhaustion. Such exhaustion, held Beard, was particularly great among the educated brain workers in society, who represented a higher stage on the evolutionary scale than the less-advanced social classes. As the brain workers who were men advanced, it became increasingly important to save their nervous energy.[20]

This attitude increased rather than lessened the double standard. For example, Dr. William Sanger, an authority on prostitution in the United States, argued that prostitution was essential in society because a wife without alternatives could not act to temper her husband's sexual demands and hence was threatened by overindulgence that could only contaminate her.[21] It was ostensibly out of the wish to protect women from such dangerous knowledge that much of the nineteenth-century concern with pornography grew. Meanwhile, virtuous women might view their fallen sisters with horror and pity. Only a few, among them Elizabeth Blackwell and later Jane Addams, suggested that economic need might lead women to prostitution. In 1910 the radical Emma

Goldman wrote that "it is merely a question of degree whether [a woman] sells herself to one man, in or out of marriage, or to many men. Whether our reformers admit it or not, the economic and social inferiority of woman is responsible for prostitution."[22]

The influence of prescriptive literature upon behavior is difficult to determine. Undoubtedly, many literate middle-class Americans of both sexes read and believed it, but even those who did not accept it had to conform to the publicly expressed prudishness that was so widely expressed. Frustrations were inevitable, since not all women could accept that sex was a "low passion confined almost entirely to men, and that pure sexless wives endured male importunities merely as their wifely duty."[23] Even as late as the beginning of the twentieth century, a marriage manual could claim that the happiest marriages were those in which sexual relations seldom occurred. Some critics of human sexuality undoubtedly agreed with the Reverend John Ware that the physical aspects of sex were so filthy that such subjects were not to be discussed between persons of good reputation.[24]

Obviously there were countertrends, and even during the years of official prudery, many Americans appreciated expressive sexuality,[25] but these were not the opinion setters of the time. The hostility to married sex was also contrary to much of religious teaching, including Puritanism. That there were large numbers of women who did not subscribe fully is evidenced by the nineteenth-century search for contraceptives. Even among those women who subscribed to Victorian attitudes about sexuality, the desire to limit family size was a major factor in forming their attitudes. Though women in the nineteenth century desired children, increasing numbers of them wanted fewer children than their mothers and grandmothers had borne. Several reasons help account for this. In an urban society children were less an economic asset; more babies survived into adulthood; and many women had begun to desire a voice in the number of their pregnancies. The number of children born to college-educated and middle-class women declined. Without any use of contraceptives, the ordinary woman engaging in intercourse with any degree of regularity would probably become pregnant every other year, and we can only conclude that some action must have been taken to limit the number of children. Obviously, one way for women to avoid pregnancy, perhaps the safest and most effective, was to deny the marital bed to their husbands, a denial made easier by Victorian notions about woman's sexuality and about the harmful effects of overindulgence for both men and women. This undoubtedly helps explain "Victorian" attitudes, although by giving them lip service, women

began to gain some control over when and how often to have intercourse.

Less frequent sexual activity does not alone account for the falling birth rate. Abortion continued to be a widely practiced method of family limitation, and also various steps were taken to prevent conception itself. To be sure, many of the methods used were not particularly helpful, and some were harmful to women. Robert D. Owen, an advocate of birth control, urged his readers to practice *coitus interruptus*, but this activity undoubtedly increased the likelihood of urinary tract infection and made intercourse quite painful, as well as unsatisfying, for many women. Some women resorted to douching, sometimes with solutions of alum, astringents, sulfate of zinc, and other ingredients that, in improper doses, could seriously damage the external genitalia as well as the vagina. This helps explain why medications for "female complaints," such as those sold by Lydia Pinkham, were so popular. Pinkham—who was much interested in botanic medicine, herbals, nutrition, physical exercise, and hygiene—and her "Vegetable Compound" also appealed to the woman who was uncertain about seeing a male physician.

Standing in the way of accurate information about contraception or the sale of an item for that purpose were the activities of Anthony Comstock and his allies. The Comstockers acted on the mindset that sexuality was to be controlled and had the support of many religious groups, leading physicians, and others who decried attempts to prevent conception as immoral. They successfully obtained federal legislation in 1873 that classified information about contraceptives as obscene and outlawed its distribution. While some have believed that the Comstock laws represented a return to the "prudery" of the Puritans, the laws were actually far more closely related to the early nineteenth-century development of separate spheres for men and women.[26]

Despite Comstockery and state and national laws that resulted from it, a growing number of contraceptive devices came onto the market. To be effective, the devices needed to be inexpensive, reliable, and readily available—standards seldom met during the many centuries in which they had been used. The nineteenth century, however, brought some important improvements. The vulcanization of rubber made a wide variety of new contraceptive devices available. Rubber condoms began to replace those made from animal ceca or other materials, and by the 1870s they started to appear in drugstores in the United States and in barbershops in England. Official attitudes remained hostile, however, and since condoms could not be patented, problems with quality con-

trol and distribution were not resolved until well into the twentieth century.[27]

A device that women, rather than men, could control appealed to many. The pessary, developed by the German physician W. P. J. Mensinga, was such an item. A pessary was a device prescribed by physicians to correct displacement and prolapse of the uterus. As such, it could be patented, and frequently was, with no reference to its use as a contraceptive.[28] Mensinga soon replaced his unvulcanized pessary with a soft, vulcanized one that had a coiled string outer circle, making it more effective than before. Its use spread in Europe, where the first contraceptive clinic opened in the Netherlands in 1882. But in 1887, when an English physician mentioned the pessary in *The Wife's Handbook*, he was expelled from the general medical council because of the hostility of organized medicine.[29] In the United States Edward Bliss Foote had developed a similar device; pamphlets recommending its use were seized and destroyed under the Comstock laws.

Toward the end of the nineteenth century, advances in chemistry resulted in the development of spermaticides,[30] which joined condoms and what would increasingly be known as the diaphragm to offer reasonably effective, inexpensive methods of contraception. The medical profession and many religious groups continued to oppose the use of these methods, and so did many women's groups. Still, information spread by word of mouth, and use of contraceptives became a middle-class phenomenon. Pressure toward general availability came about through the efforts of birth control advocates such as Margaret Sanger in the twentieth century. Once prosecuted under the Comstock laws, Margaret Sanger was a nurse who considered motherhood to be bondage and who saw women of the so-called lower classes as especially affected by this situation.[31]

Meanwhile, the pure, genteel female continued to serve as the ideal for womanhood in the United States. Actual behavior varied widely. Living conditions in parts of the country made it impossible for many women to conform to the ideal. Mythology pictured women as not suited for life's mundane tasks, but the vast majority of U.S. women still lived on farms where everyone had to make an essential contribution to the family's subsistence. In many parts of the country, the existence of black women servants in the home may have made it easier for their employers to conform to the stereotype, but economically it was clearly beyond the reach of most. And for the newly arrived immigrant women adapting to the reality of urban tenements, the life of the "lady" could only have been a dream.

The gap between myth and reality increased the gap between socio-economic classes and led to behavior among some of those aspiring to gentility that often caused travelers in the United States to poke fun. One such visitor was Frederick Marryat, whose *Diary in America* is often cited as proof of the prudishness of American womanhood. Marryat wrote that when he asked a lady if she had hurt her leg after a fall, his language shocked her. Finally, with considerable reluctance, she explained that in the presence of ladies, a gentleman refers to a leg as a limb. Despite such delicacy, and to Marryat's surprise, women moved around "without chaperones." Marryat claimed that the women in the United States prudishly denied pianos had legs. He reported a visit to a ladies' seminary where the piano had each of its four "limbs clothed in modest little trousers, with frills at the bottom of them."[32] This incident seems to have been a sophisticated hoax for Marryat's benefit and casts doubt upon the accuracy of his observations. If the young women at the seminary could make fun of Victorian prudishness, they may not have been so prudish themselves. Perhaps the prescriptive literature did not so much reflect reality as try to reform it.

The ambiguities and contradictions inherent in any attempt to cultivate Victorian manners in a largely frontier society can be seen in the observations of yet another early visitor, Mrs. Frances Trollope. She told, for example, how a well-mannered young German offended one of the principal families in Cincinnati by using the word *corset* in the presence of ladies.[33] Trollope regarded this incident as an example of inverted prudery yet was herself shocked by the openness of two young women describing their attempts to embarrass a male acquaintance seen leaving the rooms of a local prostitute. The emancipated Mrs. Trollope was able to write the story only by circumlocution, the brothel becoming "a mansion of worse than doubtful reputation," and the story one "hardly fit to tell."[34]

Her son, novelist Anthony Trollope, wrote his own account of American morals some thirty years later and found American women still troubling, particularly in the West. He reported that although women in the East had acquired "womanly grace," by which he probably meant that they acted like proper Englishwomen, women in the West were a different matter: "They are as sharp as nails, but then they are also as hard. They know, doubtless, all that they ought to know, but then they know so much more than they ought to know."[35]

The relative freedom of action of women in the United States eroded as the veneer of Victorian morality spread westward. Wealthier classes adopted the custom of chaperonage as a device to prevent unsuitable

marriages, and middle-class girls and women found themselves bound with restrictions for the sake of propriety. Respectable women were cautioned not to ride in omnibuses alone or to enter restaurants or theaters without a male escort. Many women must have resented such restrictions on their mobility, and a few broke with the new respectability, which equated outward forms with inner virtue and physical chastity. Those women who did break ranks were often ostracized. The two Claflin sisters, Victoria Woodhull and Tennessee Claflin, refused to abide by stereotypes of femininity and class-prescribed behavior. For example, when they were refused service by Delmonico's in New York City because they lacked a male escort, the sisters went outside, invited a cabbie to join them for dinner, and then enjoyed their meal.[36]

Earlier female writers, particularly domestic feminists such as Catherine Beecher and Sarah Hale, had, however, reinforced the idea that woman's proper role was wife and mother, her proper sphere the home. To step beyond these boundaries was to defy God and nature. Beecher and Hale themselves nonetheless ventured into the world of men. They observed the forms but simultaneously violated their intent, and in the process they reflected the ambivalence found in the attitudes of women in general.

There was some discussion among women's leaders about how much submission a wife owed to her husband. One way in which some of the more militant feminists, including Elizabeth Cady Stanton, thought they could solve the problem of submissiveness was by allowing divorce—a proposal that did not win favor with all women's rights advocates. This discussion slipped over into the debate about suffrage. For example, the historian Page Smith has argued that while the split between what came to be the New York and the New England wings of the woman suffrage movement was in part due to the personalities and temperaments of the women involved, it also occurred because one group had better relations with men than the other did. Stanton had an increasingly difficult marriage with Henry Stanton, who after first supporting his wife's activism became upset by it, especially after he took a seat in the legislature. Her colleague in the National Woman Suffrage Association, Susan B. Anthony, never married. Antoinette Brown Blackwell and Julia Ward Howe, leaders of the American Woman Suffrage Association, on the other hand, as Smith pointed out, were happily married, and men were included in their organization.[37] Though there is a grain of truth in Smith's argument, it is reminiscent of the controversy between lesbian and heterosexual feminists in the 1970s and 1980s, and much too simplistic. Opponents of feminists have always tried to pic-

ture them as unhappily married women, bitter spinsters, or, more recently, lesbians. But lesbians are not necessarily antimale, and there have been happily married women in the forefront of the feminist movement. The differences between the two suffrage associations in the nineteenth century can better be explained as differences in tactics, since for women's position to change, men's attitudes and position had to change, and the problem on which they disagreed was how to effect these changes. Some preferred to confront the issue head on, while others found it easier to deal with it more obliquely.

Charlotte Perkins Gilman called marriage "sanctified prostitution,"[38] as did other feminists, including Lucy Stone. Such a view was intended as an argument against the limited definition of women's work and the devaluation of that work because it did not produce a wage. It also involved the belief that women should have sexual rights within marriage and should not be forced to have intercourse against their will. Although intended to challenge the status quo and initiate change, the argument alienated potential recruits who objected to calling married women parasites and openly raised questions involving sex. In the long run, such tactics proved a failure, but they are symbolic of some of the underlying hostility to the role that women found themselves in.

Much difficulty stemmed from the fact that the male-ordered world was well equipped with weapons to use against any call for change in women's status. Not the least of these weapons was science, a field that males so dominated that they could purvey their opinions as scientific truths. Women had partially subscribed to the new notion of a lesser sexuality for women, but some would-be scientists argued that women could never be equal to men because of a whole biological structure designed to render women noncompetitive with men.

The major "scientific" investigator of this view was the Harvard professor Edward H. Clarke. He wrote before the factors involved in the menstrual cycle were fully uncovered, but this did not prevent him from advancing dogmatic ideas. Since the menstrual cycle is often variable and susceptible to environmental influences, Clarke concluded that menstruation was brought about by developments in the nervous system. Thus he wrote in 1874 that although women undoubtedly had the right as citizens to do many things men did, the nature of women's physiology rendered them incapable of doing what men did and retaining good health. Supposedly the female at puberty had a sudden and unique period of growth around the development of her reproductive system; the male, however, developed steadily and gradually from birth to manhood.[39] The reproductive system in women Clarke believed to be

related to the nervous system. Because the nervous system, to Clarke's mind, could not do "two things well at the same time," the full development of the reproductive aspect of the nervous system had to occur at puberty or it would never occur. For Clarke, the female between twelve and twenty had to concentrate on developing her reproductive system and avoid stress on other parts of the nervous system, that is, the brain. Otherwise the female would overload the switchboard, so to speak, and signals from the developing organs of reproduction would be ignored in favor of those coming from an overactive brain. Prohibitions associated with the menstrual cycle meant that even after puberty, females were not to exercise their minds without restriction.[40]

In research spanning several generations between 1890 and 1920, pioneer sex researcher Celia Mosher found that the earlier generations of women had greater menstrual difficulties than the later ones. Mosher at first concluded that during the last part of the nineteenth century, girls had been taught by Clarke and others to be sick during menstruation. The result was a self-fulfilling prophecy. She also found, and this seemed to her more important, that there was a correlation between dress and menstrual difficulties. During the 1890s and the early years of the twentieth century, most young women were put into tight corsets, banded clothing, and unsupported heavy skirts. This clothing interfered with the respiration, made it difficult to exercise, resulted in flabby abdominal muscles, and deformed the body much as the binding of women's feet in China had done. Mosher held the result to be chronic disturbances of the organs and prolonged menstrual flow.[41] She prepared tables correlating menstrual pain among college women with the width and weight of their skirts and the measurement of their waists; as the skirt grew shorter and skimpier, and the waist larger, the functional health of women improved. In 1894, 19 percent of college women had reported themselves free from menstrual difficulties; in 1915–16, 68 percent considered their periods no problem. In the earlier period, the average skirt was 13.5 feet around the hem, the average waist measurement was 20 inches, and women also wore several petticoats, some fifteen pounds of clothing hanging from a constricted waist. By the beginning of World War I, women wore their skirts above the ankle, skirts were narrowed and petticoats fewer, and waist measurements had increased by 40 percent.[42]

Whether Mosher was correct in attributing difficulties to clothing, hers is an intriguing proposition since clothing also importantly conveys to the world the self-image of the wearer. Clothes hold their own symbolic value, and not surprisingly, women who adopted unconven-

tional styles were greeted by highly charged emotional responses. In the years prior to the Civil War, some middle-class women began wearing male-like clothes as a rebellion against the confinement of traditionally female clothing. The most famous of these women was Amelia Bloomer, who urged the "Daughters of the American Republic" to "abjure the feminine fashion adopted at profligate courts in Europe." Bloomer and her allies were basically fighting with foresight and common sense what was one of the most inhibiting factors middle- and upper-class women had to face, their confining clothes. Believing that the fifteen pounds of skirts and petticoats, plus lung-squeezing stays, severely limited activity, Bloomer proposed a solution, namely, that women cut their skirt lengths to halfway between the knees and ankles and under their various petticoats wear trousers "cut moderately full and gathered in above the footwear." Actually, Bloomer did not invent the costume that eventually bore her name but adopted it from a women's dress reformer, Libby Smith Miller. Bloomer publicly advocated and wore the costume, and it became associated with her name.[43]

Women who appeared in public wearing "Bloomers" encountered ridicule and disapproval from both sexes, with particularly strong opposition coming from members of the clergy, who thought it immoral for women to wear pants because they had to spread their legs to put them on. Elizabeth Cady Stanton commented on the advantages of wearing shorter skirts while carrying out household chores, and together with Bloomer and others, she continued for a while to appear in the daring outfit. Concern that public hostility was harmful to the woman's movement, along with concern that the style was not necessarily becoming to all who adopted it, led proponents to give up the effort.

Despite the hostility, there were women who wore trousers. The most notorious of these was Dr. Mary Walker, a woman's rights advocate. Walker served for a brief period in the U.S. Army during the Civil War and claimed the right to wear trousers by special congressional action, although no record of such action is now available. Walker at first wore a short dress over long trousers, but after the Civil War she began wearing full masculine apparel. She died in 1919, still advocating trousers for women; not long after, women started to wear slacks as a matter of course.[44]

Other women, determined to escape the limitations of women's role, not only wore men's clothing but, for shorter or longer times, lived and acted as if they were men. Several women enlisted in the Civil War as men. Matilda Joslyn Gage collected stories of at least ten such

women,[45] and Loretta Janeta Velazquez, who served in the Confederate Army, wrote a book about her experiences.[46] Others simply adopted the disguise in order to see the world.[47] Some were not discovered until their death. A stagecoach driver, Charles Durkee Pankhurst, must be listed as the first woman to vote in California, since on "his" death in 1879, Pankhurst was found to be a woman.[48] Several women were known as Mountain Charley, a legendary woman who lived as a man in the western territories in the 1850s, and at least two wrote books claiming to be the person from whom the legend grew.[49] Women also took to playing men's parts on the stage.

Presumably, few women sought to assume a male identity, but many young girls and women must have dreamed of escaping the narrow world they were expected to inhabit. In a sense, dress reform represented an attempt to break away from the same restraints. Some of the physical problems accompanying menstruation may have been alleviated by dress reform, but the conviction remained that women at "that time of the month" were emotionally unstable. Personal physicians to President Eisenhower and to Hubert Humphrey, the Democratic candidate for president in 1968, commented that women could not fill leadership roles because of the influence of their periodicity, that is, their menstrual cycles and the menopause.[50] The first issue of *MS.*, a magazine founded in 1973 to present feminist materials to interested readers on the mass level, featured an article on male cycles and gave hints to women on how to discover whether the men in their lives were ebbing or flowing.[51] This was a role reversal and consciousness-raising exercise, intended to produce insight into the ridiculous and also reactionary emphasis placed by society on women's reproductive cycle, an area where men had asserted their expertise and influence.

It was not only the menstrual cycle that was regarded as "pathological" by male professionals but childbirth as well. The newly emerging specialty of obstetrics held that childbirth could no longer take place naturally but required the skill and ability of an educated physician.[52] Giving rise to such an attitude was the growing influence of the obstetrician, who was struggling to win control of the birthing process from the midwife. In this struggle the physician had been considerably aided by the physician's ability to give anesthesia. Sir James Simpson (1811–70) of Edinburgh had introduced the use of chloroform in childbirth in 1847, and in spite of the opposition of conservatives who believed that women were meant to suffer, its use spread widely, aided and abetted by endorsements from Queen Victoria.

Though chloroform eased the pain, its main effect was as a muscle

relaxant, and so the woman who had been given the drug could not bear down sufficiently to propel the baby through the birth canal. Thus the use of deep chloroform, at least in the early stages of delivery, when the pain was greatest, led to more and more intervention by the physicians. The result was the development of the high forceps, which allowed the physician to enter directly into the uterus in order to pull the baby out. Such a procedure today would be regarded as drastic intervention, but until the reaction against such medical intervention in the post–World War II world, it was more or less normal in many hospital deliveries. Intervention, in fact, was the norm. Some physicians, such as Buffalo's Irving W. Potter, resorted to turning the fetus in the uterus in order to pull it out feet first. Potter delivered more than twenty thousand babies by pulling them feet first from the mother's uterus, and his technique was widely studied if not widely adopted by physicians from all over the world.[53] He rationalized that his intervention undid the mistake that nature had made in bringing infants into the world head first, which made the largest part of the body present first. Helping further to replace the midwife in the United States was the development of the caesarean section and the special lying-in hospitals. Childbirth moved from the home to the hospital in the "interest of saving lives" and giving access to hospitals where the equipment for drastic intervention was available. It also moved childbirth from the hands of women to the control of the medical profession, where few women were active.

Charles Darwin added his voice to those accepting women's inferiority by arguing that while women are plodding and persevering, "the average of mental power in man must be above that of woman."[54] Friedrich Nietzsche went further in his classic distinction between the master and the slave, classifying woman as slave. In his *Thus Spake Zarathustra* (1883) he presented women as instruments of men who should be raised for the relaxation of men. Woman's only hope in life, he argued, was to produce Superman, that is, a person with a master mentality.[55] Sigmund Freud argued that women were incomplete men and as such could not compete in the world of men.[56] The list could go on. As a result it seems as if for every forward step in the liberation of women in the past century or so, there has been a half step backward or sideways, and sometimes more, as not only men but women have demonstrated uncertainty about the roles they have wanted to play.

If one relied upon the medical and biological literature, one might conclude that all women wanted to become wives and mothers and, once married, bravely endured the sexual act to become pregnant, happily devoting the rest of their lives to their families. Obviously, many

nineteenth- and twentieth-century women did not conform to this pattern. Many, in fact, did not marry at all but formed close, intimate relationships with other women. Some of these were probably lesbian relationships; others were not, although at times the feelings experienced in any close relationship among women could raise feelings of guilt. Even though lacking a word for their experiences, women could nonetheless find pleasures in their affectionate and sometimes passionate friendships.[57] Because homosexuality was, in the widest social context, something too awful even to hint at, those who might have identified themselves as lesbians did not bother to inform the world, and the widespread image of women as sexless may have prevented suspicions from surfacing about these relationships.

The pioneer work of the nineteenth-century feminists and their allies began to come to fruition in the twentieth century. Many factors seem to have been at work, but greater control over the consequences of their own sexuality was an important factor in giving women more freedom. By the turn of the century, there were a number of women intellectuals in various urban centers who demanded change, sometimes equated with socialism and sexual freedom. Emma Goldman, for example, championed the right of women to enjoy sex in or out of marriage and joined Margaret Sanger in her campaign to make contraception available to all women. Faced at first by opposition from organized religion, the medical profession and many respectable social figures now became advocates of birth control, and significant victories were achieved by the end of the First World War. Widespread dissemination to the economically impoverished was not achieved so quickly. Sanger saw birth control as a way not only to limit family size but also to free women to enjoy sex without constant fear of pregnancy. Gradually the idea that sex could be separated from procreation gained acceptance; so did the belief that married couples had the right to decide when to have children. Further accomplishments of planned parenthood were forthcoming from court decisions: *Griswold* v. *Connecticut* (1965)[58] held that the right to privacy of married people superseded a state law forbidding the use of contraceptive devices. *Eisenstadt* v. *Baird* (1972)[59] and *Carey* v. *Population Services International* (1977)[60] held the same for unmarried persons and minors. Additional breakthroughs came with the development of birth control pills and intrauterine devices, as well as with the resurgence of the women's movement in the 1960s and 1970s. Birth control came to be seen by many as a way to strengthen rather than destroy the family, and issues largely centered on the side effects of birth control measures and on the emphasis on women's responsibility for

birth control. This emphasis represented a full turn away from the nine-teenth-century's emphasis on men's responsibility for women's virtue.

If marriage and children remained the goal of most young women in the early twentieth century, their expectations had widened. Impressed by the images of romantic love portrayed in novels and magazines, and increasingly aware of the views of women such as Sanger, some began to question Victorian values. "Good girls" still did not engage in sex before marriage, but increasingly they were permitted to hope that they would enjoy it afterward. What had only been whispered by mothers to their daughters was now openly discussed. Most importantly, women in-creasingly accepted the idea that sex could and should be enjoyed apart from reproduction and met with few objections, if any, from men. Jane Addams, who was appalled by rouged cheeks and knee-length skirts, feared, with justification, that preoccupation with sexual freedom would divert attention from other social issues of concern to women.

Although the roots of this change lay in the late nineteenth century, women's interests did not appear to change noticeably until the 1920s. In the twenties the highly visible new woman seemed more concerned with bobbing her hair, dancing the Charleston, and asserting her free-dom to smoke, drink, and enjoy sex than with politics. The ideal white, middle-class female was no longer frail and demure but healthy and sexually outgoing. Women played tennis, drove cars, and encouraged men to regard them as pals. Advertisers decided that sex appeal sold goods. Torrid love scenes appeared on movie screens across the nation, and some women modeled themselves after stars such as Theda Bara. The flapper's goal, however, remained similar to that of the Victorian lady—to catch a man. And once married, her role as wife was no less subordinate. Neither emphasis on romantic love nor relaxation of Vic-torian inhibitions produced equality for women, in or out of marriage. Observers as disparate as writers Dorothy Parker and F. Scott Fitzgerald wrote of the emptiness and dreariness of many women's lives: Parker's own life was far from happy; further, as Zelda Fitzgerald was to reveal, F. Scott beat his wife.

The Great Depression, in part, forced women and men to temper their values because it became blatantly apparent that marriage did not nec-essarily ensure economic security for the rest of their lives. Even given hostility toward and discrimination against working wives, and the false assumptions that a married woman with a job or career worked only for pin money and prevented a man from working, women con-tinued to enter the labor force.[61] The hostility ended with the outbreak of World War II, when women became an important element in the ci-

vilian work force, as well as in the military itself. The war's end saw a mass demotion of women in the paid work force. Although many remained gainfully employed, they often found themselves in lesser jobs, and the majority retained traditional roles of housewife and mother, what Betty Friedan called the "feminine mystique." Femininity, or the role of supporting wife and mother, was in, and the birth rate increased. Psychologists of the professional or amateur variety promulgated their own versions of Freud and assured women that they should find total fulfillment in motherhood.[62] The previous years could not, however, be stuffed under the bed. Seeds of rebellion took root. Many women worked outside the home and professed satisfaction with the arrangement, and many housewives found their lives far from idyllic. The divorce rate rose, and so did reports of alcoholism and emotional disorders among women.

The resurgence of the women's movement in the early sixties was linked with other social movements of the period, including the civil rights, anti-Vietnam, and environmental movements. Much as with the earlier phases of the women's movement, this one extended demands for political and economic equality to include women's liberation. This extension implied breaking through the "biological barriers," and rebelling against the traditional double standards of the past. It involved a celebration of self and the realization of one's sexual potential. This latter was possible because of major breakthroughs in birth control technology and legalization of abortion by the U.S. Supreme Court, which made the divorce of sex from procreation more acceptable than ever before. Both extramarital and premarital sex for women was more accepted, and living together outside wedlock, what reformers for generations had called trial marriages, emerged as an option. Not all women agreed on the removal of past barriers, whereas others felt that not enough had fallen. The Supreme Court's abortion decision sparked fierce controversy, with one group arguing that it still left women under the control of the physicians while another group was vehemently anti-abortion. Feminist support for gay rights and the presence of lesbians among the leadership also made for controversy. Sexual issues constituted a major focus of a section of the women's movement, and although many women applauded the inclusion, others felt alienated. Still, for the first time in U.S. history, the majority of women accepted their sexuality and began adjusting to their new freedom.

Just as Jane Addams had disapproved the behavior of the flappers, some supporters of political and economic reforms for women refused to sanction what they regarded as the new unacceptable life-styles or

emphasis on other issues that they regarded as "noncritical," and they were also upset by challenges to traditional religious beliefs. Mothers objected to miniskirts as indecent and to unshaved legs as unfeminine and slovenly, in ways reminiscent of their own mothers' reactions to the abandonment of still longer skirts and to shaved legs. Novels, movies, and even daily family television bombarded the nation with sex. Yesterday's X-rated movie became family fare, and the *Playboy* female centerfold model was tried briefly by *Cosmopolitan*, and ongoingly by *Playgirl*, with a male model. As school boards tried to ban *Catcher in the Rye*,[63] students moved on to *The Sensuous Woman* and *The Happy Hooker*. The media focused on the blatantly sexual aspects of what they insisted on calling "women's lib" and attempted to trivialize the entire subject by identifying it with a fictitious bra-burning incident. Once again the family, religion, and society itself were made to seem threatened, and some women fought the proposed Equal Rights Amendment to the U.S. Constitution on the grounds that it would encourage homosexual marriage, lead to unisex bathrooms, and force women not employed outside the home into the paid work force. Victorian attitudes die hard. Yet despite some feminist criticism and the fears of antifeminists, the family has survived. To be sure, its survival hinges on numerous legal and economic factors, and the diversity of family forms in the United States has become more apparent. More unmarried couples openly live together than before, and while the birth rate has plummeted, polls indicate that most young women still intend to marry and have children, albeit at an older age. As Carl Degler and others have pointed out, divorce does not mean that people turn against marriage, per se, but rather that they no longer remain in unhappy ones. A smaller percentage are single in the late twentieth century than in the nineteenth. After divorce, people try again,[64] as did Ronald Reagan, perhaps the most conservative president of the twentieth century.

Postscript

Change and continuity make up contrapuntal themes of history. The revived women's movement of the early 1970s was extraordinarily optimistic and initially ahistorical. Women knew they had problems to overcome but believed they had solutions to match and offered impetus and vision to bring about change. Old advocates of liberation, along with some newer ones, were rediscovered and became role models: Mary Wollstonecraft, Elizabeth Cady Stanton, Simone de Beauvoir, among others. Hundreds of books and courses on feminism appeared and, in fact, have continued to appear. There were women's banks, a new emphasis on women athletes, a feeling of sexual liberation. Many traditional barriers fell. The culmination of this movement was to be the passage of the Equal Rights Amendment, but the progress slowed down, and change turned out to be a much more tedious educational process than many of the new recruits to feminism had imagined.

The movement changed its nature, as all movements seem to do. The continued existence of battered women and rape victims helped become a metaphor for the conditions of all women. A new strain of feminism appeared, what might be called cultural feminism, which once again held that women are different from men; they are more benevolent, nourishing, and supportive than the aggressive, conquering male. It is the male drive, this feminism argued, that gives rise to war, sexism, incest, and rape, and the male as such is inherently violent and dangerous to women, perhaps even to the world at large. This "women's

culture" has been celebrated in the arts by poet Adrienne Rich[1] and painter Judy Chicago,[2] among many others. In the social analysis this difference has been exaggerated. As Andrea Dworkin put it:

> For men the right to abuse women is elemental, the first principle, with no beginning . . . and with no end plausibly in sight. . . . Pornography is the holy corpus of men who would rather die than change. . . . [It is] Dachau brought into the bedroom and celebrated. . . . Pornography reveals that male pleasure is inextricably tied to victimizing, hurting, exploiting; that sexual fun and sexual passion in the privacy of the male imagination are inseparable from the brutality of male history.[3]

Some of this outlook was always in the feminist movement, but Women Against Violence Against Women became Women Against Violence and Pornography in the Media and finally Women Against Pornography, with men the issue.[4] If the past is an example, increasing numbers of women may seize upon some of the more reactionary elements of cultural feminism and emphasize differences between men and women rather than similarities. Perhaps they will not travel as far as some feminists of the nineteenth century who emphasized women as special creatures. Our perceptions of ourselves and our roles, whether we are men or women, have far-reaching implications and are determinants of the social perceptions we have about females or being female. In an age when women were viewed as pure, morally superior creatures and were taught to suppress their erotic feelings, no doubt many a wife failed to take pleasure in her conjugal "duty," nor did her husband expect she would. The new sexuality of the sixties and seventies emphasized that women were expected not only to enjoy sex but to be good at it, to produce multiple orgasms and be sexy, and this role for many was no more satisfying than the previous one. The appearance and spread of AIDS in the 1980s allowed many opponents of this new sexuality to mount a reaction.

Change has never been easy, and not all results of change are positive. This increases feelings of ambivalence. Although male dominance of social, political, and economic institutions has continued, the nature of this dominance has changed, and women have gained in the process. Not all women agree as to what should be changed. The major opponent of those women urging censorship of pornography is the Feminist Anti-Censorship Taskforce (FACT). The names and outlooks of the groups will change since, in many ways, their antagonism is a disagreement not so much over ultimate goals as over tactics. Both would agree that

pornography suggests a kind of male love/hate for women which some-times involves violence, perhaps a remembrance of the all-powerful woman who was the mother figure, but they seek differing solutions. Instead of banning pornography and putting down men, FACT and its allies propose an alternative solution: that men have a greater share in child raising so that "mother" will not be the sole focus of both expecta-tions and ire and so that the female figure, by reminding males of their helplessness, will not become a victim of male strength. Needed in any movement is the persistence and courage to change things, to explore options for change. Biology itself is no longer a limitation on equality of opportunity, if it ever was. The problems are cultural, social, and psy-chological, and to deal with these we must recognize them and under-stand them. The struggle for equality will be long, and there will be many skirmishes and ultimate goal changes of both men and women before we can achieve it. We hope that this book will serve as a guide to some of the pitfalls to be avoided.

Notes

1. The Background

1. Francis Parkman, *Some of the Reasons Against Women Suffage,* pamphlet written for the Massachusetts Association Opposed to the Further Extension of Suffrage to Women (Boston, 1910).

2. The quotation can be found in W. H. Auden and Louis Kronenberger, *The Viking Book of Aphorisms* (New York: Viking Press, 1962), p. 175.

3. John Stuart Mill, *The Subjection of Women* (reprint, Cambridge: MIT Press, 1970), p. 9.

4. For the biosocial explanation, see Edward O. Wilson, *Sociobiology: The New Synthesis* (Cambridge: Belknap Press of Harvard University Press, 1975), and in part, Lionel Tiger, *Men in Groups* (New York: Random House, 1969); for some of the cultural variability, see M. Kay Martin and Barbara Voorhies, *Female of the Species* (New York: Columbia University Press, 1975), and for some of the others, see below. For generalized criticism and analysis, see Elise Boulding, *The Underside of History: A View of Women Through Time* (Boulder, Col.: Westview Press, 1976).

5. Sir Henry Maine, *Ancient Law* (London: Murray, 1861), p. 122.

6. J. J. Bachofen, "Mother Right," in *Myth, Religion, and Mother Right,* selected writing of Bachofen, trans. Ralph Manheim, Bollingen series 84 (Princeton: Princeton University Press, 1967), passim; the quote is from p. 86.

7. See L. H. Morgan, *The League of the Iroquois* (Rochester, 1851), and *Ancient Society* (1871; reprint, New York: World, 1963). One result of this was rape. See Susan Brownmiller, *Against Our Will: Men, Women, and Rape* (New York: Simon and Schuster, 1975). For "social charter myths," see the article by Joan Bamberger, Michelle Zimbalist Rosaldo, and Louise Lamphere, eds., *Woman, Culture and Society* (Stanford: Stanford University Press, 1974).

317

8. John McLennon, *The Patriarchal Theory* (London: Macmillan, 1885).

9. Mircea Eliade, *The Sacred and the Profane: The Nature of Religion*, translated by Willard R. Trask (New York: Harper Torchbooks, 1961), p. 96.

10. Friedrich Engels, *The Origin of the Family, Private Property and the State*, 4th ed. (reprint, New York: International Publishers, 1942), p. 49.

11. Ibid., p. 50.

12. August Bebel, *Woman Under Socialism*, trans. from the 33d German ed. by Daniel de Leon (New York: New York Labor News, 1904), p. 5. This view, about the necessity of changing society before initiating other changes, was challenged by Simone de Beauvoir, *The Second Sex* (New York: Knopf, 1957), who was a socialist herself.

13. Emanuel Kanter, *The Amazons: A Marxian Study* (Chicago: Ker, 1926). For a different view, see Abby Wettan Kleinbaum, *The War Against the Amazons* (New York: McGraw Hill, 1983). For another effect of patriarchy theory, see Berta Eckstein-Diener (Helen Diner), *Mothers and Amazons*, ed. and trans. John Philip Lundin (Garden City: Doubleday, 1973). For a more recent example, see Marilyn French, *Beyond Power: On Women, Men, and Morals* (New York: Summit Books, 1985).

14. Robert Briffault, *The Mothers: A Study of the Origins of Sentiments and Institutions*, 3 vols. (New York: Macmillan, 1927).

15. Edward Westermarck, *The History of Human Marriage*, 5th ed., 3 vols. (London: Macmillan, 1922).

16. Ernest Crawley, *The Mystic Rose*, revised and enlarged by Theodore Besterman, 2 vols. in 1 (reprint, New York: Meridian Books, 1960), vol. 1, pp. 244–48.

17. Theodore Besterman, *Men Against Women: A Study of Sexual Relations* (London: Methuen, 1934), p. 1.

18. Ibid., passim, esp. pp. 223–32.

19. Bronislaw Malinowski, in an essay review of Briffault and Crawley that originally appeared in *Nature* (January 28, 1928) and that was reprinted in a collection of his essays and reviews entitled *Sex, Culture and Myth* (New York: Harcourt, Brace and World, 1962), pp. 122–29.

20. Joseph Campbell, *The Masks of God: Primitive Mythology* (New York: Viking Press, 1959), p. 315. For counterviews, see Annette B. Wiener, *Women of Value, Men of Renown: New Perspective in Trobriand Exchange* (Austin: University of Texas Press, 1984), and R. C. Lewontin, Steven Rose, Leon J. Kamin, *Not in Our Genes* (New York: Pantheon Books, 1984).

21. See Vern Bullough and Cameron Campbell, "Female Longevity and Diet in the Middle Ages," *Speculum* 55 (April 1980): 317–25, and Vern Bullough, "Nutrition, Women, and Sex Ratios," *Perspectives in Biology and Medicine* 30 (Spring 1987): 450–60.

22. Mathilde and Mathias Vaerting, *The Dominant Sex: A Study in the Sociology of Sex Differentiation*, trans. from the German by Eden and Cedar Paul (New York: Doran, 1923).

23. G. Rattray Taylor, *Sex in History* (New York: Vanguard Press, 1954), p. 83.

24. J. C. Flugel, *Man, Morals and Society* (London: Duckworth, 1945).

25. Sigmund Freud, *A General Introduction to Psychoanalysis*, trans. Joan Riviere (New York: Garden City Publishing, 1943), pp. 23–24. See also Freud, *Civilization and Its Discontents* (London: Hogarth Press, 1930).

26. Kate Millet, *Sexual Politics* (Garden City: Doubleday, 1970), pp. 176–203.

27. See, for example, "Archetypes of the Collected Unconscious," in *The Basic Writings of C. G. Jung*, ed. Violet Staub de Laszlo (New York: Modern Library, 1959), pp. 270–74.

28. For the Bem scale, see S. L. Bem, "The Measurement of Psychological Androgyny," *Journal of Consulting and Clinical Psychology* 42 (1974): 155–62.

29. See Erich Neumann, *The Great Mother: An Analysis of the Archetype*, trans. Ralph Mannheim, Bollingen series 47 (New York: Pantheon Books, 1955), and Ann Bedford Ulanov, *The Feminine in Jungian Psychology and on Christian Theology* (Evanston: Northwestern University Press, 1971).

30. Sigmund Freud, "The Taboo of Virginity," in *Collected Papers*, trans. Joan Riviere, 5 vols. (reprint, New York: Basic Books, 1959), 4:226, and "Some Psychical Consequences of the Anatomical Distinction Between the Sexes," vol. 5, pp. 186–97.

31. William N. Stephens, *The Family in the Cross Cultural Perspective* (New York: Holt, Rinehart and Winston, 1953), p. 246.

32. J. D. Unwin, *Sexual Regulations and Human Behavior* (London: Williams and Norgate, 1933), pp. ix–x, 85.

33. Ibid., p. 87.

34. Ibid., p. 108. Unwin further elaborated and clarified his views in *Sex and Culture* (London: Oxford University Press, 1934).

35. H. R. Hays, *The Dangerous Sex: The Myth of the Feminine Evil* (New York: Putnam's Sons, 1964), p. 281.

36. Ibid., p. 203.

37. Geoffrey May, *Social Control of Sex Expression* (New York: Morrow, 1931), pp. 3–13. See also Edward Westermarck, "Subjection of Wives," in *The Origin and Development of the Moral Ideals*, 3 vols. (London: Macmillan, 1906), vol. 1.

38. Some feminist-influenced scholarship has emphasized the comparative redundancy of the male. See, for example, Jeremy Cherfas and John Gribbin, *The Redundant Male* (New York: Pantheon Books, 1985).

2. Formation of Western Attitudes

1. See Samuel Noah Kramer, *History Begins at Sumer* (Garden City: Doubleday, 1959), p. 99; Kramer, *Sumerian Mythology*, rev. ed. (New York: Harper, 1961); Kramer, *The Sacred Marriage Rite* (Bloomington: Indiana University Press, 1969); Diane Wolkstein and Kramer, *Inanna: Queen of Heaven and Earth* (New York: Harper and Row, 1983); Joseph Campbell, *The Masks of God: Oriental Mythology* (New York: Viking Press, 1962), pp. 1–8ff.; and E. O. James, *The Ancient Gods* (New York: Capricorn Books, 1964), pp. 80–81. *Larouse Encyclopedia of Mythology*, ed. Felix Guirand, trans. Richard Aldington and Delano Ames (New York: Prometheus Press, 1960), pp. 57–58.

2. Kramer, *Sumerian Mythology*, recounts the myth in detail but these particular verses are taken from his *History Begins at Sumer*, p. 98.

3. This brief autobiography is translated by E. A. Speiser under the title of "The Legend of Sargon," in *The Ancient Near East*, ed. James B. Pritchard (Princeton: Princeton University Press, 1965), pp. 85–86.

4. Georges Contenau, *Everyday Life in Babylon and Assyria*, trans. K. R. and A. R. Maxwell-Hyslop (London: Arnold, 1954), p. 250.

5. This description is taken from the various law codes. The standard collection in English is that edited by G. R. Driver and John C. Miles, *The Assyrian Laws* (Oxford: Clarendon Press, 1955). There are also translations of some of the codes by Albrecht Goetz and Theophile J. Meek, in *The Ancient Near East*, pp. 133–67. Reuven Yaron, *The Laws of Eshnunna* (Jerusalem: Hebrew University, 1969), has a comprehensive discussion of these particular laws. There are several other editions, particularly of the Code of Hammurabi.

6. See H. W. F. Saggs, *The Greatness That Was Babylon* (New York: New American Library), pp. 332–35. See also Vern L. Bullough and Bonnie Bullough, *Prostitution: An Illustrated Social History* (New York: Crown, 1978).

7. Herodotus, *Persian Wars*, ed. and trans. A. D. Godley (London: Heinemann, 1922), I, 184–85ff.

8. Diodorus Siculus, *Bibliotheca historica*, trans. C. H. Oldfather et al. (London: Heinemann, 1933), section 2, 1–20.

9. Hildegard Levy, "Nitokris-Naqi'a," *Journal of Near Eastern Studies* 2 (1952): 264–86. Daniel David Luckenbill, ed., *Ancient Records of Assyria and Babylonia* (Chicago: University of Chicago Press, 1926), I, 260, no. 731, included the stele inscription of Semiramis.

10. A. Leo Oppenheim, *Ancient Mesopotamia* (Chicago: University of Chicago Press, 1964), p. 104.

11. William W. Hallo and J. J. A. Van Dijk, *The Exaltation of Inanna* (New Haven, Conn.: Yale University Press, 1968), pp. 1–12.

12. Alexander Heidel, *The Gilgamesh Epic and Old Testament Parallels*, 2d ed. (Chicago: University of Chicago Press, 1949), tablet 1, col. iv, p. 22. Unfortunately Heidel, through some sense of false modesty, did not translate this portion into English but instead put it into Latin. In translating it from Latin I followed basically the form set by Saggs, *The Greatness That Was Babylon*, p. 372.

13. W. G. Lambert, *Babylonian Wisdom Literature* (Oxford: Clarendon Press, 1960), p. 147.

14. Ibid., p. 232.

15. Edmund I. Gordon, *Sumerian Proverbs* (Philadelphia: University Museum, University of Pennsylvania, 1959), p. 115, no. 1.147.

16. Ibid., p. 120, no. 1.153.

17. Ibid., p. 466, no. 1.142. This translation is by Thorkild Jacobsen rather than Gordon.

18. Ibid., this is the translation by Saggs, *The Greatness That Was Babylon*, p. 407.

19. Ibid., p. 496, no. 1.159. This is Jacobsen's translation.

20. Ibid., p. 123, no. 1.156.

21. Robert Briffault, *The Mothers*, 3 vols. (New York: Macmillan, 1927), vol. 1, pp. 378–79.

22. Mathilde and Mathias Vaerting, *The Dominant Sex* (New York: Doran, 1923), pp. 32ff.

23. W. M. Flinders Petrie, *Social Life in Ancient Egypt* (Boston: Houghton Mifflin, 1923), p. 119.

24. Ibid., p. 109.

25. Gaston Maspero, *Life in Ancient Egypt and Assyria* (New York: Appleton, 1928), p. 11.

26. H. R. Hall, "Family (Egyptian)," in *Encyclopedia of Religion and Ethics*, ed. James Hastings (New York: Scribner's, 1928), vol. 5, p. 733.

27. Margaret A. Murray, *The Splendor That Was Egypt*, rev. ed. (New York: Hawthorn Books, 1963), p. 102.

28. John A. Wilson, *The Culture of Ancient Egypt* (Chicago: University of Chicago Press, 1951), pp. 96–97.

29. Barbara Mertz, *Red Land, Black Land: The World of the Ancient Egyptians* (New York: Coward-McCann, 1966), pp. 76–80.

30. J. Cerny, "Consanguineous Marriage in Pharonic Egypt," *Journal of Egyptian Archaeology* 40 (1954): 23ff. See also Ray H. Bixler, "Sibling Incest in the Royal Families of Egypt, Peru, and Hawaii," *Journal of Sex Research* 18 (1982): 264–81.

31. Reuven Yaron, *Introduction to the Law of the Aramaic Papyri* (Oxford: Clarendon Press, 1961), pp. 42–43. The best study of ancient Egyptian law is a series of articles in German by E. Seidl. See, for example, Seidl, "Eiführung in der Ägyptische Rechtsgeschichte bis zum Ende des Neuen Reiches," *Ägyptologische Forshungen*, vol. 10, 2d ed. (Glückstadt, 1951).

32. Raphael Taubenschlag, *The Law of Greco-Roman Egypt in the Light of the Papyri* (New York: Herald Square Press, 1944), p. 15.

33. For a survey of the mythology, see *Egyptian Mythology* series of the *Mythologie Generale Larousse*, trans. Delano Ames (London: Hamlyn, 1965).

34. Herodotus, *Persian Wars*, II, 135. See also Bullough and Bullough, *Prostitution*, p. 25.

35. Wilson, *Culture of Ancient Egypt*, pp. 97–98.

36. Barbara Mertz, *Temples, Tombs and Hieroglyphs* (New York: Coward-McCann, 1964), pp. 164–91.

37. For women in Hellenistic Egypt, see Sara B. Pomeroy, *Women in Hellenistic Egypt* (New York: Schocken Books, 1984).

38. Gaston Maspero, *Popular Stories of Anciet Egypt*, trans. A. S. Johns (reprint, New Hyde Park, N.Y.: University Books, 1967), pp. xlvii, 14, 24, 136–40, 185ff.

39. Vern Bullough, *Sexual Variance in Society and History* (Chicago: University of Chicago Press, 1980), pp. 60–61.

40. Stephen Wenig, *The Woman in Egyptian Art* (New York: McGraw Hill, 1969), p. 25.

41. Bullough, *Sexual Variance*, pp. 61–62.

42. Joseph Kaster, *Wings of the Falcon: Life and Thought of Ancient Egypt* (New York: Holt, Rinehart and Winston, 1968), p. 170.

43. Ibid., p. 171.

44. Ibid., pp. 169–70.

45. Adolf Erman, *The Literature of the Ancient Egyptians*, trans. from the German by Aylward M. Blackman (London: Methuen, 1927), p. 239.

46. Ibid.

47. Ibid.

48. Ibid., p. 240.

49. Ibid., p. 236.

50. Kaster, *Wings of the Falcon*, pp. 228–29. For others, see John L. Foster, trans. and ed., *Love Songs of the New Kingdom* (New York: Charles Scribner's Sons, 1974).

51. Genesis 1:27–28, King James Version.

52. Genesis 2:18.

53. I Corinthians 11:8–9.

54. Genesis 3:16.

55. Louis Epstein, *Sex Laws and Customs in Judaism* (New York: Bloch Publishing, 1948), pp. 3–24.

56. Abodah Zarah, p. 179, trans. A. Mishcon and A. Cohen in *The Babylonian Talmud*, ed. Isidore Epstein (London: Soncino Press, 1953).

57. David Mace, *Hebrew Marriage* (London: Epworth Press, 1953), pp. 143–44.

58. Louis M. Epstein, *Marriage Laws in the Bible and Talmud* (Cambridge: Harvard University Press, 1942), pp. 79–80.

59. Ibid., pp. 82ff.

60. Exodus 20:17.

61. Leviticus 20:10.

62. Kethuboth, 51b, trans. by Israel W. Slotki in the *Babylonian Talmud*, ed. I. Epstein (London: Soncino Press, 1936).

63. Genesis 34:30.

64. II Samuel 13:1–29.

65. Leviticus 20:11; Mace, *Hebrew Marriage*, pp. 159–64.

66. Judges 21:16–24.

67. Deuteronomy 22:10–14.

68. Judges 8:30.

69. Mace, *Hebrew Marriage*, pp. 210–11.

70. Leviticus 20:18.

71. Leviticus 15:24.

72. Abodah Zara, 22b.

73. Baba Mezia, 71a trans. into English by Salis Daiches and H. Freeman in the *Babylonian Talmud*, ed. I. Epstein (London: Soncino Press, 1935).

74. Genesis 39:7–18.

75. Genesis 30:1–24.

76. Judges 16:4–20.

77. II Samuel 11:2–27.

78. Frank S. Mead, *Who's Who in the Bible* (New York: Harper, 1934).

79. I Kings 11:4.

80. I Kings 16:31–33; 18:13, 19; 19:1, 2; 21:5–25; II Kings 9:7, 10, 22, 30, 36–37.

81. Proverbs 6:24–35; 7:10–27.

82. Ecclesiastes 7:28.

83. For a survey, see Edith Deen, *All of the Women of the Bible* (New York: Harper and Row, 1955).

84. Judges 4:1–24.

85. Ruth 1:16–17.

86. Proverbs 31:10–31.

87. Song of Solomon.

3. The Pedestal with a Base of Clay

1. H. D. F. Kitto, *The Greeks* (London: Penguin, 1951), p. 222. For differing views of women in Greece, see Sara B. Pomeroy, *Goddesses, Whores, Wives and Slaves: Women in Classical Antiquity* (New York: Schocken Books, 1975); Pomeroy, *Women in Hellenistic Egypt: From Alexander to Cleopatra* (New York: Schocken Books, 1984); Helene P. Foley, compiler, *Reflections of Women in Antiquity* (New York: Gordon and Breach, 1981).

2. Arnold W. Gomme, *Essays on Greek History and Literature* (Oxford: Basil Blackwell, 1937), p. 92.

3. Philip E. Slater, *The Glory of Hera: Greek Mythology and the Greek Family* (Boston: Beacon Press, 1968), p. 7.

4. H. I. Marrou, *A History of Education in Antiquity*, trans. George Lamb (New York: Sheed and Ward, 1956), p. 142.

5. Slater, *Glory of Hera*, p. 8.

6. Karen Horney, "The Dream of Woman," *International Journal of Psychoanalysis* 13 (1932): 348–60.

7. Slater, *Glory of Hera*, p. 12.

8. Ibid., pp. 72–74.

9. Samuel Butler, *The Authoress of the Odyssey*, new intro. by David Grene, 2d ed. (reprint, Chicago: University of Chicago Press, 1967), passim, but esp. pp. 105–24.

10. Kaarle Hirvonen, *Matriarchal Survivals and Certain Trends in Homer's Female Characters*, in vol. 152, *Annales Academiae Scientiarum Fennicae* (Helsinki: Suomalainen Tiedeakatemia, 1968). See also Marilyn Arthur, "The Divided World of the Iliad," *Women's Studies* 8 [1981]: 1–2).

11. See, for example, Gilbert Murray, *Five Stages of Greek Religion* (reprint, Garden City: Doubleday, 1955). The thesis was first worked out in considerable detail by Jane Harrison, *Prolegomena to the Study of Greek Religion* (reprint, New York: Meridian Books, 1955). See E. O. James, *The Cult of the Mother Goddess* (New York: Praeger, 1959). The most fervent advocate of the theory was Robert Graves, *The White Goddess* (New York: Farrar, Straus and Cudahy, 1948).

12. Hesiod, *Theogony*, ed. M. L. West (Oxford: Clarendon Press, 1966), ll. 565–616, and Hesiod, *Works and Days*, ed. T. A. Sinclair (Hildesheim: Georg Olms, 1966), pp. 42–105.

13. Hesiod, *The Homeric Hymns and Homerica*, ed. and trans. Hugh Evelyn-White (London: Heinemann, 1942), pp. 7, 9, 31, 33, 47, 53, 55, and 123.

14. Gomme, *Greek History and Literature*, p. 102. For other views, see Carol C. Gould and Marx W. Wartofsky, eds., *Women and Philosophy* (New York: Putnam, 1976), and Susan Moller Okin, *Women in Western Political Thought* (Princeton: Princeton University Press, 1979). See also Carol Gould, *Beyond Domination: New Perspectives on Women and Philosophy* (New York: Rowman and Allanheld, 1984).

15. Diogenes Laertius, *Lives of Eminent Philosophers*, ed. and trans. R. D. Hicks (London: Heinemann, 1959), I, 167, and Valerius Maximus, *Factorum et Dictorum Memorabilium Libri*, ed. Karl F. Kempf (Leipzig: Teubner, 1888), VII, ii, par. 6, ext. 1, p. 327.

16. Plato, *Republic*, ed. and trans. Paul Shoren, 2 vols. (London: Heinemann, 1935), esp. bk. 5.

17. Plato, *Republic*, 454D–456C; *Timaeus*, ed. and trans. R. G. Bury (London: Heinemann, 1952), 42A, 90E, and perhaps also *Laws*, ed. and trans. R. G. Bury, 2 vols. (London: Heinemann, 1952), 804E–806C.

18. Plato, *Timaeus*, 91C.

19. Plato, *Laws*, 783B–784B.

20. Plato, *Laws*, 839E–841E.

21. Aristotle, *Historia animalium*, trans. D'Arcy W. Thompson in *The Works of Aristotle* (Oxford: Clarendon Press, 1910), vol. 4, 608B. See also Aristotle, *Politics*, ed. and trans. H. Rackham (London: Heinemann, 1944), I, 2 (1252B), 7.

22. Aristotle, *Generation of Animals*, trans. A. L. Peck (London: Heinemann, 1953), 729A, 25–34.

23. T. U. H. Ellinger, *Hippocrates on Intercourse and Pregnancy* (New York: Abelard-Schuman, 1952); Joseph Needham, *A History of Embryology*, 2d ed. rev. (New York: Abelard-Schuman, 1959), pp. 31–37.

24. Needham, *History of Embryology*, pp. 69–74.

25. Aristotle, *Nichomachean Ethics*, ed. and trans. H. Rackham (London: Heinemann, 1962), VIII, vii, 1.

26. Aristotle, *Politics*, I, 13 (1260A), 7–8.

27. Aristotle, *Rhetoric*, ed. and trans. John Henry Freese (London: Heinemann, 1967), I (1361A), v. 6.

28. Aristotle, *Nichomachean Ethics*, VIII, vii, 1–2.

29. Aristotle, *Politics*, I, 12 (1259B), 1.

30. Aristotle, *Politics*, VII, 16 (1335A), 9–10.

31. Aristotle, *Politics*, I, 13 (1260A), 10; see also Aristotle, *Poetics*, ed. and trans. W. H. Fyfe (London: Heinemann, 1953) (1454B), 16ff.

32. Aristotle, *Generation of Animals*, I, xx (728A), 18–20.

33. Aristotle, *Nichomachean Ethics*, VIII, vii, 2–3.

34. Aristotle, *Politics*, I, 2 (1252B), 4.

35. W. K. Lacey, *The Family in Classical Greece* (London: Thames and Hudson, 1968), pp. 24–25, 151–76.

36. Lysias, *Orationes*, ed. and trans. W. R. M. Lamb (London: Heinemann, 1957), III, 6.

37. Xenophon, *Oeconomicus*, ed. and trans. E. C. Marchant (London: Heinemann, 1953), VII, 5–6.

38. Isaeus, *Speeches*, ed. William Wyse (Hildesheim: Georg Olms, 1967), III, 13–14; Lysias, *Orationes*, I, 22.

39. Lacey, *Family in Classical Greece*, p. 162.

40. Aristotle, *Nichomachaean Ethics*, VIII, x (1160B–1162A), 4–12.

41. Xenophon, *Oeconomicus*, III, 11–15.

42. Lacey, *Family in Classical Greece*, pp. 168–69.

43. Xenophon, *Lacedaemonians*, ed. and trans. E. C. Marchant (London: Heinemann, 1925), I, 3–4.

44. Lacey, *Family in Classical Greece*, pp. 170–71.

45. Aristotle, *Politics*, I, 1 (1252A–B), 3–7.

46. Lacey, *Family in Classical Greece*, pp. 24–25.

47. Aristotle, *Politics*, II, 6 (1269B), 5–7.

48. Lacey, *Family in Classical Greece*, p. 203.

49. Euripides, *Andromache*, trans. John Frederick Nims in *The Complete Greek Tragedies*, ed. David Grene and Richmond Lattimore (Chicago: University of Chicago Press, 1959), III, 582, ll. 596–601.

50. Plutarch, *Sayings of Spartan Women*, in *Moralia*, ed. and trans. F. C. Babbitt, vol. 3 (London: Heinemann, 1961), 241F, 16.

51. Aristotle, *Politics*, II, 6 (1269B–1270A), 5–11.

52. F. A. Wright, *Feminism in Greek Literature*, 1st ed. (1923; republished, Port Washington, N.Y.: Kennikat Press, 1969), p. 29.

53. *Lyra Graeca*, ed. and trans. J. M. Edmonds (London: Heinemann, 1934), I.

54. Ibid.

55. Ibid.

56. U. von Wiliamowitz-Mollendorf, *Sappho und Simonides* (Berlin, 1913); T. Reinach, *Alcée et Sapho* (Paris, 1937), but esp. the discussion by Jeannette Foster, *Sex Variant Women in Literature* (London: Muller, 1958), pp. 17–24. See also Judith Hallett, "Sappho and Her Social Context and Sensuality," *Signs* 4 (1979): 447–70, as well as the response to this by Eva Stehle Stigers.

57. Foster, *Sex Variant Women*, pp. 17–24.

58. Euripides, *Medea*, trans. Rex Warner in Grene and Lattimore, *Complete Greek Tragedies*, vol. 3, p. 67, ll. 231–51.

59. Ibid., vol. 3, p. 77, ll. 569–75.

60. Ibid., vol. 3, p. 89, ll. 889–913.

61. Ibid., vol. 3, p. 90, ll. 908–13.

62. See Euripides, *Alcestis*, trans. Richmond Lattimore in Grene and Lattimore, *Complete Greek Tragedies*, vol. 3.

63. Victor Ehrenberg, *The People of Aristophanes: A Sociology of Old Attic Comedy* (Cambridge: Harvard University Press, 1951), pp. 202–3.

64. Anaxadrides, in *The Fragments of Attic Comedy*, ed. and trans. J. M. Edmonds (Leiden: Brill, 1959), vol. 2, p. 75.

65. Quoted at length by St. Jerome, *Against Jovinianus*, in *Nicene Library* (New York: Christian Literature, 1893), ser. 2, vol. 6, pp. 383–84.

66. Vern L. Bullough and Bonnie Bullough, *Prostitution: An Illustrated Social History* (New York: Crown Publishers, 1978).

67. Thucydides, *The Peloponnesian War*, ed. and trans. C. F. Smith (London: Heinemann, 1951–53), II, 45, 2.

68. Helen McClees, *A Study of Women in Attic Inscriptions* (New York: Columbia University Press, 1920).

69. Hans Licht, *Sexual Life in Ancient Greece* (London: Routledge and Kegan Paul, 1932), pp. 18–19.

70. Philostratus, *Imagines*, ed. and trans. Arthur Fairbanks (London: William Heinemann, 1931), I, ii, 9–10.

71. I. M. Lewis, *Ecstatic Religion: An Anthropological Study of Spirit Possession and Shamanism* (London: Penguin, 1971).

72. This picture changes somewhat in the Hellenistic period. Interested readers should consult Sarah B. Pomeroy, *Goddesses, Whores, Wives and Slaves* (New York: Schocken Books, 1975), pp. 120–48. She argues that the loss in political autonomy on the part of the city-states wrought a change not only in political relationships but in women's position in family and society. Some of this change is also evident in Rome.

4. The "Rise" of Women and the Fall of Rome

1. Charles Winick, *The New People: Desexualization in American Life* (New York: Pegasus, 1968), p. 346.

2. J. D. Unwin, *Sexual Regulations and Human Behavior* (London: Williams and Norgate, 1933), pp. ix–x.

3. Ibid., p. 85.

4. Pitrim A. Sorokin, *The American Sex Revolution* (Boston: Porter Sargent, 1956), p. 77.

5. This is a term used by Crane Brinton, *A History of Western Morals* (New York: Harcourt, Brace, 1959), p. 113.

6. J. P. V. D. Balsdon, *Roman Women* (London: Bodley Head, 1962), p. 9.

7. See Sarah B. Pomeroy, *Women in Hellenistic Egypt* (New York: Schocken Books, 1984); Pomeroy, *Goddesses, Whores, Wives and Slaves: Women in Classical Antiquity* (New York: Schocken Books, 1975); Helene P. Foley, *Reflections of Women in Antiquity* (New York: Gordon and Breach, 1981); Judith P. Hallett, *Fathers and Daughters in Roman Society* (Princeton: Princeton University Press, 1984); Averil Cameron and Amelia Kuhrt, *Images of Women in Antiquity* (London: Croom, Helm, 1983), and the article by JoAnn McNamara on Roman Women in Renate Bridenthal and Claudia Koontz, *Becoming Visible: Women in European History* (2d ed., Boston: Houghton Mifflin, 1987).

8. *Livy, Ab urbe Condita Libri*, ed. and trans. B. O. Foster, Evan T. Sage, F. G. Moore (London: Heinemann, 1936), intro., p. 9.

9. Edward Gibbon, *Decline and Fall of the Roman Empire*, ed. J. B. Bury (reprint, New York: Heritage Press, 1946), p. 61.

10. Mathilde and Mathias Vaerting, *The Dominant Sex: A Study in the Sociology of Sex Differentiation*, trans. Eden and Cedar Paul (London: Allen and Unwin, 1923).

11. Seneca, *Epistolae Morales*, ed. and trans. Richard K. Gummere (London: Heinemann, 1920), I, 17 (57).

12. Cicero, *De Officis*, ed. and trans. Walter Miller (London: Heinemann, 1951), I, 17 (57).

13. This is found in R. Lattimore, *Themes in Greek and Latin Epitaphs* (reprint, Urbana: University of Illinois Press, 1962), p. 271.

14. *Livy*, I, 4, 11–13; Dionysius of Halicarnassus, *Roman Antiquities*, ed. and trans. Ernest Cary (London: Heinemann, 1950), I, 76–79; II, 25, 30, 38–46.

15. *Livy*, I, 57–60.

16. Balsdon, *Roman Women*, p. 31.

17. Diodorus Siculus, *History*, ed. and trans. C. H. Oldfather (London: Heinemann, 1933), 14, 116, 9.

18. Suetonius, "Tiberius," *De Vita Caesarum*, ed. and trans. John C. Rolfe (London: Heinemann, 1951), 2, 3; Ovid, *Fasti*, ed. and trans. Sir James Frazer (London: Heinemann, 1929), iii, p. 241.

19. Balsdon, *Roman Women*, pp. 216–21.

20. *Livy*, XXIX, ii–iii, 3, with some modifications by me. Some scholars dispute whether this is a real speech of Cato's since stylistically it is unlike any of his other extant speeches. It seems, however, that it is a good example of an attitude which was extremely influential in Rome, and Livy had some justification in using Cato to symbolize the attitude.

21. Sallust, *War with Catilins*, ed. and trans. J. C. Rolfe (London: Heinemann, 1960), 13.

22. Horace, *Odes*, ed. and trans. C. E. Bennett (London: Heinemann, 1960), III, 6.

23. Cicero, *Epistulae ad Familiaries*, ed. and trans. W. Glynn Williams (London: Heinemann, 1958), XIV, and Pliny, *Letters*, ed. and trans. W. M. L. Hutchinson (London: Heinemann, 1957), I, 4; II, 4; III, 3, 10; IV, 19; VI, 4, 7; VII, 5, 14; VIII, 11.

24. M. I. Finley, *Aspects of Antiquity* (New York: Viking Press, 1968), pp. 136–38.

25. For details of Augustan moral legislation see Hugh Last, "The Social Policy of Augustus," *Cambridge Ancient History* (New York: Macmillan, 1934), vol. 10, esp. pp. 441–55.

26. Balsdon, *Roman Women*, pp. 230–34.

27. Ibid.

28. Tacitus, *Annals*, ed. and trans. John Jackson (London: Heinemann, 1956), III, 33f.

29. Juvenal, *Satires*, ed. and trans. G. C. Ramsay (London: Heinemann, 1957), sixth satire.

30. See Catullus, Tibulus, and Propertius in the Loeb library.

31. Lucretius, *De Rerum Natura,* ed. and trans. W. H. D. Rouse (London: Heinemann, 1924), III, 894–99.
32. Ovid, *Ars Amoris,* ed. and trans. J. H. Mogley (London: Heinemann, 1962).
33. Soranus, *Gynecology,* ed. and trans. O. W. Temkin (Baltimore: Johns Hopkins Press, 1956), I, vii (32).

5. Christianity, Sex, and Women

1. Athanasius, *In passionem et crucem Domini,* XXXX, in J. P. Migne, *Patrologie cursus completus,* Series Graeco Latina, vol. 28 (Paris, 1887). The attribution of this work to Athanasius is perhaps dubious.
2. Ambrose, *Commentaria in Epistolam S. Pauli and Corinthos Primam,* cap. v, Migne, *Patrologie Latina,* vol. 27 (Paris, 1879).
3. Tertullian, *Apology,* L, 12, trans. Sister Emily Joseph Daly, in vol. 10, *The Fathers of the Church* (New York: Catholic University of America, 1950), p. 125.
4. Matthew 5:28. Unless otherwise stated quotations are from the King James translation. Though there are more accurate translations or at least more scholarly ones, this edition is used because almost until the twentieth century it was the dominant version in the English-speaking world and the most influential version in forming American attitudes.
5. St. John Chrysostom, *Homilies sur les statutes,* in vol. 3, *Oeuvres,* ed. and trans. M. Jeannin Bar-le-Duc (Nantes: L. Guérin, 1866), homily xv.
6. John 4:27.
7. For details about the women in the New Testament, see JoAnn McNamara, *A New Song: Celibate Women in the First Three Centuries,* in numbers 6 and 7 of *Women and History* (New York: Institute for Research in History and the Haworth Press, 1983). Mary Magdalene is not listed as a prostitute in the Bible but rather as a woman possessed; it was Christian tradition that made her a prostitute. See also Elisabeth Schüssler, *In Memory of Her: A Feminist Theological Reconstruction of Christian Origins* (New York: Crossroad, 1983), and William E. Phipps, *Was Jesus Married* (New York: Harper and Row, 1970), pp. 61–67.
8. Mary Daly, *The Church and the Second Sex* (New York: Harper and Row, 1968), p. 37.
9. Sarah Parker White, *A Moral History of Woman* (Garden City: Doubleday, Doran, 1937), p. 143.
10. Acts 16:14–15; 17:4, 12, 34.
11. Acts 21:9.
12. Acts 9:36–42.
13. Acts 12:12; 16:15, 40; Romans 16:2.
14. Romans 16:1, 3–4, 6, 12; Philippians 4:2–3.
15. Acts 18:26.
16. Matthew 5:31–32; 19:3–9; Mark 10:11–12.
17. Matthew 19:11–12.

18. Eusebius, *Ecclesiastical History*, ed. and trans. Kirsopp Lake (London: Heinemann, 1926), VI, viii.

19. Derrick Sherwin Bailey, *Sexual Relation in Christian Thought* (New York: Harper, 1959), p. 72, fn. 11.

20. Ibid., p. 17; Roland H. Bainton, *What Christianity Says About Sex, Love and Marriage* (New York: Association Press, 1957); White, *Moral History of Woman*, pp. 171–73.

21. I Peter 3:1–7.

22. Galatians 4:28.

23. I Corinthians 11:4–9.

24. I Timothy 2:12.

25. I Corinthians 14:34–36.

26. I Timothy 2:11–12.

27. Colossians 3:18–19.

28. Ephesians 5:22–25.

29. I Peter 3:1.

30. I Timothy 2:15.

31. I Corinthians 11:10.

32. Luke 14:26.

33. Matthew 10:37, 19:29; Mark 10:29.

34. Mark 3:17; Luke 21:23.

35. I Corinthians 7:1–12.

36. Bailey, *Sexual Relation in Christian Thought*, p. 10.

37. I Corinthians 7:28, 32–34.

38. I Timothy 4:3.

39. Hebrews 13:4.

40. Revelations 14:4.

41. I Timothy 2:14.

42. See the discussion by A. Vööbus, *Celibacy, a Requirement for Admission to Baptism in the Early Syrian Church* (Stockholm: Estonian Theological Society in Exile, 1951.)

43. Eusebius, *Ecclesiastical History*, IV, 23, 7–8.

44. Ephesians 5:22–23.

45. See McNamara, *A New Song*, esp. pp. 122–25.

46. Bailey, *Sexual Relation in Christian Thought*, p. 33.

47. See Joseph Ward Swain, *The Hellenic Origins of Christian Asceticism* (New York, 1916, a privately printed Ph.D. thesis from Columbia University), and Johannes Leipoldt, *Griechische Philosophie and Frühchristliche Askesse* (Berlin: Akademie Verlag, 1961), pp. 31ff., 60ff.

48. Emil Brunner, *The Divine Imperative*, trans. Olive Wyon (Philadelphia: Westminster Press, 1947), p. 364.

49. Morton S. Enslin, *The Ethics of Paul* (New York: Harper, 1930) p. 180.

50. Paul Ricoeur, "Wine, Eroticism and Enigma," *Cross Currents* 14 (1964): 135.

51. One of the pioneer investigators of this was Jane Harrison, *Prolegomena to*

the Study of Greek Religion (reprint, New York: Meridian Books, 1955), but esp. chaps. 9, 10, and 11.

52. W. K. C. Guthrie, *The Greeks and Their Gods* (Boston: Beacon Press, 1950), p. 311.

53. See Aristotle, *Metaphysics*, ed. and trans. Hugh Tredennick (London: Heinemann, 1936), I, v, 3–7 (968A).

54. E. R. Dodds, *The Greeks and the Irrational* (Boston: Beacon Press, 1957), p. 155.

55. See Plato, *Symposium*, ed. and trans. W. R. M. Lamb (London: Heinemann, 1953), particularly 211B, and the *Phaedrus*, ed. and trans. Harold North Fowler (London: Heinemann, 1953), 246–47, 250–53.

56. Philo, *On the Special Laws*, ed. and trans. F. H. Colson (London: Heinemann, 1958), III, 113.

57. Richard A. Baer, Jr., *Philo's Use of the Categories Male and Female* (Leiden: Brill, 1970), pp. 46, 51, and see also Philo, *On the Creation*, ed. and trans. F. H. Colson and G. H. Whittaker (London: Heinemann, 1963), pp. 69–70, 151, 162, and *Questions and Answers on Genesis*, ed. and trans. Ralph Marcus (London: Heinemann, 1961), I. 40.

58. The treatise is usually erroneously attributed to Ocellus Lucanus and can be found in Ocellus Lucanus, *De universi natura*, text and commentary by Richard Harder (Berlin: Weidmann, 1926), sec. 44, pp. 121–26.

59. W. K. S. Guthrie, *Numenius of Apamea* (London: George Bell, 1917), p. 133.

60. Plotinus, *The Enneads*, ed. and trans. Stephen MacKenna, rev. B. S. Page (London: Faber and Faber, 1956), V, 3, par. 1–9; V, 9, par. 1.

61. Porphyry, *Abstinence from Animal Food*, trans. Thomas Taylor (London: Thomas Rodd, 1823), I, 45; IV, 8, 20; there are other references.

62. John T. Noonan, Jr., *Contraception: A History of Its Treatment by Catholic Theologians and Canonists* (Cambridge: Harvard University Press, 1966), p. 58. See also Elaine Pagels, *The Gnostic Gospels* (New York: Random House, 1981).

63. Acts 8:9–24.

64. Revelations 2:6, 14–15.

65. Clement, *Stromata*, bk. 3, cap. 3 (12) in vol. 2, *The Ante Nicene Fathers*, ed. and trans. Alexander Roberts and James Donaldson, English ed. A. Cleveland Coxe (reprint, Grand Rapids: Eerdmans Publishing, 1961). It is worth a comment that the editors hesitated to translate this section and left it in Latin. There is, however, an English translation of the third book in John E. L. Oulton and Henry Chadwick, *Alexandrian Christianity* (Philadelphia: Westminster Press, 1954).

66. Tertullian, *On the Flesh of Christ*, cap. 1 in vol. 3, *The Ante Nicene Fathers*.

67. Tertullian, *Against Marcion*, bk. 4, cap. 7 in vol. 3, *The Ante Nicene Fathers*.

68. Robert M. Grant, *Augustus to Constantine: The Thrust of the Christian Movement into the Roman World* (New York: Harper and Row, 1970), p. 123.

69. Justin Martyr, *Apology*, bk. 1, cap. 29 in vol. 1, *The Ante Nicene Fathers*.

70. Justin Martyr, *Dialogue with Trypho*, 100 in vol. 1, *The Ante Nicene Fathers*; see also Erwin R. Goodenough, *The Theology of Justin Martyr* (reprint, Amsterdam: Philo Press, 1923).

71. Eusebius, *Ecclesiastical History*, IV, cap. 29; Irenaeus, *Against Heresies*, bk. 1, cap. 28 in vol. 1, *The Ante Nicene Fathers*.

72. *Acts and Martyrdom of Andrew* in vol. 8 of *The Ante Nicene Fathers*, p. 512, and *Acts of Thomas* in vol. 8, *The Ante Nicene Fathers*, p. 537.

73. Arthur Vööbus, *History of Asceticism in the Syria Orient* (Louvain: Corpus Scriptorum Christianorum Orientalium, 1958), vol. 1, p. 69.

74. The gospel can be found in various editions but the one used here is in an appendix to Jean Doresse, *The Secret Books of the Egyptian Gnostics*, trans. Philip Mairet (London: Hollis and Carter, 1960), *Gospel of Thomas*, V, 22.

75. It is true there is a conflicting set of attitudes expressed in some of the Apocrypha but it had less influence, at least in my mind. See Stevan L. Davies, *The Revolt of the Widows: The Social World of the Apocryphal Acts* (Carbondale: Southern Illinois University Press, 1980).

76. Clement of Alexandria, *Pasdagogus*, bk. 1, iv in vol. 2, *The Ante Nicene Fathers*.

77. Clement, *Stromata*, bk. 2, cap. 7.

78. Ibid., caps. 8 and 19.

79. At least this seems to be the implication of Athenagoras in *A Plea for Christians*, caps. 32–34 in vol. 2, *The Ante Nicene Fathers*.

80. Tertullian, *On the Apparel of Women*, bk. 1 in vol. 4, *The Ante Nicene Fathers*.

81. Tertullian, *To His Wife*, iv, v, vi in vol. 4, *The Ante Nicene Fathers*.

82. Tertullian, *On the Veiling of Virgins*, xvi and passim in vol. 4, *The Ante Nicene Fathers*.

83. St. Jerome, *Letters*, in *Select Letters*, ed. and trans. F. A. Wright (London: Heinemann, 1933), cvii (A Girl's Education), and cxxviii (Feminine Training).

84. St. John Chrysostom, *Commentaire sur l'epitre aux Ephesiens*, in vol. 10, *Oeuvres*, xii, and xiii, homily 10.

85. St. John Chrysostom, *Address on Vainglory and the Right Way for Parents to Bring Up Their Children*, in M. Laistner, *Christianity and Pagan Culture* (Ithaca, N.Y.: Cornell University Press, 1951), chap. 53, pp. 109–10.

86. St. John Chrysostom, *An Exhortation to Theodore After His Fall*, in vol. 9, *Nicene and Post Nicene Fathers*, ed. Philip Schaff and Henry Wace, series 2 (New York: Christian Literature, 1893), p. 346.

87. Gregory of Nyssa, *On Virginity*, trans. Virginia Woods Callahan in vol. 58, *The Fathers of the Church* (Washington, D.C.: Catholic University of America, 1948).

88. St. John Chrysostom, *Commentaires sur l'evangile selon Saint Matthieu*, lii, in vol. 7, *Oeuvres*, and *Commentaire sur l'epitre aux Ephesiens*, in vol. 10, homily 15.

89. Jerome, *Letters*, XXII, 20.

90. Ibid., LIV, and CVII, and *Against Helvidus*, trans. John N. Hritza, vol. 53, *The Fathers of the Church* (Washington, D.C.: Catholic University of America, 1948), 8aff.

91. St. Ambrose, *De Vidius*, in vol. 7, *Omnia Opera*, ed. D. A. B. Caillau (Paris: Paul Mellier, 1844), 11, lxix; 13, xxxi; 15, lxxxviii; and *De Virginitate*, 6 in vol. 7.

92. See Henri-Charles Puech, *Le Manicheisme* (Paris: Civilisations du Sud, 1949). The best source for the teachings of the Manicheans is in the writings of St. Augustine. The continued existence of these ideas is evident in the *Register of the Sciences* of Muhammad ibn Ishaq ibn al-Nadim written in the tenth century in Arabic. It was edited and translated into English by Bayard Dodge, *The Fihrist of al-Nadim*, 2 vols. (New York: Columbia University Press, 1970). See also Noonan, *Contraception*, pp. 107–30.

93. St. Augustine, *Concerning the Nature of Good*, trans. A. H. Newman in *Basic Writings of St. Augustine*, ed. Whitney J. Oates (New York: Random House, 1948), cap. xviii, p. 455.

94. St. Augustine, *Soliloquies*, trans. Thomas F. Gilligan in vol. 1, *Fathers of the Church* (New York: Cima Publishing, 1948), p. 10 (17).

95. Sister M. Rosamond Nugent, *Portrait of the Consecrated Women in Greek Christian Literature of the First Four Centuries* (Washington: Catholic University of America, 1941), p. 107.

96. See the discussion by A. D. Nock, *Conversion* (reprint, Oxford: Oxford University Press, 1952), pp. 218ff. and passim.

97. See Vern Bullough, "Transvestites in the Middle Ages, *American Journal of Sociology* 79 (1974): 1381–94.

6. Byzantium: Actuality Versus the Ideal

1. At least he was to be denied the sacrament for three years, and this was equivalent to excommunication. St. Basil, *Letters*, in vol. 28, *The Fathers of the Church*, trans. Agnes Clare Way (New York: Fathers of the Church, 1955), Letter 188, par 3.

2. Innocent, *Epistolae et Decreta* in vol. 20, *Patrologiae Latina*, ed. J. P. Migne (Paris, 1845), *Epistola*, VI, cap. 111.8.

3. *Les Nouvelles de Leon VI, Le Sage*, 48, ed. and trans. into French by P. Noailles and A. Dain, and trans. into English by Julia O'Faolain and Laura Martines, *Not in God's Image* (New York: Harper and Row, 1973). For a discussion of empresses, see Kenneth G. Holum, *Theodosian Empresses and Imperial Dominion in Late Antiquity* (Berkeley: University of California Press, 1982).

4. See O. D. Watkins, *Holy Matrimony* (London: Rivington, Percival, 1895), and Derrick Sherwin Bailey, *Sexual Relation in Christian Thought* (New York: Harper, 1959), pp. 64–80.

5. *Digest*, L, xvii, 30, in *Corpus Juris Civiles*, 3 vols. (Berlin: Weidmann, 1959).

6. *Digest*, XXIV, i, 60, 61, 62; ii, 4, 9; iii, 22, par. 7.

7. Under the Emperor Justinian, *Novella*, xxii (536), mutual consent still sufficed to effect divorce although *Novella*, cxxiv (556), prohibited divorce by con-

sent and allowed it only on specific grounds. There were considerable other changes as the law changed back and forth over the next few centuries. See Watkins, *Holy Matrimony*, pp. 291–93.

8. Bailey, *Sexual Relation in Christian Thought*, pp. 835–85; Watkins, *Holy Matrimony*, p. 418. A good example of this inability was the case of Leo VI and his wife Theaphano.

9. A. A. Vasiliev, *History of the Byzantine Empire* (Madison: University of Wisconsin Press, 1952), pp. 395–96.

10. St. Basil, *Letters*, clxxxviii, 9; ccxvii, 58, 59, 77.

11. For biographical portraits of thirteen of the empresses, see Charles Diehl, *Byzantine Empresses*, trans. Harold Bell and Theresa de Kerpely (New York: Knopf, 1963).

12. Percy Neville Ure, *Justinian and His Age* (Harmondsworth, England: Penguin, 1951), p. 197.

13. Procopius, *Anecdota*, trans. H. B. Dewing (London: Heinemann, 1940), IX, 12–13.

14. Procopius, *History of the Wars* (London: Heinemann, 1914–28), I, xxiv, 33–37.

15. Michael Psellus, *Encomium*, ed. K. N. Sathas in *Bibliotheca Graeca Medii Aevi*, 7 vols. (Venice and Paris, 1872–94), vol. 5.

16. Michael Psellus, *The Chronographia*, trans. E. R. A. Sewter (New Haven, Conn.: Yale University Press, 1953).

17. Anna Comnena, *Alexiad*, trans. Elizabeth A. S. Dawes (London: Kegan Paul, Trench, Trubner, 1928), XV, 2 (italics mine).

18. Ibid., XII, 3.

19. Ibid., XV, ii.

20. Georgina G. Buckler, *Anna Comnena: A Study* (London: Oxford University Press, 1929), pp. 121–23.

21. Philip Goldberg, "Are Women Prejudiced Against Women?" *Transaction* (April, 1968): 28–30.

22. Gail I. Peterson, Sara B. Kiesler, and Philip A. Goldberg, "Evaluation of the Performance of Women as a Function of Their Sex, Achievement and Personal History," *Journal of Personality and Social Psychology* 19, no. 1 (July 1971): 114–18.

23. Gordon W. Allport, *The Nature of Prejudice* (Cambridge: Addison-Wesley, 1958).

24. Kurt Lewin, "Self-Hatred Among Jews," in *Resolving Social Conflicts* (New York: Harper, 1948), pp. 186–200.

25. Bruno Lasker, *Race Attitudes in Children* (New York: Holt, 1935); Mary Ellen Goodman, *Race Awareness in Young Children* (Cambridge: Addison-Wesley, 1952); Kenneth B. and Mamie K. Clark, "The Development of Consciousness of Self and the Emergence of Racial Identification in Negro Preschool Children," *Journal of Social Psychology* 10 (1939): 591–99; Kenneth B. Clark, *Prejudice and Your Child* (Boston: Beacon Press, 1955); Harold Proshansky and Peggy Newton, "The Nature and Meaning of Negro Self-Identity," in *Social*

Class, Race and Psychological Development, ed. Martin Deutsch, Irwin Katz, and Arthur Jensen (New York: Holt, Rinehart and Winston, 1968), pp. 178–218.

7. Sex Is Not Enough: Women in Islam

1. Reuben Levy, *The Social Structure of Islam* (Cambridge: Cambridge University Press, 1965), p. 130.
2. Richard Burton, "Terminal Essay," sec. 4, "Social Conditions," in *The Book of the Thousand Nights and a Night,* trans. and annotated Richard Burton, 6 vols. in 3 (reprint, New York: Heritage Press, 1934), pp. 3739–46. For a more detailed examination of these nights, see Malik Ram Baveja, *Woman in Islam* (New York: Advent Books, 1981).
3. Omer Haleby, *El Ktab or the Sex Laws of Mohammad,* trans. A. F. Niemoeller (Girard, Kansas: Haldeman-Julius, 1949), p. 10. Niemoeller's translation, unfortunately, was not from the Arabic but from a French version made by Paul de Regia that was not available to me. Haleby himself, however, only wrote in the nineteenth century. There were various similar books of earlier date. See Burton, *The Thousand Nights,* pp. 3745–46.
4. Translated by A. J. Arberry in *Arabic Poetry* (Cambridge: Cambridge University Press, 1965), pp. 13–14.
5. Gustave E. von Grunebaum, *Medieval Islam* (Chicago: University of Chicago Press, 1946), pp. 262–63.
6. Koran, IV (Women), 34. There are various translations of the *Koran* into English, none of them official since it is forbidden to translate it. In this section most of the translations have been taken from "exploratory" translations of Mohammad Marmaduke Pickthall because of its wide distribution in the English-speaking world (New York: New American Library, 1953). In some cases other versions are used because they seem to better express the meaning of the original Arabic.
7. Koran, XXIV (Light), 30.
8. Koran, XXXIII (The Clans), 53.
9. Ibid., p. 59.
10. Reuben Levy, *Social Structure of Islam,* p. 126.
11. Alī ibn Abī Bakr, Burhan al-Din, al-Marghīnānī, *The Hedaya or Guide: A Commentary on the Mussulman Laws,* trans. Charles Hamilton and ed., with a preface and index, Standish Grove Grady, 4 vols. in 1 (reprint, Lahore: Premier Book House,.1957), IV, 598–99, or bk. xliv, sec. 4.
12. Koran, XXX (The Romans), 21.
13. Koran, XLII (Counsel), 11.
14. *The Sayings of Muhammad,* collected and trans. Allama Sir Abdullah al-Mamun al-Suhrawardy (London: John Murray, 1941), no. 297, p. 95.
15. Koran, IV (Women), 4.
16. *The Sayings of Muhammad,* nos. 411–18, pp. 115–16.
17. There are numerous descriptions of Paradise in the Koran. See, for example,

XXXXVI (The Poets), 55; XLVII (Muhammad), 16–17; LXXXIII (Defrauding), 21–28; LXXXVIII (The Overwhelming), 8–16; LXXVI (Time of Man), 11–22; LVI (The Event), 22–24; and LXXVII (Emissaries), 31–37. The last three refer to the ever virgin nymphs and the eternal boys. The women of Paradise were said to have been created and their virginity preserved; Koran, LV (The Beneficient), 72, and they are kept in secluded pavilions.

18. Abu abd Allah Muhammad ību al-Bukhari, *Sahīh*, trans. from the Arabic by Muhammad Asad (Lahore: Arafat Publications, 1938), L, xxxiii, vol. V, p. 98.

19. Ibid., L, liii, vol. V, p. 128.

20. Levy, *Social Structure of Islam*, p. 94; Muhammad, however, Koran, IV (Women), 24, forbade intercourse with all married women except captives.

21. Koran, II (The Cow), 223.

22. Ibid., IV (The Women), 24–25.

23. Ibid., 4.

24. Ibid., 129.

25. Ibid., 11.

26. Ibid., 12.

27. Ibid., 23. Pickthall's translation is not clear on this point and in his version the verse is numbered 19.

28. Koran, II (The Cow), 231–32.

29. Ibid., 234.

30. al-Marqhīnānī, *The Hedaya or Guide*, II, 186, bk. VII, chap. 2.

31. Levy, *Social Structure of Islam*, p. 17.

32. Koran, II (The Cow), 237; XXXIII (The Clans), 49.

33. Ibid., LVIII (She That Disputeth), 4.

34. Ibid., LXX (The Ascending Stairway), 29–31; XIII (The Believers), 5–7; IV (The Women), 3, 24f., or in some 28f.

35. Ibid., XXIV (Light), 13–15.

36. Quoted by George Allgrove, *Love in the East* (London: Gibbs and Philipps, 1962); pp. 128–29.

37. During our stay in Egypt it was widely believed that one of the reasons then-President Nasser was interested in abolishing female circumcision was to curtail the illicit drug traffic.

38. Koran, XXIV (Light), 33.

39. Levy, *Social Structure of Islam*, p. 127.

40. Robert Surieu, *Sarv-é naz: An Essay on Love and the Representation of Erotic Themes in Ancient Iran*, trans. James Hogarth (Geneva: Nagel Publishers, 1967), p. 65. The quotation comes from the story of Vis and Ramin by Gurgani in the eleventh century.

41. All of these quotations can be found in *A Dictionary of Islam*, ed. Thomas Patrick Hughes (reprint, Clifton, N.J.: Reference Books, 1965), pp. 620–21.

42. Kai Kā'ūs Iskander, *A Mirror for Princes* (The Qābūs Nāma), trans. from the Persian by Reuben Levy (London: Cresset Press, 1951), chap. 27, p. 125.

43. Hughes, *Encyclopedia of Islam*, pp. 620–21.

44. Muhammad Mustafā al-'Adawī, *Qissat ar-Rahā li's-Sayyida Fātima az-*

Zahrā or the Story of Fātima's Hand Mill, ed. and trans. Arthur Jeffery in *Islam: Muhammad and His Religion* (New York: Liberal Arts Press, 1958), pp. 217–22. This was a little eight-paged pamphlet used for devotional reading in feminine circles.

45. Sheik Nefazi, *The Perfumed Garden*, trans. Richard F. Burton, ed., with an intro. by Alan Hull Walton (New York: Putnam's, 1964), chap. 2, "Concerning Women Who Desire to Be Praised," p. 97.

46. Ibid., chap. 4, "Women Who Are to Be Held in Contempt," pp. 119–20.

47. *The Book of the Thousand Nights and a Night*, "The Story of King Shahryar and His Brother," I, 13.

48. Ibid., "Conclusion," VI, 3634.

49. Ibid., *Terminal Essay*, secs. IV, VI, 3743.

50. Quoted by Levy, *Social Structure of Islam*, p. 132.

51. This is a famous translation of the *Rubaiyat of Omar Khayyam* by Edward Fitzgerald that, though it probably represents more Fitzgerald than Omar Khayyam, in this case represents the intent of the original. This is the eleventh quatrain. There are numerous editions.

52. Philip J. Baldensperger, "Orders of Holy Men in Palestine," *Palestine Exploration Fund Quarterly Statement* (London, 1894), p. 38. See also Frederick J. Bliss, *The Religions of Modern Syria and Palestine* (New York, 1912), p. 254.

53. Raphael Patai, *Sex and Family in the Bible* (Garden City: Doubleday, 1959), p. 173.

54. Translated by Reynold Alleyne Nicholson, *Studies in Islamic Mysticism* (Cambridge: Cambridge University Press, 1921), p. 217.

55. See von Grunebaum, *Medieval Islam*, pp. 315–18; Gustave E. von Grunebaum, "Avicenna's Risala fi 1 Isq and Courtly Love," *Journal of Near Eastern Studies* 11 (1952): 233–38. Von Grunebaum feels, however, that Avicenna's concepts were not known to the European middle ages, although others were. See also A. J. Denomy, *The Heresy of Courtly Love* (New York: D. X. McMullen, 1947), pp. 29–32.

56. al-Marghīnānī, *The Hedaya or Guide*, bk. LIV, sec. 2, IV, 597.

57. Ibid., p. 150. See also the essay by Boydena Wilson in *Women and the Structure of Society*, ed. Barbara Harris and JoAnn McNamara (Durham, N.C.: Duke University Press, 1984).

8. On the Pedestal: The Beginning of the Feminine Mystique

1. Tacitus, *Germania*, trans. Sir William Peterson (London: Heinemann, 1946), caps. 18f.

2. *Leges Alamannorum*, ed. Karl Lehman in *Monumenta Germaniae historica, Leges nationum Germanicarum*, vol. 5, pt. 1 (Hanover: Hahn, 1888), p. 115.

3. *Lex Ribuaria*, ed. Rudolph Sohm, *Monumenta Germaniae historica, Legum*, vol. 5 (Hanover: Hahn, 1875–79), pp. 216, 231.

4. For more details, see Suzanne Fonay Wemple, *Women in Frankish Society: Marriage and the Cloister, 500 to 900* (Philadelphia: University of Pennsylvania

Press, 1981), p. 29 and passim. See also Renate Bridenthal and Claudia Koontz, eds., *Becoming Visible: Women in European History* (Boston: Houghton Mifflin, 1977).

5. See Jean Brissaud, *A History of French Private Law*, trans. Rapelje Howell (reprint, Boston: Little, Brown, 1969), pp. 221–23.

6. Doris Mary Stenton, *The English Woman in History* (London: Allen and Unwin, 1957), p. 3.

7. Sir Frederick Pollock and Frederick William Maitland, *The History of English Law*, 2d ed. (Cambridge: Cambridge University Press, 1952), p. 482.

8. F. M. Stenton, "The Historical Bearing of Place Name Studies: The Place of Women in Anglo-Saxon History," Royal Historical Society, *Transactions*, 4th series, 25 (1943): 1–13.

9. Gregory of Tours, *History of the Franks*, trans. O. M. Dalton (Oxford: Clarendon Press, 1927), IV, 26, 28.

10. Ibid., IV, 3.

11. Richard Winston, *Charlemagne: From the Hammer to the Cross* (Indianapolis: Bobbs-Merrill, 1954), pp. 234–35.

12. See the case of Papula in Gregory of Tours, *History of the Franks*, introduction, I, 356. See also Vern L. Bullough, "Transvestism in the Middle Ages," *American Journal of Sociology* 79 (1974): 1381–94.

13. Quoted by Lina Eckenstein, *Women Under Monasticism* (reprint, New York: Russell and Russell, 1963), p. 72. See Wemple, *Women in Frankish Society*; John A. Nichols and Lillian Thomas Shank, eds., *Medieval Religious Women* (Kalamazoo, Mich.: Cistercian Publishers, 1984).

14. Some nuns were so powerful that they became almost like bishops. See Joan Morris, *The Lady Was a Bishop*, (New York: Macmillan, 1973).

15. Ibid., p. 49.

16. Hroswitha, *The Plays of Hroswitha*, trans. Christopher St. John (London: Chatto and Windus, 1923), pp. xxxii–xxxiii.

17. Ibid., p. xxv.

18. Ibid., pp. xviii–xxix. For a more complete view, see Katharina M. Wilson, ed., *Medieval Women Writers* (Athens: University of Georgia Press, 1984).

19. The quotation was translated by R. W. Southern, *Western Society and the Church in the Middle Ages* (London: Penguin, 1970), p. 314. See also the article by Brenda Bolton in Susan Mosher Stuard, ed., *Women in Medieval Society* (Philadelphia: University of Pennsylvania Press, 1976).

20. Ibid., pp. 314–15.

21. Many people founded orders or foundations to them and some, especially the great women mystics of the thirteenth century, commanded universal attention. See Caroline Walker Bynum, *Jesus as Mother: Studies in Spirituality of the High Middle Ages* (Berkeley: University of California Press, 1982).

22. See, for example, Sally Thompson, "The Problem of the Asterian Nuns in the Twelfth and Early Thirteenth Centuries," in *Medieval Women*, ed. Derek Baker (Oxford: Basil Blackwell for the Ecclesiastical History Society, 1978), pp. 227–52.

23. Southern, *Western Society and the Church*, p. 327.

24. Ibid., p. 330. For further discussion of the *beguines*, see E. W. McDonnell, *The Beguines and Beghards in Medieval Culture* (New Brunswick, N.J.: Rutgers University Press, 1954), and Robert E. Lerner, *The Heresy of the Free Spirit in the Later Middle Ages* (Berkeley and Los Angeles: University of California Press, 1972).

25. Guido Kisch, *The Jews in Medieval Germany: A Study of Their Legal and Social Status* (reprint, New York: Ktav Publishing House, 1970), p. 204.

26. Sidney Painter, *French Chivalry* (Baltimore: Johns Hopkins University Press, 1940), pp. 98–99.

27. *Song of Roland*, vv. 3708–21. This is from the translation by Patricia Terry (Indianapolis: Bobbs-Merrill, 1965).

28. This is a translation by Norma Lorre Goodrich, *The Ways of Love* (Boston: Beacon Press, 1964), p. 37.

29. Leon Gautier, *La chevalerie* (Paris: Victor Palme, 1884), pp. 377–79.

30. For a discussion of it, see Edward Westermarck, *The History of Human Marriage*, 5th ed., 3 vols. (New York: Allerton Book, 1922), vol. 1, pp. 177–79.

31. Hector MacKechnie, article on the *Ius Primus Noctae*, *Juridical Review* 43 (Edinburgh, 1930): 303–11.

32. The best discussion and an invaluable bibliography can be found in Edward Westermarck, *The History of Human Marriage*, I, chap. 5, pp. 166–206. A good brief discussion of it can be found in Samuel Putnam, "Jus Primae Noctis," in *Encylopaedia Sexualis*, ed. Victor Robinson (New York: Dingwall-Rock, 1936). Somewhat less accurate is the pamphlet by A. F. Niemoeller, *The Right of the First Night* (Girard, Kansas: Haldeman-Julius, 1948).

33. This is quoted in G. G. Coulton, *Five Centuries of Religion* (Cambridge: Cambridge University Press, 1929), vol. 1, p. 140.

34. The translation is by Henry Adams and appears in his *Mont Saint-Michel and Chartres* (reprint, Boston: Houghton Mifflin, 1933), pp. 93–96. The whole book is devoted to a discussion of the Virgin in medieval life.

35. *The Penitential of Theodore*, XIV, 19, 20, 21, in John T. McNeill and Helena M. Gamer, eds. and trans., *Medieval Handbooks of Penance* (New York: Columbia University Press, 1938), p. 197.

36. Ibid., II, 22, on p. 186.

37. Ibid., VIII, 2–3, on p. 191.

38. *The Penitential of Finnian* (sixth century), pars. 14–17, in McNeill and Gamer, *Medieval Handbooks*, pp. 89–90.

39. Geoffrey Chaucer, *The Canterbury Tales*, trans. into modern English by Nevill Coghill (Baltimore: Penguin, 1952), "The Wife of Bath's Prologue," v. 693–96, pp. 300–301.

40. Translated in G. G. Coulton, *From St. Francis to Dante: A Translation of All That Is of Primary Interest in the Chronicle of the Franciscan Salimbene (1221–1288)* (London: David Nutt, 1906), pp. 91–92.

41. St. Thomas Aquinas, *Summa Theologica*, ed. and trans. by the Fathers of the English Dominican Province, 3 vols. (New York: Benzinger, 1947), vol. 2, pt.

2, ques. 152, "Of Virginity," art. 4, ques. 153, "Of Lust," arts. 1, 2, and ques. 154, "Of the Parts of Lust," art. 8.

42. Ibid., vol. 1, pt. 1, ques. 92, "The Production of Women."

43. Ibid., vol. 2, pt. 2, ques. 26, "Whether a Man Ought to Love His Mother More Than His Father," art. 10.

44. Ibid., vol. 2, pt. 2, ques. 169, "Whether the Adornment of Women Is Devoid of Mortal Sin?" art. 11.

45. *The Ancren Riwle* (Rule for Anchoresses), ed. and trans. James Morton in Camden Society, *Publications* 57 (1853): 59.

46. Ibid., p. 277.

47. See G. R. Owst, *Literature and Pulpit in Medieval England* (Oxford: Blackwell, 1961), pp. 375ff.

48. Coulton, *Five Centuries of Religion*, vol. 1, p. 180.

49. Eileen Power, "The Position of Women," in *The Legacy of the Middle Ages*, ed. G. C. Crump and E. F. Jacob (Oxford: Clarendon Press, 1926), p. 403.

50. Bede M. Jarrett, *Social Theories of the Middle Ages* (reprint, New York: Ungar, 1966), pp. 72–73.

51. St. Thomas Aquinas, *Summa Theologica*, supp. ques. 81, "Of the Quality of Those Who Rise Again," art. 3, reply obj. 2.

52. Ibid., supp., ques. 39, "Of the Impediments to This Sacrament," art. 1, obj. 3.

53. Quoted by Jarrett, *Social Theories of the Middle Ages*, p. 75.

54. Ibid., pp. 75–76.

55. For a discussion of dowries and their effect, see Stanley Chojnacki, "Dowries and Kinsmen in Early Reinaissance Venice," in Stuard, ed., *Women in Medieval Society*, pp. 173–98.

56. Power, "Position of Women," pp. 410–12. This is a kind of standard put-down of women. See the article by Eleanor McLaughlin in Rosemary Radford Ruether and Eleanor McLaughlin, eds., *Women of Spirit* (New York: Simon and Schuster, 1979), and the various books by Ruether, *Religion and Sexism: Images of Women in Jewish and Christian Tradition* (New York: Simon and Schuster, 1974) and *Sexism and God Talk: Toward a Feminist Theology* (Boston: Beacon Press, 1983).

57. Sidney Painter, *French Chivalry* (Baltimore: Johns Hopkins University Press, 1957), pp. 111–12.

58. C. S. Lewis, *The Allegory of Love* (New York: Oxford University Press, 1958), p. 4.

59. For an analysis of women in medieval literature, see Diane Bornstein, *The Lady in the Tower* (Hamden, Conn.: Archor Books, 1983). See also Gerard J. Brault, "Isolt and Guenevere: Two Twelfth-Century Views of Woman," in *The Role of Women in the Middle Ages*, ed. Rosemarie Thee Morewedge (Albany: State University of New York Press, 1975), pp. 41–64.

60. See Amy Kelly, *Eleanor of Aquitaine and the Four Kings* (Cambridge: Harvard University Press, 1950).

61. Andreas Capellanus, *The Art of Courtly Love*, trans. J. J. Parry (New York: Columbia University Press, 1941), bk. 1, chaps. 1–4, and final section.

62. Ibid., bk. 1, chap. 11.

63. Guillaume de Lorris and Jean de Meung, *The Romance of the Rose*, trans. F. S. Ellis (London: J. M. Dent, 1900).

64. Sir Thomas Malory, *Le Morte d'Arthur*, ed. A. W. Pollard (reprint, New Hyde Park, N.Y.: University Books, 1961), bk. XVI, chaps. 1, 3.

65. Ibid., VI, iii; IX, xli, xlii.

66. "Gawain and the Green Knight," trans. T. H. Banks in *The Age of Chaucer*, ed. William Frost (Englewood Cliffs, N.J.: Prentice Hall, 1950), 11, 2414–28, p. 317.

67. See Katharine M. Rogers, *The Troublesome Helpmate* (Seattle: University of Washington Press, 1966), pp. 59–60.

68. John of Salisbury, *Frivolities of Courtiers and Footprints of Philosophers*, trans. from portions of the *Policraticus* by J. B. Pike (London: Oxford University Press, 1938), pp. 355, 358, 360, 363.

69. Richard de Bury (Aungerville), *The Philobiblon*, with an introduction by Archer Taylor (Berkeley: University of California Press, 1948), pp. 23–24, passim.

70. Walter Map, *De Nugis Curialium* (Courtiers' Trifles), ed. Frederick Tupper and Marbury Bladen Ogle (London: Chatto and Windus, 1924), pp. 186–98.

71. Chaucer, "The Wife of Bath's Prologue," v. 688–92, *Canterbury Tales*, pp. 300–301.

72. Ibid., "The Clerk's Tale."

73. Power, "Position of Women," p. 404.

74. Chaucer, "The Wife of Bath's Prologue," and "The Wife of Bath's Tale."

75. John Charles Nelson, *Renaissance Theory of Love* (New York: Columbia University Press, 1958), p. 78.

76. Maurice Valency, *In Praise of Love: An Introduction to the Love Poetry of the Renaissance* (New York: Macmillan, 1958), p. 3.

77. The subject is somewhat controversial, but probably the best account in English is by Eric John Dingwall, *The Girdle of Chastity* (reprint, New York: Macaulay Company, n.d.). There has been some attempt to find evidence for the custom during the Crusades, and though this is the legendary tradition of its beginning, there is no hard evidence for such an assumption. Most of the devices sold or listed today as medieval chastity girdles are nineteenth-century anti-masturbatory devices.

78. Geoffrey de la Tour-Landry, *The Book of the Knight of La Tour-Landry*, ed. and trans. Thomas Wright for Early English Text Society, rev. ed. (New York: Greenwood Press, 1969), LXXV, p. 98.

79. See, for example, Louise Collis, *Memoirs of a Medieval Woman: The Life and Times of Margery Kempe* (New York: Crowell, 1964).

80. See Lula McDowell Richardson, *The Forerunners of Feminism in French Literature of the Renaissance* (Baltimore: Johns Hopkins University Press, 1929), pp. 12–34; Marguerite Favier, *Christine de Pisan* (Lausanne: Editions Recontre, 1967); M. Laigle, *Le livre des trois vertus de Christine de Pisan, Bibiotheque du XV siecle*, XVI (Paris, 1912); Charity Cannon Willard, *Christine de Pizan: Her Life and Works* (New York: Persea Books, 1984).

81. Charity Cannon Willard, "A Fifteenth-Century View of Women's Role in Medieval Society," in Morewedge, ed., *The Role of Women in the Middle Ages*, pp. 90–120.

82. Giovanni Boccaccio, *Concerning Famous Women*, trans. Guido A. Guarino (New Brunswick: Rutgers University Press, 1963).

83. Leon Battista Alberti, *I Libri della Famigilia*, trans. under the title of *The Family in Renaissance Florence* by Reneé Neu Watkins (Columbia: University of South Carolina Press, 1969), bk. 3, pp. 208–9.

9. The More Things Change, the More They Remain the Same

1. G. Rattray Taylor, *Sex in History* (New York: Vanguard Press, 1954), p. 141.

2. E. Troeltsch, *The Social Teachings of the Christian Church*, 2 vols. (London: Allen and Unwin, 1931), vol. 1, p. 546, and Luther, *Table Talk*, no. 5538, in *Luther's Works*, ed. and trans. Theodore G. Tappert (Philadelphia: Fortress Press, 1967), pp. 449–50. See also Rosemary Ruether and Eleanor McLaughlin, *Women of Spirit: Female Leadership in the Jewish and Christian Tradition* (New York: Simon and Schuster, 1979).

3. Luther, *Table Talk*, no. 55, p. 8.

4. Ibid., no. 1658, pp. 160–61.

5. Roland H. Bainton, *Women of the Reformation* (Minneapolis: Angsburg Publishing House, 1971), p. 23.

6. Roland H. Bainton, *What Christianity Says About Sex, Love and Marriage* (New York: Association Press, 1957), p. 82.

7. Luther, *Table Talk*, no. 1659, p. 161.

8. Ibid., no. 233, p. 31.

9. Ibid., no. 2807b, p. 171.

10. Ibid., no. 3523, p. 221.

11. Ibid., no. 28476, pp. 174–75.

12. Ibid., no. 154, pp. 22–23.

13. Quoted in *Sex and the Church*, ed. Oscar E. Feucht and other members of the Family Life Committee of the Lutheran Church (St. Louis: Concordia Publishing House, 1961), p. 84.

14. See Derrick Sherwin Bailey, *Sexual Relation in Christian Thought* (New York: Harper, 1959), p. 173.

15. John Calvin, *In Genesis*, ii, 18, in *Opera*, ed. G. Baum, E. Cunitz, et al. (Brunswick and Berlin: C. A. Schwetschke, 1863–1900), vol. 1, p. 14.

16. John Calvin, *Institutes of the Christian Religion*, 2, chap. xiii, par. 3, trans. Ford Lewis Battles in vols. 20 and 21, *Library of Christian Classics*, ed. John T. McNeill (Philadelphia: Westminster Press, 1960), 1, pp. 479–80.

17. P. E. Hughes, ed., *The Register of the Company of the Pastors of Geneva in the Time of Calvin* (Grand Rapids: Eerdmans Company, 1966), pp. 344–45.

18. *Calvin Institutes*, 4, chap. xv, 21; 2, 1321–22.

19. Williston Walker, *John Calvin* (reprint, New York: Schocken Books, 1969), p. 236.

20. Quoted in Edmund S. Morgan, *The Puritan Family*, rev. ed. (New York: Harper and Row, 1966), pp. 61–62.

21. John Knox, "The First Blast of the Trumpet Against the Monstrous Regiment of Women," in *The Works of John Knox*, collected and ed. David Laing, vol. 4 (Edinburgh: Bannatyne Club, 1855), p. 373.

22. Ibid., p. 409.

23. For a discussion of this, see James E. Phillipps, "The Background of Spenser's Attitude Towards Women Rulers," *Huntington Library Quarterly* 5 (October 1941 and July 1942): 5–32, 211–34, esp. 19–20.

24. Quoted in S. R. Maitland, *The Reformation in England* (London: J. Lane, 1906), pp. 209, 214–15.

25. Katharine M. Rogers, *The Troublesome Helpmate* (Seattle: University of Washington Press, 1966), p. 137.

26. Bailey, *Sexual Relation in Christian Thought*, p. 201.

27. Ibid., p. 202.

28. Quoted in Bainton, *Women of the Reformation*, p. 55.

29. Ibid., pp. 97–98.

30. John Edward Sadler, *J. A. Comenius and the Concept of Universal Education* (New York: Barnes and Noble, 1966), pp. 177–78, 193–94.

31. Quoted in Mary Daly, *The Church and the Second Sex* (New York: Harper and Row, 1968), p. 56.

32. Ibid., p. 57.

33. Ibid., pp. 58–59.

34. St. Francis de Sales, *Introduction to the Devout Life*, ed. and trans. John K. Ryan (Garden City, N.Y.: Image Books, 1955), pt. 3, xxxviii, pp. 215–16.

35. Vern Bullough and Bonnie Bullough, *The Care of the Sick: The Emergence of Modern Nursing* (New York: Prodist Press, Neale Watson, 1978), pp. 61–62.

36. Daly, *The Church and the Second Sex*, p. 62. See also Margarita O'Connor, *That Incomparable Woman* (Montreal: Palm Publishers, 1962).

37. Daly, *The Church and the Second Sex*, p. 64.

38. For a discussion of this, see Vern L. Bullough, *The Development of Medicine as a Profession* (Basle: Karger, 1966).

39. Jacob Burckhardt's *The Civilization of the Renaissance in Italy*, originally published in 1860, developed this concept. The book has often been reprinted, and the first English translation was made by S. G. C. Middlemore in 1878. For a more modern view, see Joan Kelly, *Women, History and Theory* (Chicago: University of Chicago Press, 1984).

40. Ibid., p. 294, in the Modern Library edition (New York: Random House, 1954).

41. Foster Watson, ed., *Vives and the Renascence Education of Women* (London: Edward Arnold, 1912), chap. 4, pp. 54–56.

42. Ibid., chap. 10, quoted p. 86.

43. Quoted in Josephine Kamm, *Hope Deferred: Girls' Education in English History* (London: Methuen, 1965), p. 40.

44. Ibid., p. 43.

45. Quoted by William H. Woodward, *Desiderius Erasmus Concerning the Aim and Method of Education* (Cambridge: Cambridge University Press, 1904), p. 152.

46. Richard Mulcaster, *Positions* (reprint, London: Longmans, Green, 1888), chap. 36, pp. 133–34.

47. For a discussion of this, see Ruth Kelso, *Doctrine for the Lady of the Renaissance* (Urbana: University of Illinois Press, 1956), esp. p. 36, where this summary is found.

48. Baldesar Castiglione, *The Book of the Courtier*, trans. Leonard Eckstein Opdycke (New York: Scribner's, 1903), III, 12–13, pp. 182–83.

49. Erasmus, *Colloquies*, trans. Craig R. Thompson (Chicago: University of Chicago Press, 1964), pp. 219–23. Erasmus, however, in his *Council of Women, Colloquies*, pp. 441–47, made fun of feminine vanity, but he was not so hostile as many of his contemporaries.

50. See Lula McDowell Richardson, *The Forerunners of Feminism in French Literature of the Renaissance* (Baltimore: Johns Hopkins University Press, 1929), pp. 63–64.

51. Ibid., p. 112.

52. See Marjorie Henry Isley, *A Daughter of the Renaissance* (The Hague: Mouton, 1963), pp. 207, 210, 216. For salons in general, see Carolyn C. Lougee, *Le Paradise des femmes: Women, Salons and Social Stratification in Seventeenth-Century France* (Princeton: Princeton University Press, 1976).

53. Quoted in J. E. Neale, *Queen Elizabeth: A Biography* (Garden City: Doubleday, 1957), pp. 14–15.

54. See Louis B. Wright, *Middle Class Culture in Elizabethan England* (Chapel Hill: University of North Carolina Press, 1935), chap. 13. "The Popular Controversy over Women."

55. Doris Mary Stenton, *The English Woman in History* (London: Allen and Unwin, 1957), p. 67. See also Mary Beard, *Women as Force in History* (New York: Macmillan, 1946).

56. Eva Figes, *Patriarchal Attitudes: Women in Society* (London: Faber and Faber, 1970), p. 69.

57. See Jakob Sprenger and Heinrich Kramer, *Malleus Maleficarum*, English trans. and ed. Montague Summers, limited ed. (London: Pushkin Press, 1948). Extensive literature on witchraft exists. Helpful in this respect are Alan MacFarlane, *Witchraft in Tudor and Stuart England* (London: Routledge and Kegan Paul, 1970), and William E. Monter, *Witchcraft in France and Switzerland* (Ithaca: Cornell University Press, 1976). Monter gives a more feminist orientation than most other scholars.

58. See H. R. Trevor Roper, *The European Witch Craze of the Sixteenth and Seventeenth Centuries and Other Essays* (New York: Harper and Row, 1969), pp. 90–192.

59. Wallace Notestein, *A History of Witchcraft in England* (reprint, New York: Russell and Russell, 1965), pp. 114–15.

60. For the most comprehensive treatment of the subject, see Rossell Hope

Robbins, *The Encyclopedia of Witchcraft and Demonology* (New York: Crown Publishers, 1959), p. 100, from whence this quotation is derived. See also the article "Witchcraft in Germany." For a discussion of the background, see Jeffrey Burton Russel, *Witchcraft in the Middle Ages* (Ithaca: Cornell University Press, 1972).

61. R. Scot, *The Discoveries of Witchcraft*, ed. B. Nicholson (London: 1886), p. 227.

62. For a discussion, see James T. Johnson, *A Society Ordained by God: English Puritan Marriage Doctrine in the First Half of the Seventeenth Century* (Nashville: Abingdon Press, 1970).

63. See Allan Gilbert, "Milton on the Position of Women," *Modern Language Review* 15 (1920): 7–27, 240–64. See also the various works of John Milton, particularly *Paradise Lost*, IV, 295–308, 635–38, 750–70; VIII, 551–56; IX, 1183–84; X, 145–56, 889–908; XI, 163–65, 629–36, in *Complete Poetry and Selected Prose*, ed. E. H. Visiak (Glasgow: Nonesuch Press, 1948). See also the various citations in Rogers, *Troublesome Helpmate*, pp. 151–59.

64. François Rabelais, *Pantagruel*, in the *Portable Rabelais*, trans. and ed. Samuel Putnam (New York: Viking Press, 1946), pp. 477–78.

65. Ibid., pp. 478–79.

66. Quoted in C. Willett Cunnington and Phyllis Cunnington, *The History of Underclothes* (London: Michael Joseph, 1951), p. 48.

67. Quoted in Norah Waugh, *Corsets and Crinolines* (London: B. T. Batsford, 1954), p. 27.

68. Cunnington and Cunnington, *History of Underclothes*, p. 51.

69. See Roger Baker, *Drag: A History of Female Impersonation on the Stage* (London: Triton Books, 1968), and C. J. Bulliet, *Venus Castina: Famous Female Impersonators* (reprint, New York: Bonanza Books, 1956).

70. Quoted in Christina Hoke. *The English Housewife in the Seventeenth Century* (London: Chatto and Windus, 1953), p. 99.

10. China and India: Inferiority Is Not Only Western

1. For a summary, see M. A. Indra, *The Status of Women in Ancient India* (Banaras: Motilal Banarasidass, 1955). Full of interesting data is an early French work (1867) by Clarisse Bader, *Women in Ancient India*, translated into English by Mary E. R. Martin (London: Kegan Paul, Trench, Trubner, and Company, 1925).

2. *Laws of Manu*, 5, pp. 147–51, in *Sacred Books of the East*, ed. G. Bühler, vol. 15 (reprint, Delhi: Motilal Banarasidass, 1964).

3. Ibid., 9, pp. 2, 5–6.

4. Ibid., 2, pp. 213–15.

5. Ibid., 9, pp. 17–18.

6. Ibid., 3, pp. 55–58.

7. Ibid., 11, p. 67.

8. Sudhakar Chattopadhyaya, *Social Life in Ancient India* (Calcutta: Academic Publishers, 1965), pp. 110–11.

9. David Mace and Vera Mace, *Marriage: East and West* (Garden City: Doubleday, 1960), p. 263.

10. R. C. Majumdar, H. C. Raychaudhuri, and Kalikinkar Datta, *An Advanced History of India* (London: Macmillan, 1953), p. 822.

11. A. S. Altekar, *The Position of Women in Hindu Civilization* (Banaras: Motilal Banarasidass, 1956), pp. 5–6.

12. R. N. Dandekar, "The Role of Man in Hinduism," in Kenneth W. Morgan, *The Religion of the Hindus* (New York: Ronald Press, 1953), p. 140.

13. P. S. Sivaswamy Aiyer, *Evolution of Hindu Moral Ideals* (Calcutta: University of Calcutta, 1935), pp. 57–59.

14. Altekar, *Position of Women*, pp. 33, 55–61.

15. Ibid., pp. 17–19, and J. A. Dubois, *Hindu Manners, Customs and Ceremonies* (Oxford: Clarendon Press, 1906), p. 337.

16. Johann Jakob Meyer, *Sexual Life in Ancient India* (New York: Barnes and Noble, 1953), p. 346 n. 1. Meyer's account relies heavily on two Hindu epics, the *Rāmayāna* and the *Mahābhārata*, and includes long extracts from them. I have utilized it as a primary source.

17. Ibid., p. 375.

18. See Kanwar Lal, *The Cult of Desire: An Interpretation of Erotic Sculpture of India* (New Hyde Park, N.Y.: University Books, 1967).

19. For an excellent brief discussion of this, see the articles on "Sex Mysticism" and "Tantrism," in George Benjamin Walker, *The Hindu World: An Encyclopedic Survey of Hinduism*, 2 vols. (New York: Praeger, 1968). For a more detailed examination, see Vern L. Bullough, *Sexual Variance in Society and History* (reprint, Chicago: University of Chicago Press, 1980), pp, 262ff.

20. For example, see the *Kama Sutra of Vatsyayana*, trans. Richard Burton (New York: Dutton, 1962), and P. Thomas, *Kama Kalpa or the Hindu Ritual of Love* (Bombay: D. B. Taraporevala, 1959). For more details, see Bullough, *Sexual Variance in Society and History*.

21. Meyer, *Sexual Life in Ancient India*, pp. 376–80.

22. Ibid., p. 375.

23. There is a popular retelling of this story in Aubrey Menen, *The Ramayana* (New York: Scribner's, 1954), pp. 103–25.

24. Meyer, *Sexual Life in Ancient India*, p. 380 n. 2.

25. Ibid., p. 277.

26. Altekar, *Position of Women*, pp. 29–30.

27. See Vern L. Bullough and Bonnie Bullough, *Prostitution: An Illustrated Social History* (New York: Crown, 1978), pp. 72–86. For an account of sacred prostitution, see N. M. Penzer, ed., *The Ocean of Story*, trans. C. H. Tawney from Somadeva's *Kathā Sarit Sagara*, 10 vols. (London: Charles J. Sawyer, 1924), vol. 1, app. 4, pp. 231–80.

28. Meyer, *Sexual Life in Ancient India*, p. 6.

29. *Laws of Manu*, 3, p. 56.

30. Meyer, *Sexual Life in Ancient India*, pp. 496–500.

31. For a discussion of this, see I. B. Horner, *Women Under Primitive Buddhism* (New York: Dutton, 1930).

32. Edward Thompson, *Suttee: A Historical and Philosophical Enquiry into the Hindu Rite of Widow Burning* (London: Allen and Unwin, 1928), pp. 16–18.

33. Ibid., passim, and see also Walker, *The Hindu World*, the articles on suttee and widows, and Mace and Mace, *Marriage: East and West*, pp. 237–44.

34. Dun Jen Li, *The Essence of Chinese Civilization* (New York: Van Nostrand, 1967), pp. 397–402.

35. Marcel Granet, *Chinese Civilization* (New York: Knopf, 1930), p. 201.

36. R. H. van Gulik, *Sexual Life in Ancient China* (Leiden: Brill, 1961), p. 5.

37. Ibid., pp. 5–8. For an example of such an alchemy text, see the *Nei P'ien* of Ko Hung, which dates from the early fourth century and can be found in the book *Alchemy, Medicine, Religion in the China of A.D. 320*, trans. J. R. Ware (Cambridge: MIT Press, 1966).

38. Herrlee Creel, *The Birth of China* (reprint, New York: Ungar, 1954), p. 284.

39. T'ung 'Tsu Ch'ü, *Law and Society in Traditional China* (Paris: Mouton, 1965), pp. 103–4.

40. Creel, *Birth of China*, p. 302.

41. Tung 'Tsu Ch'ü, *Law and Society*, pp. 118–19.

42. See *The Chinese Classics*, ed. and trans. James Legge, 5 vols. (reprint, Hong Kong: Hong Kong University Press, 1960), vol. 4, pp. 56–58.

43. Ibid., vol. 4, p. 89.

44. Albert O'Hara, *The Position of Women in Early China* (Washington, D.C.: Catholic University Press, 1945). This is a translation of the *Lieh Nü Chuan*, or *Biographies of Chinese Women*.

45. Creel, *Birth of China*, p. 287.

46. *Chinese Classics*, vol. 4, p. 561.

47. *The Sayings of Confucius*, trans. James R. Ware (New York: New American Library, 1955), vol. 17, p. 23.

48. See van Gulik, *Sexual Life in Ancient China*, pp. 44–45; Florence Ayscough, *Chinese Women, Yesterday and Today* (Boston: Houghton Mifflin, 1937), and L. Wieger, *Moral Tenets and Customs in China*, trans. L. Davrout (Ho-Kien-fu: Catholic Mission Press, 1913), p. 25.

49. *The Book of Songs*, trans. Arthur Waley (London: Allen and Unwin, 1937), pp. 283–84.

50. O'Hara, *Position of Women in Early China*, p. 263.

51. Eloise Talcott Hibbert, *Embroidered Gauze* (New York: Dutton, 1941), pp. 21–41.

52. A translation and discussion of these can be found in Nancy Lee Swann, *Pan Chao: Foremost Woman Scholar of China* (reprint, New York: Russell and Russell, 1968), pp. 83–84.

53. Ibid., pp. 85–86 (chaps. 3 and 4).

54. Ibid., p. 87 (chap. 5).

55. O'Hara, *Position of Women in Early China*.

56. Quoted in van Gulik, *Sexual Life in Ancient China,* pp. 103–4.

57. Ibid., pp. 111–12.

58. Joanna F. Handlin, "Lü K'un's New Audience: The Influence of Women's Literacy on Sixteenth-Century Thought," in *Women in Chinese Society,* ed. Margery Wolf and Roxane Witke (Stanford: Stanford University Press, 1975), pp. 13–39. The quote is from page 16.

59. Lao-Tse, *The Tao te Ching, or The Wisdom of Laotse,* ed. and trans. Lin Yutang (New York: Modern Library, 1948), bk. 1, chap. 6, p. 64.

60. Ibid., bk. 4, chap. 28, p. 160.

61. Ibid., bk. 6, chap. 61, p. 279.

62. Ibid., bk. 3, chap. 25, p. 145.

63. Chinese prudishness later suppressed many of these texts but they were preserved in Japan and many of them have been translated by Akira Ishihara and Howard S. Levy, *The Tao of Sex* (Tokyo: Shibundo, 1968). See also Michel Beurdeley et al., *Chinese Erotic Art* (Rutland, Vt: Tuttle, 1969).

64. Ishihara and Levy, *The Tao of Sex.*

65. This is quoted by van Gulik, *Sexual Life in Ancient China,* p. 254.

66. There are various translations of the *I Ching,* including one by James Legge that is easily available (reprint, New York: Dover, 1963).

67. Liu Wu-chi, *An Introduction to Chinese Literature* (Bloomington: Indiana University Press, 1966), p. 147.

68. Howard S. Levy, *Chinese Footbinding: The History of a Curious Erotic Custom* (New York: Walton Rawls, 1966), p. 41.

69. Ibid., pp. 37–39.

70. Ibid., pp. 44–63.

71. Edward H. Schafer, *The Vermillion Bird: T'Ang Images of the South* (Berkeley: University of California Press, 1967), pp. 81–82.

72. Granet, *Chinese Civilization,* p. 427.

11. Role Change and Urbanization

1. See Louise A. Tilly and Joan W. Scott, *Women, Work, and Family* (New York: Holt, Rinehart and Winston, 1978), or any number of other studies on families at this time.

2. For a discussion of some of these women, see Evelyn Beatrice Hall, *The Women of the Salons* (reprint, Freeport, N.Y.: Books for Libraries Press, 1969), and J. Christopher Herold, *Love in Five Temperaments* (New York: Atheneum, 1961).

3. See Edmond de Goncourt and Jules de Goncourt, *The Women of the Eighteenth Century,* trans. Jacques Le Clercq and Ralph Roeder (New York: Minton, Balch, 1927).

4. See, for example, Nancy Mitford, *Voltaire in Love* (New York: Harper, 1957), p. 83.

5. Goncourt and Goncourt, *Women of the Eighteenth Century.*

6. Simone de Beauvoir, *Must We Burn de Sade?* trans. Annette Michelson (London: Peter Nevill, 1953), p. 38.

7. François de Salignac de la Mothe-Fenelon, *Education des filles* (reprint, Paris: Ernest Flammarion, 1937), chap, 1, p. 6. There is an English translation entitled *Fenelon on Education* by H. C. Barnard (Cambridge: Cambridge University Press, 1966).

8. For a description of the school and its curricula, see W. H. Lewis, *The Splendid Century* (reprint, Garden City, N.Y.: Doubleday, 1957), pp. 239–59.

9. Jean Jacques Rousseau, *Emile,* trans. Barbara Foxley (London: J. M. Dent, 1911), p. 357.

10. Josephine Kamm, *Hope Deferred: Girls' Education in English History* (London: Methuen, 1965), pp. 102–3.

11. Hannah More, *Strictures on Female Education* (London: T. Cadell, 1779), vol. 1, p. 64.

12. Hannah More, *Essays on Various Subjects Principally Designed for Young Ladies* (Philadelphia: Young, Stewart, and McCulloch, 1786), p. 145.

13. Hannah More, *Hints Towards Forming the Character of a Young Princess,* 5th ed., 2 vols. in 1 (London: Cadell and Davies, 1819), chap. 1.

14. Erasmus Darwin, *A Plan for the Conduct of Female Education in Boarding Schools* (reprint, New York: Johnson Reprint Corporation, 1968), p. 10.

15. Quoted in Kamm, *Hope Deferred,* p. 129.

16. Mary Wollstonecraft, *A Vindication of the Rights of Women* (London: J. M. Dent, 1929), p. 23. See also *Mary Wollstonecraft* by Eleanor Flexner (New York: Coward, McCann, and Geoghagan, 1972).

17. Mary Wollstonecraft, *Vindication,* p. 215.

18. Quoted in Doris Mary Stenton, *The English Woman in History* (London: Allen and Unwin, 1957), p. 313.

19. Ibid.

20. See Theodor Gottlieb von Hippel, *On Improving the Status of Women,* trans. and ed. Timothy F. Sellner (Detroit: Wayne State University Press, 1979).

21. For an example of how this kind of explanation entered the popular literature for and about women, see Dolores Peters, "The Pregnant Pamela: Characterization and Popular Medical Attitudes in the Eighteenth Century," *Eighteenth Century Studies* 14 (1981): 432–51.

22. M. Ludovicus (John Campbell), *A Particular but Melancholy Account of the Great Hardships, Difficulties, and Miseries, That Those Unhappy and Much to Be Pitied Creatures, the Common Women of the Town, Are Plung'd into at This Juncture. The Causes of Their Misfortunes Fully Laid Down; and the Bad Effects That too Much Rigour Against Them Will Produce* (London: printed for the author, 1752), pp. 6–16. We could not resist giving the title in full.

23. John Fielding, *An Account of the Origin and Effects of a Police Set on Foot by His Grace the Duke of Newcastle in the Year 1753, upon a Plan Presented to His Grace by the Late Henry Fielding, Esq.; To Which Is Added a Plan for Preserving Those Deserted Girls in This Town, Who Become Prostitutes from Necessity* (London: A. Millar, 1758), p. 32.

24. Ibid., p. 49.

25. Ibid., pp. 51–53.

26. (Jonas Hanway), *Letters Written Occasionally on the Customs of Foreign Nations in Regards to Harlots* . . . (London: John Rivington, 1761), p. 13. For details, see Vern L. Bullough, Prostitution and Reform in Eighteenth-Century England," in *Unauthorized Behavior during the Enlightenment*, ed. Robert P. Maccubin, a special issue of *Eighteenth Century Life* 9 (May 1985).

27. [Daniel Defoe], *A Plan of the English Commerce Being a Compleat Prospect of the Trade of This Nation*, 2d ed. (1730; reprint, New York: Augustus M. Kelley, 1967), pp. 90–92.

28. M. Dorothy George, *England in Transition* (London: Penguin Books, 1953), p. 117.

29. Quoted by Ivy Pinchbeck, *Women Workers and the Industrial Revolution, 1750–1850* (London: Frank Cass, 1969), pp. 199–200.

30. Ibid., p. 200.

31. Ibid., pp. 315–16.

32. Philip Aries, *Centuries of Childhood: A Social History of Family Life*, trans. Robert Baldick (New York: Knopf, 1962), p. 117.

33. Quoted in John Langdon-Davies, *A Short History of Women* (New York: Blue Ribbon Books, 1927), pp. 329–30.

34. Quoted in Fred K. Vigman, *Beauty's Triumph* (Boston: Christopher Publishing House, 1966), p. 48.

35. For a discussion of this, see Arthur Loesser, *Men, Women and Pianos: A Social History* (New York: Simon and Schuster, 1954), pp. 65ff.

36. Quoted in *The Genteel Female: An Anthology*, ed. Clifton Joseph Furness (New York: Knopf, 1931), p. 9, from *An Essay: In Which Are Given Rules for Expressing Properly the Principal Passions and Humours* (1782).

37. William R. Taylor and Christopher Lasch, "Two Kindred Spirits: Sorority and Family in New England, 1839–1846," *New England Quarterly* 36 (March 1963): 35.

38. Quoted in Milton Rugoff, *Prudery and Passion* (New York: Putnam's, 1971), p. 61.

39. Percy Bysshe Shelley, "A Discourse on the Manners of the Ancient Greeks Relative to the Subject of Love," in *Shelley's Prose*, ed. David Lee Clark (Albuquerque: University of New Mexico Press, 1954), p. 222.

40. Johann Fichte, *Grundlage des Naturrechts nach Principien der Wissenschaftslehre von Johann Gottlieb Fichte's Sammtlische Werke*, ed. J. H. Fichte (Berlin: Veit, 1845), vol. 3, p. 336.

41. Shelley, "Notes on Queen Mab," *Works*, p. 806.

42. Friedrich von Schlegel, "Uber die Diotima," in *Friedrich von Schlegel: Seine prosaischen Jugendschriften*, ed. J. Minor (Wein: Verlagsbuchhandlung Carl Konegen, 1906), vol. 1, p. 59.

43. Schlegel, *Lucinda*, trans. Bernard Thomas in *The German Classics*, vol. 4 (Albany, N.Y.: J. B. Lyon, n.d.), p. 131.

44. Arthur Schopenhauer, "Of Women," in *Studies in Pessimism*, trans. T. Bailey Saunders (London: Swan Sonnenschein and Company, 1893).

12. Women in Colonial America

1. Mildred Campbell, "Social Origins of Some Early Americans," in James M. Smith, ed., *Seventeenth-Century America* (Chapel Hill: University of North Carolina Press, 1959), p. 74.

2. Arthur W. Calhoun, *A Social History of the American Family*, 3 vols. in 1 (reprint, New York: Barnes and Noble, 1945), p. 323.

3. Ibid., p. 324 and passim.

4. George F. Willison, *Behold Virginia: The Fifth Crown* (New York: Harcourt, Brace, 1951), p. 200.

5. William Bradford, *Of Plimoth Plantation* (Boston: Wright and Potter, 1898), pp. 285–86.

6. For a thorough discussion of laws and punishments, see Alice Morse Earle, *Curious Punishments of Bygone Days* (reprint, Detroit: Singing Trees Press, 1968), and Edwin Powers, *Crime and Punishment in Early Massachusetts, 1620–1692* (Boston: Beacon Press, 1966).

7. See, for example, Thomas Cobbet, *A Fruitful and Useful Discourse Touching the Honour Due from Children to Parents* (London, 1656), p. 18.

8. John Demos, *A Little Commonwealth: Family Life in Plymouth Colony* (New York: Oxford University Press, 1970), p. 83.

9. Thomas Parker, *The Copy of a Letter Written to His Sister* (London, 1650), p. 13.

10. John Winthrop, *The History of New England, 1630–1649*, 2 vols. (Boston: Thomas B. Wait, 1826), vol. 2, p. 216. See also Lyle Koehler, "The Case of the American Jezebels: Anne Hutchinson and the Female Agitation During the Years of Antinomian Turmoil, 1636–1640," in Jean E. Friedman and William G. Shade, *Our American Sisters: Women in American Life and Thought*, 3d ed. (Boston: D. C. Heath, 1976), pp. 18–19.

11. David Hall, ed., *The Antinomian Controversy, 1636–1638* (Middleton, Conn.: Wesleyan University Press, 1968), pp. 312, 315–16.

12. Anne Bradstreet, *The Works of Anne Bradstreet*, ed. John Harvard Ellis (New York: Peter Smith, 1932), p. 101.

13. Ibid., p. 361.

14. Julia Cherry Spruill, *Women's Life and Work in the Southern Colonies* (Chapel Hill: University of North Carolina Press, 1938), p. 15.

15. Carl Degler, *At Odds: Women and the Family in America from the Revolution to the Present* (New York: Oxford University Press, 1980), p. 180.

16. Edmund S. Morgan, "The Puritans and Sex," *New England Quarterly* 15 (December 1942): 591–607.

17. See Vern L. Bullough, "An Early American Sex Manual, or, Aristotle Who?" *Early American Literature* 7 (1973): 236–46. This is reprinted in Bullough, *Sex, Society, and History* (New York: Neale Watston, Science History, 1976).

18. Ibid., pp. 242–43.

19. Vern L. Bullough and Bonnie Bullough, *Prostitution: An Illustrated Social History* (New York: Crown, 1978), pp. 197–99.

20. For a discussion, see David H. Flaherty, *Privacy in Colonial New England* (Charlottesville: University of Virginia Press, 1972), pp. 212–13.

21. Alice Morse Earle, *Colonial Days in Old New York* (Port Washington, N.Y.: Friedman, 1962), p. 163.

22. See Elizabeth Anthony Dexter, *Colonial Women of Affairs: A Study of Women in Business and the Professions Before 1776* (New York: Houghton Mifflin, 1924).

23. William Oliver Steven, *Nantucket, the Far Away Island* (New York: Dodd, Mead, 1966), p. 103.

24. Alexander Hamilton, *Gentleman's Progress: The Itinerarium of Dr. Alexander Hamilton, 1744* (Chapel Hill: University of North Carolina Press, 1948), p. 155.

25. Anne Grant, *Memoirs of an American Lady* (New York: Dodd, Mead, 1903), pp. 114–16.

26. Mary Sumner Benson, *Women in Eighteenth-Century America* (New York: Columbia University Press, 1935), p. 276.

27. François de Chastellux, *Travels in North America in the Years 1780, 1781, 1782*, 2 vols. (London: Robinson, 1787), vol. 1, p. 120.

28. John Smith, *Hannah Logan's Courtship: The Diary of Her Lover*, ed. Albert C. Myers (Philadelphia: Ferris T. Leach, 1904), pp. 160, 222, 224.

29. Thomas Anburey, *Travel Through the Interior Parts of America*, 2 vols. (Boston: Houghton Mifflin, 1923), vol. 2, pp. 25–26.

30. Geoffrey May, *Social Control of Sex Expression* (New York: Morrow, 1931), pp. 248–49.

31. There are several accounts of bundling in America. Probably the most famous is that by Henry Reed Stiles, originally published in 1871 but available in several editions, including one under the title *Bundling: Its Origin, Progress and Decline in America* (reprint, New York: Book Collectors Association, 1934). See also C. F. Adams, "Some Phases of Sexual Morality and Church Discipline in Colonial New England," Massachusetts Historical Society, *Proceedings*, 2d series, 6 (June 1891): pp. 503–10.

32. George Francis Dow, *Everyday Life in the Massachusetts Bay Colony* (New York: Benjamin Blom, 1967), p. 118.

33. James Fordyce, *Sermons to Young Women*, 2d ed., 2 vols. (London: A. Miller and T. Cadell, 1766). The first American edition appeared in 1787.

34. This is a rather controversial subject, partly because of the political implications drawn from a rather poorly researched report by Daniel Patrick Moynihan, *The Negro Family: The Case for National Action* (Washington, D.C.: Government Printing Office, 1965). For a discussion of the various points of view and a bibliography, see Deborah G. White, "Female Slaves: Sex Roles and Status in the Antebellum Plantation South," *Journal of Family History* (Fall 1983): 248–61.

35. Robert E. Brown and B. Katherine Brown, *Virginia, 1705–1786* (East Lansing: Michigan State University Press, 1964), p. 68.

36. Thomas Anburey, *Travels*, vol. 2, pp. 342–43.

37. W. J. Cash, *The Mind of the South* (New York: Random House, 1960), p. 89.

38. Linda K. Kerber, *Women of the Republic: Intellect and Ideology in Revolutionary America* (Chapel Hill: University of North Carolina Press, 1980), p. 30. See also Mary Beth Norton, *Liberty's Daughters: The Revolutionary Experience of American Women, 1750–1800* (Boston: Little, Brown, 1980).

39. Abigail Adams, March 31, 1776, in *The Book of Abigail and John: Selected Letters of the Adams Family, 1762–1784*, ed. L. H. Butterfield, Marc Friedlander, and Mary Jo Kline (Cambridge: Harvard University Press, 1975), p. 121.

40. Paul Leicester Ford, ed., *The Writings of Thomas Jefferson*, 10 vols. (New York: G. P. Putnam, 1892–1899), vol. 5, p. 390.

41. Abigail Adams, in Butterfield et al., *Book of Abigail and John.* Judith Sargeant Murray continued the life of her husband, John Murray, in *The Life of Rev. John Murray*, new ed. (Boston: Universalist Publishing House, 1869). Katherine Susan Anthony, *First Lady of the Revolution: The Life of Mercy Otis Warren* (New York: Doubleday, 1958), see also Mercy (Otis) Warren, *History of the Rise, Progress and Termination of the American Revolution* (reprint, New York: AMS Press, 1970).

42. Spruill, *Women's Life and Work in the Southern Colonies*, p. 15.

43. E. R. Turner, "Women's Suffrage in New Jersey, 1790–1807," *Smith College Studies in History* 1 (July 1916).

44. An early account of her escapades appeared under the title *The Female Review: or, Memoirs of an American Young Lady* (Dedham: Nathaniel and Benjamin Heaton, 1797). The author was probably Herman Mann. This account was republished with an introduction and notes by John Adams Vinton (Boston: J. K. Wiggins and William Parsons Lunt, 1866). Vinton's work was republished as Extra Number 47 of the *Magazine of History with Notes and Queries* (1916). The most scholarly investigation was by W. F. Norwood, "Deborah Sampson, Alias Robert Shirtliff, 'Fighting Female of the Continental Line,'" *Bulletin of the History of Medicine* 31 (1957): 147–61. Deborah Sampson later married and in some listings can be found under the name of Deborah Gannett.

45. Kerber, *Women of the Republic.*

46. Benjamin Rush, "Thoughts upon Female Education," in *Essays, Literary, Moral, and Philosophical* (Philadelphia: Thomas and Samuel Bradford, 1798), pp. 75–92.

47. Kerber, *Women of the Republic*, p. 56.

48. Franklin's *Reflections on Courtship and Marriage* was published anonymously, and it was not until the third edition of 1758 that he was listed as the author. Franklin enjoyed women but he also tended to put them down as intellectual equals, as in his famous *Advice to a Young Man on the Choice of a Mistress*, in which he advised choosing an older woman rather than a younger one, for many reasons, including the fact that all mares looked the same in the dark. See *Satires and Bagatelles*, ed. Paul McPharlin (Detroit: Fin Book Circles, 1937).

49. Kerber, *Women of the Republic*, p. 224.

50. Sidney Ditzion, *Marriage, Morals and Sex in America* (New York: Bookman Associated, 1953), pp. 22–48.

51. Koehler, "The Case of the American Jezebels," p. 54.

13. Growth of Feminine Consciousness in the United States and Movement Toward Equality

1. Mary R. Beard, *Women as Force in History* (New York: Macmillan, 1946).

2. Lynn White, Jr., *Educating Our Daughters* (New York: Harper, 1950), p. 18.

3. For a survey of attitudes toward the single woman, see Dorothy Yost Deegan, *The Stereotype of the Single Woman in American Novels* (New York: Columbia University Press, 1951).

4. Mirra Komarovsky, *Women in the Modern World: Their Education and Their Dilemma* (Boston: Little, Brown, 1953), pp. 292–93.

5. Herbert Marcuse, *Counterrevolution and Revolt* (Boston: Beacon Press, 1972).

6. Mary Daly, *The Church and the Second Sex* (New York: Harper and Row, 1968), pp. 105ff.

7. The classic example of such a theme is Gertrud von le Fort's *The Eternal Woman*, first published in Germany in 1934. It was translated into English by Placid Jordan (Milwaukee: Bruce, 1962). Carrying the same theme was one of the best sellers of the sixties and seventies, Helen Andelin, *Fascinating Womanhood* (Santa Barbara: Pacific Press, n.d.).

8. Elizabeth Blackwell wrote her own story, *Pioneer Work in Opening the Medical Profession to Women* (London: Golancz, 1950), a popular biography. See also Elinor Rice Hays, *Those Extraordinary Blackwells* (New York: Harcourt, Brace and World, 1967), a biography of the whole Blackwell family, many of whom were active in the feminist movement.

9. George Templeton Strong, *Diary*, ed. Allan Nevins and Milton Halsey Thomas, 4 vols. (New York: Macmillan, 1952), vol. 4, p. 256 (Oct. 2, 1869).

10. Bradwell v. Illinois, 16 Wall. 130 (1873).

11. Emily Hahn has written her own history of feminism, *Once Upon a Time* (New York: Cromwell, 1974).

12. For some documents detailing the experiences of women in employment, see Gerda Lerner, *The Female Experience* (Indianapolis: Bobbs-Merrill Company, 1977), pp. 260–316. See also Sarah Slavin Schramm, *Plow Women Rather Than Reapers: An Intellectual History of Feminism in the U.S.* (Metuchen, N.J.: Scarecrow Press, 1979).

13. Richard Wright, "Man of All Work," in *Eight Men* (New York: Avon Books, 1961).

14. Margaret Fuller, "The Great Lawsuit: Man Versus Men, Woman Versus Women," *Dial* 4 (July 1843): 1–47.

15. Margaret Fuller, *Woman in the Nineteenth Century* (Boston, 1855).

16. Ralph Waldo Emerson, "Woman," a lecture read before the Woman's Rights

Convention, Boston, September 20, 1855, and reprinted in *Miscellanies* (Boston: Houghton Mifflin and Company, 1884).

17. For documents, see Lerner, *The Female Experience*, pp. 191–200.

18. Gerda Lerner, "Women's Rights and American Feminism," *American Scholar* 40 (Spring 1971): 235–48.

19. See, for example, Joan Roberts, "Pictures of Power and Powerlessness: A Personal Synthesis," in *Beyond Intellectual Sexism: A New Woman, A New Reality*, ed. Joan Roberts (New York: McKay, 1976), pp. 14–60; Mary Jo Buhle, *Women and American Socialism, 1870–1920* (Urbana: University of Illinois Press, 1981); Jo Freeman, *The Politics of Women's Liberation* (New York: McKay, 1973), p. 47.

20. See the "Pastoral Letter of the General Association of the Massachusetts (Orthodox) to the Churches Under Their Care," in Aileen Kraditor, *Up from the Pedestal* (Chicago: Quadrangle Books, 1968), pp. 49–52.

21. William L. O'Neill, *The Woman Movement* (London: Allen and Unwin, 1969), pp. 103–7.

22. The document has been widely published and is available in many collections. See Kraditor, *Up from the Pedestal*, pp. 183–88, for one such copy.

23. Charles W. Ferguson, *The Male Attitude* (Boston: Little, Brown, 1966), pp. 222–23.

24. Robert Riegel, *American Feminists* (Lawrence: University of Kansas Press, 1963), p. 25.

25. Frances Willard, *Glimpses of Fifty Years*, quoted in Leo Markum, *Mrs. Grundy* (New York: Appleton, 1930), p. 406.

26. Page Smith, *Daughters of the Promised Land* (Boston: Little, Brown, 1970), pp. 163–66. For her concern about this, see Lerner, *The Female Experience*, pp. 81–86.

27. Ellen Carol DuBois, *Feminism and Suffrage* (Ithaca, N.Y.: Cornell University Press, 1978), and Sarah Slavin, *Women and the Politics of Constitutional Principles*, a project of the American Political Science Association Task Force on Citizenship and Change, 1985.

28. See Alan P. Grimes, *The Puritan Ethic and Woman Suffrage* (New York: Oxford University Press, 1967).

29. See Andrew Sinclair, *The Better Half: The Emancipation of the American Woman* (New York: Harper and Row, 1965), pp. 208–19.

30. William Quentin Maxwell, *Lincoln's Fifth Wheel: The Political History of the United States Sanitary Commission* (New York: Longmans, Green and Company, 1956).

31. Muller v. Oregon, 208 U.S. 412 (1907).

32. West Coast Hotel v. Parrish, 300 U.S. 379 (1937).

33. See, for example, Charlotte Perkins Gilman, *Women and Economics* (reprint, New York: Harper Torchbooks, 1966), p. 164.

34. Betty Friedan, *The Feminine Mystique* (New York: Norton, 1963).

35. Schramm, *Plow Women Rather than Reapers*.

36. Bonnie Bullough, ed., *The Law and the Expanding Nursing Role*, 2d ed.

(New York: Appleton, Century Crofts, 1980). See also Lemons v. The City and County of Denver, F.2d, 22EPD 30, 852 (10th Cir. 1980).

37. Gunther v. County of Washington, 602 F.2d 882 (9th Cir. 1979).

38. R. L. Feldberg, "Comparable Worth: Toward Theory and Practice in the United States," *Signs* 10 (1984): 311–28, and R. Pear, "U.S. Panel on Civil Rights Rejects Pay Equity Theory," *New York Times*, April 12, 1985.

14. Biology, Femininity, Sex, and Change

1. Thomas Cobbet, *A Fruitful and Useful Discourse Touching the Honor Due from Children to Parents* (London, 1956), p. 25.

2. Amy Lowell, "The Sisters," in *The Poems of Amy Lowell* (Boston: Houghton, n.d.), pp. 460–61.

3. Virginia Woolf, *Orlando* (New York: Harcourt Brace Jovanovich, 1956), pp. 227, 229–30.

4. See Frederick C. Mosher, *Democracy and the Public Service* (New York: Oxford University Press, 1968).

5. For a similar but contemporary argument, see Roger D. Masters, "Explaining 'Male Chauvinism' and 'Feminism': Cultural Differences in Male and Female Reproductive Strategies," *Women & Politics* 3 (Summer–Fall 1983): 165.

6. See Robert Wiebe, *The Search for Order, 1877–1920* (New York: Hill and Wary, 1967), p. 39.

7. See Jewel L. Prestage, "Political Behavior of American Black Women," in *The Black Woman*, ed. LaFrances Rodgers-Rose (Beverly Hills, Calif.: Sage, 1980), pp. 233–45.

8. Matilda Joslyn Gage, *Women Church and State* (Chicago: C. H. Kerr, 1893).

9. *The Woman's Bible* (1893: reprint, Seattle: Coalition Task Force on Women and Religion, 1974).

10. See, for example, Mary Daly, *The Church and the Second Sex* (New York: Harper and Row, 1968), and *Gyn/Ecology: The Metaethics of Radical Feminism* (Boston: Beacon Press, 1978).

11. Sarah Slavin Schramm, *Plow Women Rather Than Reapers: An Intellectual History of Feminism in the U.S.* (Metuchen, N.J.: Scarecrow Press, 1979), pp. 33, 25–26, 28.

12. On the "expediency" as opposed to natural rights argument, see Aileen S. Kraditor, *The Ideas of the Woman Suffrage Movement, 1890–1920* (New York: Columbia University Press, 1965), chap. 3.

13. See W. E. Pusey, *The History and Epidemiology of Syphilis* (Springfield, Ill.: Charles C. Thomas, 1933); Theodore Rosebury, *Microbes and Morals* (New York: Viking Press, 1971); Vern L. Bullough, *Sexual Variance in Society and History* (reprint, Chicago, Illinois: University of Chicago Press, 1980), pp. 552f.

14. Bullough, *Sexual Variance*, pp. 496–99; Vern L. Bullough, "Sex and the Medical Model," *Journal of Sex Research* 11 (1975): 291–303; Vern L. Bullough,

"Homosexuality and the Medical Model," *Journal of Homosexuality* 1 (1975): 97–116. Both of these last articles are reprinted in Bullough's *Sex, Society and History* (New York: Science History, Neale Watson, 1976).

15. Tissot's work was originally published in Latin in 1758 but was widely translated. For English readers, see S. A. D. Tissot, *Onanism: or, A Treatise upon the Disorders of Masturbation*, trans. A. Hume (London: J. Pridden, 1766).

16. Sylvester Graham, *Lecture to Young Men* (1834; reprint, New York: Arno Press, 1974), pp. 32–33.

17. Mrs. Elizabeth Osgood Goodrich Willard, *Sexology as the Philosophy of Life* (Chicago, 1867), pp. 306–8.

18. William Acton, *The Functions and Disorders of the Reproductive Organs in Childhood, Youth, Adult Age, and Advanced Life Considered in Their Physiological, Social, and Moral Relations*, 5th ed. (London: J. and A. Churchill, 1871).

19. William Acton, *Prostitution, Considered in Its Moral, Social and Sanitary Aspects* (London: John Churchill, 1857), p. 20.

20. George M. Beard, *Sexual Neurasthenia, Its Hygiene, Causes, Symptoms, and Treatment with a Chapter on Diet for the Nervous*, ed. A. D. Rockwell (New York: E. B. Treat, 1884).

21. William Sanger, *A History of Prostitution* (New York: Harper, 1858), pp. 488–89.

22. *Mother Earth*, January 1910, quoted in Alix Shulman, *To the Barricades: The Anarchist Life of Emma Goldman* (New York: Thomas Y. Crowell Company, 1971), p. 165.

23. William Acton, *Prostitution*, p. 15.

24. John Ware, *Hints to Young Men on the Relation of the Sexes* (Boston: A. Williams, 1879).

25. Daniel Scott Smith, "The Dating of the American Sexual Revolution: Evidence and Interpretation," in *The American Family in Social-Historical Perspective*, ed. Michael Gordon (New York: St. Martin's Press, 1973), pp. 321–35.

26. C. Thomas Dienes, *Law, Politics, and Birth Control* (Urbana: University of Illinois Press, 1972).

27. Vern L. Bullough, "A Brief Note on Rubber Technology and Contraception: The Diaphragm and the Condom," *Technology and Culture* 22 (1981): 104–11.

28. Ibid., p. 106.

29. John Peel and Malcolm Potts, *Textbook of Contraceptive Practice* (Cambridge: Cambridge University Press, 1969), p. 4.

30. Vern L. Bullough and Bonnie Bullough, *Sin, Sickness, and Sanity: A History of Sexual Attitudes* (New York: New American Library, 1977), pp. 91–117.

31. See Margaret Sanger, *Motherhood in Bondage* (1928; reprint, Elmsford, N.Y.: Maxwell Reprint, 1956).

32. Frederick Marryat, *A Diary in America* (New York: Knopf, 1962), pp. 273–74, 419.

33. Frances Trollope, *Domestic Manners of the American*, ed. Donald Smalley (New York: Vintage Books, 1949), p. 136.

34. Ibid., pp. 137–38.
35. Anthony Trollope, *North America* (London: Chapman and Hall, 1862), p. 400.
36. Emanie Sachs, *The Terrible Siren* (New York: Harper, 1928), p. 63.
37. Page Smith, *Daughters of the Promised Land* (Boston: Little, Brown, 1970), pp. 163–65.
38. Charlotte Perkins Gilman, *Women and Economics* (New York: Harper, 1966), pp. 65–66.
39. Edward H. Clarke, *Sex in Education: or, A Fair Chance for Girls* (Boston: James R. Osgood and Company, 1874), pp. 37–38.
40. Ibid., pp. 40–41.
41. Celia Duel Mosher, "Normal Menstruation and Some of the Factors Modifying It," *Johns Hopkins Hospital Bulletin* 12 (1901): 178–79.
42. Celia Duel Mosher, *Woman's Physical Freedom* (New York: Woman's Press, 1923), pp. 1, 29.
43. Charles Nelson Gattey, *The Bloomer Girls* (New York: Coward-McCann, 1968).
44. Mary Walker has often been the subject of study. The only full-length biography of her is by Charles McCool Snyder, *Dr. Mary Walker* (New York: Arno Press, 1974). For other descriptions, see Lidya Poynter, "Dr. Mary Walker—Pioneer Woman Physician," *Medical Woman's Journal* 53 (October 1946): 10; James A. Brussel, "Pants, Postage and Physic," *Psychiatric Quarterly Supplement* 35 (1961): 322–34 (this publication is hostile to Walker). See also Linden F. Edwards, "Dr. Mary Edwards Walker (1832–1919): Charlatan or Martyr?" *Ohio State Medical Journal* 4 (1867): 314–16, 5 (1867): 167–70. A popular account, "Dr. Mary Walker's Eccentric Dress Drew Attention from Her Real Achievements," *Literary Digest*, March 15, 1919, is interesting. See also Bullough, *Sexual Variance*, pp. 597–99.
45. Cited in Stewart H. Holbrook, *Dreamers of the American Dream* (Garden City: Doubleday, 1957), p. 187.
46. Loretta Janeta Valezquez, *The Woman in Battle*, ed. C. J. Worthington (Hartford, Conn.: T. Belknap, 1867).
47. See, for example, Roseanne Smith, "Women Who Wanted to Be Men," *Coronet* (September 1957): 62–64; C. J. S. Thompson, *Mysteries of Sex: Women Who Posed as Men and Men Who Impersonated Women* (London: Hutchinson, n.d.), pp. 139–52.
48. Mary Chaney Hoffman, "Whips of the Old West," *American Mercury* 84 (April 1957): 100–10.
49. For a discussion of the various Mountain Charley's and the biographical account of two of them, see Mrs. E. J. Guerin, *Mountain Charley: or, The Adventures of Mrs. E. J. Guerin, Who Was Thirteen Years in Male Attire*, intro. Fred W. Marzulla and William Kostka (Norman: University of Oklahoma Press, 1968).
50. *New York Times*, July 26, 1970; *Los Angeles Times*, February 21, 1982. For a more complete discussion, see Vern L. Bullough and Martha Voght, "Women, Menstruation, and Nineteenth-Century Medicine," *Bulletin of the History of*

Medicine 47 (1973): 66–82, reprinted in Bullough, *Sex, Society and History,* pp. 133–49.

51. Estelle Ramey, "Men's Cycles," *MS.* (Spring 1972): 8–15.

52. Judy Barret Litoff, *American Midwives: 1866 to the Present* (Westport, Conn.: Greenwood Press, 1978). For others, see Jane B. Donegan, *Women and Men Midwives: Medicine, Morality and Misogyny in Early America* (Westport, Conn.: Greenwood Press, 1978); Catherine M. Scholter, "'On the Importance of the Obstetric Art': Changing Customs of Childbirth in America, 1760–1825," *William and Mary Quarterly,* 3d series, 34 (1977): 426–45.

53. Vern L. Bullough and Sheila Groeger, "Irving W. Potter and Internal Podalic Version: The Problem of Disciplining a Skilled but Heretical Doctor," *Social Problems* 30 (October 1982): 109–16.

54. Charles Darwin, *The Descent of Man,* 2d ed. rev. (London: John Murray, 1874), part 3, chap. 19.

55. Friedrich Nietzsche, *Thus Spake Zarathustra* (1883), trans. Thomas Common, reprinted in *Philosophy of Nietzsche* (New York: Modern Library, 1954).

56. Sigmund Freud, *New Introductory Lectures on Psycho-Analysis* (reprint, New York: Norton, 1964), includes his essay on femininity. Various essays on the subject can also be found in his *Collected Papers,* ed. Joan Reviere (New York: Basic Books, 1959), and in the standard edition of the *Complete Psychological Works* (London: Hogarth Press, 1953). See also Freud, *Civilization and Its Discontents,* trans. James Strachey (New York: Norton, 1961). For a criticism of Freud's misogynism, see Kate Millet, *Sexual Politics* (Garden City: Doubleday, 1970).

57. Carroll Smith-Rosenberg, "The Female World of Love and Ritual: Relations Between Women in Nineteenth-Century America," *Signs* 1 (1975): 1–30.

58. Griswold v. Connecticut, 381 U.S. 479 (1965).

59. Eisenstadt v. Baird, 405 U.S. 438 (1972).

60. Carey v. Population Services International, 97 S. Ct. 2010 (1977).

61. See Lois Scharf, *To Work and to Wed: Female Employment, Feminism, and the Great Depression* (Westport, Conn.: Greenwood Press, 1980).

62. See Ferdinand Lundberg and Marynia F. Farnham, *Modern Woman: The Lost Sex* (New York: Harper and Brothers Publishers, 1947); Marie N. Robinson, *The Power of Sexual Surrender* (New York: A Signet Book, 1959); Dee Garrison, "Karen Horney and Feminism," *Signs* 6 (Summer 1981): 672.

63. See also Raymond B. Agler, "Problem Books Revisited," *Book Selection and Censorship in the Sixties* (New York: R. R. Bowker Company, 1969), pp. 75–90.

64. Carl Degler, *At Odds: Women and the Family in America from the Revolution to the Present* (New York: Oxford University Press, 1980), pp. 457–58.

Postscript

1. Adrienne Rich, *Of Woman Born* (New York: Bantam Books, 1981).

2. Judy Chicago, *The Dinner Party: A Symbol of Our Heritage* (Garden City: Anchor Books, 1979).

Notes to Page 314

3. Andrea Dworkin, *Pornography: Men Possessing Women* (New York: Putnam, 1981).

4. Part of this is based upon a provocative article by Marcia Pally, "X-Rated Feminism: Ban Sexism, Not Pornography," *The Nation* 240 (June 29, 1985): 794–97.

Bibliographical Note

$$T$$hroughout this study we have tried
to cite the sources utilized as well as note some of the available second-
ary and reference materials. By no means, however, are these references
complete, nor do they represent the only books and articles consulted.
During the past decade, a literal explosion of materials has occurred, so
much so that it has become impossible for any one person or any three
persons to read it all. Nearly every journal one picks up has an article or
articles giving new insights into the women of the past, and gradually
some of this material is working its way into general texts. Most profes-
sional historical and literary groups have developed subsections dealing
with women such as Women in Technological History (WITH) of the
History of Technology Group.

In fact, one of the major differences between this book and its prede-
cessor published is the vast outpouring of materials. Where *The Subor-
dinate Sex* of 1973 could have been regarded as a pioneering overview of
women in history, this book will be just one of many published this year
that deal with the general topic of women, even though its emphasis on
attitudes still makes it more or less unique.

The best way to keep up with the outpouring of studies is to follow
Women's Studies Abstracts, which grows thicker and thicker with each
issue and year. There are a number of specialty journals such as *Femi-
nist Studies, Frontiers, Hecate, Heresies, International Journal of Wom-
en's Studies, Lilith, New Directions for Women, Quest, Psychology of
Women Quarterly, Signs, Women and Politics, Women and History,*

361

Bibliographical Note

Women and Literature. Many other journals have articles on women, and in historical studies women's history is one of the richest and most exciting areas. We would urge the readers of this book to sample for themselves. The various references cited in the notes together with a perusal of some of the journals would offer a good start.

Index

Index

Index

Index

Index

Index

Index

Index

CPSIA information can be obtained
at www.ICGtesting.com
Printed in the USA
LVHW03s2112120718
583544LV00002B/262/P